Sources of architectural form

Sources of architectural form provides a critical history of Western architecture theory from the ancient world to the present day. It looks at how the architect generates architectural form in order to explain a number of issues, including the origins of style, the persistence of tradition, and the role of genius.

This book describes the major design theories in eight chronological periods, conveying their flavour with contemporary quotations. Each theory is analyzed for its strengths and weaknesses. Gelernter identifies an important relationship between theories of design and theories of knowledge and explains and analyses each period's dominant epistemological concepts.

The contemporary theories of education are also examined, as many theorists from Vitruvius to Gropius included precepts for teaching as integral components of their ideas.

Despite a long history of creative thinking about the sources of design ideas, no theory emerges a clear winner.

Mark Gelernter is a Professor of Architecture in the College of Architecture and Planning at the University of Colorado.

To George, Wendie, Ben, Janet
and, most of all, Alexander

Sources of architectural form

A critical history of
Western design theory

Mark Gelernter

Manchester University Press

Manchester and New York

Distributed exclusively in the USA and Canada by St Martin's Press

Copyright © Mark Gelernter 1995

Published by Manchester University Press
Oxford Road, Manchester M13 9NR, UK
and Room 400, 175 Fifth Avenue, New York, NY 10010, USA

Distributed exclusively in the USA and Canada
by St Martin's Press, Inc., 175 Fifth Avenue, New York, NY 10010, USA

British Library Cataloguing-in-Publication Data
A catalogue record for this book is available from the British Library

Library of Congress Cataloging-in-Publication Data
Gelernter, Mark, 1951–
 Sources of architectural form: a critical history of Western
design theory/Mark Gelernter.
 p. cm.
 Based on a thesis (doctoral)—Bartlett School of Architecture and
Planning, University College, London.
 Includes bibliographical references.
 ISBN 0–7190–4128–7.—ISBN 0–7190–4129–5 (pbk.)
 1. Architectural design—History. I. Title.
NA2750.G45 1995
720'.1—cd20 94–12283
 CIP

ISBN 0–7190–4128–7 *hardback*
 0–7190–4129–5 *paperback*

Typeset in Great Britain
by Northern Phototypesetting Co Ltd, Bolton

Printed in Great Britain
by Redwood Books, Trowbridge, Wiltshire

Contents

Figures

Acknowledgements

The ideas in this book originated in my doctoral dissertation for the Bartlett School of Architecture and Planning in University College London, England. The Bartlett School has a strong tradition of innovative thinking about architectural design theory and education, beginning with Lord Richard Llewelyn Davies's bold vision in 1960 of a multi-disciplinary education for architects, and Dr Jane Abercrombie's pioneering studies in the psychology of design education. Although these two were no longer in the School when I began my studies, I was fortunate to work with those who continued the Bartlett heritage. I crossed the Atlantic to participate in this tradition, and I stayed for over a decade to study and then to teach. I offer my gratitude to the Bartlett for the intellectual nourishment I received.

Among my former colleagues in London, I owe the greatest debt to Professor John Musgrove and Professor Bill Hillier, who developed a 'Copernican Revolution' in our philosophical understanding of the designing activity. Their work provided the essential clues I needed to help unravel some of the confusion in Western design theory. Additionally, Professor Musgrove not only supervised my dissertation, but also later engaged me to illustrate his edition of Sir Banister Fletcher's History of Architecture. I learned a great deal about history while treading in the footsteps of Sir Banister.

I would also like to thank Professor Newton Watson, the former Head of the Bartlett School, for his continued and sympathetic support. I enjoyed many conversations on new educational thinking with Professor Martin Symes. Before he left for Princeton, Professor Robert Maxwell expanded my appreciation of cultural influences on architectural thinking. Robert Fisher helped me understand the relative merits of the Beaux-Arts and Modernist educational ideas. I gained much

from discussions with Dr Philip Tabor, whose feeling for – and creative control of – the educational experience in the design studio is surpassed by no one. Dr Mark Swenarton usefully commented on several drafts from his own special perspective on history. Teaching with Dr Julienne Hanson helped me see the educational implications of the Bartlett's architectural research unit.

On returning to the United States, Dean Raymond Studer gave me unbridled opportunities to test a new educational structure based on some of the themes in this book. Dr Willem van Vliet graciously helped move this book towards publication. From our first meeting in the Bartlett, Professor Robert Gutman continues to lend his support and thoughtful advice. I am indebted to Dean Robert Harris, who offered a number of helpful comments on an early draft that helped give the book its present shape. Through joint projects and her boundless enthusiasm for clarifying our modern educational theories, Dr Frances Downing helped me think more rigorously about a number of philosophical issues. Joint projects and discussions with Gordon Brown also helped me dig more deeply into design and education theory. For teaching me more than I probably taught them, I will always remember my students on both sides of the Atlantic, particularly Robert Mull, Kathryn Piotrowska, Robert Wood, Zehan Albakri, Stephen James, Joanna Downs, Jason Fournier, Cameron Kruger, Juana Gomez, Terry Mulholland, Stefan Hampden, Dean Lindsey, Nancy Lands and Robin Manteuffel.

I thank Professor Roger Stonehouse for his crucial role in getting this book to press. I additionally owe a great deal to Katharine Reeve, the Arts editor at Manchester University Press, for her enthusiastic support of this project and wise guidance through the publishing process. Lynn Lickteig and Carole Cardon provided superb photographic support. Finally, I offer my enduring gratitude to my wife Janet, who provides a continuing perspective on another culture, and without whose editorial help I would never have expressed these ideas as clearly.

1

Introduction

The central problem of design theory

This book examines the history of Western design theory from the ancient world to the present. Design theory encompasses a wide variety of subjects, from describing the essence of beauty to asserting the social and political consequences of the building layouts. Comprehensive coverage of all of these issues is beyond the scope of a single volume. Instead, this book will focus on a particular issue that lies at the core of design theory: what is the source of an architect's design ideas? At the beginning of the design process the architect possesses only a random collection of information, requirements, intentions and assumptions, and then suddenly on the drawing board appears a proposal for a building form. How is this idea generated, what influences its shape, from what is it derived?

This is a central question for design theory for a number of reasons. For architects, this is the key issue at the heart of their practice. Faced with the daunting task of conceiving a building form, should one first study the functional requirements, or manipulate a geometrical system, or give expression to inner intuitions? During this critical and almost magical stage of creating something apparently out of nothing, architects have naturally desired a set of normative principles that could guide their activities. Many theories about the source of form were developed entirely to help govern architectural practice, and much practice subsequently derived from these theories.

This question about the source of form is equally central to theories in other fields from art and architectural history to anthropology. Although these other fields are not concerned with creating building forms themselves, many wish to explain interesting social and historical phenomena which are manifested in the built environment. Why, for example, do most of the buildings created by a given culture –

even though they are designed at different times by different individuals – possess so many similar features that they can be said to share a style? And if one can explain the forces which usually constrain architects to work within a shared approach most of the time, how can one explain the apparently sudden changes in architectural styles as, for example, from the Gothic to the Classical in Renaissance Italy? Furthermore, why do some buildings clearly reflect the prevalent values of the cultures that built them, while others anticipate cultural values which only emerge later? Many theories about cultural stability, change, replication and promulgation appeal to built form as evidence, and this in turn demands some conception of how the designers created these forms.

We will explore, then, what important theorists from the ancient world to the present have offered as the source of architectural form. We will examine what each theorist asserted, and analyze the merits and shortcomings of these ideas in several areas. First of all, are the ideas consistent within themselves? We will see that more than a few noted design theorists in history proposed theories that were internally contradictory. If we accept one part of the theory, we cannot logically accept the other. Secondly, do the theories adequately account for the reality of the built environment? If architects really did design as described by the theory, would the resulting built environment take its present form? We will find a few theories that, if true, could not possibly have generated the buildings or patterns of styles and stylistic changes in our architectural heritage. This criticism will refrain wherever possible from offering normative judgements of the theory; that is, we will not consider whether architects ought to design according to the precepts of a particular theory. Whether buildings ought to look like machines, as Gropius insisted for example, will be left for the reader to decide.

We will also examine these theories within the broader context of the history of Western philosophy. Architectural theorists did not invent their theories in a vacuum, but rather inherited from their cultures a number of attitudes, methods and even specific philosophies that shaped their ideas about the source of form. Contemporary theories of art often exerted the most obvious influence, and we will examine these where appropriate. Equally, the design theories often took ideas from the theories of knowledge, or epistemology, with which they were contemporary. Some theories of design, we will see, are nothing more than theories of knowledge in another guise. Other design theories borrowed from epistemology specific conceptions of the mind and its processes. Yet other design theories consciously react-

ed against their society's dominant conception of knowledge. The relationship between theories of knowledge and theories of creation is pervasive and fundamental, and we will examine it in some detail throughout the book. Finally, all of the theories of art, knowledge and design took shape under the influence of a prevailing set of cosmological beliefs, those most basic views in a culture about the nature of the world, the nature of humans and their abilities, and the relationships between the two. These beliefs changed far less frequently than the numerous design and epistemological ideas that we will explore. But at a few critical periods in the history of the West the cosmological system changed so dramatically that it completely redirected subsequent philosophy. We will examine these important changes where necessary.

This book will also examine the theories of design education that often accompanied the theories of design. The two are closely linked. A number of important design theorists worked in educational institutions and wrote their theories explicitly to help their students learn how to design. Others wrote mainly for an audience of architectural practitioners, but saw the educational implications of their ideas. For whatever reason, theorists from Vitruvius to Gropius often presented their theory of design and their theory of education together, as one coherent package. It helps to understand the one by examining the other.

Theories of form

The following eight chapters explore the major Western theories of design, knowledge and education in chronological order, each chapter addressing a significant historical period. Before launching into this chronological sequence, however, it is worth taking a broad view of what is to come. Curiously, although many theorists in many different cultures generated a rich variety of ideas on our central theme, they tended to work out variations on five basic ideas. Ranging from the notion that forms are generated within the creative imagination to the notion that they derive from function and climate, these five provide the conceptual foundations for most of the historical theories that this book will examine.

Theory 1: An architectural form is shaped by its intended function. According to this view, the form of a good building is shaped by the various physical, social, psychological and symbolic functions it is expected to perform.[1] The ideal shape of a concert hall, for example,

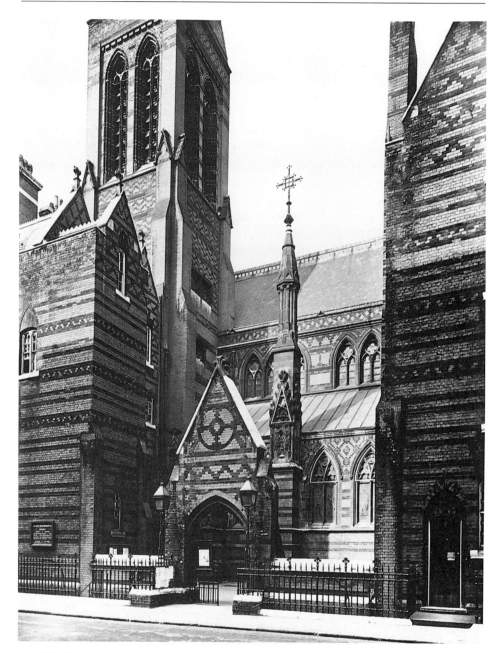

1 All Saints, Margaret Street, London, England, 1849–59. William
Butterfield. Form follows function? Although functionally equivalent to
Figure 2, this building possesses an entirely different style.

2 *facing* St Pancras, London, England, 1822–24. W. & H. W. Inwood.

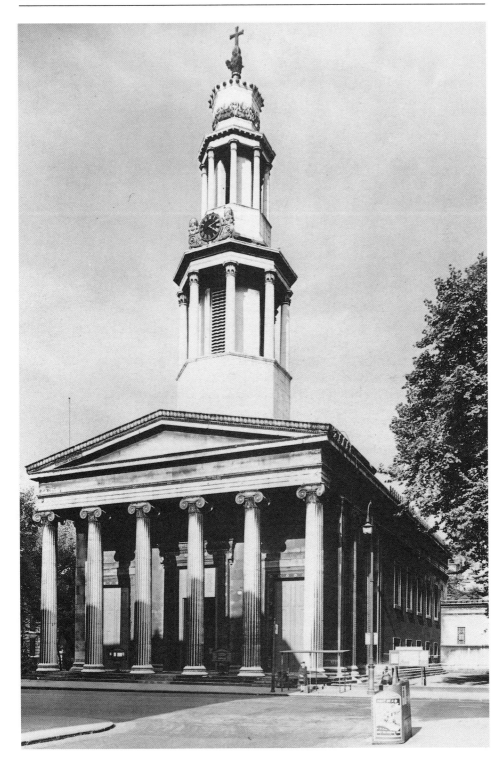

should be generated by setting out uninterrupted sight lines for every spectator; the shape and location of the foyers should be determined by the flow of people to and from their seats; and the outside appearance should be shaped by the symbolic role of a concert hall as a focus of civic pride.

According to this view, the ideal architectural form is already latently contained in the information about the client's needs, climatological conditions, community values, and so on, waiting to be discovered by the diligent designer. Those who have asserted this view claim that the designer must be like a scientist, because both are concerned with finding some form in a body of pre-existing 'facts'. According to Christopher Alexander, just as the scientist avoids preconceptions, gathers together the objective 'facts' about nature, analyses them for possible underlying regularities and then induces a general law, so the designer in this view avoids preconceptions, gathers together the objective 'facts' about the design problem, analyses the inherent form implications, and then draws out (synthesizes) the final building form.[2] In both cases, personal values or dispositions are intentionally put aside as the scientist/designer rationally discovers that which already exists. The designer in this view is little more than a mechanism by which a predetermined form is discovered.

Good buildings are, of course, shaped to a considerable extent by the functions they must satisfy; but as the sole description of how a building form is invented this does not tell the entire story. If function were the sole determinant of form, one would expect every building performing the same function in the same place to take the same form, and clearly this does not happen. Throughout Europe and America one can find examples of Gothic, Classical and Modernist churches in the same city, with the same climate, and meeting equally well the same functions, but all possessing quite different appearances (Figures 1, 2).

Furthermore, if designing a building involved nothing more than satisfying functional requirements, one would expect to find no evidence of the particular architect's personality in the solution, just as one would not expect to find evidence of a particular mathematician's hand in the solution of a quadratic equation. Yet buildings do show the imprint of the architect's personality, to the extent that historians can often guess a building's author by the idiosyncratic characteristics of its massing, form and detailing. If one looks at the collected works of any given architect, one will inevitably find certain similar preoccupations or themes running through many of his or her buildings, even though the buildings may have been designed for quite different

functions and climates. The theory of function alone cannot explain these other influences on the buildings' forms.

Theory 2: Architectural form is generated within the creative imagination. According to this theory, an idea for an architectural form originates within the inner resources or intuitions of the designer. The architect draws upon a special feeling for form, or puts old ideas together in a new and unprecedented way, so that an original form never before seen magically blossoms in the brain and emerges from the pencil. Good designers claim to experience this feeling, historians and critics claim to see individual 'genius' in some architectural works, and educators talk of 'innate talent' for design in some students, but the exact source of form is not clear and indeed seems to defy rational explanation. What all proponents of this theory agree is that this source is somehow dependent upon the individual personality of the designer, and that some designers have a greater gift for employing this source than others. According to most versions of this theory, while the designer does attempt to meet the functional requirements of the design project while drawing upon these inner resources, this source can be distorted and crushed by too many outside constraints like an unusually tight budget or a difficult site.

This theory also seems partly true. Some designers clearly possess a more sensitive feeling for form and manage to invent more original forms than others. This theory also explains why the collected works of any given architect show recurring themes despite the individual buildings' different functional requirements; the similarities derive from the forms originating within the same personal resources. But this theory on its own is also unsatisfactory. If every building were indeed an individual expression of its designer's personal inner creative urges and resources, then one would expect to find in the collected works of a society considerable variety in all of its building forms, in the same period as well as over several generations. Yet clearly it is possible to discern distinct similarities, or patterns, in the output of architects. Our ability to classify buildings as Renaissance, or Gothic Revival, or Post-Modern, shows how architects working at the same time tend to use shared ideas about form (Figures 3, 4). And the recurring use of generic forms like the basilica plan, or the courtyard, or the atrium in many periods and styles shows how some ideas are shared by many generations. While the existence of shared ideas does not necessarily invalidate the theory of creative expression, the theory on its own does not explain how these shared notions influence individual minds. Do these patterns result from similar wiring in every human mind, or from ideas unconsciously acquired in one's own cul-

ture? If so, how is it that different designers use these shared resources differently? The theory of creative invention does not tell us.

Theory 3: Architectural form is shaped by the prevailing Spirit of the Age. In an attempt to solve the last problem, this theory posits the existence in every age of a certain spirit, or set of shared attitudes, which pervades all of its cultural activities and sets a particular stamp on its artistic creations. No matter how much an individual designer might think he is following personal creative urges, this view holds that his work will unconsciously respond to the world-view, sense of taste, and artistic values he inevitably shares with his fellow designers. To a considerable extent, the source of his design ideas is to be found 'in the air' around him. So even though his work may exhibit individual characteristics which can be attributed to his personal skill, it will also display overriding characteristics which readily identify it as originating in the Renaissance, or the Gothic Revival, or Post-Modernism.

The evidence of built form does suggest that designers at any given time share certain ideas which infuse their work; but as a theory about the source of form, the concept of a Spirit of the Age leaves several puzzling problems. First of all, what exactly is this invisible and shared Spirit which shapes individual actions? Is it simply the sum total of all the individuals' actions, or is it something more difficult to explain like a common psychological urge or even a divine force? Secondly, while the existence of such a Spirit might help explain the continuity of a design approach, or style, in any given age, how does it explain the sudden changes in style from one age to the next? That is, if the designers are under the coercive influence of the prevailing Spirit, how are some designers able to step outside the Spirit and to create a new style apparently in advance of what later will become the new prevailing Spirit?

Thirdly, how does this idea explain that some ages would appear to possess several Spirits simultaneously? At the turn of the century, for example, one Spirit extolling the virtues of the future Modern Age showed itself emerging in the work of the Modernist pioneers like Peter Behrens and Walter Gropius, while another Spirit extolling the virtues of great ages past showed itself in the works of Edwardian architects like Sir Edwin Lutyens and Herbert Baker. Now if the Spirit of an Age is simply a descriptive summary of all the prevailing architectural tendencies, one would have to search for some formula that would simultaneously incorporate both Behrens and Lutyens, which historians of the Spirit persuasion have never managed to do. Instead, proponents of this theory are usually inclined to plump for one at the

3 Skyline Tower, Hamburg, Germany, 1985. Coop Himmelbau. Shared spirit of the age? This and Figure 4 illustrate how architects responding to different functional requirements none the less often share certain stylistic interests.

4 Parc de la Villette, Paris, France, 1984–. Bernard Tschumi.

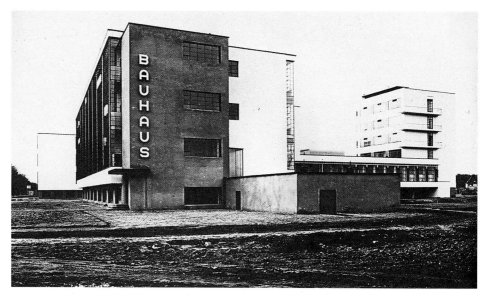

5 The Bauhaus, Dessau, Germany, 1926. Walter Gropius. The selective
spirit: compared to Figure 6, which building 'correctly' expressed the spirit
of the early twentieth century?

6 Viceroy's House, New Delhi, India, 1912–31. Sir Edwin Lutyens.

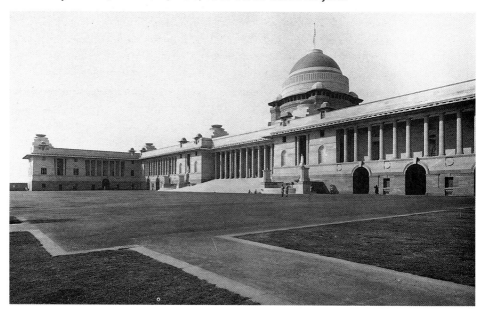

expense of the other. In his history of Modern design, for example, Sir Nikolaus Pevsner dismissed as inconsequential the later Classical designs of Sir Edwin Lutyens, because they did not follow Pevsner's concept of the emerging twentieth century Spirit (Figures 5, 6).[3] If the Spirit of an Age truly exerts a coercive influence over the artistic efforts of all the individuals within the age – as it must do in order for the theory to work – how can there be designers who fail to follow its direction? The only possible explanation is that there are several Spirits from which a designer must choose, and then this freedom of choice contradicts the basic premise of the entire theory.[4]

Theory 4: Architectural form is determined by the prevailing social and economic conditions. Like the theory of the Spirit of the Age, this theory asserts that all individual artistic efforts fall under the coercive influence of larger shared forces; but where the theory of a Spirit attributes this coercive influence to non-physical forces like a shared psychological urge, this theory attributes the influence to more physical conditions like the methods of economic production and distribution prevalent in the architect's society. By virtue of living in any given society, an architect will unconsciously acquire that society's underlying ideological assumptions, and as his design emerges on the drawing board these assumptions will colour its development. The building design, according to the proponents of this view, becomes a mirror of the architect's social reality. So Levau's and Hardouin-Mansart's grandiose and formally symmetrical forms for the palace of Versailles can be seen as a reflection of the hierarchical social order in seventeenth-century Absolutist France, while Frank Lloyd Wright's asymmetrical yet grand early Prairie houses can be seen as a reflection of the primacy of the individual in twentieth-century democratic America (Figures 7, 8).

Unfortunately, it is almost impossible to find a one-to-one correlation between a socio-economic system and the building forms it is claimed to have shaped. The same basic Classical forms used in seventeenth-century France were also popular in times and cultures as diverse as those of Imperial Rome, Renaissance Italy, Britain and America, and Prussia (Figures 9, 10). And conversely, in the same socio-economic system one can find quite different architectural forms created side by side as, for example, in the stylistic battle in early nineteenth-century Britain between the Classical and the Gothic (Figures 1, 2). The similarities of form in different social systems might be explained by identifying some important factor common to all of these social systems, but then one is forced to play down the quite different characteristics of these various ages, which defeats the

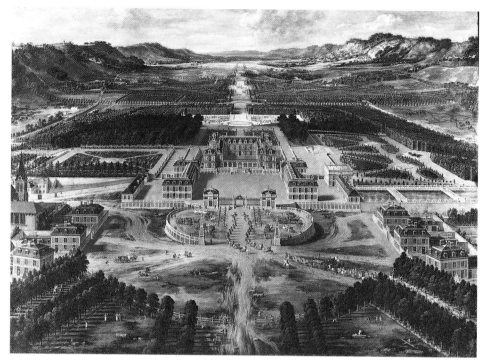

7 Perspective view of Versailles, France in 1668. Le Vau, Mansart, Gabriel. Drawing by Pierre Patel. Form follows social conditions? Is this building an inevitable expression of the Absolutist monarchy in seventeenth-century France?

8 Robie House, Chicago, Illinois, 1909–10. Frank Lloyd Wright. Is this building an inevitable expression of twentieth-century democracy in the United States?

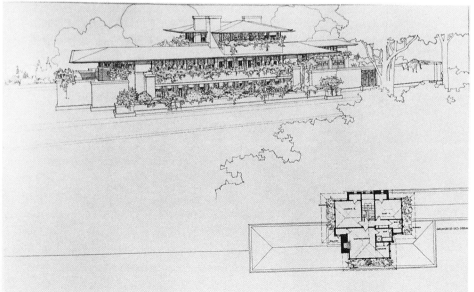

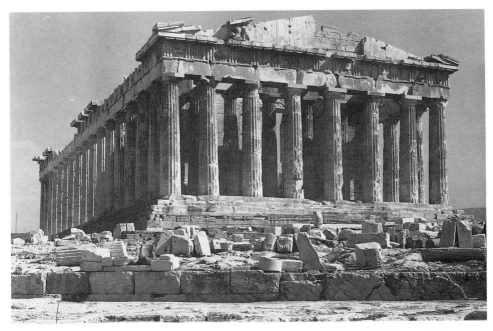

9 Parthenon, Athens, Greece, 447–436 BC. Ictinus and Callicrates. If form follows social and economic conditions, then how did the same form appear in Periclean Athens and Napoleonic Paris? (Compare with figure 10.)

10 The Madeleine, Paris, France, 1804–49. Pierre Vignon.

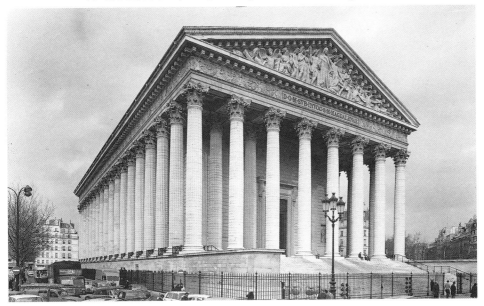

point of the theory. The differences of form in the same social system
might be explained by highlighting different nuances in the society –
for example, Pugin's passionate Catholicism might explain his choice
of the Gothic over the Classical – but then we are back into the same
problem as in the Spirit theory: how is the individual able to choose
the social system to which he will respond, if the social system exerts
a coercive influence over the individual in the first place?

Furthermore, the evidence of history suggests that changes in archi-
tectural ideas often precede social or economic changes, not the other
way around. Emil Kaufmann has noted what he calls the 'precocity of
the architectural phenomenon':

> This means that the architectural transformation goes ahead of the cor-
> responding and related changes in general thought and in social struc-
> ture. In the late eighteenth century there was a revolution in
> architectural thinking long before the revolution proper broke out.
> Similarly in the seventeenth century the endeavours of Italian and
> French architects to set up a new architectural system came before
> Louis XIV established the new order in the state, and before the great
> metaphysical systems of the Baroque ... The Renaissance in the arts
> was prior to the movement of the Reformation; and the architectural
> upheaval about 1900 preceded the political crises of the twentieth cen-
> tury.[5]

Like the functionalist and the Spirit theories, this theory also has
difficulty explaining the stamp of the designer's personality on a build-
ing form. Proponents of this view are so keen to show how a given
social and economic system engenders a certain building design that
they sometimes speak as if the building naturally and inevitably
emerges from the social system all by itself, without the aid of a
designer. At most, the designer is considered to be merely the mecha-
nism by which the social conditions express themselves in building
form. Even if one were to concede that characteristics in individual
buildings might be due in some way to idiosyncratic skills in the
buildings' designers, this theory cannot explain how these skills mingle
or jointly act with the larger forces of the social system.

*Theory 5: Architectural form derives from timeless principles of form
that transcend particular designers, cultures and climates.* Where the
theories discussed so far stress the uniqueness of individual buildings,
this theory suggests that certain universal forms underlie all good
architecture, no matter what the particular circumstances of the design
problem, designer or culture. According to one version of this theory,
the theory of types, there are certain architectural forms like the basi-

lica, the courtyard, or the atrium, that derive logically from the geo-
metrical possibilities of building form, and that provide the underlying
basis for many different stylistic versions of that type. For example,
the basilica type with its high central nave and lower side aisles has
provided the essential organizing principle for ancient Roman law
courts, Romanesque churches, Gothic cathedrals, and a Wildlife
Center by Michael Graves (Figures 11, 12). By basing one's designs on
one of these universal types, it is argued, one can ensure that everyone
will appreciate its timeless beauty and that everyone will understand
immediately how to use it. For example, one would expect to find the
main front door in the end of a basilica plan because this is now
assumed to be an essential characteristic of the type (even though his-
torically the entrance moved from side to end).

Another version of this theory looks not to whole forms, but to
general principles of form which are even more abstract and universal-
ly applicable than types. For many centuries these principles were
thought to be embodied in the five Orders of architecture (Tuscan,
Doric, Ionic, Corinthian, Composite), each of which set out specific
rules for the proportions of columns and the spaces between them, the
proportions of entablatures relative to the columns, and the details of
embellishment and ornament for the complete ensemble (Figure 13).
Starting with one of these systems, it was thought, the designer could
create any number of new building types, each of which still obeyed
the essential characteristics of good design. More recently, some theo-
rists have set out universal principles of abstract visual form – rhythm,
proportion, scale, contrast, colour, and so on – which they claim lie
behind all visual form, including painting, drawing, sculpture, archi-
tecture and film. Like the five Orders but even more universally appli-
cable, knowledge of these principles enables the designer to create an
endless variety of visual forms, all of which still obey universal rules.[6]

Taking the theory of types first, while this might explain how simi-
lar architectural forms are used by many generations in many different
cultures and climates, it does not explain how the abstract types are
clothed in their particular styles as architects put them to use. The dif-
ferences between a Gothic cathedral and Michael Graves's Wildlife
Center are as interesting as their similarities, but this theory does not
explain how they came to be so different given the same typological
starting-point. Furthermore, how are new types – like skyscrapers or
multi-storey top-glazed atria – first invented? Presumably architects
adapt old types for new purposes, but this theory does not explain
how. And if architectural types are continually changing over time by
this unspecified procedure of adaptation, to what degree can one still

11 Basilica Nova of Maxentius, Rome, c. 313 AD. Universal architectural types? Despite different cultures, functions and styles, this building shares a similar geometrical organization with Figure 12.

12 Environmental Education Center, New Jersey; designed 1980. Michael Graves.

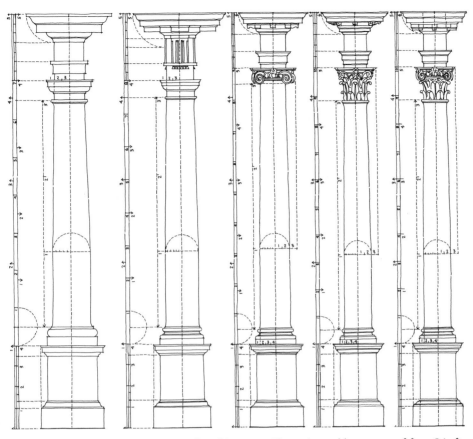

13 The Five Orders of Architecture. The universal language of form? Left to right: Tuscan, Doric, Ionic, Corinthian, Composite.

claim these new types are universally applicable? How can one be guaranteed of a timeless beauty or utility in one's form, for example, if one's form has been based on a type invented just last year?

As for the universal principles of form, few architects today need convincing that the five Orders do not provide the essential principles for organizing all architectural form. Unfortunately, this same criticism can equally be applied to the so-called universal principles of abstract form. In order to make these principles as universally applicable as possible, they are usually presented in generic and non-specific terms. Books on the subject usually show, for example, how the principle of balance works in the abstract, seldom in terms of specific buildings. And when books do use particular buildings to illustrate these universal principles, the buildings are usually drawn in the same neutral style and their particularizing characteristics are played down in order to stress their common adherence to a visual principle.[7] But if

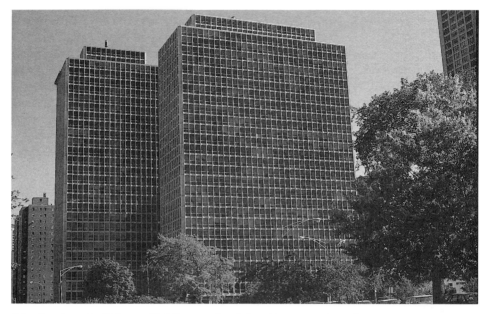

14 Apartments, Chicago, Ill. Mies van der Rohe. Abstract universal
principles? Compared with Figure 15, do we uncover the essential
characteristics of each building by insisting that they both follow the same
universal principles of good form?

these principles of visual form were the only factors which shaped
building designs, it would be impossible to explain why many differ-
ent buildings which are purported to have followed these universal
principles none the less turn out looking very different from each
other. Clearly architects have employed particular *versions* of these
principles which make the visual rhythm in a Baroque building, for
example, very different from that in a Mies van der Rohe building
(Figures 14, 15). Like the theory of types, the theory of abstract visual
form completely sidesteps the interesting question of how these univer-
sal notions are transformed into particular applications.

A paradox in Western theories of design

None of these theories, then, seems on its own able to give a complete
and convincing account of the source of design ideas. If a theory can
explain the role of the creative individual in the generation of form,
then it cannot also explain how individuals seem to fall under the
coercive influence of a prevailing style or a predominant ideology. If a
theory can explain these coercive influences, then it cannot explain the

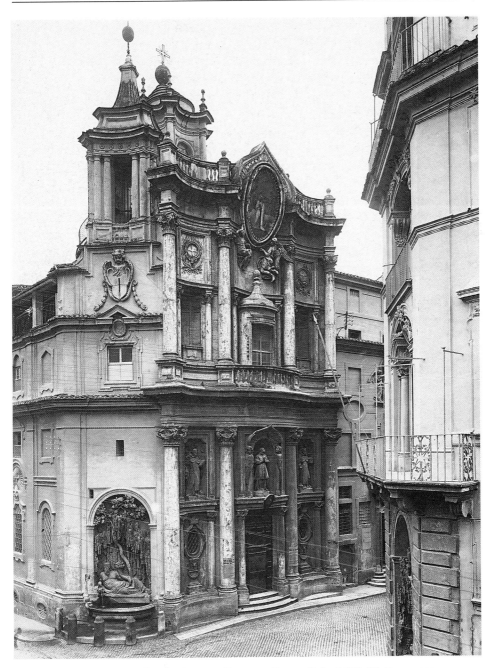

15 S. Carlo alle Quattro Fontane, Rome, Italy, 1634–82. Francesco Borromini.

idiosyncratic characteristics of individual buildings or the procedures by which these coercive influences are overthrown and changed. If a theory can explain how particular and unprecedented requirements of function, site and climate help give unique characteristics to forms, it cannot also explain why architects who attend strictly to these idiosyncratic requirements often generate versions of familiar form types used throughout history for many different functions and climates. And if a theory can explain how architects employ universal types, it cannot explain how these types are transformed into distinctive idiosyncratic forms with unique appearances.

Whether consciously or not, many designers today recognize the inadequacies of any single theory, and tend to use two or more of these ideas simultaneously to explain the source of design ideas. Read recent books or magazines on architecture, listen to practicing architects describing their designing procedures, attend lectures or design reviews in schools of architecture, and most of the above theories will appear jumbled together, spoken in the same breath as if they all belong to the same coherent set of ideas. For example, one might hear in the same exposition or criticism that good design requires creative, original thinking, that the designer's work should not deny the Modern spirit of the times, that the designer should attend carefully to the specific requirements of the climate, the culture and the design program, and that the designer should obey certain universal principles of form like balance and proportion.

Simply juxtaposing these does not make a coherent theory. Indeed, on closer inspection they would appear to fall into two quite diametrically opposed camps in their attitudes to the source of form, each side arguably incompatible with the other. On the one side are theories which seem to maintain that the source of form lies outside the designer, independent of his personal idiosyncrasies, and waiting to be discovered or passively received. The theory of functional determinism, for example, implies the existence of an ideal form inherent in any given set of constraints, which any person with patience and diligence will eventually discover. Both the theory of the Spirit of the Age and the theory of socio-economic determinism suggest that forms in any given age and culture will inevitably acquire a certain appearance and form, no matter how individual designers might struggle to do otherwise. And the theory of architectural types suggests that forms exist independently of individual designers and are deployed by anyone who finds them useful. The creation of any given architectural form, it is implied in all of these views, can and will occur independently of particular individuals' skills or insights. If Walter Gropius

had not been around to express the functional requirements, Spirit of the Age and prevailing socio-economic conditions in his Machine Age buildings in the 1920s, for example, similar buildings would most certainly have been designed by someone else. So insignificant is the individual designer in this group of theories that Paul Frankl, an influential proponent of one of these ideas, wrote his entire history of post-medieval Western architecture only once referring to an architect's name.[8]

On the other side, taking almost exactly the opposite view, is the theory that the source of form somehow lies inside the designer's mind. Far from being passively discovered in a shared outside world, architectural form in this view is actively invented within an individual designer. It is the individual's personal views, experiences, inner emotions, insights and tastes that uniquely generate forms and, since no two personalities are the same, no two personalities could ever generate the same forms even if they were working within exactly the same constraints. In this view, if Walter Gropius had not happened upon the architectural scene with his unique talents and insights, the subsequent history of twentieth-century architecture would most certainly have taken a very different direction even though the outside conditions remained exactly the same. Indeed, so dependent is the creation of form upon personal inner resources in this view that – in complete opposition to the determinist views expressed earlier – outside constraints are claimed to impair or even prevent creation. Too many functional requirements will overwhelm a creative idea, for example, and architects who respond too readily to the prevailing Spirit of the Age or to the prevailing socio-economic conditions are considered pedestrian and lacking in creativity.

These two attitudes towards form clearly pull in opposite directions. Where the first view emphasizes the importance of external information and forces at the expense of the designer, the second emphasizes the importance of the designer at the expense of transpersonal conditions; where the first has the designer passively discovering an external form, the second has the designer actively expressing an internal one; where the first encourages the designer to avoid personal preconceptions and to get in tune with outside conditions, the second encourages the designer to draw upon his personal preconceptions and intuitions as much as possible, and to turn his back on outside constraint.

These two views behave like Gestalt diagrams, in which one drawing allows of two different and mutually exclusive interpretations (Figure 16). At any one instant it is possible to see either the rabbit or

the duck, but any attempt to see both simultaneously results either in vacillating between the two images or in seeing nothing meaningful at all. In the same way, it would appear that the Western theories of design can discuss architectural form either as a product of outside determinants or as a product of inner creative intuitions, but they cannot give a meaningful account of the source of form which would simultaneously incorporate both.

Not only is this paradox intellectually unsatisfying, it has also created practical problems in the field of architecture. Architects unequivocally require the guidance of a theory when facing the complexities of designing a building, and so when one or another of these theories periodically rises to prominence and offers a direction to follow, architects usually embrace it with enthusiasm. In their enthusiasm, however, some architects accept the theory dogmatically, and follow it to the letter of the law. Now since each of these theories only partially accounts for the source of form, architects who dogmatically embrace one of these theories inevitably find themselves pursuing a narrow and unbalanced conception of design. Those who rigorously espouse the functionalist idea and refuse to let any personal feelings or ideas infuse their forms create workable but soulless buildings (Figure 17). Those who rigorously espouse the notion of creative genius and bridle at constraints create personally satisfying visions of architecture which bear little relationship to the required functions (Figure 18). And those who enthusiastically accept the Spirit of the Age argument become obsessed with determining the latest pulse of society, and reject as outdated and therefore disposable any architectural style now out of fashion (Figure 19). Where the complexities of architecture demand richness, these one-sided theories about the source of design ideas encourage shallowness.

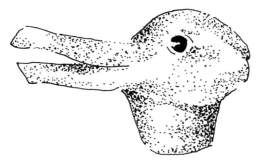

16 Gestalt diagram. One can see either a rabbit or a duck, but not both simultaneously.

17 *facing* University Hospital, Denver, Co. Functionalism in the extreme.

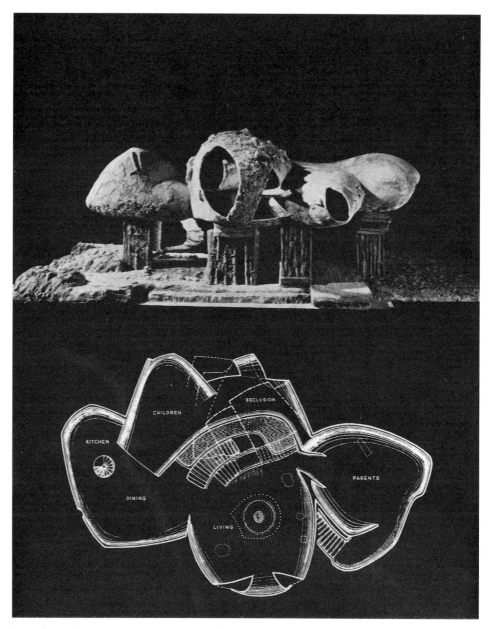

18 The Endless House Project, 1960. Frederick Kiesler. Creative expression
in the extreme.

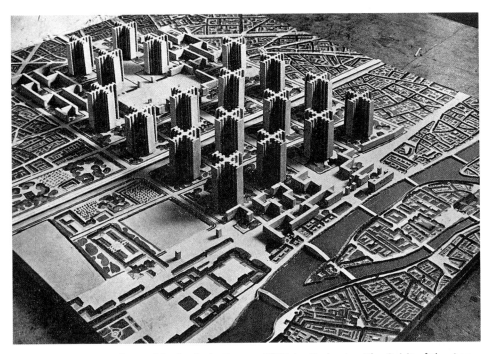

19 Plan Voisin for Paris, France, 1925. Le Corbusier. The Spirit of the Age in the extreme.

Furthermore, since each theory has a polar opposite, proponents of one theory continually find themselves engaging in stylistic and verbal battles with proponents of the opposite theory. As will be seen later in this book, these battles include the 'quarrel between the ancients and the moderns' in the seventeenth century, the fight between the Classicists and the Gothic Revivalists in the nineteenth century, the battle between the Expressionists and the New Objectivity rationalists after the First World War, and the continuing dispute between the functionalists and the formalists since the 1960s.

This paradox in design theory also creates much confusion in the field of architectural criticism. Is a building to be judged meritorious because it expresses the prevailing Spirit of the Age, or because it turns its back on the prevailing age and anticipates a new spirit? Modernist critics employed both arguments to justify the same stylistic movement. Is a building sufficiently worthy if it humbly satisfies its functional requirements without individual panache, or contrarily can we praise a building which displays distinctive personal invention even if it does not function well? Functionalists in the 1960s argued for the former, while architectural journals are often filled with the latter. Are there universally objective standards of design against which we can

evaluate all buildings, or is architectural taste relative to the critic's personal inclinations? Studio teachers in schools of architecture often assert the former, while the students who are receiving their criticism often assume the latter. Each of these views seems one-sided and incomplete, but the polar opposite nature of our existing design theories makes it difficult to formulate a balanced set of criteria.

Our paradoxical conception of design causes further practical confusion in architectural design education. In schools of architecture today, many teachers talk about design as a process of resolving constraints, and therefore they emphasize functional requirements and discourage the students' preconceived ideas. But at the same time they talk about design as a creative activity, and therefore they emphasize personal invention and worry that too many constraints will prove inhibiting. So while they exhort their students to find form in outside constraints, they often minimize the amount of information given out about the problem or make it intentionally vague in order to encourage creativity. Building costs, for example, one of the major constraints in design, are almost never considered in design projects, and building regulations are either ignored altogether or are followed only until they compromise a good design idea. Furthermore, while the teachers often tell students at the beginning of a project that the greatest rewards will go to the projects which most thoroughly satisfy all of the problem's requirements, usually the highest marks go to projects which are cleverly original yet which do not always satisfy the program. Students are well aware of these contradictions, and complain of them often; but the inherent paradox in the educators' conception of design prevents an easy resolution.

The paradox also leads to confusion about the entire role of education. Those who attribute to the mind personal, creative intuitions which operate in opposition to outside influences are inclined to claim that these special intuitions are inherent in the mind itself, given at birth. For them, an educational system can have only a limited influence on the development of the design skill. It may nurture an innate ability, but it can never put into a mind an ability or skill which nature itself left out. On the other hand, those who focus attention on sources of form outside the designer, and see the designer merely as the discoverer of a form already existing, are inclined to claim that the skills of rational discovery are easily taught to anyone with reasonable intelligence. In broader educational terms this reflects the familiar nature versus nurture arguments between behavioralists like B. F. Skinner who argue that the individual's character is completely determined by external determinants, and the so-called 'pro-

gressives' like Montessori who argue that the individual's character results from the growth of inner resources.[9]

The subject–object problem

It will be part of the task of this history book to track the origin and development of this paradox in design and education theory. It infuses all of Western design theory, and so we must understand its character in order to comprehend individual theories that were developed within its framework.

The paradox derives from a conceptual problem built deeply into Western culture's most fundamental assumptions about the individual and his relationship to the world. Known to professional philosophers as the *subject–object problem*, it is responsible for similar confusion in many other fields from psychology to the philosophy of science. While many theorists in these other fields are aware of the subject–object problem's pernicious influence on their own underlying concepts, the influence of this problem on architectural theory has so far gone largely unnoticed.[10]

The subject–object problem originated in a philosophical system first invented by the ancient Greeks, and was then taken up in one form or another by all successors to the Greek tradition. As the following chapters explain in more detail, the Greeks originally developed this system to explain the origin and nature of the universe – that is, as a cosmological system – and then later evolved it into a theory of how knowledge is possible – an epistemological system – as problems with the original ideas began to develop. The system they developed suffered from a troublesome flaw. In attempting to explain the relationship between man and the world he inhabits, they inadvertently set up a dualistic conception of the individual which allowed of two simultaneous but mutually exclusive interpretations: on the one hand, the individual can be thought of as a physical object in nature whose actions and behavior are completely determined, like all other physical objects, by the inexorable laws of the universe; but on the other hand, the individual can just as easily be thought of as a freely thinking, freely acting and creative subject whose actions and behavior are determined by his or her own personal inner drives and desires, free from external coercion. In the one view, the individual is a physical object and an integral part of his surroundings, while in the other view he is a subjective being standing outside his surroundings, observing and acting upon nature from which he has detached himself.

Immediately such a duality was set up, no end of problems emerged
when explaining the interactions between the individual and the out-
side world. Is an individual's behavior determined by conditions in his
environment, or by his own internal wiring? Is knowledge passively
received from the outside, or is it invented within? These are problems
which continue to plague Western epistemology, psychology and soci-
ology.

In terms of design theory, given this dual conception of the indivi-
dual, anyone trying to explain the source of design ideas can choose
between two equally plausible possibilities. If the designer is thought
to be an autonomous subject who initiates his own actions on the
world, it follows that he must somehow create his own ideas from
internal resources and then give them to the outside world. Yet if he is
thought to be an integral part of the outside world and subject to
external coercion, it follows that he must passively receive information
which originates outside himself. From the designer's personal per-
spective, one looks like an 'artistic' process of inventing new informa-
tion and then giving it to the outside world, while the other looks like
a 'scientific' process of taking in existing outside information (Figure
20).

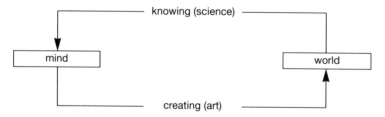

20 The apparent duality created by the subject–object problem between
knowing (science) and creating (art).

Although one intuitively feels that designing involves both sides of
the equation, the logic of the duality makes it virtually impossible to
link the two together. It makes the individual who knows, the indivi-
dual who takes in information from the outside, an object in a larger
system and a recipient of objective, transpersonal material; while it
makes the individual who creates, the individual who generates ideas
from within, an autonomous and subjective being who transcends the
existing and even the shared. Given the logic of the duality, a shift in
attention from the processes of knowledge to the processes of creation

necessarily entails a change in the underlying conception of the individual and his or her relationship to the external world. The two processes cannot be related together within the logic of the system because they assume opposing world-views.

This begins to explain the paradoxical and diametrically opposed theories of design discussed earlier. It also begins to explain the intriguing relationship between theories of knowledge and theories of design. At first glance, one would assume that designers concern themselves with the creation side of this equation, while epistemologists concern themselves with the opposite. Yet the underlying ambiguity of the subject–object problem has allowed theories from each side to blend indeterminately into the other. There are theories of creation that look like theories of knowledge, we have already seen, and equally there are theories of knowledge that look like theories of creation.

To explain this curious relationship further, let us look briefly at the major design and epistemological traditions that have emerged in the West in terms of Figure 20, and in relation to each other. Theorists throughout history have articulated variations on six archetypal interpretations of the individual's relationship to the outside world. Three of these are ostensibly concerned with creation, and three are concerned with knowledge. For the sake of convenience these theories will be labelled with the names by which they became most famous as they rose to prominence at different points in history, but all of these views can be found as continuous strands of thought throughout the entire history of the West. Even when one view advanced to the forefront in any given period the others were still to be found as minority views in the background or even as anomalies in the other's concepts.

The theories of creation

Taking the three archetypal theories of creation first, the most influential was the Classical tradition. In essence, Classicism claims that the source of architectural form is to be found outside the mind of the designer, as an objective property of the external world. By virtue of this external existence, the source of form is universally true and objectively valid, and therefore remains unchanged no matter how individual designers, cultures or environmental conditions might change. Yet architectural form in the Classical view does not magically appear without any help from the designer. In the most sophisticated accounts, the form is invented within the individual designer's mind, while the designer is contemplating the externally objective

truths. It is as if the principles of the Classical language, like ideal
proportion, are prefigured in the designer's mind and are used by him
or her as templates to ensure that the form he creates will obey the
objective laws of the shared language. So while the source of form
ultimately exists out in the external world, it is linked to a rational
process of discovery and elaboration within the designer's mind. Since,
according to this view, the form is a property of the external world
and not of the designer's mind, the designer prepares himself for the
designing task largely by acquiring a working knowledge of the uni-
versal language.[11]

A second and almost equally influential theory of creation –
Romanticism – developed the opposite view. Far from finding the
source of form in an external, universally valid design language, the
Romantic view insists that form is to be found in the inner intuitions
of the individual designer. The source of form is not as clear, but
Romanticism stresses the importance of individual ability, inspiration
and genius, and often turns its back on the external world to celebrate
the expression of inner ideas. From this point of view it makes no
sense to study a body of knowledge about an external design lan-
guage, because the source of design ideas is to be found inside the
designer. Education in the Romantic tradition stresses the cultivation
of personal resources.[12]

A third archetypal theory of creation, to be called Positivism in this
book, is not so well known or so clearly delineated as the other two;
it is a concept taken from philosophy to describe a general trend of
thought which goes under different names in different fields ('rational-
ism' or 'determinism' in architecture, 'realism' in art). It may cause
some initial confusion to call 'positivist' that which most architects
traditionally call 'rationalist', but as will be shown later, the term
'rationalist' has been used uncritically in architectural theory and does
not accord with its traditional use in philosophy. To avoid confusion
later when the disciplines are discussed together, the standard philo-
sophical term for this view – Positivism – will be used.[13] Essentially
this view emphasizes the importance of external phenomena unmediat-
ed by the individual mind, even to the point of denying the mind any
important role in apprehending those phenomena. As far as the
Positivist is concerned, the material in the outside world jumps unaid-
ed into the mind. For the artist this means painting exactly what he
sees without idealizing or prejudging the phenomena before him, and
for the architect this means discovering the form which is innately
contained in the external constraints of the design program without
imposing his own preconceptions upon that form. Since in this view

the designer simply discovers a form already prefigured out in the world, the Positivists take Christopher Alexander's early line that design is a scientific process of discovery.

Although all three of these theories are concerned with describing the act of creation, they range from a process which actively creates new material to a process which passively receives existing material (Figure 21).

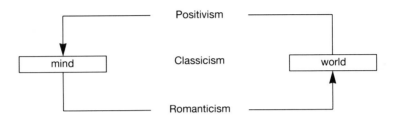

21 The three traditional theories of creation generated by the subject–object problem.

The location of Classicism in the center of the diagram is not meant to suggest that Classicism managed to find a successful middle ground between the extremes. It was more aware than the other two of the need to bring both mind and world into balance but, as will be seen later, it did not manage so much a true synthesis of the two sides as much as an uneasy conflation, in which first one side and then the other could be emphasized without a clear understanding of the relationship between the two.

The theories of knowledge

The same pattern can be seen in the West's major theories of knowledge. In attempting to explain how the mind knows of the external world, epistemologists also set up a duality between mind and world and then elaborated every logical possibility. And even though epistemologists address a problem exactly opposite to that studied by design theorists (i.e., how information is received instead of how it is created), they eventually developed three archetypal lines of thought that can be seen as conceptual counterparts to the theories offered by the designers.

Before setting out these three views, a comment must be made about the kind of knowledge of the world which interests epistemologists. They are not concerned simply with describing how the mind

receives its sensory data about the world, because this is a biological and chemical matter for neurophysiology to explain. What interests epistemologists is how the mind has knowledge of more generic and universal ideas lying behind the flux of sensory experience. Where neurophysicians try to explain how the mind comes to know the particular sensory characteristics of, say, individual horses and triangles, epistemologists want to explain how the mind knows of the abstract concepts 'horse' and 'triangle' which reside in no one horse or triangle yet which are common to all horses and triangles.

One archetypal epistemological tradition, termed Empiricism, asserts that knowledge of universals and abstract concepts originates in and refers to the external world. Through reiterated experience with the sensory world, the human mind gradually discovers underlying regularities which amount to little more than abridged expressions of the sensory phenomena. Generalized principles, in other words, are induced from a collection of particular elements. In an extreme expression of this view, the mind offers little to the knowledge except simple sorting procedures; the mind at birth is more or less a blank tablet upon which the external world writes its knowledge. This theory is the common-sense view of many English-speaking nations.

As an idea about the relationship between mind and world, Empiricism parallels the Positivist notions of design theorists. In the same way that Empiricism has the individual passively receiving information which originates in the outside world, Positivism claims that a designer merely discovers a form which is already prefigured by the external determinants. Creation does not enter into either one. The Empiricist scientist and the Positivist designer are both advised to analyze data found in the external world and then synthesize out of it either a general law for the scientist or a building form for the designer.

A second archetypal line of thought, Continental Rationalism, agrees with Empiricism that certain knowledge must be of an objective world external to the individual mind, but it proposes a different method for apprehending that knowledge. Arguing a case which may seem strange to many Britons and Americans raised on scientific Empiricism, the Rationalists disdain the value of sensory experience because it is subject to illusionary error, and argue instead for the use of pure reason. They claim that while objective knowledge originates in and refers to an external world, that same knowledge is also somehow prefigured in the structure of the mind. So instead of looking to the illusion-ridden sensory world for objective information, it is more reliable to turn in on the mind and to use introspective reasoning for

discovering there the world's essential knowledge. In contrast to the Empiricists, who emphasize the external sensory world as the sole source of knowledge and attribute only perfunctory organizing activities to the mind, the Rationalists locate a second source of certain knowledge in the mind and acknowledge only minor influence from the sensory world.

In terms of the mind's relationship to the external world, Rationalism parallels Classicism. Both claim the existence of a body of knowledge about the external world which is objectively and universally true, yet which is apprehended and actively manipulated by a thinking mind. Just as the Rationalist posits an ultimate source of knowledge out in the world but a rational discovery process linked to a source within the mind, the Classicist claims he is guided by external, objective rules of ideal form but actively creates from internal resources his own variations on the accepted themes. The difference between Rationalism/Classicism and Empiricism/Positivism is a matter of degree: both traditions agree that proper knowledge must originate in and be about an objective world external to the mind, but one gives more credit than the other to the mind for its active role in the operations.

The third archetypal line of thought, German Idealism, gives even more power to the mind. Not only is certain knowledge of the world to be found in the mind, they claimed, it must also originate in the mind. The mind for the Idealists creates the world. They agree with the Rationalists that introspective reason is used to apprehend knowledge of the world, but where the Rationalists think of the mind 'capturing' the essential structure of a world which exists independently of the mind, the Idealists think of the mind 'creating' the world from inner resources, and then surveying its own work. The similarity of this to Romanticism is obvious, with both traditions denying the existence of an independent external reality and claiming that the mind relies instead upon its inner resources either for design ideas or for knowledge of a self-created outer world.

Here the cycle is completed, for just as Positivism set out to establish a theory of creation but then conceived a theory of knowledge, Idealism set out to establish a theory of knowledge but then developed a theory of creation. All six lines of thought comprise a logical pattern, systematically ranging from a preoccupation with the outer world to a preoccupation with the subjective mind (Figure 22).

Like the theory of Classicism, the theory of Rationalism does not represent a true synthesis of the two extremes. Although it attempted more than Positivism and Idealism to bring mind and world together,

it will be seen later that its proposal remains an uneasy conflation. Eventually we will find a few theories that did reconcile these two, by the way, but they emerged only very recently in the history of the West, and have not yet engendered popular theories of design.

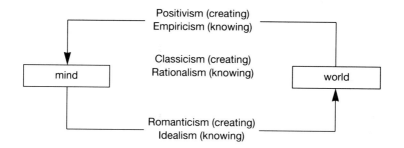

22 Theories of knowledge and creation generated by the subject–object problem.

Now that we have seen the abstract logic of the subject–object problem and the manner in which it ties theories of design to theories of knowledge, let us turn to a chronological history of these theories in the West. The abstract analysis just completed and the historical study to follow are meant to complement each other. The abstract pattern becomes convincing only when it is seen to exist over time, and the historical evidence becomes meaningful only when it is seen in terms of its underlying logic. We will discover numerous interesting variations on these themes, and we will see how new ideas brilliantly answered shortcomings of their predecessors, only to create new problems for their successors. This abstract pattern should help us examine the following history of ideas in context, not distract us from the rich variety of ideas in our philosophical heritage.

Notes

1 See Edward Robert de Zurko, *Origins of Functionalist Theory*, Columbia University Press, New York, 1957.

2 Christopher Alexander, *Notes on the Synthesis of Form*, Harvard University Press, Cambridge, Mass., 1964. Alexander has since repudiated this position.

3 Nikolaus Pevsner, *Pioneers of Modern Design from William Morris to Walter Gropius*, Penguin Books, Harmondsworth, 1974. First published in a different form as *Pioneers of the Modern Movement* in 1936.

4 For a more thorough criticism of the Spirit of the Age, see David Watkin, *Morality and Architecture*, Clarendon Press, Oxford, 1977.

5 Emil Kaufmann, *Architecture in the Age of Reason*, Dover Publications, Inc., New York, 1968, pp. 126–7.

6 For an influential theory of architectural types see J. N. L. Durand, *Précis des Leçons d'Architecture* (Paris, 1821), and *Partie Graphique des Cours d'Architecture*, Paris, 1821, republished by Dr Alfons Uhl, Nordlingen, 1981. For a typical example of abstract visual form see Lillian Garrett, *Visual Design: A Problem-solving Approach*, Van Nostrand Reinhold Company, New York, 1967.

7 See Roger Clark and Michael Pause, *Precedents in Architecture*, Van Nostrand Reinhold Company Inc., New York, 1985.

8 Paul Frankl, *Principles of Architectural History: The Four Phases of Architectural Style 1420–1900*, trans. James O'Gorman, The MIT Press, Cambridge, Mass., 1968.

9 B. F. Skinner, *Beyond Freedom and Dignity*, Alfred A. Knopf, New York, 1972; Maria Montessori, *Montessori Method*, trans. A. E. George, Heinemann, 1912.

10 A notable essay that addresses the subject–object problem in the related field of art theory is Erwin Panofsky, *Idea: A Concept in Art Theory*, trans. Joseph Peake, Harper & Row, Publishers, New York, 1968. In architecture see Bill Hillier and Adrian Leaman, 'The Man–Environment Paradigm and its Paradoxes', *Architectural Design*, Aug. 1973, pp. 507-11.

11 See Julien Guadet, *Eléments et Théorie de l'Architecture*, 4th edn, Librairie de la Construction Moderne, Paris, 1909.

12 See Jean-Jacques Rousseau, *A Discourse on the Arts and Sciences*, in *The Social Contract and Discourses*, trans. G. D. H. Cole, J. M. Dent & Sons, London, 1973.

13 See Leszek Kolakowski, *Positivist Philosophy*, trans. Norbert Guterman, Penguin Books, Harmondsworth, 1972.

2

The ancient world

The origins of design theory and education

It is difficult to determine when builders began to reflect on the source of their design ideas, or when the first theories of design were proposed. Little primary evidence has survived from the ancient world other than carved inscriptions, oblique references to architecture in texts, and a few drawings. From this scanty evidence, one can only surmise what architectural theories might have been written in books now lost, or might have been followed by architects even before such things were explicitly written down.

For many millennia, the earliest builders in our prehistoric past most certainly worked without theory. Through trial and error over generations they developed building forms that were suited to the materials at hand, the climate in which they lived and their social systems. If a form failed, they tried a variation; if the variation worked, they passed it on to the next generation as a set of specific rules. The fairly casual building shapes and siting in Stone Age settlements imply pragmatic responses to particular conditions, while the lack of strong geometry implies an indifference to a larger intellectual ordering system (Figure 23).

Around 100,000 years ago the first dead were buried. This implies the first belief in an afterlife and the development of some cosmological system. Although settlements and buildings remained casual in outward form throughout most of the Stone Age, they acquired additional symbolic or religious meanings. In Çatal Hüyük, Anatolia (c.6250 BC), for example, numerous rooms are set aside for special shrines (Figure 24). Those who built huts therefore had to assure the proper forms and arrangements for their culture's cosmological beliefs. Any rules passed down from one generation to the next about important arrangements for cosmological reasons would have constituted an embryonic theory of design.

23 Beidha, Jordan, *c.*7000–6000 BC. The lack of strong geometry implies an indifference to a larger intellectual ordering system for design.

24 Çatal Hüyük, Anatolia, *c.*6250 BC. Shrines set aside within the settlement indicate a strengthening relationship between design and a system of cosmological beliefs.

By the time of the ancient Near East and Egypt we have a better understanding of the cosmological beliefs and their influence on art and architectural design. To explain natural and human events like the changing of the seasons, sudden floods, the birth and death of individuals, our ancestors had developed a pantheon of gods whose actions caused events on earth. A system of myths explained the origins of these gods and their motivations. Attention focused not so much on the here and now of the sensory world, but on the world of the gods and their possible actions on the world. Many human activities were directed to placating or influencing the gods to assure good fortune and avoid disaster. In the Homeric *Iliad*, written between the eighth and seventh centuries BC, Achilles' fate in his battle with Hector is determined not by his own skills and decisions, nor by some forces in the natural world, but rather by the supernatural will of the supreme god Zeus. None the less, Homer allows Achilles to 'escape the will of Zeus's at times, either by bribing, flattering or coaxing Zeus himself or by invoking the support of other gods who can sway Zeus's decisions.

Art played an important part in this cosmological system, and reveals early ideas about the source of artistic ideas. Paintings and sculptures were employed variously to capture the spirit of animals so they could be controlled, to represent gods so they could be worshipped, to portray myths so they could be understood by an illiterate population. In consequence, the artists, too, focused not so much on the sensory world as on the world of the gods and spirits. Their art is what we term conceptual rather than naturalistic. Although artists clearly wished to portray real objects in the natural world like animals and men, they largely ignored the phenomenal appearance of individual objects, and expressed instead the abstract, generic characteristics common to all objects of that type. For example, ancient Egyptian artists colored humans not to represent actual skin tones but rather to distinguish between the sexes; the relative sizes of individuals in a scene represented their relative social importance, not their actual body sizes (Figure 25). Although nature is the ultimate source of conceptual art, it is only used as an impetus to ponder the abstractions it represents, and is never used as the model against which the final product is judged for verisimilitude. And although the individual creates the art, there is no sense of individuality, no idea that the artist has offered his own personal and individual point of view. The source of artistic form derives neither entirely from the outside world nor entirely from within creative internal resources.

25 Palette of King Narmer, front view, c.3200–2980 BC. In this example of conceptual art, the sizes of individuals represent their social importance, not their actual appearance.

The first design theories

This early cosmological system eventually gave rise to the first theories of design. No direct evidence of these theories remains, although we can confidently surmise their existence. As the nomadic cultures began to settle in one place and establish permanent homes for themselves, it seems they felt obliged also to provide a home for their deities. According to Kostof, 'The onus attached to this divine provision was overwhelming. How could mere mortals presume to know the kind of built environment that would please the gods, so that they would consent to dwell there, at least from time to time? ... To a number of ancient cultures, the answer was obvious. The form of the temple must be god-given, and the recipient must be the highest representative on earth of divine authority.'[1] The earthly kings took on this responsibility, and often claimed to have the form for a temple revealed to them by the divinity. Although some early kings did personally lay out the form of a temple as 'divinely' supplied to them, increasingly they devolved this responsibility to the first professional architects. The architects were supposed to act on behalf of the king and to base their designs on his divine sources.

From the architects' point of view, this divine conception of the source of form must have presented a dilemma: they were expected to direct the construction of buildings according to the divine designs, but they themselves did not have direct access to those sources. In response the architects looked for some guidance, some rules or procedures, which would ensure that the forms they designed secularly would accord with the divine original. For many ancient architects, the guidance came from geometry. Perhaps based on the belief that orderly geometry reflected the order of the divine world, they established precise geometrical systems with which to generate forms. The ancient Egyptians took one major dimension of an important room in the proposed design as the basic module, for example, and then employed regular multiples and fractions of that module to determine the dimensions of everything else in the scheme. In addition, they derived the relative proportions of elements in plan and elevation from simple geometrical figures, most notably the square and a few triangles with specified ratios of base to height (1:1, 1:2, 1:8, 3:4, and 5:8, a ratio which is close to the golden section).[2] Along with the organizational concept of symmetry, this helped create buildings with clear rational order (Figure 26). Although the modern mind might well assume that this particular system simply grew up over time as a culturally relative tradition, to the ancient Egyptian mind it represented a precious revealed truth about the divinity's

timeless and universally valid design requirements. Here is the beginning of several ideas that will later appear throughout the history of Western design theory, separately and in conjunction with each other: good design is based on timeless principles of form; these principles originate in a divinity; and geometrical systems can capture these principles.

In the face of this rule-governed and divinely inspired approach to design, interestingly, many Egyptian architects offered the first hint of a self-awareness of personal skills. An inscription left by the architect Senmut on his tomb describes himself thus: 'I was the greatest of the great in the whole land; one who had audience alone in the Privy Council. I was a real favourite of the King; foreman of foremen; superior of the great; one to whom the affairs of Egypt were reported; ... I was a noble who was obeyed; I had access to the writings of the prophets; there was nothing which I did not know concerning what had happened since the beginning.'[3] These are not the boasts of someone who sees himself as a humble and passive mechanism through which divine sources of form physically manifest themselves. At the same time, though, they are not boasts about special inner sources of form; he asserts his greatness on the special position he had achieved in the ruling hierarchy and, importantly, on the knowledge he possesses through access to the prophets' writings. The source of knowledge still lies outside himself. The great architects of Egypt were admired for their inventiveness – indeed, this was thought to be an inherent part of their skill[4] – but what they made of this special skill, and how they reconciled this with the notion of divinely given, rule-governed design, we are left to imagine.

Similar ideas about the source of architectural form appear in the early stages of the Greek civilization. One of the earliest Homeric hymns tells the story of Apollo searching for a site on which to build his temple. After several possible sites were rejected, he finally settled on one at the foot of a mountain and then

> ... laid out the foundations, broad and very long from beginning to end;
> and on them
> the sons of Erginos, Trophonios and Agamedes,
> dear to the immortal gods, placed a threshold of stone.
> And the numberless races of men built the temple all around
> with hewn stones ...[5]

After Apollo himself provided the design for the temple, one standard commentary on this text suggests, the architects/master builders Trophonios and Agamedes laid the first courses, and then other workmen completed the building.[6] As in earlier cultures, the architect appears to stand halfway between the god and the work-force, physically inter-

26 Plan of Funerary Temple of Queen Hatshepsut, Deir el-Bahri, Egypt,
c.1480 BC. Egyptian architects attempted to reflect in their building designs
the rational order of the divine world.

preting the divine source of form and then directing the builders according to its instructions.

Early design education

Informal design education began in prehistoric times as soon as there were skills to acquire. According to Margaret Mead, 'the ability to learn is older – as it is also more widespread – than is the ability to teach'.[7] Indeed, the ability to learn appears to be an ancient biological function possessed by all animals, while the desire and ability to teach appears to be a more recent cultural activity. At its most rudimentary level, learning – even among animals – involves trial and error problem solving. An early shelter builder possibly piled rocks together, and when they collapsed he may have experimented with a roof of broken tree branches, until eventually he created a successful shelter. While struggling with the problem, he repeated those forms which worked, and avoided those which repeatedly failed. By this simple mechanism he learned at least one way of building a shelter that he could subsequently repeat.

But these early individuals did not live alone, and were not entirely dependent upon their own personal inventive skills for solving every problem. Others in their culture had faced similar problems, and had developed successful artifacts and skills for dealing with them. By imitating successful forms already existing within their cultural traditions, these individuals were guided to successful solutions without suffering the inevitable failures inherent in the trial and error approach. Even the animal world learns skills through imitation.[8] Cultural traditions allowed the individual to share in the collective experiences of many generations, and made their collective work more efficient. These two processes of learning – imitation and trial and error experimentation – originated in our dim past and are still the fundamental basis of learning today.

Although in the earliest stages of culture individuals depended entirely upon unconscious forms of imitation, with increasing complexity in the culture the adults began to see the need for more explicit directions to the young. Starting with little more than 'demonstrating the right behavior or ... pointing with disapproval at the wrong behavior', the efforts to teach essential skills and behaviour to the young gradually became more formalized.[9] Out of this grew the apprenticeship system behind all craft training even today, and behind most subsequent systems of architectural education. In the apprenticeship system, a novice who wished to learn a skill assisted a master who already commanded that skill.

Working alongside the master as he himself performed the skill, the novice observed the master, attempted the skill, and then was corrected. Often the master could not give a reason why the skill ought to be performed in a particular way, other than that it worked. Theory and abstract knowledge were not important components of this early educational system.

This entirely pragmatic education changed once the early architects took up the challenge of designing according to divine principles. As long as builders merely extemporized on forms which had successfully worked in the past, the 'knowledge' they required for their craft involved little more than a command of a physical skill and a mental image of the successful forms. But once architects sought one true and timeless form of building, and offered a precise design method by which the true forms could be realized, then it naturally followed that a young architect would have to learn those essential rules of design before he could pursue his profession. Since those rules of design are not immediately obvious in the visible world – indeed, they are divinely revealed religious truths – then the young pupil had to be immersed in an abstract and even arcane body of special professional knowledge. The essential knowledge required for design became a set of trade secrets jealously guarded and handed down from father to son. There was now a tension in this arrangement between the aspect of training that taught timeless principles common to all, and the aspect that taught one master's personal use and interpretation of those principles. Most subsequent architectural education would inherit these dual and sometimes conflicting functions.

The Greek revolution in philosophy

In a remarkable cultural revolution between the sixth and fourth centuries BC, the ancient Greeks radically transformed many of these early ideas about cosmology, art and architecture. The outward manifestations of this revolution are familiar enough: the first acknowledgement of the importance of the individual and the invention of democracy, the first 'scientific' curiosity about the world, and an unprecedented naturalism in art so lifelike that it set the standards for Western art well into the twentieth century. Significantly, we will also find that this same Greek cultural revolution invented the conceptual split between mind and world and the resulting subject–object problem. A number of the basic epistemological traditions that we briefly examined in the last chapter emerged as the Greek philosophers attempted to work out the

implications of their newly invented conceptual duality.

The Greek revolution was nothing less than a fundamental reorientation of thinking in two important areas. First of all, they attached an unprecedented importance to the individual and his ability to think for himself. Where earlier peoples in the ancient world were content to accept traditional myths and the traditional authority for their understanding of the world, the Greeks wanted to reason through their own understandings, based on what made sense to them personally. This attitude reflected a new conception of individuality, and it also invented the new business of philosophy. Secondly, they took an unprecedented interest in the secular world. Earlier ancient cultures, we have already seen, attributed events in the natural world to extra-natural or divine forces. The Greeks, contrarily, turned away from these metaphysical and divine accounts of the world and looked instead to physical nature itself for the ultimate cause of physical events. This idea eventually led to the development of natural science and naturalism in art.

These two beliefs – in the reasoning powers of the individual and in the physical causes of physical events – are so fundamental to the Western view of the world today that they may seem mundane. They are, however, not inevitable or obvious. Throughout most of human history (and in many cultures today) individuals did not wish to reason for themselves in preference to accepting the explanations they received from their cultural traditions. Likewise, it is not immediately obvious that natural events are caused by natural events alone. When one hears a thunderclap, for example, how can one assume that it results from electrical energy and not from a god speaking? Even if it were possible to trace the causal effects of thunder through a complex chain of physical events involving energy transfer and sound-waves, how can we be sure that the entire chain was not first set in motion by some ultimate cause standing outside the physical world? The Greek revolution was less a sudden awakening to the true facts of reality than it was a bold intellectual experiment in testing the powers of individual reasoning and in explaining everything secularly rather than divinely.

The new Greek cosmology

The Ionian philosopher Thales (*c.*630 BC–*c.*545 BC) offered the first purely material description of nature by reducing all physical objects and events to one material cause.[10] Yet immediately this idea presented him with a problem: how can a material substance cause animated events like the changing of the seasons, the birth and death of animals, or the transformation of water into ice? It cannot, of course, if material

substance is taken to mean some inanimate object like stone. Only if the physical material itself is animated can it cause animation elsewhere. So instead of thinking of the material substance behind the world's events as something dead and inanimate, Thales had to think of it as something live and animated, like some kind of organism.

Following the organism analogy, Thales suggested that the world has a physical 'body', an animating 'soul' and, because the world displays the sort of order in its layout and operations of which only a rational mind can conceive, an organizing 'mind' as well. With all the essential elements of corporeality, liveliness and order linked together in one coherent and non-metaphysical analogy, Thales must have thought he had discovered a conception of the world completely self-contained, purely materialistic and free from any external forces. All objects in the world – including men – are microcosms of the larger organism and answer only to its demands, not to anything outside it. Yet just as an arm participates in the body of which it is a part, the body, soul and mind of each individual object participate in the 'body', 'soul' and 'mind' of the world at large, thus avoiding the opposite danger of the outside world deterministically governing the actions of everything within it.

But the subject–object problem was now embryonic in Thales' cosmology. Its use of ideas like physical bodies, animating souls and organizing minds necessarily made a distinction between 'those properties which make [man and nature] corporeal and those which make [man and nature] live and conscious'.[11] Thales tried to explain the events of the world purely in terms of physical matter, but to make his theory work he had to posit the existence of several other forces like mind and spirit which are less capable of being described as physical matter, and thus which stand as curious anomalies in his system.

Pythagoras (?572 BC–?497 BC) and his school of followers inherited this new conception but then exacerbated the distinction between the animating soul and the animated body. The Pythagoreans conceived of the soul not as something intrinsically tied to the material world, but rather as an independent entity which can be freed from its undesirable confinement in the body once it has undergone a rite of purification. Although they still conceived of the soul in material terms they set out the possibility, at least, that the animating matter can operate independently of the physical matter. This took Western philosophy further down the road of a basic duality in its underlying cosmology.

Pythagoras also developed a distinction – later to influence most Western philosophy and design theory – between matter and form. In his studies of geometry he noted that geometrical figures like triangles

possess certain unchanging formal characteristics that are independent of the figure's physical material. The angles of a triangle add up to 180 degrees whether the triangle is made of wood or bronze. Likewise, Pythagoras reasoned, every other object in the world must also possess an underlying form that exists independently of its physical matter and provides its essential characteristics. So while the material world is always changing, coming into being and passing away, its underlying form remains the same. Where in earlier cosmologies geometry might have been considered a reflection of the divine, now geometry is considered the underlying structure of the physical world. Here also is the first suggestion that the seeker after true knowledge of the world will have to rely on reason, not senses, for the latter give knowledge only of the changing, ephemeral appearance of things while the former gives knowledge of the underlying timeless forms. The mind has been linked in some undefined way with an eternal structure behind appearance, thus giving the first hint of the Rationalist idea.

Subsequent Greek philosophers pushed these ideas further, and ended up with logically consistent but diametrically opposed conclusions. According to Heraclitus (active 504 BC) nothing ever stays the same, while according to Parmenides (?515 BC–c.450 BC) and Zeno (?489 BC–?) nothing ever changes. After these extremes it was no longer possible to conceive of the world as deriving from one material substance. Subsequent pre-Socratic philosophers became pluralists and accepted several, inherently different entities as the basis of natural phenomena. Here, for the first time, a duality in the essence of reality was conceded, and it was quickly expressed in terms of an animating force and an animated matter. Anaxagoras (?500 BC–?) made a clear distinction between the material, which he identified with the physical substance of the world, and the immaterial, which he identified with the organizing mind and the animating soul. This latter grouping he called simply *Nous*, or Mind, and attributed to it not only the ability to animate the physical world but also to organize it and run it on ordered principles. Furthermore, because of the old Greek idea that the creation of the cosmos is not the creation of something out of nothing but rather the imposition of order on to original chaos – that is, an activity of mind – Anaxagoras was also able to attribute to the mind the creation of the world. Here can be found the first seeds of the Idealist tendency, for now a Mind which exists outside the physical world yet somehow resides within it is responsible for the creation, organization and running of physical nature. And the human mind, by virtue of participating in this world-Mind, not only knows the principles by which this Mind operates but also participates in the operations themselves.

The Atomists Leucippus (active ?450 BC) and Democritus (c.460 BC–?) took the opposite extreme and left an independent, animating mind out of their conception of the world altogether. In their theory, everything in nature including the soul consists of tiny physical particles colliding with and recoiling from each other in a boundless space. The entire system is completely materialistic and even deterministic; the human mind knows of the outside world not because it actively participates in a world-Mind which organizes the world, but rather because atoms given off by objects (collections of atoms themselves) strike the atoms in the human soul and physically impart an image of themselves. The Atomists gave a purely mechanical description of reality, and the first hint of the Positivist tendency. So starting with Thales' original attempt to explain the world in purely material terms, the early Greek philosophers not only elaborated a duality between mind and world, but also generated a number of logical and opposed possibilities within its terms.

The Sophists and Socrates

The pre-Socratic philosophers had attempted to explain the nature of the physical world but had created conceptions very far removed from common sense. In a world which appears to be moving and changing all the time, Parmenides was convinced, all change is an illusion; and in a world which appears to be filled with solid physical objects, according to the Atomists, those objects are really voids filled with spinning particles. The more these early Greek theories proliferated, contradicting the senses and each other, the more hopeless it looked that any one, true explanation of reality could ever be found. In despair, the sceptical Sophists finally called into question this entire enterprise of natural philosophy. There is, they claimed, no world that exists independently of individual observers and, even if there were one, the human faculties would not be equal to the task of apprehending it. According to them, each man sees his own reality and each view is equally valid.

This scepticism set the stage for a major shift of emphasis in Greek philosophy, because 'skepticism is the challenge that brings the problem of knowledge to the fore'.[12] The pre-Socratics were interested primarily in descriptions of nature and only incidentally had they touched on the question of how the mind apprehends that nature. Although the seeds of some important epistemological concepts had emerged in their work these were only developed to reinforce their ideas about the larger cosmology. But in the face of the Sophist challenge it was no longer possible to be so cavalier about epistemology. For those who still desired the certainty that comes from objective knowledge a defense would have

to be made of the mind's ability to apprehend that knowledge.

Socrates (c.470 BC–399 BC) was the first to face this challenge, and in so doing he shifted the emphasis of Greek philosophy from nature to mind. Instead of starting with a particular conception of nature and then deriving from this a conception of the mind, as the pre-Socratics had done, the philosophers after Socrates would start with the assumption that the mind does indeed have certain knowledge of the world, and would then derive from this a conception of the world that would make such knowledge possible. Just as there was no intrinsic reason in the first Greek revolution to look for the causes of physical events in terms of physical causes, so, too, there was no intrinsic reason in this second revolution to believe that an objective world does exist and that it can be apprehended by the subjective mind. As Bishop Berkeley and David Hume demonstrated convincingly in the eighteenth century, the world one individual comprehends cannot be known with any empirical or rational certainty to be the same world comprehended by others. The philosophers after Socrates desired objective knowledge, assumed as a matter of faith it was there to be found, and set out on an ambitious philosophical journey to show how the individual, subjective mind could apprehend it.

Platonic Rationalism

Socrates' student, Plato, developed this new view into a complete system of philosophy. As Plato saw it, he had inherited a puzzling dilemma from his philosophical predecessors. On the one hand, if he accepted for his knowledge of the world the evidence of his senses, he would have to accept the view of Heraclitus and the Sophists that everything is changing, coming into being, passing away, and different for every observer. There can be no certain knowledge here. On the other hand, if he turned to the more comforting Pythagorean idea that the world does organize itself according to precise and timeless mathematical relationships, he was faced with the dual problem of explaining how this timeless form changes into the flux of sensory experience and how the mind can come to know of its underlying order.

Plato's solution to the problem was to think of form as an ideal pattern, or generic type, which physical matter imperfectly tries to copy.[13] Looking at all the particular horses in the world, for example, it is possible to discern behind their individual differences certain essential characteristics they all share which make them uniquely horses and not donkeys or birds. This 'essence' of horse, which is not to be found completely or perfectly in any one particular horse yet which seems to be

the ideal towards which all horses imperfectly aspire, Plato called the ideal Form of Horse. For Plato this ideal Form is not merely a descriptive summary of 'horse' qualities. Since it cannot be found in any one object and since any one object is only an imperfect manifestation of its ideal type, Plato assumed that this ideal Form must be something separate from, and superior to, individual physical objects. The world for Plato consists of two separate but interrelated realms: an existential realm of physical objects, the realm which can be seen with the senses and which continually comes into being and passes away; and a metaphysical realm of ideal Forms, which transcends sensory experience and which is populated with the ideal generic types from which the objects of the sensory world are derived. The transcendental realm of Forms embodies the essence of all things in their clearest, most perfect form, while the realm of physical objects imperfectly copies those Forms much as, Plato suggested, a shadow imperfectly copies the object from which it is cast.[14] In his theory of physics, Plato reduced the basic elements of the world to four geometrical solids, the cube, the pyramid, the icosahedron, and the octahedron, which later became known as the Platonic solids. Curiously, architects much later changed these into the sphere, the cylinder, the cone, the pyramid and the cube, presumably because these are more suitable building blocks for architectural form (Figure 27).

Once Plato had established the existence of timeless generic Forms and had explained their relationship to the material world, he had only to show how these Forms can be apprehended by the individual human and then he would secure his ultimate object, universally valid knowledge. Obviously he could not rely on the senses for this knowledge, because the metaphysical realm of Forms that contains objective knowledge has no physical embodiment. The senses can reveal information only about the existential realm of imperfect material objects. Somehow he would have to provide the mind with some kind of direct access to the realm of ideal Forms that would transcend the senses altogether.

Plato proposed to find this connection between the mind and the Forms in the human soul. Like Pythagoras and Anaxagoras, he attributed to the soul the useful characteristics that it exists independently of the physical human form, that it is immortal, and that it participates somehow in the organizing and animating force of the universe at large. For Plato, of course, this organizing and animating activity belongs to the realm of ideal Forms, so by implication the soul participates in the realm of Forms. To spell out this connection more exactly, Plato pursued the notion that since the soul is immortal, it must have existed before it got temporarily trapped in a physical body. Therefore,

27 The Platonic solids. Architects have long mistakenly identified the Platonic solids as the sphere, the cylinder, the cone, the pyramid and the cube. Plato himself proposed, in order of increasing complexity, the cube (earth), the tetrahedron (fire), the octahedron (air) and the icosahedron (water).

one can assume, before joining the body the soul will have 'seen' the realm of ideal Forms of which it was an integral part. Now once the soul is joined to the body, the physical world of changing material objects tends to cloud its memory, and the clear visions it once had of a timeless Form are replaced by the more ephemeral sightings of the Form's imperfect material copies. Fortunately, Plato maintained, on the occasion of seeing one of the Form's physical manifestations the soul can sometimes recall its former vision of the Form itself. In this regard the senses help jog the memory of the soul but they do not in themselves lead to knowledge of the metaphysical realm of Forms. True knowledge of the world in Plato's theory is to found by turning inwards, and interrogating one's inner resources.

In Plato's theory can be found the first coherent and logical solution to the problems first raised by Thales' organic conception of the world, and it would exert considerable influence on future Western thinking. Any Rationalist theory which claims access to timeless principles of the world without recourse to the senses will have its roots in Plato, even

though its proponent would never consciously countenance the concepts of immortal souls and metaphysical realms. Yet in developing this solution Plato was forced to make even greater distinctions between the physical world and the immaterial soul and mind, between the perceiving senses and the reasoning mind, and between knowledge of the changing and contingent and knowledge of the timeless and universal. The dualities of the subject–object problem were now firmly established, and one persuasive philosophical system had been constructed fully within their terms.

Aristotelian Empiricism

The theory of ideal Forms was not without serious problems, as Plato's student Aristotle (384/3 BC–322/1 BC) soon discovered. To begin with, how exactly do the objects in the sensory realm relate to the Forms in the metaphysical realm? Plato himself seemed to be of two minds about this. At times he wrote as if the physical objects participate in the Forms, in which case the Forms would have to be in some way immanent in the world and thus subject to tainting from the physical world, while at other times he wrote as if the objects merely imitate the Forms, in which case the Forms could be transcendent but then less obviously connected to the physical objects themselves. Furthermore, how exactly does the soul apprehend the Forms when it sees them in its physically freed state before it has joined a body? Sometimes Plato spoke as if the soul 'sees' the Forms with its own 'eyes' even though the Forms themselves are immaterial and invisible, while at other times he seemed to suggest that the soul immediately apprehends the Forms through some sort of intellectual intuition, although the exact nature of this intuition he never spelled out.[15]

As far as Aristotle was concerned, all of these problems directly followed from Plato's decision to make form something separate from matter and to relegate each to a separate realm. To avoid these problems and generally to simplify Plato's complex philosophy, Aristotle decided to abandon the theory of two realms and to think of both form and matter as two different properties of the same physical world.[16] To see the physical relationship between form and matter, Aristotle suggested, one has only to look at some organic processes like an acorn growing into an oak. The acorn starts out as a shapeless bit of physical matter, but inherently built into it is an animating force which causes it to grow into a certain form. The form of the oak, in other words, is innately contained within the physical matter of the acorn itself and constitutes the goal towards which the young plant aspires as it grows up.

Aristotle had brought the organic conception of the world to its clearest and most logical expression, linking the animating spirit of objects to their inherent form and finding both immanently within the operations of the physical world itself.

Like Plato, Aristotle considered true knowledge to be knowledge of form. But now that he had placed form securely in the physical, sensory world itself he had provided a more obvious channel to its apprehension. Even though different individual objects in a class of objects – say, horses – might superficially appear to be different in many respects, a careful and extensive survey of all the objects in the class will soon reveal those qualities which are common to them all and those which superficially change. The common features which emerge through this kind of empirical observation will give clear and certain knowledge of the universal form which all objects in the class must innately possess and towards which they all imperfectly grow. So where Plato had relied exclusively upon reason and upon contemplation of a metaphysical realm for his certain knowledge of the world, Aristotle in pursuit of the same end emphasized the use of the senses and contemplation of the physical realm. This is not to say that Aristotle denied the importance of reason, because through reasoning the universal forms, or norms, are generalized from sensory experience; but the use of reason in Aristotle has become little more than a procedure for sorting and clarifying that which originates outside the observer and is apprehended through the senses. In comparison with Plato the source of knowledge has clearly begun to move outside the mind.

To twentieth-century Britons and Americans raised on scientific Empiricism, Aristotle's theory seems closer to the mark than Platonism, which is not surprising since scientific Empiricism ultimately derives from Aristotle. His theory is not without serious problems though, and as will be seen in the chapters on the Renaissance and the Baroque his ideas or variations on them would lead into outwardly sensible but inwardly confused notions about the mind's exact relationship to these sensory data. So despite the appeal of Aristotle for many people today, it will be seen that theorists throughout the history of the West vacillated frequently between Plato and Aristotle, finding salvation in the one from the shortcomings of the other. The differences between these two Greek philosophers, it has been remarked, represent not so much competing interpretations of ultimate reality as much as two irreconcilable temperaments, the one preferring the pure and ideal picture of the world he finds within himself, the other preferring the more chaotic but more down-to-earth realities of the sensory world outside him.[17]

Greek art and architecture theory

Art theory

The same secular interests that created Greek philosophy also created a new naturalistic art. Art in earlier cultures, we have already seen, reflected the prevailing interest in the divine by portraying abstractions rather than closely observed sensory phenomena. The Greek artists chose instead to portray nature itself, attending as closely as possible to its every detail (Figure 28). The idea that art copies nature has been, of course, one of the fundamental assumptions of Western art throughout most of its history, falling out of favour only in the Middle Ages and then in the first half of the twentieth century. However, this new conception of art was not inevitable or more correct. As Gombrich has pointed out in his study of the origins of naturalism in ancient Greece, the idea that art should copy nature is clearly an invented, minority view in terms of art theory throughout the rest of the world.[18]

Although the Greek artists wanted to record nature, they were not as interested in the changing and ephemeral as they were in the timeless and ideal. Like the Greek epistemologists, they drew a distinction between contingent matter and the more stable form behind it. In terms of art, this meant that they wanted to portray the perfect Horse, not 'Bessie' with a crooked nose, a limp leg and awkward proportions. But what could be the artistic source for the perfect Horse? Every horse they could see in sensory nature had imperfections of one kind or another. The artists confronted exactly the same problem as that which had challenged the epistemologists; how does one gain knowledge of the timeless form behind sensory experience?

The Greeks developed two theories for discovering ideal form. The first theory, the one discussed and practised most frequently by the ancient Greek artists, followed an idea like Aristotle's that the more perfect norm is to be found in reiterated experience within the class of objects to be portrayed. They had many anecdotes of painters who brought together the most beautiful models and, by selecting the most beautiful parts from each, managed to create an ideal beauty more perfect than any of the flawed originals. Because this theory looks for an idealized artistic image in a class type, or norm, it has been termed 'normative idealism'.[19] Although this was a popular theory – and it shows up time and again throughout all of subsequent Western art theory – it suffers from a vicious cycle. One must gather together many examples of the most beautiful models in order to discover the essence of their underlying beauty; but one must already know what the underlying

28 *Doryphorus (Spear Bearer)*, a Roman copy of the original by Polyclitus, 450–440 BC. The ancient Greeks rejected the earlier tradition of conceptual art in favor of a naturalistic art that closely observed sensory appearance.

beauty is in order to select examples of it in the first place.

The second theory for discovering ideal artistic form derived from Plato. Plato, it will be recalled, distinguished between a perfect realm of unchanging ideal Forms and a realm of changing sensory appearance that imperfectly copies the Forms. As far as Plato was concerned, art could only imperfectly copy nature, which itself could only imperfectly copy the ideal Forms, and hence art would always be 'three times removed from truth'. None the less, the artists did see a way that they could gain access to the more perfect realm: through geometry, symmetry and proportion. From earlier cultures, as well as from Pythagoras and Plato, they inherited the belief that geometry captures the essential order of the world. Plato even included basic geometrical shapes in his realm of Forms. The artists naturally concluded that if they arranged their art according to geometrical principles, then it would participate in that which makes the universe intelligible and beautiful. Like their earlier ancient predecessors, the Greek artists developed rational systems of proportion for achieving this end. In the next chapter, we will see, Neoplatonists in the early Christian world provided a more direct route to the realm of ideal Forms, through intuitions; but in ancient Greece artists remained content with the power of their geometrical systems.

Both of these theories, normative idealism and geometrical systems, relied upon rational, logical thinking. Yet even Plato was compelled to mention that much artistic creation seemed to be conducted in a state of mania which was 'outside the bounds of ordinary reason'. In the *Ion*, he said:

> For all good poets, epic as well as lyric, compose their beautiful poems not by art [rule], but because they are inspired and possessed. And as the Corybantian revellers when they dance are not in their right mind, so the lyric poets are not in their right mind when they are composing their beautiful strains: but when falling under the power of music and metre they are inspired and possessed ... For the poet is a light and winged and holy thing, and there is no invention in him until he has been inspired and is out of his senses, and reason is no longer in him: no man, while he retains that faculty, has the oracular gift of poetry.[20]

The Greeks could not make much sense of this 'inner' source of art, given their preoccupation with the objective outer world, and they finally concluded that this inspiration was some sort of possession by a divine force outside the artist. In both of their rational accounts of the source of form, the artist 'reached out' to some external and ostensibly objective source, either to the world of sense experience or to the world of ideal Forms. When forced to account for a source that seemed to orig-

inate within the artist, they could only attribute it to some external force acting on the artist's psyche. In his history of aesthetics, Beardsley describes the apparent contradiction between Plato's idea that beauty is created through cool, rational procedures on the one hand, and through passionate frenzy on the other, and then tries to offer several ways Plato might have reconciled the two; yet ultimately he is forced to say that no resolution is really possible.[21] The now well-established split between subject and object would not allow it, because the rational procedures are tied to objective sources outside the artist, and 'passionate', irrational procedures are tied to subjective sources inside the artist's mind.

Architecture theory

These revolutionary ideas in Greek cosmology, epistemology and art theory did not immediately affect architecture. Like their earlier ancient predecessors, Greek architects wished to build temples that would suit their divinities' expectations, and continued to search for rules that would help them generate what they believed were divinely determined forms. Like the Egyptians, they found these rules in geometry and proportion. The Greeks started with a basic module found within the building itself – for example, the width of a triglyph in a Doric temple or the lower diameter of a column – and then derived from this unit all of the other dimensions in the building. Over time standard temple types emerged which specified the number of columns and their locations, the ratios of plan width to length and column diameter to height, the design and location of mouldings, and so on (Figure 29). Eventually these evolved into the Orders upon which most subsequent Classical architecture is based (Figure 13). Although the modern world now thinks of these various rules and forms as nothing more than cultural traditions which grew up over time and then became 'fossilized', to the early Greeks these rules represented timeless and universally objective truths with which mortal men capture divine sources of form (Figure 30).

Like the Egyptians, the early Greeks also seemed to assume that part of the designer's skill involved the gift of invention. The legendary first architect of Greece, Daedalus, was credited with and admired for inventing a number of new building forms and mechanical devices, from labyrinths and steam baths to wax-and-feather wings for manned flight. Like the Egyptians, it is not clear whether the early Greeks ever attempted to reconcile the notion of creative invention with rule-governed design, except to the extent that they seemed to have assumed that several of Daedalus' inventions had been copied from Egypt.[22]

Greek architectural treatises until the fourth century BC apparently

29 The Doric Order. One of five temple types that codified forms, structure, proportions and details. This sixteenth-century interpretation of the Greek rules by Vignola derives every size from the lower diameter of the column, from a module (one half of a diameter) or from a part (one twelfth of a module).

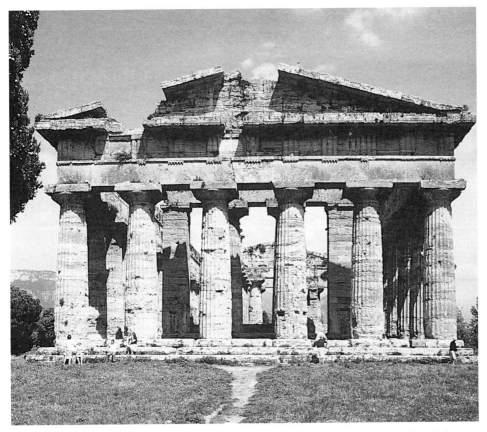

30 Temple of Hera II, Paestum, Italy, c.460 BC. The Greeks believed that their codified rules captured the rational order of the divine.

concentrated on explaining the accepted properties and proportions of the Orders, and on discussing technical construction matters. None of the books has survived; the contents are known only from references to them in later Latin writers. Presumably they were written in order to codify the rules and help with the training of young architects. But as the philosophical revolution in Greece began to take hold, treatises in the fourth century apparently fell for the first time into arguing explicitly about style: against the defenders of the old Doric tradition were ranged the proponents of the newer Ionic form then sweeping across Greece. According to the latter, the Doric order suffered from a fatal flaw in its underlying organization, because the logic of the system could not geometrically allow a satisfactory termination of the triglyphs and metopes at the corners of the frieze (Figure 31). On the basis of this criticism the Ionic order was eventually preferred over the Doric through the remainder of the Greek age.[23] Now compared to the earlier notions about the source of architectural form, this debate reveals a fundamental and even astonishing reorientation of thinking. As long as architects

31 The triglyph problem in the Doric order. The location of triglyphs was determined by two irreconcilable rules: first, they should line up on the centers of equally spaced columns, and on the centers of the spaces between columns; second, the end triglyph must meet the corner of the frieze. The Greeks attempted the two adjustments above, neither of which was considered aesthetically or philosophically satisfactory.

believed that the rules of architecture are divinely given and are there-
fore independent of the personal prejudices or inclinations of individual
designers, it would have been inconceivable for a mortal individual
explicitly to challenge these rules and to offer others quite different in
their place. Those who believed in a divine source of form just might
have accepted a new set of rules on the grounds that a more accurate
version had recently been revealed to man, but the conservative nature
of this attitude would make acceptance on these grounds unlikely. An
architectural style once thought to be divinely given had been over-
thrown on the secular grounds that it was logically inconsistent and
visually offensive. Probably without consciously recognizing so – and
yet entirely within the secularizing spirit of the Greek cultural revolu-
tion – the proponents of the new style had begun to shift the source of
form away from the divine world, from which individuals can only pas-
sively receive preordained ideas, and towards the world of man and his
culture, where individuals can criticize and change design ideas accord-
ing to their own perceptions and sense of logical clarity.

Vitruvius

Only one book on architecture has survived from the ancient world, Vit-
ruvius' *The Ten Books on Architecture*. Writing around 25 BC in the
reign of the first Roman emperor, Augustus, Vitruvius compiled what
he considered to be the essential principles of architecture, town plan-
ning, construction and design education. He based his material both on
his own experiences as a practising architect and on his understanding
of ancient practices. His work apparently summarized the established
views of ancient Greek and Roman architects up to his time, although
we obviously have no other books with which to corroborate his inter-
pretations. None the less, when the Italian architects later revived
ancient ideas in the fifteenth-century Renaissance, they treated Vitruvius
with the utmost reverence as the unquestioned – and only – voice of
authority from the past. Vitruvius is worth studying as much for his
influence on subsequent theories as for his exposition of ancient prac-
tices.

Vitruvius' conception of the source of form emerges in his account of
how primitive men created the first shelters. At first they experimented
with digging caves or assembling green boughs, and some even imitated
the nests of swallows and built out of mud and twigs. They improved
these first experiments 'by observing the shelters of others and adding
new details to their own inceptions', and by modifying constructional

forms and details which failed in winter storms.[24] The original source of form, then, was found first in experiments with building materials, then in adaptation and refinement as climate and use tested the shelters, and also in imitation of successful shelters elsewhere.[25] The source of form is thoroughly embedded in the physical world itself, and owes nothing to an extra-sensory divine overseer.

To this extent Vitruvius has inherited the Greek preoccupation with the physical world; and yet like the Greek epistemologists and artists, he was not content to limit his interests to the changing, ephemeral world alone. Just as his predecessors desired to base their knowledge or art on timeless principles behind appearance, so, too, did Vitruvius wish to base architectural design on more than the contingencies of a particular site, climate or individual designer. Much of his book attempts to set out the 'fundamental principles of architecture' and the timeless characteristics of form which would help practising architects achieve a universal validity and beauty in their works. But in pursuing this end, Vitruvius fell into exactly the same problem that had plagued his Greek predecessors. If one turns away from divine sources of knowledge or art and looks instead to the sensory, physical world, how can one find any timeless principles in a world which continually comes into being and passes away?

Throughout his book Vitruvius continually begs this question by appealing to ancient practices as sufficient justification for a particular principle of design. Since ancient architecture had already reached a peak of perfection, Vitruvius seems continually to assume, it must follow that it had already discovered the true principles of timeless design. Therefore, if modern architects follow ancient practice, by definition they will follow the true principles. Only when Vitruvius steps away from this position on occasion, and discusses how he thinks the ancients themselves discovered the underlying principles of design, does it become clear how much his solution suffers from confusion similar to that in the Greek theories.

Vitruvius explained that the ancients discovered the timeless principles in nature as they experimented with their forms. By rejecting failures and retaining successes, they refined the forms until eventually they could no longer improve their designs. He describes how the Doric order, for example, gradually came into being as carpenters experimented with the roof framing system and construction details, always refining it until it reached its level of perfection. Elsewhere, he explains how the more slender proportions of the Ionic order naturally emerged as posterity 'made progress in refinement and delicacy of feeling'.[26] It is obvious enough how the ancients judged the technical success or failure

of an experiment, but how did they judge if it was beautiful or not? To answer this, Vitruvius suddenly introduced an additional criterion that the ancients used for judging their work: the 'truth of Nature'. 'For in all their works they proceeded on definite principles of fitness and in ways derived from the truth of Nature. Thus they reached perfection, approving only those things which, if challenged, can be explained on grounds of truth. Hence, from the sources which have been described they established and left us the rules of symmetry and proportion for each order.'[27] This is the old Greek theory of normative idealism in another guise, together with its usual vicious cycle. The ancients tested their experiments against the truth of Nature, but they must therefore know the truth of Nature in advance of their experiments. And if they already know the truth of Nature, they do not need to experiment in order to find it.

This same problem shows in his other explanation of timeless principles, the analogy to the human body. Vitruvius describes how the ancients examined many examples of 'well shaped men' and discovered certain unvarying proportions. They also discovered how the ideal human body can fit precisely within a circle drawn from his navel, and within a square touching the feet, head and outstretched hands (Figure 32). Vitruvius accepted these proportions as fundamental principles of nature, and recommended them to architects. Yet once again the ancients already had a preconceived notion of 'well shaped men' before they chose the examples to study.

Leaving these problems with the origins of design principles aside, how did Vitruvius think that the architect would employ these principles? In his most famous phrase, Vitruvius explains that the designer of any building must give due regard to 'durability, convenience, and beauty'[28] (known more familiarly in Sir Henry Wotton's English translation as 'commodity, firmness, delight'). The architect satisfies these by first establishing a standard geometrical module from which he can derive the overall dimensions and proportions of the building, just as in ancient Egyptian and Greek practice. Once the basic form is established, the architect should next 'consider the nature of the site, or questions of use or beauty, and modify the plan by diminutions or additions in such a manner that the diminutions or additions in the symmetrical relations may be seen to be made on correct principles, and without detracting at all from the effect'.[29] In later Positivist theories, the particular requirements of site, climate and function create the form; in Vitruvius, the particular requirements only *adjust* a form that has already been created through manipulation of a geometrical system.

When Vitruvius discusses the adjustments to the form, intriguingly,

32 Leonardo da Vinci. Vitruvian figure from the *Canone de Proporzioni*. Da Vinci later rendered Vitruvius' assertion that the ideal human figure precisely fits a geometrical order. Vitruvius took this as evidence that all good forms in nature reflect an underlying order and proportion.

the subjective mind sneaks back into his system: 'The look of a build-
ing when seen close at hand is one thing, on a height it is another, not
the same in an enclosed place, still different in the open, and in all these
cases it takes much judgment to decide what is to be done. The fact is
that the eye does not always give a true impression, but very often leads
the mind to form a false judgment.'[30] Vitruvius advises the architect to
be wary of this problem, and suggests that he will obtain the best results
if he adds or subtracts from the building form to suit the site; but then
suddenly and without any further explanation he adds 'these results,
however, are also attainable by flashes of genius, and not only by mere
science'.[31] What Vitruvius means here, one can only assume, is that the
architect may occasionally have to step outside the mechanical rules and
use his own intuitive judgement or sense of correctness when attempt-
ing to accommodate all of the building's various and conflicting require-
ments. Elsewhere, when discussing the skills employed in drawing a
plan, he contrasts Reflection, which is 'careful and laborious thought,
and watchful attention directed to the agreeable effect of one's plans',
to Invention, which is 'the solving of intricate problems and the discov-
ery of new principles by means of brilliancy and versatility'.[32] Like his
predecessors, Vitruvius gives no account of how these subjective, inven-
tive skills are reconciled with design based on objective and timeless
properties of Nature.

Vitruvius on education

Ancient design education, we have already seen, started with practical
training in the apprenticeship system and then, as knowledge of abstract
principles became more important to the design process, offered addi-
tional training in theory. Apparently these two sides never satisfactorily
melded together. By the time Vitruvius wrote, a split between practical
training and knowledge of universal principles was sufficiently apparent
for him to warn against excessive reliance on one without the other. The
essential knowledge required by the architect, he claimed,

> is the child of practice and theory. Practice is the continuous and regular
> exercise of employment where manual work is done with any necessary
> material according to the design of a drawing. Theory, on the other hand,
> is the ability to demonstrate and explain the productions of dexterity on
> the principles of proportion ... It follows, therefore, that architects who
> have aimed at acquiring manual skill without scholarship have never been
> able to reach a position of authority to correspond to their pains, while
> those who relied only upon theories and scholarship were obviously hunt-
> ing the shadow, not the substance. But those who have a thorough know-

ledge of both, like men armed at all points, have the sooner attained their object and carried authority with them.[33]

To this command of skill and knowledge of theory he adds the importance of personal abilities: 'one who professes himself an architect should be well versed in both directions. He ought . . . to be both naturally gifted and amenable to instruction. Neither natural ability without instruction nor instruction without natural ability can make the perfect artist.'[34] About natural ability he says no more; about instruction he suggests a curriculum breathtaking in its comprehensive coverage. The intending architect must study drawing, geometry, history, philosophy, music, medicine, law and astronomy. Although he offers this proposed curriculum partly in the spirit of a good general education, Vitruvius gives examples of how this knowledge will help the architect create good cities and buildings. He admits that this may be a great deal of knowledge for one person to assimilate, but he does claim that the architect will be able to learn sufficient of this material to influence his design decisions. The reason, he says, is that 'the arts are each composed of two things, the actual work and the theory of it. One of these, the doing of the work, is proper to men trained in the individual subject, while the other, the theory, is common to all scholars: for example, to physicians and musicians the rhythmical beat of the pulse and its metrical movement.'[35] So although Vitruvius warns not to split practice from theory in education, he himself assigns the former to practical training in a particular subject, and the latter to a liberal arts training in principles common to all arts and sciences. In doing so he solidified a split between, on the one hand, learning a particular approach to design while actively practising under the supervision of a master and, on the other, learning universal principles which are divorced from practice yet which are common to all architecture and all human knowledge. How these two are to be brought together Vitruvius does not say. Nor does he say how natural ability and genius have anything to do with either practice or theory. Are some people more gifted than others in apprehending the universal principles, or in applying those principles in practice? How can personal invention be related to timeless principles? The roots of some of the confusion in contemporary design education are already well established in the ancient world.

Notes

1 Spiro Kostof ed., *The Architect: Chapters in the History of the Profession*, Oxford University Press, New York, 1977, pp. 4-5.
2 *Ibid.*, pp. 8–9.

3 Martin Briggs, *The Architect in History*, Da Capo Press, New York, 1974, p. 7.

4 Kostof, *The Architect*, pp. 3–4.

5 *To Apollon*, in Apostolos Athanassakis, *The Homeric Hymns*, The Johns Hopkins University Press, Baltimore, 1976, pp. 23–4.

6 T. W. Allen, W. R. Halliday and E. E. Sikes, eds, *The Homeric Hymns*, The Clarendon Press, Oxford, 1936, p. 243.

7 Margaret Mead, *Continuities in Cultural Evolution*, Yale University Press, New Haven, 1964, p. 44.

8 *Ibid.*, pp. 41–3.

9 *Ibid.*, p. 46.

10 For the following interpretation of Thales and the rest of the early Greek philosophers, see R. G. Collingwood, *The Idea of Nature*, Oxford University Press, London, 1976; and Errol Harris, *Nature, Mind and Modern Science*, George Allen and Unwin Ltd, London, 1954.

11 Harris, *Nature*, p. 64.

12 *Ibid.*, p. 86.

13 For Plato's theory of ideal Forms see especially his dialogues *The Republic, Phaedo*, and *Symposium*, trans. B. Jowett, *The Dialogues of Plato*, 4th edn, the Clarendon Press, Oxford, 1953.

14 Plato, *The Republic*, in *The Dialogues*, Jowett, vol. III, pp. 214–18.

15 Plato, *Phaedo*, in *The Dialogues*, ed. Jowett, vol. I.

16 Aristotle, *Metaphysics*, trans. W. D. Rose, *The Works of Aristotle*, the Clarendon Press, Oxford, 1928, vol. VIII.

17 W. T. Jones, *A History of Western Philosophy*, vol. I, *The Classical Mind*, Harcourt, Brace and World, Inc., New York, 1969, pp. 217-18.

18 Gombrich offers an intriguing explanation of the Greek revolution in art. Drawing upon the principles of interactionist psychology, he suggests that representational art always starts with a 'schema' in the artist's mind which is then tested against sensory evidence. Gombrich transforms this psychological principle into a historical one and claims that 'making comes before matching', leading to the conclusion that primitive art represents the necessary first expression of the schemata alone while the revolutionary Greek art represents the first attempt in Western history to test the schemata against appearance. Ernst Gombrich, *Art and Illusion: A Study in the Psychology of Pictorial Representation*, Phaidon Press, London, 1977.

19 Harold Osborne, *Aesthetics and Art Theory: An Historical Introduction*, Longmans, Harlow, Essex, 1968, p. 51.

20 Plato, Ion, in *The Dialogues*, ed. Jowett, vol I, pp. 107–8.

21 Monroe Beardsley, *Aesthetics from Classical Greece to the Present: A Short History*, Macmillan, New York, 1966, p. 45.

22 Kostof, *The Architect*, p. 4.

23 D. S. Robertson, *Greek and Roman Architecture*, 2nd edn, Cambridge University Press, Cambridge, 1980, pp. 106–11.

24 Vitruvius, *The Ten Books on Architecture*, trans. Morris Hicky Morgan,

Dover Publications, Inc., New York, 1960, p. 38-9.

25 It is intriguing that Vitruvius accounts for the two essential techniques of learning that Margaret Mead observed in numerous primitive cultures and that Jean Piaget has established as the basic learning techniques of children – experimentation and imitation. Mead, *Continuities,* pp. 41–44; for Piaget see the last chapter of this book.

26 Vitruvius, *Ten Books,* p. 104.

27 *Ibid.,* p. 109.

28 *Ibid.,* p. 17.

29 *Ibid.,* p. 174.

30 *Ibid.,* pp.174–5.

31 *Ibid.,* p. 175.

32 *Ibid.,* p. 14.

33 *Ibid.,* p. 5.

34 *Ibid.*

35 *Ibid.,* p. 11.

3

The Middle Ages

Shift from the secular to the divine

Towards the end of the Roman Empire, the secular spirit that had originally inspired ancient Greek cosmology, epistemology and art began to fade. Perhaps because individuals in the late despotic phases of the empire felt less control over their own destinies, or perhaps because they were painfully aware of barbaric raids and civil strife as the empire crumbled, they began to lose faith in their own abilities to control or even to understand events in the world around them. Increasingly people turned for comfort to the worship of deities they believed to be all-knowing, all-powerful and all-good. According to several of these cults, the deity resided in a divine otherworld as pure and beautiful as the secular world was tainted and mean. Offering further comfort, these cults promised that the human soul could be united for eternity with this divine realm, after a short but miserable life in the physical world. As one might expect, this change in the underlying cosmology exerted a powerful effect on philosophy, art and architecture theory in this period.

Neoplatonism

Before these tendencies had submerged classical modes of philosophy altogether, one last attempt was made in the third century BC to reconcile the new mood with some of the old concepts. The Neoplatonic school of philosophy, as the name suggests, reinterpreted Plato's philosophy in order to develop a version more commensurate with the new mystical spirit. The world in Plato's cosmology, it will be remembered, consists of two realms: the transcendental world of pure forms that cannot be seen in the senses yet contains the ideal essence of everything; and the phenomenal world of physical objects

that can be seen by the senses yet contains only imperfect copies of the ideal forms. The former is superior to the latter and, even though it cannot be sensed, it alone contains the source of true and timeless knowledge.

In an age preoccupied with the otherworldly, the attraction of this theory is understandable. True reality is not the chaotic and mean phenomenal realm in which men unfortunately find themselves, but rather is a transcendental realm of pure, beautiful and timeless forms. Furthermore, the thought that timeless verities could be found in the transcendental realm must have appealed to the Neoplatonists' desire for stabilizing certainties in an uncertain world. However, where Plato had given access to the transcendental realm through rational thinking, in the new spirit of the age the Neoplatonists no longer trusted the powers of reason. They needed to find another route to the transcendental realm.

Plotinus (c. AD 203–69) proposed the most influential solution to this problem. In his philosophy the ultimate source of reality is the One, or the Absolute, that is beyond all conception and knowledge. Like a sun, it radiates a force or energy that creates successive levels of reality, each one less real as its distance from the One increases. The first emanation from the One Plotinus called *Nous*, or Divine Mind; from *Nous* emanates Soul, which includes human souls; and from Soul emanates the physical world, which includes human bodies. For reasons Plotinus never explained, this movement works in both directions: first these various levels of reality emanate from, and then they return to, the One. It is because of this reunifying movement in the cosmos that individuals residing in the physical world can rejoin the divine One from which they originally emanated. According to Plotinus, individuals may return to the One in two ways. Through reincarnation they may be born into higher and higher spheres or, more interesting for the issues in this book, they may experience an immediate union through a special kind of mystical intuition.

In explaining the mystical intuition, Plotinus developed a new source of knowledge which would influence several post-medieval theorists, even though they would not necessarily have agreed with the cosmological system upon which it was based. Because the natural world and man are faint imitations of the divine One from which they derive, they have within themselves a piece, or an echo, of the divine. Therefore, if one contemplates either of these with the right meditative frame of mind, one will eventually discover the essential character of the One. In contemplating beautiful objects in nature, for example, one eventually discovers the inherent form which gives the object its

beauty, and the discovery of its form leads, in turn, to a discovery of the One which is the form's original source. Alternatively, one can turn away from the outside world altogether and discover in one's inner self the divine essence:

> In order, then, to know what the Divine Mind is we must observe soul and especially its most God-like phase ... One certain way to this knowledge is to separate first, the man from the body – yourself, that is, from your body – next to put aside that soul which moulded the body, and, very earnestly, the system of sense with desires and impulses and every such futility, all setting definitely towards the mortal: what is left is the phase of the soul which we have declared to be an image of the Divine Intellect, retaining some light from that sun, while it pours downward upon the sphere of magnitudes (that is, of Matter).[1]

Following either the outer or the inner route, one will gain knowledge of ultimate reality intuitively, without relying on the ancient Greeks' enquiring scientific empiricism or rational thought.

This extra-rational and extra-perceptual access to the transcendental reality provided Plotinus with a new source of artistic ideas. Whereas Plato had assumed that art only imperfectly copies nature, which in turn only imperfectly copies the ideal forms, and thus is 'three times removed from truth', for Plotinus both nature and art derive from the forms in the same way:

> ... the arts are not to be slighted on the ground that they create by imitation of natural objects; for, to begin with, these natural objects are themselves imitations; then, we must recognize that they give no bare reproduction of the thing seen but go back to the Ideas from which Nature itself derives, and, furthermore, that much of their work is all their own; they are holders of beauty and add where nature is lacking. Thus Pheidias wrought the Zeus upon no model among things of sense but by apprehending what form Zeus must take if he chose to become manifest to sight.[2]

The artist creates an artistic image not by reproducing what he sees in the visible world, but rather by reproducing what he intuitively 'knows' about the transcendental realm from which that visible world derives. With direct access himself to the source of natural objects, he may be able to capture the ideal form even more fully than can the object in nature. For Plotinus, then, the artist has an intuitive vision of an ultimate reality beyond sense experience, and he can imitate it – make it physically manifest – in his art work without recourse either to perception or reason. To the extent that the individual artist is an emanation of the ultimate reality and thus possesses a personal inner

echo of that ultimate reality, the source of his artistic images is to be found within himself. Discussing the beauty of form in a stone sculpture, Plotinus emphasizes that 'this form is not in the material; it is in the designer before ever it enters the stone; and the artificer holds it not by his equipment of eyes and hands but by his participation in his art'.[3] This has been termed 'metaphysical idealism', because the artist finds his images in a transcendental realm.[4] It will exert considerable influence first on the Renaissance, and later on Romanticism in the nineteenth century.

Early Christian philosophy

Parallel with the early mystery cults and Neoplatonism, and shaped by the same otherworldliness and quest for certainty that preoccupied the entire age, grew the Christian church. Although Christianity began as one of many informal religious sects in the first century AD, by the fourth century it had come to dominate all other religions in the West. With a well-organized institutional structure and a self-assured leadership, it established itself as the official state religion of the Roman Empire, outlawed rival sects, and began to develop an orthodoxy of concepts that eventually dominated the next nine centuries. During this time most of the ancient Greek concepts and philosophical attitudes discussed so far virtually disappeared.

To a certain extent, Christian cosmology can be seen as a logical development of the earlier mystery cults and Neoplatonism. Like these earlier views, Christianity turned its back on the physical world and focused attention firmly on the otherworldly divine; like the earlier views, it concerned itself not so much with life in the here and now, as with how to achieve salvation and therefore ensure an eternal life in the hereafter. In explaining the exact relationship between the world of man and the otherworldly divine, however, Christianity diverged from these earlier views in one important respect.

The divergence hinged on the nature of God and His relationship to the physical world. Neoplatonism considered God to be the guiding intellect and energizing spirit that pervaded the entire universe. Although both of these qualities were strongest and most pure at their original source in the One, they could still be found in more diluted forms in every object in the universe, no matter how humble. Like the ancient Greek organic analogy, this pantheism meant that everything in the universe – including man – actively participates in the universe's guiding and motivating forces. The individual can know about the organizing principles of the world because part of that organization is

within himself; and he can influence events which influence him, to a certain extent, because he participates in those energizing and motivating forces that cause things to happen. From its Jewish origins, however, Christianity inherited the concept of a God as a specific Being who stands outside the universe altogether. God created the universe out of nothing, and then ordered and directed it from without, much as a model maker might construct a miniature railway engine and track according to his or her own plans and then, to make it move, physically push the engine around its course. At first glance it would appear that the model possesses both design in its physical appearance, as well as some motivating force that causes it to move; but both of these conditions have been supplied entirely from outside, and are not properties in which the model itself can claim to have participated. For the organic analogy, Christianity substituted an analogy of Creator and created, with the former actively organizing and directing, and the latter passively being organized and directed. Christians' knowledge of ultimate reality – and their personal fate – now depends entirely upon a God standing outside themselves and their world.

When ultimate reality was still thought to lie within the universe itself, and was thought to be ordered according to principles which the human organism could understand, then man could confidently rely on his own powers of perception, reason or intuition to gain knowledge of this reality. But when, as W. T. Jones points out, ultimate reality is thought to lie 'outside the universe in the realms of a creator god, ineffable, exalted, and infinite, essentially different from his creation and incapable therefore of being understood by it ... [then] man's only hope is in the generosity of higher powers; his best attitude is one of humility and pious respect; and the key to his whole future is unquestioning faith in the extrarational, supernatural revelations of the ultimately incomprehensible divine'.[5] Man, it was assumed in the Middle Ages, did not have sufficient powers on his own to understand the nature of the world. Any knowledge he did possess about ultimate reality had been given to him by God in various divine Scriptures. Although the Scriptures were written by men, these individuals were only a passive medium through which God had revealed the truths he wished mankind to know. So where ancient man in search of universal truths had looked out into the physical world or into his mind for knowledge that he could see or reason for himself, medieval man in search of truths examined the pre-established doctrines contained in a few crucial texts. The ancient problems of epistemology, of how the human mind can know certain truths about the outside world, had now virtually disappeared. What man knows has been

given to him by God, and since God is not an evil deceiver, the knowledge thus received can be relied upon as true, without doubt or question. When a statement in the Scriptures contradicted everyday sense experience or even another statement elsewhere in the Scriptures, medieval man put this down to human inadequacies. His own feeble powers of perception and reason were simply not up to the task, he assumed, of understanding God's divine plan or organizing principles. Faith in the divine revelations was more reliable than reasoning or perceiving for oneself.

The two essential components of the old Greek outlook – the secular interest in physical nature and the priority of the individual – were now entirely gone. Western culture was frightened and weary of the physical world, and had reverted to the much earlier ancient world preoccupation with the metaphysical world of the gods. Likewise, individuals no longer thought of themselves as possessing self-sufficient powers of observation, reason or creative action; now in the Middle Ages they saw themselves as entirely dependent upon an all-powerful external force. In earlier ancient cultures, individuals still thought they could influence the deities that determined their own fate; now in the Middle Ages they have no control over their God. Without these two components of the Greek view, the subject–object problem and its dualistic consequences for philosophy inevitably diminished.

Medieval art and architecture theory

This Christian cosmology shaped the medieval conception of art. Some church thinkers were opposed to art altogether, for its use of naturalistic images drew too much attention to the debased physical world of the here and now, and diverted men's and women's attentions from a more proper concern with the divine hereafter. This view arose several times throughout the period, for example in the writings of Tertullian at the beginning of the third century, and later in the Iconoclastic movement in the eighth and ninth centuries.[6] Early on, however, many Christian leaders saw the educational value of visual art, for it could provide necessary religious instruction to the illiterate, and could help lead people's thoughts to a contemplation of God. So where visual art in ancient Greece and Rome possessed an intrinsic interest of its own, in the Middle Ages art was considered interesting only in so far as it symbolized the Divine.

This new conception of art presented the artists with a problem: if

art no longer captures realistic images of the sensory world, but instead should lead men's minds to contemplate an extrasensory divine world, upon what, exactly, should their visual images be based? The Divine itself is entirely beyond sense and even beyond mortal comprehension, so there can be no obvious source of images there. St Augustine (354-430) offered one possible solution that found adherents through the entire medieval age. Like much of the ancient world, Augustine assumed that the world is organized rationally. Beneath the apparent complexity and even chaos of the visual world he knew one could find precise mathematical ratios and numbers. And like many Greek artists, he claimed that this mathematical order in objects creates beauty. Now since, in Christian cosmology, this order in the universe was created by God, Augustine recognized that to appreciate the rational beauty in physical objects is effectively to appreciate the divine perfection of God's creative activities. An aesthetic experience which captures this rational order in its most intense form, he believed, can become religious wisdom. In this spirit, artists and architects in the entire medieval period attempted to capture in their work the mathematical harmony, proportion and number that they believed expresses and celebrates God's divine order. The importance of geometry has remained a constant throughout our entire history so far; what changes is whether this geometry is considered to reflect the order of the Divine or the order of nature.

This medieval preoccupation with divine structure held equally true for architectural design. Medieval architects started with simple geometrical figures, like circles, equilateral triangles and squares, and then through a series of prescribed steps generated complex geometrical forms that organized the building both in section and in plan. This geometry, the medieval architects believed, not only assured the structural fitness of the building, but also guaranteed that the building would necessarily embody the essential characteristics of the Divine (Figure 33).

In the nineteenth and twentieth centuries, some historians like Viollet-le-Duc underrated this metaphysical basis of the geometry in Gothic architecture, because they wished to prove that the geometrical order derived solely from structural considerations. As James Ackerman has shown, however, the medieval masons often determined the geometry in Gothic cathedrals quite independently of structure, and the selection of one geometry over another often had more to do with matters of internal consistency and geometrical elegance than with constructional exigency. For example, the foundations of Milan cathedral were laid well before basic decisions had been made about

33 Medieval cathedral geometry. As in the ancient world, medieval archi-
tects hoped that a rational geometrical system would capture the essential
order of the Divine. Here equilateral triangles determine all of the major
proportions, although medieval buildings also employed complex combina-
tions of squares, non-equilateral triangles and circles.

the design of the piers or the height of the overall building section;
and at one point an equilateral triangle was proposed as the ordering
principle of the section, presumably on the grounds of its geometrical
perfection, even though the exact height of such a triangle is incom-
mensurate and therefore physically difficult to build (Figure 34).
Furthermore, in a dispute between the Italian master builders and a
Frenchman whose advice they sought on a structural problem in the
same cathedral, the Italians were so keen to justify their geometrical
scheme that, to the astonishment of the Frenchman, they naively
denied their pointed arches would exert any thrust on the buttresses.
Clearly a close correspondence between the geometrical structure of
the building and the underlying structure of the cosmos was of
paramount importance, and could even override more prosaic tech-
nical problems.[7]

Both artists and architects, then, wished to capture in their work the
rational order of the cosmos. But how exactly were they to apprehend
this order? The Greeks had exerted much effort attempting to

34 Milan Cathedral geometry. An equilateral triangle creates difficult measuring problems for the masons. If the horizontal dimension is a conveniently even integer or fraction then the vertical dimension is not, and vice versa.

solve this problem, but for the Middle Ages it posed no problem at all. God, they confidently assumed, would simply reveal to the artists any knowledge of mathematical harmonies that they would need for their work. How they might have understood this to work we can see by referring back to Neoplatonism. Plotinus had linked the artist with a source of form in the Divine, and had established a relationship which could allow of two interpretations. Looking at it in one direction, the artist could be thought of as the instigator of, and an active participant in, the artistic process: he can 'look into' the Divine, see there the essential reality of the supersensual realm, and then recreate his vision in a physical medium. Alternatively, the artist could equally well be thought of as a more passive participant in a process that works in the opposite direction: the Divine 'gives' knowledge of the structure to the artist, who then simply manifests it in his artistic work. Plotinus was inclined to the former, since his view of the world still presupposed man to be an active participant in the organizing and animating principles of the cosmos; but the medieval Christians were inclined to the latter, because their cosmological system had to stress the gulf between God and man, and could not allow man to look into the mind of God on his own terms and understand what he 'sees' there. St Augustine described this receptive process as a 'divine illumination'. Just as sunlight makes physical objects visible to the eye, so, too, does an illumination emanating from God make the eternal struc-

ture of the Divine intelligible to the human mind.[8] The artist had become a mechanism through which God expresses Himself in the visual arts.

The ancient Greek and Roman artists, of course, also aimed to capture an underlying order in their work. But where their preoccupation with the physical world encouraged them to express such order through faithfully realistic and naturalistic images, the medieval artists held no interest in the physical world in itself, and therefore felt little desire to achieve truth to the senses. Since the important thing for the Middle Ages was not so much the visual image as the idea for which this image stood, medieval art acquired an abstract style which captured enough of a character or a scene to make it obvious what the painting or sculpture referred to, without concentrating unnecessarily upon phenomenal detail. In visual images of this period, most of the techniques used by ancient artists to achieve realistic effects were abandoned. In place of shades and shadows which model a form in three dimensions, the medieval artists drew and painted flat, two-dimensional forms; where ancient artists used perspective to convey visual depth, medieval artists often used reverse perspective, in which important characters in the background are physically larger than their subordinates in the foreground; and where ancient images show characters living in realistic settings, the backgrounds of medieval images are often stylized and abstract. It did not matter if the figure in medieval art stood stiffly at attention, as long as its form evinced the underlying mathematical order, and as long as the viewer could recognize the story to which it referred (Figure 35). The portrayal of nature was no longer a desirable end in itself, but rather a necessary means to a greater end.

At the same time, the cosmological system in the Middle Ages diminished any conception of autonomous creative powers. Because the artist is supplied with his artistic sources by God, he can take no personal pride in his work other than that God happened to speak through him and not someone else. Nor would he actively seek original perceptions, for he was content to receive what God had deigned to give him. This attitude inevitably diminished the conception of a personal artistic viewpoint, because the artistic vision of the timeless Divine supplied by God belongs neither to the individual artist nor to his or her own time and place. The whole point of art, after all, was to express timeless verities about a universally shared and universally objective reality. No one would have been the least interested in one individual artist's personal opinions of the divine truth.

The lack of a personal viewpoint is reflected in medieval paintings,

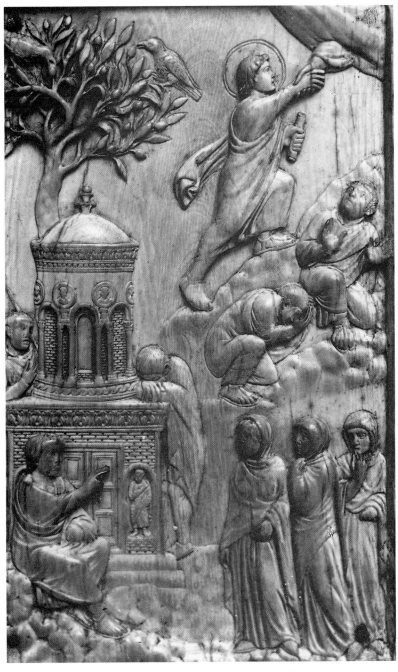

35 *Three Marys at the Sepulcher*, and *The Ascension*, late fourth or early fifth century AD. Medieval art marks a rejection of Greek naturalism and a return to the earlier conceptual tradition.

which literally have no spatial or temporal perspective. In numerous paintings, for example, the front and two sides of buildings are folded out flat so that all can be seen simultaneously, while figures like Christ appear twice in the same scene showing two different stages of the same story (Figure 36). The medieval artist depicted not what was subjectively perceived, but what had been divinely revealed as objectively valid for all viewpoints and for all time. With complete faith in God to supply knowledge of the Divine, and with little sense of personal artistic insights or powers, the ancient Greek concerns about explaining the source of artistic ideas no longer interested the medieval mind.

Scholasticism

The cosmological and artistic views just discussed dominated the Western world for more than nine centuries, lasting longer than the Classical period of Greece and Rome, and longer, so far, than the modern age from the Renaissance to the present. The longevity alone of this Christian era describes the success with which its views and institutions satisfied the requirements of the time. Towards the end of the eleventh century, however, new forces began to stir which eventually dismantled the medieval cosmological system and replaced it with the modern conception still largely in use today. This reorientation of thinking also effectively reasserted some of the old Greek conceptions and, with them, the components of the subject-object problem. Where the medieval view had deprecated the powers of the individual, the emerging new view reasserted a self-conscious awareness of the individual's powers of observation and reason. Where the medieval view had conceived of the physical world as a symbol of the divine, the emerging view looked once again at the sensory world as an object with its own intrinsic interest.

Although the new view was not fully asserted until the fifteenth century (when the Renaissance philosophers finally abandoned the heart of medieval cosmology altogether), its tentative appearance can be traced from the beginning of the second millennium. Many reasons have been offered for the changed perspective in the eleventh century: the physical world looked less threatening once the raiding barbarians of previous centuries had been assimilated into the established culture; the final Day of Judgement prophesied for the year 1000 came and went, and when men found themselves still alive in the physical world they took an interest in its affairs; the rise of cities and the resumption

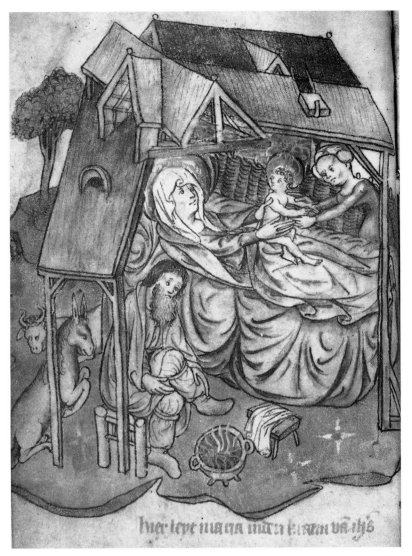

36 *Book of Hours: The Nativity*, Utrecht, c.1410–20. Medieval art typically
has no spatial or temporal perspective. In this relatively late example, the
building is represented as if it were seen from several viewpoints
simultaneously, while the scale of the building is inconsistent with the
figures within.

of trade gave individuals more direct control over their own destinies, and placed them less at the mercy of distant secular or religious leaders; and increasing contact with an intellectually assertive Islamic world forced Christians to justify their beliefs more rationally to the sceptical non-believers. Whatever the reason, the effect was that, towards the end of the eleventh century and into the twelfth, a number of thinkers including St Anselm of Canterbury (1033–1109), Roscelin (c.1050–1120) and Peter Abelard (1079–1142) began to undertake systematic philosophizing once again. After centuries of simply accepting the revelations of the Scriptures on faith, these philosophers felt compelled to give logical reasons for Christian beliefs, reasons which they personally could feel were internally consistent and externally coherent. They were not grand system builders in the style of the ancient Greeks or later post-medieval philosophers, for they still implicitly accepted the fundamental tenets of Christianity and set out only to solve a few technical problems within the Christian framework. Compared to the previous centuries, however, the intention alone to solve a problem in the cosmological system reveals a new desire to see the world for oneself, and an increasing faith in one's ability to do so.

These philosophers began also to look at the physical world again. In a heated debate between Realists and Nominalists regarding the status of universal concepts like Horse, the Realists asserted the old Platonic idea that the universal concept is more real than the particular sensory examples of horses which derive from it. The Nominalists, on the other hand, successfully argued the Aristotelian view that a universal concept is merely a collective name for those properties which are common to all individual members of a class. The latter position directed attention once again to sensory particulars, because in order to apprehend a universal concept like Horse, one must examine carefully many examples of particular horses in the physical world.

The rediscovery in the twelfth century of Aristotle's major works hastened this reawakening of the empirical spirit. Although these books were virtually lost to the West in the troubled centuries following the collapse of the Roman Empire, Islamic scholars had preserved and translated them and then, in response to the West's increasing interest in books and learning, made them available to travelling monks and scholars. In Aristotle, the Western scholars found a method and an attitude quite foreign to the abstract, otherworldly preoccupations of their age. Well into the thirteenth century, Aristotle's books were eagerly read mainly for the voluminous factual and practical material they contained, not for the philosophical con-

cepts upon which they were based. Indeed, throughout the century, the teaching of Aristotle's metaphysics and natural sciences were regularly banned by the authorities, because many of his philosophical ideas contradicted fundamental Church doctrines.

The secularizing spirit could not be stopped so easily. So great was the esteem in which late medieval thinkers held Aristotle that he became known simply and reverently as 'The Philosopher'. In the middle of the thirteenth century St Thomas Aquinas (c.1225–c.1277) attempted a grand synthesis of Aristotelian philosophy and Christian theology which, although originally viewed with some suspicion, was finally declared the official philosophy of the Roman Catholic Church in 1879. St Thomas's contemporary, Roger Bacon (c.1214–c.1292), also cited Aristotle as justification for what some modern commentators have called the first proposal for an empirical, scientific method since antiquity. In explaining his 'experimental science' he said 'there are two modes of acquiring knowledge, namely, by reasoning and experience. Reasoning draws a conclusion and makes us grant the conclusion, but does not make the conclusion certain ... unless the mind discovers it by the path of experience ... He therefore who wishes to rejoice without doubt in regard to the truths underlying phenomena must know how to devote himself to experiment'.[9]

Compared to their predecessors in earlier centuries, these philosophers clearly show a renewed interest in the sensory world and a faith in their ability to see things for themselves. In comparison to the Renaissance thinkers yet to come, however, these Scholastic philosophers still belong firmly in the Middle Ages. They still accepted without question the Divine revelations of the Bible, they continued to quote from authorities as sufficient justification in itself for accepting a particular notion (even though their main authority was now Aristotle), and their overwhelming interest still lay in understanding divine reality. They used reason and observed sensory nature mainly to give deeper insights into the operations of God. As far as Bacon was concerned, 'the whole aim of philosophy is that the Creator may be known through the knowledge of the creature, to whom service may be rendered in a worship that gives him honor'.[10]

Although little was written about art theory in this period, the arts themselves reveal a similar fusion of medieval otherworldliness with a renewed interest in sensory appearance. The paintings and friezes by Giotto (c.1267–1337), for example, display a softening of images, a modelling of three-dimensional forms and an observation of sensory detail that astonished his contemporaries (Figure 37). The Renaissance art historian Vasari attributed to Giotto the revival of the art of paint-

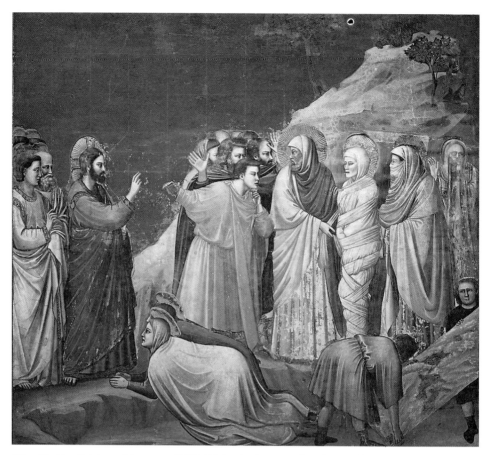

37 Giotto, *Raising of Lazarus*, 1305–06. In the late medieval period, Giotto fused a renewed naturalism with traditional medieval interests in the conceptual. Here figures mostly stand stiffly at attention in the same spatial plane, but the forms are more modelled in light, and the faces reveal more closely observed personal expressions.

ing, and called him 'the pupil of Nature'.[11] At the same time though, he continued the medieval tradition of representing important figures like the Madonna larger than the other characters in the painting, even though realistic perspective would demand the opposite; while he modelled figures with shading, the source of light is diffuse and ethereal, representing an otherworldly origin; and the backgrounds to the figures are only abstractions of landscapes. Similar tendencies can be seen in the sculptures of Giovanni Pisano (*c*.1250–*c*.1314) produced in the same period (Figure 38). These artists clearly began to test their images against the 'truth of the senses', but at the same time they still infused the work with a sense of the Divine.[12] In terms of architecture, Paul Frankl argues that the change from Plato to Aristotle in the Scholastic age corresponds to the change from the Romanesque to the Gothic. Where the Romanesque architects used simple and clearly

articulated forms of cubes, spheres and cylinders that appealed to the intellect, the Gothic architects fused forms together into complex compositions, elaborated rich decoration, and sought to delight the senses (Figures 39, 40).[13]

Education in the guilds and universities

Little is known about design education from the close of the ancient world to the end of the first millennium AD. Craft guilds, or *collegia*, flourished in the Roman Empire as informal and voluntary organizations of workers; whether they undertook major responsibility for training young designers is not clear. Authorities in the fourth century transformed some into semi-public organizations with responsibility for supplying essential services and materials. From the fifth to the eleventh centuries they declined and then, with the exception of some continued activity in the Byzantine Empire, virtually disappeared.[14] During this time of limited economic and constructional activity one assumes that training was handled informally, probably within the family. Almost certainly a form of the apprenticeship system continued, just as it had from prehistoric times through the ancient world. The apprenticeship system would have suited the Middle Ages at the height of Christian influence. Just as the individual willingly accepted for his conception of reality the pre-established revelations in the Scriptures so, too, did he accept that his activities in the physical world – including how to design buildings – should be constrained and directed by long-standing cultural traditions. The important thing in designing buildings, after all, was not the individual creative perception or expression, but rather knowledge of that pre-established and shared body of information which linked architectural form with the spirit of the Divine. In this sense the medieval architects were like the Egyptian and early Greek architects who sought objectively true, divinely inspired forms.

The eleventh century, it has already been mentioned, saw a resurgence of city life and economic activity, a tentative interest in the physical world, and an increasing faith in individual powers. Parallel with all of these grew new craft guilds. Like their earlier cousins, the *collegia*, these organizations were at first informal and voluntary, later regulated by the various municipal authorities. Workers in the same trade banded together to pursue common interests like securing raw materials, providing financial security for their widows, worshipping together and, most importantly, controlling and regulating the craft

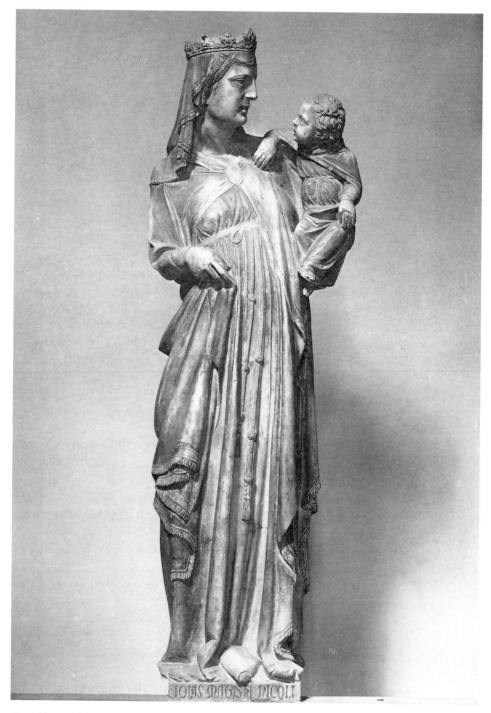

38 Giovanni Pisano, *Virgin and Child*, c.1305. Like Giotto, Pisano also fused a more closely observed phenomenal appearance with a continued sense of an underlying divine order.

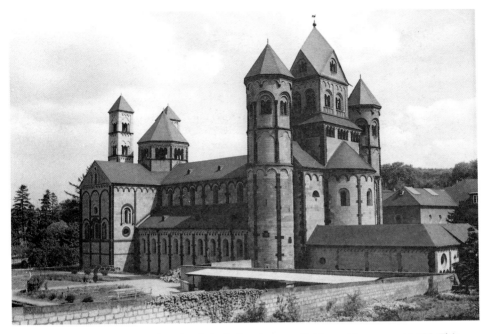

39 Abbey Church of Maria Laach, near Coblenz, Germany, c.1156. This Romanesque church employs simple and clearly articulated geometrical forms that appeal to the intellect.

itself. One form this control took was to establish a monopoly and combat foreign trade, thus ensuring a steady and profitable supply of work for the guild members. The other form of control was to regulate the quality of work each member produced, thus providing some justification for their monopoly and ensuring that regions renowned for certain crafts like woollen or leather goods would maintain their reputations. To regulate the quality of work, the guilds naturally took over responsibility for training the young.

Typically, an intending young craftsman served an apprenticeship under a master – who was himself a qualified practitioner and member of the guild – for seven years. The master supplied his apprentice with food, clothing and shelter, and taught him the essential skills and knowledge required in the first stage of his education. The apprentice, in turn, gave the master free help on the projects in the workshop. Occasionally, the parents of an apprentice paid a premium to a particularly well-regarded master, to ensure their child a place in a good workshop. An apprentice architect usually first learned a building craft, carpentry or masonry or both, and worked alongside the builders on actual projects. At the same time, through his membership in the guild and from his master, he learned trade secrets including

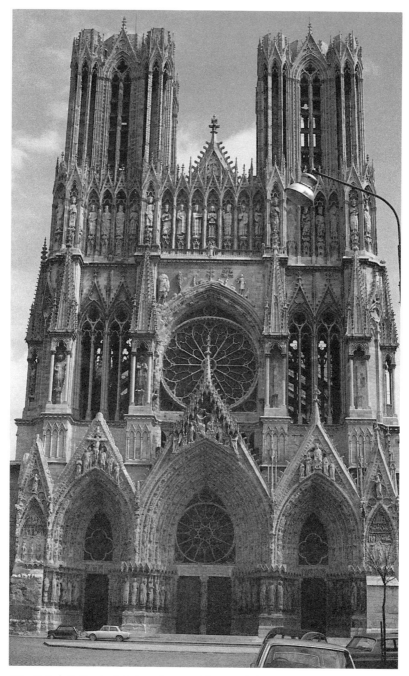

40 Reims Cathedral, Reims, France, 1211–end thirteenth century. This
Gothic cathedral, in contrast to Figure 39, fused forms together into
complex compositions, elaborated rich decoration and sought to delight

how to generate a plan and elevations through geometrical manipulations, how to design important construction details, and how to design façades. Many of these secrets were transmitted by means of jealously guarded pattern books, which set out specific exemplars of good practice. Distinguished practitioners in each generation added to these books, drawing upon their own experiences and innovations, and in this way the guild's design traditions naturally evolved over time. Unlike Vitruvius' proposal for basing education on abstract principles found in the liberal arts, education in the guild was based first and foremost on particular examples of architectural, geometrical and decorative form.

After training with a master, the intending architect worked for three more years as a journeyman, travelling to observe and sketch notable exemplars around Europe, and working on various building sites in various trades to gain experience. After settling down, he presented a *masterpiece* of work to the guild in order to prove his competence, and to qualify as a master in his own right. If he passed this test he was allowed to secure commissions for work and even to take on apprentices himself. This was essentially the apprenticeship system of the medieval world.

Parallel with the guild system grew another institution that would shape design education in the twentieth century: the universities. Education other than craft training in the Middle Ages was almost exclusively run by — and for — the Church. Parish priests taught the masses basic religious truths, while higher training in the arts and sciences was reserved for those who intended to serve the Church in some administrative role. Schools were usually attached to monasteries or cathedrals for this latter purpose. With the rise of city life, the revival of trade and renewed interest in learning in the eleventh and twelfth centuries, however, these religious schools found it increasingly difficult to satisfy the new requirements for trained lawyers, doctors, secretaries and logicians. By the end of the twelfth century the first universities emerged to meet the demand. Educationally, the universities continued to teach much of the curriculum of the cathedral schools, but they took their institutional structure from the craft guilds (the names universitas and collegium derive from Roman and medieval guilds).[15] The craft guilds were, after all, the main institutions for regulating training and ensuring competence in the medieval period, and the first universities saw themselves as purveyors of a commodity which happened to be teaching and learning.

Like the craft guilds, the first universities inducted the students into an established tradition. These institutions were interested neither in

developing new knowledge nor in developing the students' original, creative skills. Like Scholasticism generally, they intended to reveal pre-established divine truths more exactly, by rigorously deducing propositions from authoritative texts. The university students acquired skills for inquiring into these divine truths just as the students in the mason's guild acquired skills for manipulating the divine geometries of the cathedrals.

A student at an early university was an apprentice teacher. First he studied under a recognized master for four to five years, learning the standard interpretations of the few standard texts (mostly Aristotle's), and honing his ability to reason through argument. He underwent an examination for his Bachelor's certificate, which was the direct equivalent of a journeyman's certificate in the craft guilds. After further years of study, which included helping the master to teach, he undertook similar exams for a Master's or a Doctor's certificate (these were roughly the same in the early universities), at which time the university received him as a fellow master and entitled him to teach the standard doctrines himself. The Master's degree was the equivalent of a master's certificate in the craft guilds, in that it licensed him as competent to pass on to new apprentices the essential body of knowledge possessed by the scholars' guild. It is ironic that the universities began as a craft guild, given the modern universities' disdain for technical training.

Notes

1 Plotinus, *Enneads*, trans. Stephen MacKenna, vol. IV, The Medici Society Ltd, London, 1926, section V, iii, 9; p. 30.
2 *Ibid.*, V, viii, 1; p. 74.
3 *Ibid.*, V, viii, 1; p. 73.
4 Harold Osborne, *Aesthetics and Art Theory: An Historical Introduction*, Longmans, Harlow, Essex, 1968, p. 54.
5 Jones, W. T. *A History of Western Philosophy*, Harcourt, Brace and World, Inc., New York, 1969, vol. II, *The Medieval Mind*, p. 65.
6 Beardsley, *Aesthetics*, pp. 90–1.
7 James S. Ackerman, 'Ars sine scientia nihil est: Gothic theory of architecture at the cathedral of Milan', in James S. Ackerman *et al.*, eds., *Medieval Architecture*, The Garland Library of the History of Art, vol. 4, Garland Publishing, Inc., New York, 1976.
8 Frederick Copleston, *A History of Philosophy*, Image Books, Garden City, 1963, vol. 2, part I, p. 78.
9 Roger Bacon, *Opus Majus*, trans. Robert Burke, vol. II, University of Pennsylvania Press, Pennsylvania, 1928, pp. 583–4.

10 *Ibid.*, vol. I, p. 49.

11 Giorgio Vasari, *The Lives of the Artists*, trans. George Bull, Penguin Books, Harmondsworth, 1965, p. 61.

12 This fusion of the sensory and extrasensory is discussed in Max Dvorak, *Idealism and Naturalism in Gothic Art*, trans. Randolph J. Klawiter, University of Notre Dame Press, Notre Dame, Indiana, 1967.

13 Paul Frankl, *Gothic Architecture*, Penguin Books, Harmondsworth, 1962, p. 261. Frankl attributes this view to Drost, *Romanische und gotische Baukunst*, Potsdam, 1944, but argues that the correspondence is perhaps not as hard-edged as Drost had suggested.

14 J. Tanner *et al.*, *The Cambridge Medieval History*, vol. VI, *Victory of the Papacy*, at the University Press, Cambridge, 1929, pp. 474 ff.

15 Harry Elmer Barnes, *An Intellectual and Cultural History of the Western World*, Dover Publications, Inc., New York, 1965, vol. I, pp. 409–10.

4

The Renaissance

The revival of ancient concepts

In the fourteenth and fifteenth centuries, Italian humanists rejected the medieval view and attempted to revive the philosophy, art and architecture of the ancient world. They contrasted the glory of ancient civilization to the debased culture of the Middle Ages, and wished to begin again where the Roman Empire had left off. Scholastic philosophy, as we saw in the last chapter, had tentatively begun a revival of some ancient concepts in the thirteenth century, but now the pace picked up dramatically.[1] In this 'rebirth' of the ancient Classical world, we find an emphatic return to the two essential characteristics of Greek thought: a preoccupation with the secular rather than the divine, and a self-conscious awareness of the individual and his powers.

The revived interest in the sensory world shows most dramatically in the early Renaissance art. A succession of painters and sculptors continued the tentative naturalism of Giotto and Pisano, and took increasing delight in recording the details of phenomenal appearance. From the Lorenzetti brothers Pietro (c.1280–1348?) and Ambrogio (c.1285–1348?), through Donatello (1386?–1466), Lorenzo Ghiberti (1381?–1455) and Piero della Francesca (c.1420–92), one can see an increasing desire – and an increasing ability – to base artistic images fully in the sensory world (Figure 41). By the time of the High Renaissance at the turn of the fifteenth century, artists like Leonardo da Vinci (1452–1519) had created some of the greatest examples of sensory realism in the history of Western art (Figure 42).

The same secularizing tendency also encouraged a reassertion of individual powers. Renaissance man would develop, to use Cassirer's phrase, 'a selfconscious awareness of consciousness itself'.[2] One expression of this awareness shows in the new conception of educa-

tion offered by humanist reformers like Vittorino da Feltre (1378–
1446) and Guarino of Verona (1370–1460). Where earlier education in
the church schools and the universities mainly offered 'facts' for the
students to digest, the new education turned its attentions to the indi-
vidual and stressed the development of his personality and character.[3]
Another expression of this new awareness shows in the increasing pre-
occupation with personal fame. In the Middle Ages, when men wished
to contrast their own inadequate powers with the absolute powers of
God, vanity was almost considered a sin.[4] In the Renaissance, contrar-
ily, men flexed their newly awakened personal abilities and took pride
in what these abilities enabled them to accomplish. Ghiberti, for
example, 'exuded what at that time seems a new boastfulness in the
individuality of his achievement, in the fact of everything being his
own work'.[5]

The Renaissance added to these another component: a romantic
worship of everything ancient. The respect with which the Renais-
sance viewed ancient Rome ran so deep that many humanists and
artists despaired of ever reaching similar heights if left to their own
devices. The Middle Ages, they believed, had dulled their sensitivities
and had rendered them incapable of seeing truths with the same clari-
ty, or of creating art with the same naturalness and harmony, as their
ancient predecessors. To help themselves over this cultural deficiency,
they proposed to study and even to copy the works of the ancients so
that their own work would acquire some of the desirable ancient
qualities.

So on top of the re-emerging duality between subject and object, the
Italian humanists added another which was to become increasingly
problematical as the Renaissance developed. The humanists wanted to
abolish preordained explanations of reality and understand everything
on the basis of their own observations and powers of reason; but at
the same time they were willing to accept the doctrines of the ancients
as truths more accurate or more worthy than those they could discov-
er. They overthrew one cultural tradition because it denied them per-
sonal access to knowledge about the world, only to replace it with
another, older tradition which ultimately had the same effect.

Among the humanists and artists of the early Renaissance, all of
these new attitudes flowed indeterminately together, without a formal-
ized theory that could explain how mind, world, and ancient prece-
dents interact. The philosophers, on the other hand, faced the problem
more explicitly. They could no longer assume, as their Scholastic pre-
decessors had done, that God guaranteed the validity of any knowl-
edge gained through reason or the senses. They rediscovered the

42 Leonardo da Vinci, *Madonna and Saint Anne*, c.1501–13? In painting, Leonardo thoroughly re-established the naturalistic tradition.

41 *facing* Donatello, *St Mark*, 1411–13. Donatello's sculpture reflects his desire to record phenomenal appearance, and marks a return to the naturalistic Greek tradition.

problem of epistemology and attempted once again to explain how
reliable knowledge of the external world can be gained from the sub-
jective viewpoint.

Faced with exactly the same problem which had engendered the
ancient theories of knowledge, and well aware of the two Greek
philosophers who had most satisfactorily answered it, Renaissance
philosophers not surprisingly chose to resuscitate first Aristotle and
then Plato as possible ways forward. One of the last Scholastic
philosophers, William of Ockham (1290?–1349), chose the way of
Aristotle, and attempted to rid philosophy of the Neoplatonic flavour
that had lingered on from the Middle Ages. He insisted that knowl-
edge must be gained through the human senses, not through some
intuitive grasp of supersensual Ideals or Forms. With this appeal to
the senses he inspired the Ockhamist movement, whose members
revived the enquiring, scientific curiosity about the natural world that
had characterized Aristotle and his followers. From this would flow all
subsequent Empiricism in Western philosophy.

Platonism would not be pushed aside, however. To promote the
virtues of Platonic – in reality Neoplatonic – thinking in favor of
Aristotelianism, Marsilio Ficino (1433–99) directed the influential
Accademia Platonica in Florence and translated many of the Platonic
and Neoplatonic texts. He reasserted the familiar Platonic notion that
all objects in the sensory world are only imperfect copies of metaphys-
ical Ideals. As in earlier Christianized versions of Plotinus, he consid-
ered these Ideals to exist first in the mind of God and secondly, since
God gives impressions of these Ideals to the human soul while in its
pre-physical state, in the minds of men. Once joined to a physical
form the soul largely 'forgets' its knowledge of the Ideals, but this
knowledge can be rekindled with instruction from outside. When the
Ideals are revived and fully operational, they are used as *formulae*, or
templates, for interpreting experiences in the sensory world. Upon see-
ing a four-legged animal with long legs and a long neck, for example,
one compares these data to one's repertoire of inner Ideals like Horse
or Giraffe in order to see which one it fits most closely. So where the
re-emerging Aristotelian tradition stressed the priority of sense
experience as the source of knowledge, Ficino's Neoplatonism revived
the possibility that the more perfect knowledge is to be found within
the mind itself. Sense perceptions may help the mind recognize its
inner contents, but they can never in themselves lead to knowledge of
the timeless Ideals: 'sense is satisfied with particular objects alone,
whereas the familiar objects of the intellect are the universal and ever-
lasting reasons of things'.[6] With this reassertion of the theory of

Forms, the ancient duality between Aristotle's Empiricism and Plato's Rationalism once again provided the conceptual foundations for Western thinking.

Art theory in the High Renaissance

In the middle of the fifteenth century artists began to search for a more explicit theory that could explain their activities. Like the ancient Greeks, they wished to record nature as accurately as possible and, like the Greeks, they wished to record the ideal rather than the imperfect and ephemeral. They faced exactly the same conceptual problems: what in nature should they copy, and how should they go about it? Like the epistemologists, when they revived this question they also revived the dualities of the subject–object problem. As Panofsky explains, 'In its attitude toward art the Renaissance thus differed fundamentally from the Middle Ages in that it removed the object [of art] from the inner world of the artist's imagination and placed it firmly in the "outer world". This was accomplished by laying a distance between "subject" and "object" ... a distance which at the same time objectifies the "object" and personalizes the "subject"'[7]. How the latter apprehends the former became the major challenge of Renaissance art theory. Like the philosophers, the art theorists turned first to the Aristotelian and then the Platonic traditions to solve the problem.

Leon Battista Alberti (1404–72) was the first theorist seriously to address the new challenge. In his books *On Painting* (1436), *On Sculpture* (1464) and the *Ten Books on Architecture* (1450–72), he attempted to explain the source of artistic and architectural ideas within the Aristotelian tradition. Alberti fully sympathized with the efforts of his contemporaries to render sensory appearance as accurately as possible. In this spirit he conceived of a painting as a window through which the painter sees the world,[8] and he asserted that a painter 'has nothing to do with things that are not visible. The painter is concerned solely with representing what can be seen'.[9] This makes the artist a passive recorder of phenomenal appearance, one who neither improves nor edits that which immediately appears to his senses. Yet like the ancient Greeks, Alberti was not content to let the artist record any impressions which happened to impinge upon the senses; some impressions are more beautiful than others, and only the beautiful are worthy of the artist's attentions. He criticized the ancient painter Demetrius for ignoring this important distinction: '[he] failed

to obtain the ultimate praise because he was much more careful to make things similar to the natural than to the lovely'.[10]

But what distinguishes the beautiful from the not-beautiful? Like the Greeks, Alberti identified the beautiful with those characteristics of nature which appear to be the unchanging norms common to a species, and the not-beautiful with those characteristics which are idiosyncratic and ephemeral accidents in individual objects. Following the Greeks, Alberti accepted that the typical in nature is more real than the idiosyncratic, and is therefore more worthy of attention.

Like theorists in both the ancient world and the Middle Ages, Alberti further accepted that this structure behind appearance is rationally organized, and therefore that it can be described mathematically: 'I am ... convinced of the Truth of *Pythagoras's* Saying, that Nature is sure to act consistently, and with a constant Analogy in all her Operations'.[11] He devoted much of his work to setting out the numbers 'which seem to be greater Favourites with Nature than others' and deriving from them a set of proportional ratios which he claimed lie behind ideal beauty.[12] Following this line of reasoning, Alberti was able to argue that both art and architecture imitate nature. If nature is ordered on rational and mathematical laws, and if the artist and architect use those same laws to organize their work, then by necessity they will capture the underlying order of nature.[13] This ancient idea continued to influence art and architectural theory.

In these arguments so far, Alberti clearly aimed to make art as objective as possible. By basing the source of form in the underlying structure of nature itself, a structure which he implicitly assumed must exist independently of any individual mind perceiving it, he hoped to avoid the unpleasant possibility that every mind might perceive a different beauty. His aversion to subjective opinions clearly shows in his claim that the design of buildings

> must without doubt be directed by some sure Rules of Art and Proportion, which whoever neglects will make himself ridiculous. But there are some who will by no means allow of this, and say that Men are guided by a Variety of Opinions in their Judgment of Beauty and of Buildings; and that the Forms of Structures must vary according to every Man's particular Taste and Fancy, and not be tied down to any Rules of Art. A common Thing with the Ignorant, to despise what they do not understand![14]

Yet in setting out his theory of ideal beauty, Alberti was forced to acknowledge the active, autonomous mind. By basing art on certain ideal norms which cannot be found complete in any individual sensory

objects, and whose existence, therefore, can only be inferred from sensory experiences, Alberti had to explain how the mind manipulates the material seen in the world in order to arrive at its underlying structure. He began by reviving the ancient concept of normative idealism – the companion of Aristotle's Empiricism – in which the most beautiful parts from many natural models are averaged together to discover their mean type.[15] As we have seen, this involves a vicious cycle: in order to discover the ideal beauty, the artist is supposed to average together the most beautiful objects seen in nature; but in order to know which objects are the most beautiful, the artist must already know the ideal beauty. To solve this problem, Alberti suggested elsewhere that the mind must have an innate facility for immediately perceiving beauty well in advance of any sorting or measuring. In discussing how the ancients had determined the proper proportions for the architectural orders, he suggested they used a 'natural Instinct or sense in the Mind by which ... we judge of Beauty and Gracefulness', and that by using this instinct the ancients were able to judge one column too thick and another too slight.[16] And elsewhere, he asserted that 'the Judgment which you make that a Thing is beautiful, does not proceed from mere Opinion, but from a secret Argument and Discourse implanted in the Mind itself'.[17]

Having introduced this intriguing new power of the mind, Alberti then declined to say more about it: 'Whence this Sensation of the Mind arises, and how it is formed, would be a Question too subtle for this Place.'[18] He has implied that the mind possesses an innate filter for discriminating between those objects which possess the ideal beauty and those which do not. This still makes the mind dependent upon the outer world for its knowledge of ideal beauty, in the sense that it needs the raw sensory material from which to make its selections. But at the same time this gives the mind new powers actively to search out and to distinguish the beautiful from the not-beautiful. In fact, the apprehension of beauty *depends* on this power. So where Alberti's ideas about an absolute, objective structure in nature denied the importance of mind, his idea about innate powers brought the mind emphatically back into the artistic process. Although his successors would push this to greater extremes, in Alberti these powers of the mind were only tentatively asserted. For him, all minds are the same, all minds connect up to the same reality, and all minds work only on material taken in by the senses and cannot invent new things from within their own resources. At best, the mind in Alberti's theory is a standard machine for sorting and discriminating.

Besides elaborating the subject–object problem, Alberti also gave

theoretical justification to the use of Classical forms. Although he accepted in principle that the Renaissance artists should be able to see as well as anyone the ideal beauties in natural objects, he accepted the popular notion that the Romans had seen and captured these eternal verities more clearly in their own works of art. So instead of struggling against contemporary cultural shortcomings and suffering through the arduous process of abstracting ideals from nature, Alberti suggested that the Renaissance artists would find it much easier to discover the ideal forms in the ancient works. In one sense, the ancient works of art would serve as teaching exemplars, showing the novice artist how the ideal beauties are manifested in good works of art and then providing the general rules for future artistic creation; but in another sense they would serve as a sort of artistic shorthand, providing convenient solutions to artistic problems without each artist having to work from first principles.

Alberti did not think the ancients should be followed slavishly. On the contrary, he encouraged his readers to use the ancients as a sound starting point for their own artistic efforts:

> Thus by a continued and nice Examination of the best Productions, still considering what Improvements might be made in every thing that [the architect] sees, he may so exercise and sharpen his own Invention, as to collect into his own Works not only all the Beauties which are dispersed up and down in those of other Men, but even those which lie in a Manner concealed in the most hidden Recesses of Nature, to his own immortal Reputation. Not satisfied with this, he should also have an Ambition to produce something admirable, which may be entirely his own invention.[19]

But what, exactly, is the relationship between the individual and the Classical tradition? In one place Alberti claims that the individual cannot fully see the ideal beauties until they have been pointed out to him by the Classical forms. Yet elsewhere he claimed that the mind must already contain an innate ability to see any ideal beauty presented to it; it does not need the authority of ancient work to convince itself it has seen ideal beauty. And if the mind does not have this innate ability, how can it be sure the Romans got it right? Giving Alberti the benefit of the doubt, he might have been heading towards a concept of virtually innate ideas, in which the mind needs help to see what it does not yet realize is innately contained within itself. Two hundred years later Descartes developed this idea further in his Rationalist philosophy.

Alberti suggested that the artist should use Classical ideas as a

springboard for his own creative inventions. But how far beyond the bounds of the existing Classical language can the artist leap before he or she no longer captures the essential characteristics of ideal beauty? Alberti's own reliance on Classical forms, proportions and ornaments suggest that, for him, only the Classical language can capture the universe's ideal beauty (Figure 43). Yet if this were true, how is it possible for an artist to 'produce something admirable which may be entirely of his own invention'? Alberti never did acknowledge or reconcile this ambiguity between individual invention and timeless principles.

Leonardo da Vinci offered a form of Aristotelianism pushed to greater extremes. Like Alberti, he insisted that 'all our knowledge has its origin in our perceptions',[20] and that the artist's main task is to imitate nature as accurately as possible; but where Alberti had the artist represent only the most beautiful and ideal objects found in perceptions, for Leonardo *anything* reaching the senses is suitable material for art. The artist should not select from nature according to some preordained notions of beauty, nor should he or she attempt to improve on what is seen, for this will lead to undesirable mannerism. If one turns to the sensory world for the source of art, Leonardo reasoned, then one should admit the logical conclusion of this attitude and accept anything found there.

Leonardo agreed with Alberti and most ancient thinking that certain invariant laws underlie nature and should be used to guide the generation of artistic images. But where Alberti found these laws only behind the ideal and the beautiful, Leonardo insisted that they must lie behind everything in nature whether beautiful or not. If the artist wants to achieve good effects he must follow these laws which comprise, according to Leonardo, a science of art: 'Those who fall in love with practice without science are like pilots who board a ship without rudder or compass, who are never certain where they are going. Practice ought always to be built on sound theory.'[21] Leonardo wrote as if objective laws of nature – like the mathematics of perspective and harmony – jump immediately into the mind without any mediating activity on the part of the artist, and then guide the artist as he or she renders an accurate image of sensory appearance. Leonardo was so committed to the primacy of the senses and so afraid of unnaturalistic mannerism that he failed to explain how exactly these laws are discovered, or even why an artist with sharp senses would need the 'science' at all. If the artist renders an image exactly as he sees it, as Leonardo's positivism claimed he should be able to do, then the perspective will be correct whether the artist understands the mathematics

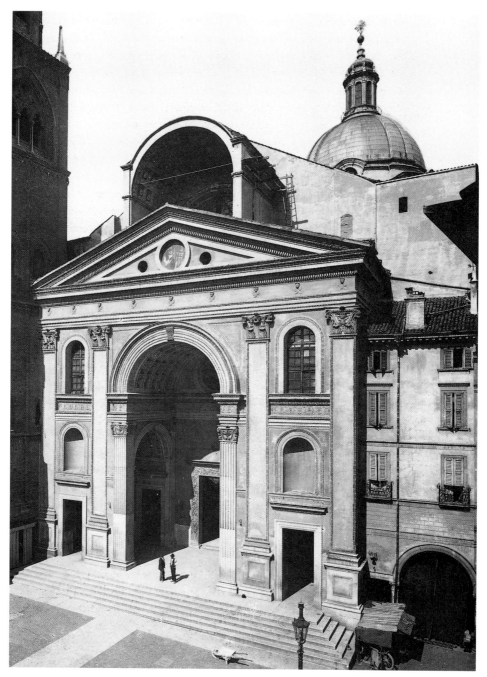

43 S. Andrea, Mantua, Italy, designed 1470. Leon Battista Alberti. Alberti,
like the ancient Greeks and Romans, assumed that the canonised forms of
Classicism would capture the universe's ideal beauty.

of perspective or not. And if the artist needs to know the theory of perspective in order to render a natural scene accurately, then obviously the artist is interpreting the sensory image through an idea in his mind. In his enthusiasm for unadulterated sense experience, Leonardo seems to have fallen into the familiar problem of scientific Positivism: by keeping the subjective mind out of the operation, how are the so-called objective laws of nature ever discovered, and of what use are they to a mind which supposedly can see the laws immediately in any sensory data anyway?

In unwitting contrast to this passive, receptive conception of art, Leonardo also took up Alberti's notion of inner mental powers and made them more potent. Where Alberti had restricted the mental skill to that of a filter which could distinguish the beautiful from the not-beautiful, Leonardo made it an ability to reorganize creatively the material gained in perception. According to Leonardo, the artist first stocks his or her mind with images taken from sensory nature, and then draws upon this reservoir of knowledge when constructing the artistic image. Sometimes the images may be used exactly as seen, while other times they may be mixed together to create imaginative new ideas: the artist can draw, he claimed, 'not only the works of nature, but infinitely more than those which nature produces',[22] including unknown landscapes, monsters, and so on. Taking images of men and images of bulls from experience, for example, the mind can combine these creatively to form a Minotaur.

In focusing attention on the mind's ability to create new ideas within itself, Leonardo had reached the limits of his Empiricism and had slipped unwittingly into Neoplatonism. A Neoplatonic tone shows, for example, in the comparison he made between the inventive faculty of the artist and the creative powers of God: 'The divinity which is the science of painting transmutes the painter's mind into a resemblance of the divine mind. With free power it reasons concerning the generation of the diverse natures of the various animals, plants, fruits, landscapes, fields, landslides in the mountains, places fearful and frightful.'[23] In this same spirit, he wrote elsewhere as if ideas and artistic forms originate in the artist's mind before everything else: the painter must 'strive in drawing to represent [his] intention to the eye by expressive forms, and the idea originally formed in [his] imagination'.[24] And in general, 'whatever exists in the universe through essence, presence, or imagination, he has it first in his mind and then in his hands'.[25] Although Leonardo, if pressed, would have insisted that the inner ideas originated in the artist's sensory experience, these latter comments are now only a small step away from the possibility

that the ideas might be infused in the mind in advance of experience. The Mannerists developed just such a view.

The Mannerist extremes

In the first decades of the sixteenth century, art theorists turned to the other strand of Renaissance thinking, namely the Neoplatonism of Ficino. Like Alberti and Leonardo, these theorists set an accurate rendition of nature as the ultimate aim of art; but where Alberti and Leonardo sought the source of form in the sensory world, the Neoplatonists attempted to find it prefigured in the artist's mind. Like Ficino and Plotinus before him, they asserted that sensory appearance is only an imperfect copy of timeless metaphysical Ideals, and that God had implanted a copy of those Ideals in the human mind. Any artist who wishes to render nature, they therefore believed, will have more success by focusing on the inner Ideals from which nature derives than by mimicking the imperfect copies of the Ideals that exist out in the sensory world.

However, they carried this idea to greater extremes and created two quite incompatible points of view. In one direction, the new awareness of individual powers stressed the personal nature of this inner source of form, and led to an even greater cult of individual insights. The concept of artistic 'genius' was invented in this period. In the other direction, the preoccupation with nature's objective structure stressed the shared and universal character of this inner source, even though it is apprehended by individual minds. Many textbooks and treatises were written at this time which claimed to establish the objective and universal rules of art and architecture, without reference to personal insights or skills. In this period – usually termed the age of Mannerism because of its mannered use of Renaissance ideals and artistic forms – the subject-object problem engendered the most extreme distinction yet between inner personal and outer shared artistic resources.

The work and writings of Michelangelo Buonarroti (1475-1564) represent the transition from the ideals of the High Renaissance to the extremes of Mannerism. He began his career as an artist under the influence of early Renaissance empiricism, with its emphasis on finding ideal form in sensory experience, and created astonishingly realistic and emotionally moving forms (Figure 44). Later in life, after about 1530, the dominance of Neoplatonism in Italian thinking caused him increasingly to look for the ideal form within his own internal

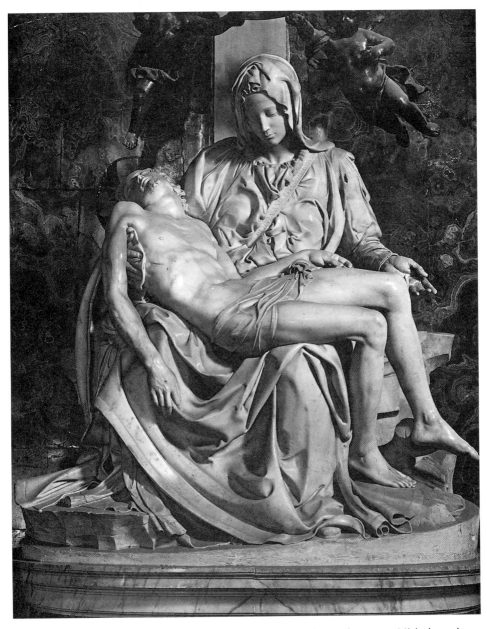

44 Michelangelo, *Pietà*, 1498–99/1500. In his early career, Michelangelo worked within the naturalistic tradition of the Renaissance.

resources. Taking up the now well-established Neoplatonic argument,
Michelangelo asserted that Beauty in nature is only an imperfect copy
of ideal Forms in the supersensual Divine. Like Plotinus, he believed
that the artist can apprehend these Ideals by reflecting on the beauty
of sensory objects, and then through intuitive imagination discover in
his own mind the Ideals from which the sensory objects are imperfect-
ly derived. Once the artist has apprehended the Ideals he can use this
knowledge to create a beauty more perfect than any seen in nature.

But Michelangelo increasingly turned away from sensory nature,
convinced that he could see the Ideals directly in his mind without
having to reflect on beauty in nature. God gave him a special gift, he
maintained, to 'see' the divine sources of nature and hence of art in
his own mind, and then to transform these Ideals into physical works
of art. So in his later phase he talked of art not as an imitation of
nature so much as an expression of a personal inner vision of the
Divine.

Because he believed he possessed a direct, intuitive access to the
ultimate source of beauty, Michelangelo saw no need for rules of art
or mathematical systems of proportion. He was not at all convinced,
as Alberti and Leonardo had been, that the world is based on an
underlying mathematical structure. Dürer's formulae for the propor-
tions of the human body attempt to regulate that 'for which no fixed
rule can be given',[26] he complained. For Michelangelo, all decisions
about the shape and displacement of an artistic form are to be decided
by the artist's God-given intuitive judgement. If the artist is lucky
enough to possess this intuitive judgement he does not need rules, and
if he does not possess this ability no rules will help him.

Michelangelo did not throw away all external sources of artistic
form. His paintings and sculpture still took nature as their subject
matter and his architecture continued to use the Classical elements
inherited from the early Renaissance. Yet in using these external
sources he distorted and manipulated them in accordance with
internal preoccupations. The most noted example in architecture is his
design for the vestibule to the Laurentian Library in Florence (Figure
45). Although he used all of the Classical elements expected in a
Renaissance building, he deployed them in a whimsical and personal
fashion. He set the mandatory entablature above a pair of engaged
columns, but recessed the columns into the wall where they apparently
offer no supporting function at all. Although the columns themselves
seem to rest on a set of brackets, the brackets are too small to carry
the load and are even separated from the columns by a small gap.
Burckhardt called this play on the Classical language of architecture

45 Michelangelo, Laurentian Library Stairs, S. Lorenzo, Florence, Italy,
1524–33. Later in life, under the influence of Neoplatonism, Michelangelo
turned to mannered expressions in art and architecture.

an 'incomprehensible joke'. Michelangelo acknowledged the existence
of a shared Classical language, by making reference to some of its
basic elements; but then he self-consciously destroyed the language by
deploying those elements in accordance with rules which only he
could know. Although Michelangelo never completely lost his link
with the shared, external world, he pushed stronger than anyone
before him towards the priority of the subjective.

In later years Michelangelo became obsessed with the Ideals in his
mind. Condivi said of him that 'he has not been very satisfied with his
works and has always belittled them, feeling that his hand did not
approach the idea which he formed in his mind'.[27] His work was more
expressionistic, less tied to the sensory world (Figure 46).
Michelangelo had become, according to Hauser,

> the first example of the modern lonely, demonically impelled artist – the
> first to be completely possessed by his idea and for whom nothing exists
> but his idea – who feels a deep sense of responsibility towards his gifts
> and sees a higher and superhuman power in his own artistic genius. A

degree of sovereignty is attained here, in the light of which all earlier
conceptions of artistic freedom fade into nothingness. Now, for the first
time, the full emancipation of the artist is achieved; now, for the first
time, he becomes the genius such as we have known him to be since the
Renaissance.[28]

Other Mannerist artists after 1530 also rejected objective, sensory
nature in favour of new and unusual artistic effects, often with little
regard for verisimilitude. A shift in taste stressed the new, the capri-
cious, the extravagant and the bizarre.[29] The important thing was the
personal expression, not the objective rendition (Figure 47). Giordano
Bruno (1548–1600), a natural philosopher and ardent Neoplatonist,
summed up the subjective mood: 'poetry is not born of the rules,
except by the merest chance, but ... the rules derive from the poetry.
For that reason there are as many genres and species of true rules as
there are of true poets.'[30]

After about 1550 a new generation of artists and theorists took
these same ideas in quite the opposite direction. They started, ordinar-
ily enough, with standard explanations of Neoplatonism. Giovanni
Paolo Lomazzo (1538–1600) in his two books *Trattato dell'Arte della
Pittura, Scultura, e Architettura* of 1584 and *Idea del Tempio della
Pittura* of 1590 and Federico Zuccaro (1542-1609) in his *Idea de'
Pittori, Scultori e Architetti* of 1607 both express roughly the same ver-
sion of metaphysical idealism. Beauty is a quality directly given to the
mind of man from the mind of God and does not rely on any sense
impressions. The artist draws directly upon his inner Ideals. Now
where Michelangelo and his followers had stressed the possibility that
each mind might understand these Ideals differently, the later
Mannerists returned to the earlier intention of Neoplatonism that each
mind should, in principle, understand the same Ideals if only it looks
inwards carefully enough. Unfortunately, Lomazzo and Zuccaro com-
plained, contemporary artists had lost the sensibilities of their prede-
cessors in the High Renaissance and therefore could not do this. These
two theorists proposed to regain a clear understanding of the Ideals by
studying how they were employed in the great work of the past. Here
is the same idea, a generation later, that studying masterworks of the
past will reveal objective truths now lost in an age of reduced mental
ability.

Lomazzo's *Trattato* displays this attitude most strikingly. Although
he cursorily conceded the importance of natural genius in the painter,
Lomazzo then committed his entire book to the notion that the best
source of artistic images is to be found in the works of the masters.

46 Michelangelo, *Rondanini Pietà*, c.1554–64. This later reworking of his earlier Pietà theme emphasizes personal expression over a realistic recording of phenomenal appearance.

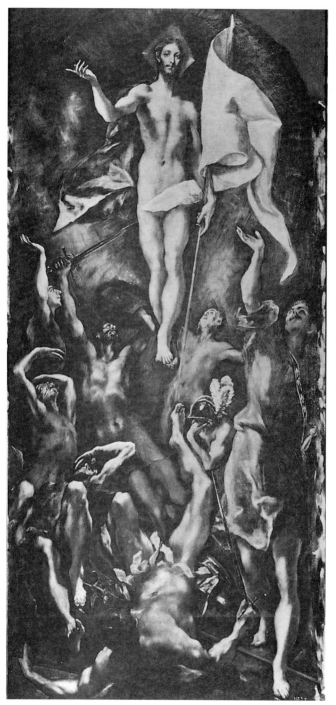

47 El Greco, *Resurrection*, c.1597–1604. Personal expression of
overpowering emotions overtakes verisimilitude.

Through seven hundred pages he examined every conceivable problem a painter faces, from subject matter to color and light, and he analyzed the best paintings and sculptures of the past to determine the ideal solution for each problem. Every human emotion was discussed and the proper method for portraying each one was set out in detail.

Architectural treatises published in this period reveal the same attitude. In *Works on Architecture* (published between 1537 and 1551) Sebastiano Serlio (1475–1554) described the proper rules and proportions of the Classical Orders, based on those first set out by Vitruvius. Giacomo da Vignola (1507–73) developed this further in his *Rules of the Five Orders of Architecture* (1562), in which he amended Vitruvius' proportions to accord more exactly with his own observations of the remains of Roman architecture. Andrea Palladio (1508–80), in his *Four Books of Architecture* (1570), also reworked the proportions of Vitruvius, and then showed how they could be used to create contemporary buildings (Figures 48, 49). All of these books attempt to set out absolute rules for design, presumably based upon the universal principles of nature, yet drawn from sources one or two times removed from the original. Where Alberti had employed the ancient works as a convenient short cut for discovering the universal truths of design, increasingly they were appealed to as absolute and final authorities. A means to an end had become an end in its own right. So, paradoxically, the age that saw the first extreme of artistic subjectivity and the first philosophical explorations of creativity also saw the solidification of the Classical tradition with its claims to objective truth and its reliance on precedence. By 1600 the paradoxes inherent in the subject–object problem were firmly ensconced in the artistic enterprise of the West.

The new art academies

These new ideas in the theories of art and knowledge transformed the contemporary theory and practice of design education. In the Middle Ages, it will be remembered, the artists and architects participated in shared cultural traditions, and therefore took their design ideas from pre-established doctrines and acceptable codes of practice, not from personal, creative insights or from personal perceptions of nature. For them the apprenticeship in the guilds provided the most suitable educational system, because it inducted the young aspirant into the pre-established secrets of the craft. The intention was not to reason why certain things are done, or to dream up other possible ways of doing things, but rather to assimilate existing bodies of knowledge and skill.

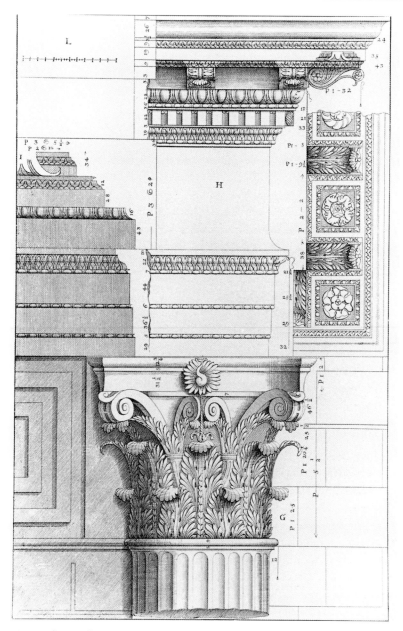

48 Andrea Palladio, *The Four Books of Architecture*, 1570. In this plate,
Palladio recorded his own measurements of the ancient Roman Temple of
Mars and amended Vitruvius.

49 Andrea Palladio, *The Four Books of Architecture*, 1570. In this plate, Palladio illustrated how he employed the Classical rules of architecture to create original compositions.

The Renaissance could not tolerate this kind of education. The 'self-conscious awareness of consciousness itself' meant that the individual could no longer rely upon pre-ordained dogma for knowledge of the world. He would insist on understanding and reasoning for himself. Furthermore, the desire to find common structures behind all human knowledge (for example, similar mathematical relationships in music and architecture) discouraged specialist training in one field and encouraged a generalist education. The Renaissance ideal was the Universal Man. So where the old educational system explained how to do a particular task, a new system would need to explain why it is done that way. And where the guild relied on a master skilled in the operation of the craft yet relatively ignorant of its underlying principles, the new system would need a teacher who understood the craft's underlying principles even if he had little practical skill. The Renaissance increasingly distinguished between the practical craftsman and the theoretical scholar, and stressed the value of the latter. In this sense the Renaissance revived the concept of education suggested (but

never implemented) by Vitruvius.

Although Alberti hinted at some of the new educational ideals, Leonardo first explicitly spelled out a new educational program. Leonardo had argued that the painter should be guided by the 'science of painting' which included the principles of perspective and proportion as well as the most accurate ways of portraying light, shadow, human gestures, and even human emotions. Now if good painting depends on a knowledge of these laws, then it follows that the young painter must be well versed in the laws before he can seriously engage in real painting. Leonardo noted that the young painter should 'first study science and then follow the practice born of that science'.[31] To this end Leonardo proposed a new system for art education. Where the apprentice in the guild learned everything in the workshop and had little training in theory, Leonardo would have the young painter taken out of the workshop altogether in the first years of his education and steeped in the new principles of art. He never instituted this program, but his idea formed the basis of academic art education well into the twentieth century. The aims of the new system, according to Pevsner, were primarily to separate art from handicraft and to teach the painter more knowledge than skill.[32] Although a few tentative efforts were made to implement this new educational program, Renaissance art and design education was mostly conducted within the guilds and according to the principles of the apprenticeship system.

The Renaissance humanists invented another institution – the academies – which at first had nothing to do with design education. During the Mannerist period and then in the Baroque, however, the academies challenged and ultimately won from the guilds the right to educate the young in art and architecture. The humanist academies led to the Academies of Art and the influential 'academic method' of education that would dominate formal design education well into the twentieth century. Although this system of education will be discussed more fully in the next chapter, it is worth examining here how the original academies acquired a number of their basic concepts from contemporary Mannerist philosophy.

Interest in a new educational system began with the reappearance of Neoplatonism in the latter half of the fifteenth century. Along with the renewed appreciation of Plato's philosophy, many humanists admired the informal school, or Academy, which had grown up around Plato and his followers. It represented the ideal of a community of scholars committed to the pursuit of knowledge, and so they set up similar philosophical circles and called them Academies in honor of

Plato. The first of these academies, including Marsilio Ficino's Accademia Platonica in the 1470s, were little more than informal social gatherings. Their members met without any differentiation between teacher and taught, without any formal structure, and without definite limits on what might be discussed. Without a teaching program these early academies offered no competition to the medieval guilds. Following the rise of Mannerism in the 1530s and 1540s, however, these informal philosophical circles gradually changed into strictly organized and regulated enterprises – later into government institutions – whose interest in free debate gave way to a desire to establish timeless bodies of knowledge about their respective academic fields. Such a change was not surprising, given the later Mannerist preoccupation with rules.[33] They were convinced that, once they had discovered the timeless knowledge, they could 'set out the truth' for all to see, putting an end for ever to futile debate.

The codification of knowledge was accompanied by a strong desire to teach that knowledge to the young. As Leonardo had already suggested, if good work in a given field depends upon knowledge of the field's basic principles, then the young must be initiated into those principles before anything else. Once the academies presumed to possess the ultimate truths of reality, furthermore, there could be no more friendly discussions among equals. As Pevsner points out, 'It was only one step from lecturing and debating academies ... where all members took part in discussions and were potential lecturers, to institutions of a university character with competent lecturers and listeners attending to obtain a systematic introduction into a subject'.[34] Once the academies took up the task of teaching they came into direct and acrimonious conflict with the guilds over the right to educate.

Vasari saw the suitability of this new academic structure for artists and in 1563 convinced Cosimo de' Medici to found the first official, regulated art academy, the Accademia del Disegno. Vasari took up Leonardo's separation of practice from theory, and tried to mingle guild-like workshop training with academy-like theoretical training. The students continued to work in the shops of their masters, but in addition three 'Visitatori' elected from the academy visited them regularly and criticized their work according to the academy's principles. The academy itself offered supplementary courses on theoretical subjects like geometry, anatomy and perspective. In subsequent reforms, Federigo Zuccaro proposed to consolidate these two parts by bringing the students and masters into workshops in the academy itself. The academy would continue to supplement its practical training in the workshops with theoretical training in lectures. Zuccaro eventually

implemented this idea in the Accademia di S. Luca in Rome, and completed the conflation of the guild workshop with the academic lecture hall. The students now divided their time between indoctrination into accepted artistic practice in the studio projects and study of universal principles in the lectures. All future art and architecture educational systems took up this problematical distinction.

The rise of Positivist science

Concepts of knowledge and art in any given period, we have seen so far, always drew upon the prevailing conception of the cosmological order. In the later stages of the Renaissance and then increasingly in the age of Mannerism, the 'natural philosophers' developed a new conception of the universe which transformed most subsequent Western thinking. Although it did not exert any influence on art and epistemological theories until the Baroque, it is worth studying its original development here; many of its fundamental notions grew out of the debates which have just been discussed and, gestating in the age of Mannerism, it managed to acquire some of that age's underlying tensions.

Like the Greeks, the Renaissance humanists conceived of the world as possessing a physical body, an animating soul and an organizing mind, and even as late as the sixteenth century had 'attributed to nature reason and sense, love and hate, pleasure and pain, and found in these faculties and passions the causes of natural processes'.[35] Due to the influence of late Gothic Scholasticism, the organic analogy which the Renaissance inherited was a form of Aristotelianism. Aristotle, it will be remembered, employed the organic analogy to explain growth and change in nature as an innate tendency for physical matter to grow into a particular form. In this view there are no absolute distinctions between that which animates and that which is animated, or that which is mental and that which is physical, because the animating and organizing force which drives individuals is the same force which animates and organizes the world at large.

But the revival of Platonism at the end of the fifteenth and throughout the sixteenth century could not accept the Aristotelian view. The problem with Aristotelianism, the Neoplatonists argued, is that explaining natural growth in terms of inherent 'tendencies' does not explain anything at all. It says, essentially, that a certain cause leads to a certain effect because the cause has a 'natural tendency' to produce that effect; which is not saying anything interesting. Instead of

thinking of changes in nature as a function of qualitative and psychical 'tendencies', the Neoplatonists suggested, it would be better to return to the Platonic and Pythagorean idea that changes in nature are a function of quantitative changes in structure. They developed this idea; but as will be seen, they pushed it to extremes unimagined by Pythagoras or Plato and thereby destroyed the organic analogy and the delicate balance between mind and world that the ancient Greeks had always maintained.

Nicholas Copernicus (1473–1543) mounted the first serious attack on the organic analogy.[36] The concept of an organism had always implied differentiated organs, each with its own special qualities and functional role in the overall system. The ancient Greeks and the early Renaissance philosophers had conceived of the universe as a series of concentric spheres with the earth in the center, then several layers of different qualities like water, air and fire, and then finally the outermost skin, the *quinta essentia*. But with the posthumous publication in 1543 of his heliocentric theory of the solar system, Copernicus took the world away from the center and undermined the notion of differentiated functions. In his system everything is made of the same kind of matter everywhere and responds to the same force of gravity. By replacing the heterogeneous substances of the organic analogy with one homogeneous substance, he made it possible to believe that laws which hold true on earth will hold equally true anywhere in the universe; and, by making the universe one substance with no differentiation of quality, he encouraged the idea that everything in the universe is quantifiable.

At the beginning of the seventeenth century John Kepler (1571-1630) elaborated this attack with his three laws of planetary motion. Where Aristotle had claimed that everything in the world has an innate tendency to grow and thus to be always on the move, Kepler claimed contrarily with his law of inertia that everything has an innate tendency to remain stationary. In Kepler's system movement is caused not by some inner vital force in all objects but rather by a mutual, physical attraction of neighboring bodies. He had replaced the concept of a vital energy producing qualitative changes with the new concept of mechanical energy producing purely quantitative changes. So where the organic analogy had attributed growth and change in nature to the immaterial life force of nature's soul and mind, now, according to Kepler, all change in nature could be described more effectively in purely material and mechanical terms. At the end of his *Astronomia Nova* (1609), he offered a new analogy of the universe as a clock whose movements can be ascribed to simple magnetic and material

forces, just as the movements of a clock are caused by a simple
weight. He also noted that these causes can be described with arith-
metic and geometry.

Kepler's contemporary, Galileo Galilei (1564–1642), pressed the
attack to its logical conclusion. There are two kinds of entities in the
universe, he claimed: there are universally objective *primary* qualities
of size, shape, weight and position without which an object in the
world could not exist; and there are personally subjective *secondary*
qualities like color, taste and smell which do not belong to the object
itself, but which are merely figments of the imagination in the person
who observes the object. When thinking of any object in the world,
Galileo said:

> I immediately feel the need to conceive simultaneously that it is bound-
> ed and has this or that shape; that it is in this place or that at any given
> time; that it moves or stands still ... I cannot separate it from these
> conditions by any stretch of my imagination. But that it must be white
> or red, bitter or sweet, noisy or silent, of sweet or foul odor, my mind
> feels no compulsion to understand as necessary accompaniments ... For
> that reason I think that tastes, odors, colors and so forth are no more
> than mere names ... and that they have their habitation only in the sen-
> sorium. Thus, if the living creature were removed all these qualities
> would be removed and annihilated.[37]

The mind is now so irrelevant to the larger order of the universe that
even many of the qualities it perceives are dismissed as figments of the
imagination.

With Galileo the organic analogy was finally demolished. The uni-
verse had become a regular, orderly and highly predictable clockwork,
inexorably grinding away towards the purpose for which it had been
designed, and deterministically governed by its own internal logic and
structure. Where the individual in the Greek analogy had some
influence over nature by virtue of his own mind participating in the
mind which controls nature, in the mechanical analogy he or she has
no control whatsoever. The individual is simply one more physical
body in the system, devoid of any personal animating force. The uni-
verse continues to operate in precisely the same way, encompasses the
same structure, and has exactly the same appearance, whether humans
exist or not. The only animating force in this analogy, as Kepler
pointed out, can be the clockmaker who originally designed the mech-
anism and set it going for a definite purpose, and it was in this capaci-
ty that the natural philosophers placed God. Like a clockmaker,
however, even He could have no further influence on the mechanism's

actions once He set it into operation. No external force, either human or divine, could interfere with or divert the mechanism from its deterministic path. The natural philosophers had proposed an absolute split between mind and world, and the next generation in the seventeenth century would have to struggle with its consequences.

Notes

1 Historians have sometimes tried to draw a sharper distinction between the end of the Middle Ages and the beginning of the Renaissance. Hauser attributes the traditional view of a rebirth after a period of darkness to the great nineteenth-century historians like Burckhardt who wanted to 'strike a blow at the romantic philosophy of history'. According to Hauser, they wanted to counter the reviving interest in the medieval period, with its emphasis on social hierarchy and authority, by emphasizing the contrast between the light of the modern age and the darkness of the Middle Ages, and by showing that all the great liberal ideas like 'freedom of thought and freedom of conscience, the emancipation of the individual and the principle of democracy, are achievements of the fifteenth century'. Arnold Hauser, *The Social History of Art*, Routledge & Kegan Paul, London, 1962, vol. 2, pp. 1–6.

2 Ernst Cassirer, *The Individual and the Cosmos in Renaissance Philosophy*, trans. Mario Domandi, Basil Blackwell, Oxford, 1963, p. 1.

3 Copleston, *History*, vol. 3, part II, p. 12.

4 St Augustine, for example, severely chastised himself for his early youthful pride in his intellectual powers: *Confessions*, trans. J. G. Pilkington, Liveright, NY, 1943, III, vii, 12; IV, xv, 24 and 26; V, x, 18 and 20.

5 Michael Levey, *Early Renaissance*, Penguin Books, Harmondsworth, 1977, p. 24.

6 Marsilio Ficino, *Five Questions Concerning the Mind*, in Ernst Cassirer, Paul Kristeller, John Randall, Jr, (eds), *The Renaissance Philosophy of Man*, University of Chicago Press, Chicago, 1948, p. 206.

7 Panofsky, *Idea*, pp. 50–1.

8 Leon Battista Alberti, *On Painting*, trans. John Spencer, Yale University Press, New Haven and London, 1966, p. 56.

9 *Ibid.*, p. 43.

10 *Ibid.*, p. 92.

11 Leon Battista Alberti, *Ten Books on Architecture*, trans. James Leoni, Alec Tiranti Ltd, London, 1955, p. 196.

12 *Ibid.*

13 Noted in Anthony Blunt, *Artistic Theory in Italy 1450–1600*, Oxford University Press, Oxford, 1940, p. 19.

14 Alberti, *Architecture*, p. 113.

15 Blunt points out that 'Alberti has simplified Aristotle's views on this point, for he arrives at the type-beauty by a process of more or less arithmetical

averaging, whereas in Aristotle some faculty nearer to the imagination is involved.' Blunt, *Artistic Theory*, p. 18.

16 Alberti, *On Architecture*, p. 201.

17 *Ibid.*, p. 194.

18 *Ibid.*

19 *Ibid.*, p. 206.

20 Da Vinci, *The Notebooks of Leonardo Da Vinci*, Jean Paul Richter, comp. and ed., Vol. II, Dover Publications, Inc., New York, 1970, p. 288.

21 Da Vinci, *Treatise on Painting*, trans. Philip McMahon, Princeton University Press, Princeton, 1956, p. 48.

22 In Blunt, *Artistic Theory*, p. 37.

23 *Ibid.*, p. 113.

24 In Richter, *Notebooks*, p. 252.

25 Da Vinci, *Treatise*, p. 24.

26 Related by his contemporary Ascanio Condivi, *The Life of Michelangelo*, trans. Alice Sedgwick Wohl, Phaidon Press Ltd, Oxford, 1976, p. 99.

27 Condivi, *Life*, p. 107.

28 Hauser, *Social History*, vol. 2, p. 60.

29 Frederick B. Artz, *From the Renaissance to Romanticism*, University of Chicago Press, Chicago, 1962, p. 112.

30 Giordano Bruno, *The Heroic Frenzies*, trans. Paul Eugene Memmo, Jr, The University of North Carolina Press, Chapel Hill, 1966, p. 83.

31 Da Vinci, *Treatise*, p. 47.

32 Nikolaus Pevsner, *Academies of Art Past and Present*, Cambridge University Press, Cambridge, 1940, p. 34.

33 There were also strong social and political reasons why the academies became institutionalized in the age of Mannerism. The sixteenth century saw the rise of the Absolutist State and the accompanying need to limit individual initiative and to direct everything towards the greater need and glory of the state.

34 Pevsner, *Academies*, p. 11.

35 Collingwood, *Nature*, p. 95.

36 *Ibid.*, pp. 91–105.

37 Galileo Galilei, *The Assayer*, trans. Stillman Drake and C. D. O'Malley, in *The Controversy on the Comets of 1618*, University of Pennsylvania Press, Philadelphia, 1960, p. 309.

5

The Baroque

The Baroque dualities

The Renaissance and Mannerist theorists generated many new ideas about art, nature, epistemology and education, and proposed an entirely new conception of the cosmos; but the theories they developed left many tantalizing questions unanswered and not a few paradoxes unresolved. The successors to this rich tradition took up the new conceptions, and attempted over the next 150 years to polish the rough edges and to resolve the outstanding problems. In abandoning the old Greek organic analogy of the cosmos for the new mechanistic one, however, the theorists in the Baroque had to struggle with more extreme fissures between mind and world, reason and sense, determinism and freedom, and internal and external sources of form. The epistemologists continued to explore their ideas within the traditions of Rationalism and Empiricism, but the more they worked out the implications of these theories, the more they found themselves arriving at unexpected and undesirable conclusions. By the end of the Baroque period Rationalism had degenerated into metaphysical fantasies, and Empiricism had concluded in solipsism with no reliable route to knowlege of an external world.

Art in this period also reflected these dualities. The historian Burckhardt has portrayed the Baroque as a less than satisfactory continuation of the Renaissance's Classicism, plagued by 'irregular' and capricious outbreaks of subjectivism; Wölfflin interpreted the Baroque as a major change of direction, in which the naively objective Classicism inherited from the Renaissance gave way to a fresher impressionistic tendency;[1] and more recently, Artz has interpreted the Baroque as a synthesis of the Renaissance's Classicism with the emotion and tension of the Mannerists.[2] All of these interpretations reveal a continuing struggle to reconcile the inner and outer sources of art that the artists and theorists inherited from the Renaissance.

Rationalism and the priority of reason

The Rationalist tradition rose to prominence in the Baroque, and flavoured much of the period with its emphasis on clear reason and its belief in rational structures in the world. Galileo Galilei, we have already seen, proposed that objects in the world possess subjective secondary and objective primary properties. Only the latter are real, and they are also geometrical: 'Philosophy is written in this grand book – I mean the universe – which stands continually open to our gaze, but it cannot be understood unless one first learns to comprehend the language and interpret the characters in which it is written. It is written in the language of mathematics, and its characters are triangles, circles, and other geometrical figures, without which it is humanly impossible to understand a single word of it.'[3] Since there exists a correspondence between the system of geometry and the objective properties of bodies in the physical world, Galileo reasoned, one should be able to discover truths about the physical world by manipulating the geometrical system itself. Furthermore, since geometry is based on deduction, in which theorems are logically deduced from self-evident first axioms, the method of science should be deductive as well. He explained in his *Dialogues Concerning Two New Sciences* (1632) that the scientist first sets out a definition of some possible natural law, deduces some theorems from the definition, and then sees if the theorems hold up to the facts.[4] Unfortunately, Galileo did not fully explain how the scientist develops this definition, or hypothesis, in the first place. Galileo seemed to think that it would immediately jump into the mind of anyone who had learned the mathematical language of the universe. Nor did he explain how the scientist can be sure that a tested hypothesis really is the true description of nature's underlying order. If fifty tests confirm an invented hypothesis, how can the scientist be sure an unconducted fifty-first test will not refute it? Subsequent generations of natural scientists viewed this deductive method as arbitrary pattern inventing and, on the whole, favoured instead the inductive method of the Empiricists.

René Descartes

Galileo concerned himself primarily with the structure of the world, and gave less thought to how the mind apprehends that structure. Like Socrates before him, René Descartes (1596–1650) reversed this emphasis by thinking first about how the mind can know of an external reality, and only second what kind of a reality it must therefore

be. Like all Rationalists, Descartes mistrusted the senses and did not think that they could ever provide reliable knowledge of the outside world. He cited the faulty knowledge given by mirages and dreams. Without access to the world through the senses, however, how can the mind know of the world's underlying structure? Plato suggested that the soul has 'seen' the structure in a former life; but, as Aristotle had shown, his account had several serious shortcomings. Plotinus had the divine One infuse knowledge of the structure into the mind where it can be apprehended through an immediate intuition; but this relied too heavily upon an extra-physical explanation for Baroque tastes. Descartes drew ideas from these, but refashioned them to avoid their shortcomings.

Essential knowledge about the world's structure, he agreed with Plotinus, is 'infused' or 'prefigured' in the mind. He claimed he could 'discover generally the principles of first causes of everything that is or that can be in the world, without ... deriving them from any source excepting from certain germs of truths which are naturally existent in our souls'.[5] As Copleston has pointed out, this does not mean a baby is born with a clear conception of the world's structure already innately formed in its mind; rather, the 'germs of truth' are virtually innate, in that the mind has a propensity for thinking in certain ways even though it may not have actually turned its thoughts in those directions.[6] Only on the occasion of some sense experience of the outside world does the mind awaken and then comprehend the knowledge which is already potentially existing within itself. To explain this, Descartes drew an analogy to innate diseases. Some diseases are innate in certain families, he said, not because 'the babes of these families suffer from these diseases in their mother's womb, but because they are born with a certain disposition or propensity for contracting them'.[7] The appearance of the disease requires both the inner propensity and the outer cause; likewise, the recognition of innate knowledge within the mind requires both the inner, virtual germs of truth, and the occasion of outer sense experience to make that germ blossom. Although there is a tendency in popular philosophy to think that Descartes rejected altogether the use of sensory experience, he clearly requires it as an integral part of his system. He even criticized 'those Philosophers who, neglecting experience, imagine that truth will spring from their brain like Pallas from the head of Zeus's.[8]

So far this follows Plotinus. But where Plotinus had the mind immediately apprehending the entire structure of the world through some extra-rational intuition, Descartes more convincingly explained how the mind rationally builds up its picture of reality from only a few

truths innately contained within itself. After doubting everything which might possibly be an illusion, the mind is left only with a few things that are absolutely true. From this solid foundation the mind uses the two 'mental operations by which we are able, wholly without fear of illusion, to arrive at the knowledge of things',[9] i.e., intuition and deduction. The mind starts its search for objective knowledge by employing its intuition, which is

> not the fluctuating testimony of the senses, nor the misleading judgment that proceeds from the blundering construction of imagination, but the conception which an unclouded and attentive mind gives us so readily and distinctly that we are wholly freed from doubt about that which we understand. Or, what comes to the same thing, intuition is the undoubting conception of an unclouded and attentive mind, and springs from the light of reason alone.[10]

Using this intuition it is possible for the individual to discover in his mind certain indubitable realities like 'the fact that he exists, and that he thinks; that the triangle is bounded by three lines only, the sphere by a single superficies, and so on'.[11]

From these inner clues, the method of deduction can then be used to build a complete picture of the outer world. Just as the mathematician deduces from the basic definition of a triangle a series of propositions about the properties of triangles, Descartes maintained that the natural philosopher would be able to deduce from the fundamental principles first found by intuition in the mind an entire system of certain knowledge about the external world. Discovering the structure of the world is almost like solving a jigsaw puzzle for Descartes, in which one finds the first few pieces in one's mind, and then reconstructs what the rest of the pieces must be out in the world. Like Galileo, Descartes believed this sort of deduction would not only clarify that which is already known about the world, but would also discover hitherto unknown truths.

Descartes assumed he had offered a considerable improvement on earlier conceptions of Rationalism, because where in earlier ideas the mind comprehends everything about the world in one intuitive insight, an implausible notion at best, Descartes more reasonably placed only a few essential truths in the mind and then explained how the mind can lead itself step by step to discover the rest of the world's secrets. Furthermore, he replaced the earlier extra-rational, divine and spiritual explanations of Rationalism with one clearly rooted in the logical operations of the individual mind, and thereby gave Rationalism a more secular and more obvious source of its knowledge.

His entire Rationalist program, it must be realized, was based on an unsupported assumption. That is, he had to assume that all minds have the same structure, operate according to the same laws, and have prefigured in them the same innate truths. Otherwise it would not be possible to achieve completely objective knowledge. If the truths contained in one mind are different from those contained in another, or if the mental procedures used to apprehend those truths are different from one mind to another, then obviously different people would have different understandings of the world external to them. Descartes recognized that cultural conditioning and personal factors like inattentiveness, lack of experience or insufficient mental exercise might easily cloud any one individual's intuitive apprehension of the universally shared innate truths, and so he did not go against common sense and try to argue that everyone has exactly the same conscious knowledge of the world; rather he claimed – and had to claim, if he wanted to retain objectivity – that the same information is virtual in every mind and is similarly accessible to anyone who carefully exercises his or her powers of intuition and deduction. The only justification Descartes offered for this crucial assumption is the medieval Scholastic one that God is not an evil deceiver; since we all clearly and distinctly think the world is the same for all of us, it must necessarily be so, otherwise God would be deceiving us.

Using his new Rationalist method, Descartes proceeded to develop what he hoped would be a more accurate description of the outer world. He was particularly keen to combat the mechanistic, deterministic analogy of the natural scientists, because he wished to save the free will of individuals. How he arrived at his own model of the world is not important here; suffice it to say that he set up a dualistic conception of reality with a material realm, within which resides the body, and a spiritual, transcendental realm, within which resides the mind. Each operates according to its own laws, and so while the deterministic clockwork of Baroque cosmology can influence the human body, it can have no effect on the human soul or will. This dualistic system obviously saved individual freedom, but it generated a new problem which would plague Descartes as well as his successors: how can the two realms interact? How, for example, can the mind experience the pain of a wound inflicted on the body, and how can the body move in response to the commands of the mind? The relationship of mind to body in Descartes's scheme has been described as analogous to a pilot in a ship, in the sense that the mind can induce actions in the conveying body without actually being an integral part of it.[12] Even Descartes felt uneasy with this relationship. He suggested

that body and mind might be linked together in the pineal gland (as an anatomist he could find no other function for this gland), but clearly this is one of the least satisfactory features of his system. The old organic analogy of nature had placed mind in the closest union with body, the mechanistic analogy of the Renaissance cosmologists had stressed world and ignored mind, and now as an intentional characteristic of his philosophical system Descartes had separated mind and world into two absolutely distinct spheres. From Descartes on, the dualities between mind and body, mind and world, physical determinism and spiritual free will would become self-conscious and fundamental problems for Western philosophy.

Continental Rationalism

Descartes's Rationalist successors carried his theories to greater extremes. Benedictus de Spinoza (1632–77) and Gottfried Wilhelm Leibniz (1646–1716) agreed with Descartes that reliable knowledge of the world must be found within the reasoning mind. Spinoza pushed this to its logical conclusion, and rejected even Descartes's limited use of the senses in apprehending knowledge. Anything rational must be real, he noted; otherwise, an idea rationally developed in Descartes's method may not necessarily correspond to something existing out in the world. And if the rational is real, then any object which can be thought and which can be shown to be rational must exist, even if it has never been seen in the senses. Knowledge about the outside world was purely a matter of deductive logic for Spinoza.

Both Spinoza and Leibniz attempted to solve Descartes's troublesome mind–body dualism and, starting from the same assumptions, ended up with opposed conclusions. Spinoza proposed what was to become known as a parallelist theory, in which each side of the duality operates according to its own laws and independently of, yet somehow parallel with, the other side. In Spinoza's system, when an effect takes place in the physical world, it affects an ultimate reality which then in turn affects the mind; so instead of saying that the physical world acts on the mind, Spinoza would say that changes in the physical world correspond to identical changes in the mind. This solution was so convoluted that one historian of philosophy has noted: 'Spinoza's philosophizing serves primarily to demonstrate that something was radically wrong with at least some of the assumptions from which he began.'[13]

Leibniz alternatively attempted to reduce world to mind. Physical matter, he proposed, consists of a large number of infinitely small,

self-contained forces (he called them monads) which, when manifested to the senses, appear to take up space and to be physically extended. By the Cartesian assumption that anything not physical must be a mind, Leibniz was left with a world which consists ultimately of a kind of metaphysical mind. However, the monads that constitute an individual's body cannot cause change in the monads that constitute his mind and vice versa. To explain how a mind seemingly can will a finger to move, Leibniz also proposed a theory of parallelism. God constructed the entire universe such that a series of events occurring in the physical domain correspond exactly to a series of events occurring in the mental domain. The finger moves not because the mind willed it, but because the mental events leading up to the thought, 'I wish to move my finger' happened to occur precisely when a series of physical events were leading up to a finger being moved. For Leibniz, the world is like two independent clocks, one mental, the other physical, set into motion at the same time and running at precisely the same speed.

Although this idea has to be admired for its ingenuity, the whole theory of parallelism 'is so far fetched that almost any other hypothesis that accounts for the facts would be preferable'.[14] Well within the constraints of Descartes's assumptions, Spinoza and Leibniz had made the mind so powerful that it no longer conversed with the outer sensory world at all; and they had constructed metaphysical flights of fancy with no means of verification other than that the line of argument leading up to their invention seemed logical. The Continental Rationalists pursued the notion of innate, rational ideas to its logical conclusion, and found little reliable knowledge about the outside world.

Empiricism and the priority of sense

Empiricism in natural science

For many natural scientists who did not trust Galileo's Rationalist pattern-making, Empiricism offered a method more congenial to their interests in sensory nature. Francis Bacon (1561–1625) championed this tradition, and adjusted it to accord more exactly with the new mechanistic analogy of the world. Whereas earlier Empiricists regarded the mind as active, something which looks out into the world for the knowledge it can find there, in the new analogy Bacon had to regard the mind as more passive, something which merely receives the

knowledge that the outer world gives it. In principle, Bacon claimed, the mind is 'even and like a fair sheet of paper with no writings on it';[15] and when the mind is properly receptive nature will simply 'write' upon it all of the essential truths about reality. Unfortunately, Bacon realized, in practice the 'minds of men are strangely possessed and beset [with prejudices and preconceptions] so that there is no true and even surface left to reflect the genuine rays of things, it is necessary to seek a remedy for this'.[16] This tendency of the mind to corrupt the information flowing into the senses has created errors in most previous knowledge, Bacon maintained, and so men must clean their minds entirely and start afresh.

According to Bacon, the proper method of science cannot be deductive, because deducing laws from starting propositions cannot reveal any new truths about the world that are not already contained in the existing information. Instead, the seekers after Truth must 'lay their notions by and begin to familiarize themselves with facts',[17] and then through a process of induction discover 'axioms duly and orderly formed from particulars'.[18] The scientist should draw up a list of every known case in which the phenomenon under scrutiny (his example was heat) occurs, does not occur, and only partially occurs. Then the scientist should reject every casual factor (like light) that fails to occur where the phenomenon occurs, occurs where the phenomenon fails to occur, and occurs in a proportion inconsistent with the partial occurrences of the phenomenon. Bacon himself conceded the impossibility of this method when he later allowed the limited use of what he called the 'Indulgence of the Understanding, or the Commencement of Interpretation or the First Vintage'. These were his names for a preliminary hypothesis or guess as to what the causal factor might be by which the scientist might cut through the overwhelming mass of data required by the pure inductive method.

Isaac Newton (1642–1727), the most famous proponent of the Empiricist tradition and the culminating genius of Baroque science, rejected even this limited use of hypotheses: 'whatever is not deduced from the phenomena is to be called an hypothesis; and hypotheses, whether metaphysical or physical, whether of occult qualities or mechanical, have no place in experimental philosophy. In this philosophy particular propositions are inferred from the phenomena, and afterwards rendered general by induction.'[19] As far as Newton was concerned, information about nature's underlying structure jumps unaided into the attentive scientist's mind. First the scientist surveys the empirical evidence available and then, without any preconceptions about the laws he might expect to find, looks for recurring regulari-

ties. Once found, these regularities are rigorously tested to ensure that they will always hold true for all instances, whereupon they are generalized as universal laws of nature. Effectively the general laws are induced from the particular phenomena under scrutiny to create an 'abridged expression' of that particular part of nature, much as a book reviewer might reduce a full length novel down to its essential outline.[20] Newton's view became the most influential conception of science in the subsequent history of the West, shaping not only the scientists' understanding of their task, but also the conceptions of thinkers in other fields who hoped to achieve the rigor and certainty which seemed to have been achieved in natural science. The influence on Christopher Alexander and the design methodology movement of the 1960s is unmistakable. Yet despite the obvious attractions of this view, it runs counter to the scientists' actual behaviour. First of all, while the successors to Newton claim to observe phenomena without a prejudiced mind, in reality they must have some point of view which tells them which phenomena to observe. As Fowler points out in his analysis of scientific method, 'countless apples fell to the ground and were observed to do so before the time of Newton';[21] but because natural scientists before him had not thought as intensely about the problem of gravitation and thus had not formed ideas about how it might work, they had not recognized the importance of the phenomena before them.

Secondly, Newton assumed the data would present its regularities to the attentive observer without him or her using any hunches or creative hypotheses about what those regularities might be. But as Popper has pointed out, without a theory of what to look for, an amorphous mass of data will not necessarily reveal any pattern at all.[22] Many scientists before Copernicus, for example, had access to an extensive body of information about the movement of planets and the solar system, and from this they inferred various laws about the structure of the universe, all of which could claim some reality in the basic data. But when Copernicus changed the conceptual theory altogether, from geocentricity to heliocentricity, the same data took on a new form; with a new hypothesis many old causal connections were abandoned, to be replaced by new ones suggested by the new theory. The generalized laws did not intrinsically and objectively follow from obvious relationships in the raw data, as much as the relationships in the data followed from the new hypothesis.

John Locke

Just as Descartes attempted to build surer epistemological foundations
for Rationalism so, too, did John Locke (1632–1704) try to explain
Empiricism more thoughtfully than the natural scientists had so far
attempted. He began with a familiar rallying cry: 'Whence has [the
mind] all the *materials* of reason and knowledge? To this I answer in
one word, from EXPERIENCE. In that all our knowledge is founded;
and from that it ultimately derives itself.'[23] On these grounds Locke
emphatically denied the existence of innate knowledge genetically
implanted in the mind, and proposed instead an analogy of the mind
similar to Bacon's. At birth, he claimed, the human mind is merely a
blank tablet of wax – a *tabula rasa* – upon which experience subse-
quently impresses all knowledge of the outer world. But what, exactly,
is impressed? An object in front of a viewer obviously does not physi-
cally jump into the mind. According to Locke, all objects in the world
possess certain qualities like extension, solidarity, color and taste, that
have the power to cause ideas of those qualities to appear in the mind
of a perceiver. So the mind does not know the qualities directly but
only the mental ideas it has been given of the qualities. The ideas
which first come in through the senses are simple ones like 'redness',
'sweetness', 'hardness' and 'roundness'; later, the mind combines these
into complex ideas like 'apple'. Manipulating the simple ideas even
further, the mind can separate ideas 'from all other ideas that accom-
pany them in their real existence: this is called abstraction: and thus
all its general ideas are made'.[24] By this means the mind can conceive
of an abstract idea like infinity. Starting with the simple idea of a dis-
tance perceived between two bodies, the mind can repeat this distance
to itself without end until it conceives of an infinite distance. So while
the mind begins only with the raw data of particular sensory qualities,
eventually it is able to discover new and universal laws about nature
beyond the senses. Locke believed he had provided the mind with as
many powers and with as much access to universal knowledge as the
Rationalists, but without relying upon the concept of innate ideas.

In making sensory data the source of all knowledge Locke was
faced, of course, with the problem of subjectivity inherent in percep-
tion. As the Rationalists had pointed out, the mind often perceives
things which do not seem actually to exist objectively in reality (like
mirages or colors which change under different lighting conditions),
and so they doubted the reliability of all perceptions. Locke proposed
to avoid this difficulty by borrowing Galileo's distinction between pri-
mary and secondary qualities. Those qualities perceived in the world

which everyone would admit are subjective – like color, taste and smell – are only secondary. The objects out in the world do not actually possess these qualities, but they none the less have the power to create an impression of these qualities in a perceiving mind. Without a mind to perceive it, indeed, a secondary quality does not even exist except as a potential to be perceived. On the other hand, Locke assured his readers, primary qualities like size, shape and weight do correspond to properties in the objects themselves. With this distinction, Locke hoped to limit the damage of the Rationalist attack on perception by separating those experiences which are clearly subjective from those which could still offer objective knowledge.

Unfortunately, Locke's theory suffered from a serious flaw. If all the mind ever knows are the ideas it has about external objects, and not the objects themselves, then how can it be sure its ideas correspond to objects out in the world? Even Locke conceded that 'having the idea of anything in our mind, no more proves the existence of that thing, than the picture of a man evidences his being in the world, or the visions of a dream make thereby a true history'.[25] Locke retreated from these sceptical conclusions, quickly pleading that 'nobody can in earnest be so sceptical as to be uncertain' about the existence of external objects. This was hardly reassuring for an age which demanded absolute certainty in its knowledge, and his successors would press this unpleasant conclusion firmly home.

Bishop Berkeley

Bishop George Berkeley (1685–1753), for example, noted that Locke's crucial distinction between primary, objective qualities and secondary, subjective qualities, is entirely fallacious. He asked whether anyone can

> by any abstraction of thought, conceive the extension and motion of a body [the primary qualities], without all the other sensible qualities [the secondary qualities]. For my own part, I see evidently that it is not in power to frame an idea of a body extended and moved, but I must withal give it some color or other sensible quality ... In short, extension, figure, and motion, abstracted from all other qualities, are inconceivable.[26]

Those qualities which are supposedly independent of the mind, in other words, cannot be separated from those which Locke had admitted are mind-dependent. Even worse, Berkeley pressed on, *all* perceived qualities are of the latter type. Just as the color of an object

changes under different lighting conditions, its size and shape change according to an observer's relative position. A table top which looks rectangular when viewed from directly above looks trapezoidal when viewed from the side, and the trapezoidal shape changes as the viewer walks around the table. The size changes as the viewer varies his or her distance from the table. Which is the objective shape and size when two viewers look at the same table from different positions? One never perceives the table as a rectangle of a particular size except from one particular position, and there is no *empirical* reason to believe that this view is any more accurate or more objective than any of the others.

The principle of Empiricism, Berkeley continued, does not even allow for the existence of abstract general ideas, the foundation of universally objective knowledge. Locke had claimed that the mind can step beyond the sensory experience of this equilateral or that scalene triangle in order to think of 'Triangle' in the abstract, and so can derive universal knowledge from knowledge of particulars. Berkeley denied this possibility. All knowledge starts as sensory particulars, he agreed, but at this level it remains. He asked whether it is possible for anyone to think of a triangle which is 'neither oblique, nor rectangle, neither equilateral, equicrural, nor scalenon, but *all* and *none* of these at once'.[27] General ideas are always held in the mind in terms of the particular ideas gained from experience. Once it is admitted that knowledge is always in terms of sensory particulars – particulars which are dependent upon individual minds – the idea of objective universal knowledge looks increasingly difficult to maintain.

Since in the Empiricist view one is only justified in claiming the existence of that which can be seen, Berkeley concluded, the objects of perception are nothing more than perceived qualities. There is no such thing, in other words, as a physical, material world which exists independently of minds and which radiates information about its various qualities. Only the qualities themselves exist, and they exist only when they are being perceived. Critics of Berkeley have often taken this to mean that the objects of sense perception disappear when they are not being perceived by anyone. Berkeley avoided this problem by employing God to perceive them when no one else is looking, thus ensuring that any minds turning their attentions to the world's qualities will receive the same impressions.

David Hume

David Hume (1711–76), the culminating genius of the Empiricist tradi-

tion, soon undermined even this claim. Where is the sensory evidence, he asked, for believing in the existence of a shared, outer world? This belief is founded, to begin with, on the apparent evidence of identity or resemblance. For example, suppose an observer enters a room and sees an image of a table; and further suppose the image recurs every time the observer leaves and re-enters the room. After so many occurrences of seeing this same image, the observer begins to assume that all of these temporally distinct yet visually identical images are really the same thing, and thus naturally jumps to the conclusion that they must all be caused by one unchanging object in the room. But if one attends strictly to the sensory data experienced, Hume pointed out, this is an unwarranted conclusion. The image of the table seen in early morning light, for example, does not possess the same coloring as the image seen late at night under artificial light. Nor, as Berkeley had already pointed out, is the image seen from ten feet away the same as the one seen from a few inches away. The mind has jumped beyond the actual sensory data to *assume* they are the same images, when it has really seen only a series of 'variable and interrupted' images over a period of time. Furthermore, there is no empirical evidence whatsoever that the image continues to exist in the intervals when it is not being perceived.

The belief in the existence of an outer world also depends on the concept of cause and effect: that is, one assumes the sense impressions received by the mind are caused by objects out in the world. But where, asked Hume, is the sensory evidence for this idea of a necessary connection between a cause and its effect? He examined several instances of supposed causal relationships, between fire and heat, for example, but in every instance he pointed out that the sensory evidence itself displays only one event, and then another close by, but no necessary connection. An observer may begin to assume one event causes another after perceiving the two many times together, but as far as the sensory evidence itself is concerned, 'All events seem entirely loose and separate. One event follows another; but we never can observe any tie between them. They seem *conjoined*, but never *connected* … the necessary conclusion *seems* to be that we have no idea of connexion or power at all, and that these words are absolutely without any meaning, when employed either in philosophical reasonings or common life.'[28]

Many of the other ideas used to justify a belief in an objective outer world, like the ideas of uniformity in nature, the existence of other minds, and Berkeley's perceiving God, Hume demolished with a similar line of reasoning. All the mind can ever gain from the senses them-

selves, Hume showed time and time again, is a random flux of inter-
mittent and constantly changing impressions. There is no order in this
material as it is apprehended, nor is there any evidence that it origi-
nates anywhere other than in the sense organs themselves (to believe
that the impressions 'in here' are caused by something 'out there' is to
rely on the unjustified causal argument). A strict Empiricist knows
nothing more than that he or she is currently experiencing a personal
display of random shapes, colors, sounds, and so on, and cannot make
any inferences whatsoever from this material about an outer world, or
even an inner self. The principle of Empiricism strictly applied, Hume
had conclusively shown, results in epistemological scepticism.

Although Hume demolished the various inferences made by the
mind from its sense impressions about a so-called objective world, he
admitted that all minds seem to have an irresistible urge to make such
leaps. He knew his readers 'an hour hence ... will be persuaded there
is both an external and internal world'.[29] He attributed this urge to a
power of the imagination, by which the mind attempts to impose
some order and meaning on the random data gained by the senses.
Taking the example earlier of the table in the room, the mind is not
content to see only a random array of different images; instead, it
actively searches for the features which seem common to all the
images, conveniently ignores the differences, and even fills in the gaps
when the table is not being perceived. The mind's desire to see order
in variable and interrupted impressions is so great that it acts 'like a
galley put into motion by the oars'[30] and transforms *some* similarity in
images to *complete* similarity, or identity. To resolve the contradiction
between what it sees and what it wants to see, the mind *invents* an
idea of continuous substance which it supposes lies behind all the
interrupted images: 'we often feign some new and unintelligible princi-
ple, that connects the objects together, and prevents their interruption
or variation. Thus we feign the continu'd existence of the perceptions
of our senses, to remove the interruption; and run into the notion of a
soul, and self, and substance, to disguise the variation.'[31] To the strict
Empiricist, of course, these inventions do not originate in experience
and are therefore not admissible as knowledge about the world; but,
as will be seen in the next chapter, this idea of Hume's that the mind
imposes order on sense experience would be employed by Immanuel
Kant in his attempted synthesis of Rationalism and Empiricism.

With Hume a three-hundred-year-old philosophical program had
come to an inevitable and unsatisfactory end. The concepts of mind
and world which held so much promise when they were first formulat-
ed in the early Renaissance were now seen to be problematical in the

extreme, leading either to empty metaphysical fantasies in its Rationalist mode or to random impressions and a lack of certainty in the Empiricist mode. In both cases the logic and the lines of reasoning leading to the unsatisfactory conclusions were above reproach, so if the conclusions seemed dubious it could only be that the starting premises were faulty. By 1750 the philosophers had reached a crisis in their understanding of the mind and the world, a crisis which would lead in the next generation to a major reorientation of the West's philosophical assumptions.

Art and architecture theory and the academies

The Baroque art theories also began the seventeenth century with a dualistic response to the excesses of Mannerism, one camp reasserting the importance of sensory data, the other camp emphasizing the logical structure behind appearance. Just as Rationalism dominated epistemology in the middle of the century, so, too, did Classicism with its emphasis upon logic, reason and teachable doctrine dominate art and architecture theory. Finally, as the Empiricists at the end of the seventeenth and in the first half of the eighteenth century showed the limits of reason and turned attention once again to the priority of sense, the artists and architects ushered in the Rococo phase of the Baroque, characterized more by feeling and sensory delights than by logic and reason.

Realism vs. Idealism in the early Baroque

One response in the seventeenth century to the excesses of Mannerism was a return to 'truth to the senses'. Caravaggio (1573–1610) led this movement, by attempting to reproduce in his paintings images exactly as they appeared to his senses, no matter how faulty, ugly or ignoble. Painting should not select from nature according to some preconceived ideal, but rather should give as realistic a portrayal of sensory impressions as possible; and so the painter once again was to consider himself a passive receptor of any and all images emanating from the outside. Although there were few theoretical works written at the time to justify this view, Caravaggio's realism found expression in a succession of painters throughout much of the seventeenth century, including Diego de Velasquez (1599–1660), Rembrandt van Rijn (1606–69) and Jan Vermeer (1632–75) (Figure 50).

The main theory in this period came from the other reaction to the

50 Jan Vermeer, *Kitchen Maid*, c.1658. Where the High Renaissance artists attempted to idealize their subjects, the Realists in the early Baroque intentionally painted images exactly as they appeared to the senses, however humble they were.

excesses of Mannerism, a renewed Classicism. As far as the Classicists of the Baroque were concerned, they had to fight a battle on two fronts: in response to the Mannerists, whose art copied other works of art more than nature, they wanted to anchor art firmly in the sensory appearance of nature once again; but in response to the Realists, whose art had gone back to natural sources, the Classicists wanted to correct the vulgarities of naive realism and return to the Idealism of the Renaissance. In other words, they sought some middle ground

where nature is the ultimate source of art, but is selectively screened and filtered, so that only the most perfect images are used for artistic sources. Following the usual tradition, they expected to find this middle ground by turning once again to a careful study of the ancient works, where they would find ideal natural images already perfectly captured.[32]

Giovanni Pietro Bellori (1615–96) attempted to give this revived Classicism a theoretical foundation and, in keeping with the dualities of the age, his theory shows a confused juxtaposition of Neoplatonic metaphysical idealism with Aristotelian normative idealism. In 'The Idea of the Painter, Sculptor and Architect, Superior to Nature by Selection from Natural Beauties', Bellori addressed the central problem of idealism: how are the ideal artistic forms to be discovered if they are not immediately revealed in sense experience? At first his explanation seems to derive directly from the Neoplatonism of the Mannerists: 'The highest and eternal intellect, author of nature, in fashioning his marvelous works looked deeply into himself and constituted the first forms, called Ideas, in such a way that each species was expressed by that original idea.'[33] These Ideas, Bellori further claimed, 'remained forever beautiful and well-ordered ... eternally just and most beautiful', while the natural objects of the sensory world 'are subject to change and deformity' and only imperfectly copy the supersensual ideals. For this reason, the 'noble Painters and Sculptors, imitating that first maker, also form in their minds an example of superior beauty, and in beholding it they emend nature with faultless color or line'.[34] He even mentioned how a genius can infuse an Idea directly into the marble or canvas. But when he explained how the artist comes to know of these ideals, he ignored the usual Neoplatonic solution that they are infused in the mind by God, and opted instead for the contrary normative idealism solution that they are found in reiterated experience of the sensory world. He noted the familiar examples of ancient artists who, after gathering together the most beautiful models in nature, then selected the most beautiful parts from each to discover the ideal form behind appearance. This involved Bellori in the familiar circular argument, of course: he desired ideals which could guide the selection of beauties, but he first had to select beauties in order to discover his ideals.

With this unresolved conflation of metaphysical and normative idealism, Bellori believed he could successfully combat the two extremes of Realism and Mannerism. On the one side, 'those who glory themselves with the name of Naturalists have no idea whatever in their minds; they copy the defects of bodies and satisfy themselves with

ugliness and errors'; while on the other side, 'those who borrow from the genius and copy the ideas of others [create] works that are not natural children but bastards of nature'.[35] At the same time, though, Bellori agreed with his Renaissance predecessors that the most practical way to discover the Ideals in nature is to 'study the most perfect antique Sculptures' and the works of 'the other outstanding masters', because they already contain the Ideals in a readily accessible form.[36] So are the ideals possessed by the artists before experience, or gained in experience, or found in the work of their predecessors? Like Leonardo in art theory and Descartes in epistemology, Bellori had tried to avoid the two extremes of innate ideas cut off from sensory appearance, on the one hand, and naive Empiricism uninformed by organizing ideals, on the other; but like them, his attempted synthesis only juxtaposed incompatible ideas.

French Classicism and the Royal Academies

After 1660 the center of artistic influence in Europe moved from Italy to France, where it subsequently took up more strongly the French preoccupation with Cartesian reason and rational order. Just as Descartes believed his logical method would lead to the discovery of certain truths about the world, the artists believed there could be a similar logical method, or set of rules, for art. According to George de Scudéry, 'every art has certain rules which by infallible means lead to the ends proposed'; and, Charles de St-Évremond was convinced, 'there are certain eternal rules, grounded upon good sense, built upon firm and solid reason, that will always last'.[37]

In painting, Nicolas Poussin (1593/94–1665) most clearly expressed this rationalist spirit. As Bellori had advised, he painted only the most beautiful models and would not entertain as subject matter anything but the most noble events and people. He also sought guidance in the ancient works, basing many of his images on measurements he took from Roman statues (Figure 51). The ancients were now considered so infallible that nature itself was corrected if it did not match the appearance of the ancient work. But the most significant aspect of Poussin's work, as far as the issues in this book are concerned, was the increasing priority he gave to outline (*trait* or *dessin*) over color. The Renaissance theorists had discussed the ability of line drawing to capture the underlying essence of an image more accurately than can color, and Poussin raised this to an overriding principle. His work gave literal artistic expression to the philosophers' distinction between primary and secondary qualities.

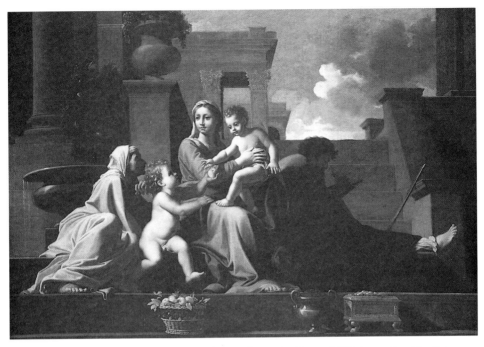

51 Nicolas Poussin, *Holy Family on the Steps*, 1648. In contrast to the
Realists, Poussin attempted to portray the ideal behind sensory
appearance. Note how the flat painting style reveals forms as if under an
intense ethereal light, and how the Classical architecture in the
background self-consciously links the painting to the Classical tradition.

In architecture, François Mansart (1598–1666) expressed the new
Classical mood (Figure 52). Compared to his predecessors, he stressed
a clear, rational order in his building designs, emphasized the indivi-
dual geometrical parts out of which the whole was composed, and
employed the ancient architectural Orders more correctly. François
Blondel (1617–86) offered the theoretical justification for this revived
Classical correctness in his *Cours d'Architecture* (1675–98). Architec-
ture, he claimed, must follow the laws of nature and reason rather
than the mere fantasies of the individual mind. One important mani-
festation of reason is orderliness, which enables the human mind to
understand an architectural form. Following the rational spirit of the
period, Blondel assumed that the logical basis of architecture would
enable certain absolute and eternally valid rules to be established. This
was particularly true of the architectural orders which, based on
human proportions, must never be altered. Like all Classicists before
him, Blondel further assumed that students would most easily learn
the timeless rules of architecture by studying the works of classical
antiquity and, he added, the works of the Italian Renaissance.[38]

52 Chateau, Maisons (Seine-et-Oise), France, 1642–46. François Mansart.
The dominant Rationalism in seventeenth-century French philosophy found
expression in Mansart's rational ordering systems and correct use of the
Classical orders.

As in the age of Mannerism, the belief that art is guided by certain
universal principles and rules gave rise to an art academy.[39] In 1648,
instigated by Charles Lebrun and others, the King's minister Mazarin
founded the Académie Royale de Peinture et de Sculpture; and in
1671, under the initial professorship of François Blondel, Mazarin's
successor Colbert founded the Académie Royale d'Architecture.[40]
These Academies never intended to replace the apprenticeship system
of education completely, but rather proposed to teach the universal
principles of art and architecture to students who were already
apprenticed to masters in workshops, or *ateliers*, outside the aca-
demies proper. In the academic lectures the students studied the orga-
nizing principles of arithmetic, geometry, perspective and mechanics,
and in the drawing classes they learned the drawing skill which could
be used to capture the essence behind sensory objects; only in their
master's workshop, under the master's supervision, did the students
apply these principles and carve sculptures, paint paintings or design
buildings. Art education was still caught half-way between a self-con-

scious system, in which the students learned the general principles that would enable them to choose their own particular artistic paths, and an unselfconscious system, in which the students were indoctrinated into the style and methods of one particular master.

Another basic presupposition of the Baroque Academies was a belief in the similarity of minds. As Descartes had already realized in his Rationalist epistemology, logical, universal rules used to discover objective truths can work only if all minds are structured in the same way, operate according to the same laws, and have implanted in them the same innate truths. Likewise, for the Classicists in the Academies to believe that certain logical rules about composition will lead infallibly to intelligible and universally beautiful paintings or buildings, they had to assume that all minds perceive the same beauty in the same objects, and use the same logical mental procedures for transforming Classical principles into works of art. Their belief in the similarity of minds showed in their arrangement for the teaching staff. They employed twelve different professors who served in rotation, one every month, to set the life-models, to supply drawings to be copied, and to correct the students' work. According to Pevsner, this was to make it 'impossible for any one personality within the academy to exert a preponderant influence';[41] but it equally demonstrates the belief that all professors understand the same body of knowledge, teach the same rules, and see the same faults in student work.

The rise of artistic subjectivity

The academies in the middle decades of the seventeenth century took up the rational side of the Baroque, emphasized the exclusive validity of rule and logical form, and stressed the application of fixed precepts. Towards the end of the century and through the first half of the next, however, artistic theory paralleled the contemporary shift in epistemology from Rationalism to Empiricism, and emphasized instead the priority of sensory appearance. At first this was perhaps mainly a reaction to the excessive rationalizing in the academies, but eventually it would become a celebration of the subjective and even idiosyncratic.

Nothing demonstrates more clearly the shift from the rational to the empirical in later Baroque art theory than the 'Querelle des Anciens et des Modernes', a debate which began in the French academies in 1671 and ended twenty-eight years later with the sensual tendency winning out over the rational. Against the 'Anciens' or 'Poussinistes' who defended the old rationalist order were pitted the 'Modernes' or 'Rubenistes', led by Röger de Piles (Figures 51, 53). Where the

'Anciens' stressed the priority of line over color because line is able to cut through the surface appearance of things and capture their under-lying form, the 'Modernes' turned this around and stressed the impor-tance of color, because it can more accurately capture the mood or feeling of the object. And where the 'Anciens' accepted Fréart de Chambray's assertion that real art experts are only those who 'exam-ine and judge things in the manner of Geometricians',[42] the 'Modernes' wanted to use sentiment as a guide in art criticism. The 'Querelle' reflects an unmistakable shift from a preoccupation with an objective, rational order lying behind appearance to a preoccupation with the individual's subjective impression of the objects in appearance.

The works of Jean-Antoine Watteau (1684–1721) and François Boucher (1703–70) demonstrate most clearly the new sensual mood in French painting (Figure 54). Both substituted frivolity, grace and sen-sual charm for the serious themes and cool order of Poussin's work. In architecture, the preoccupation with sensory delight at the expense of rational order can be found in its most extreme version in the Rococo churches of Balthasar Neumann (1687–1753) and Jakob Prandtauer (1660–1726), both of whom virtually dissolved the geomet-rical forms of their buildings under writhing decoration (Figure 55). The English Baroque school of Christopher Wren (1632–1723), Sir John Vanbrugh (1664–1726) and Nicholas Hawksmoor (1661–1736) also stressed picturesque effects and personal invention over rational order and the correct use of Classical motifs (Figure 56).

With little interest in logical, objective rules, the artists of this period were not overly inclined to write about theory; the little theory there was in France tended only to praise 'variété, enjouement, grâces'.[43] The first philosophical foundations for this new subjective trend came instead – and almost inadvertently – from the physician and later architect of the East Front of the Louvre, Claude Perrault (1613–88) (Figure 57). Like many Baroque thinkers, he assumed that any problem can be solved by a judicious application of reason, and that any art or science thus treated can achieve an even higher level of perfection. When late in life he turned his attentions to architecture, he noted the disagreements among authors on the correct proportions of the Orders, and he wished to settle this matter once and for all. This had been attempted often before, usually by taking the averages of many measurements, but these usually resulted in *ad hoc* compro-mises and inconsistent rules. Perrault proposed to avoid these prob-lems altogether by simply inventing a new system from scratch, one whose rules would be entirely rational and convenient for architects to use. This was a heretical proposal, of course, because until then archi-

53 Peter Paul Rubens, *Fall of the Damned*, 1614–18. The 'Modernes' in
the French academies favoured Rubens's dramatic and richly coloured
sensual style over the more austere and rational Classicism of Poussin
(Figure 51).

54 Jean-Antoine Watteau. *A Pilgrimage to Cythera*, 1717. French Baroque
rationalism eventually gave way to this more sensually charming style.

tects had accepted that the rules of Classicism were either divinely
given or were an expression of nature's underlying order, and were
definitely not arbitrary inventions. To justify his rules, Perrault had to
argue that beauty in architecture has no objective existence, is entirely
arbitrary, and depends only on custom. The proportions of archi-
tecture, he claimed, 'could be changed without shocking either com-
mon sense or reason';[44] and elsewhere he said there are various
arrangements in architecture 'which reason and common sense ought
to make appear deformed and offensive … [yet which] become tolera-
ble … and finally agreeable through custom'.[45]

Perrault had liberated beauty from sources either in God or in
nature, and now felt free to offer his own invented system based on a
module one third the diameter of a column, rather than the accepted
module of one diameter (Figure 58). At the same time, though, he did
not want to accept the artistic subjectivity and relativity which his
theory implied. Rules are required in all human activities, he agreed
with his age, and when nature fails to supply rules 'as it did in the
case of language, fancy and custom … it is up to human agencies to
furnish them, and, in order to do so, a definite authority, taking the
place of reason, should be generally agreed to.'[46] According to
Herrmann, Perrault had stressed the role of culture in the development

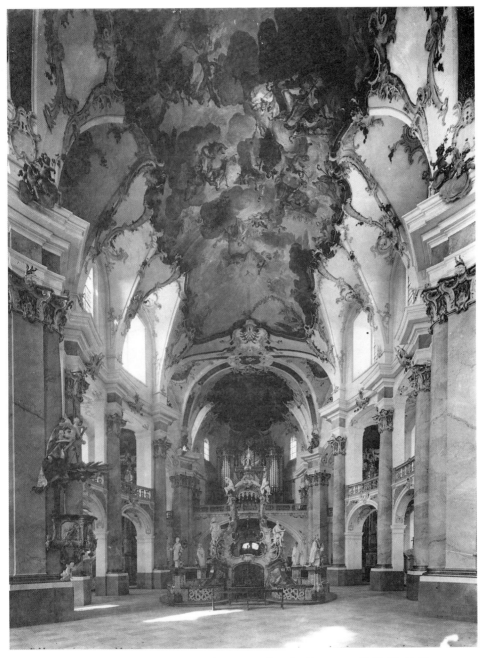

55 Vierzehnheiligen Pilgrimage Church, Germany, 1743–62. Balthasar
Neumann. Sensory delight and drama entirely suppress rational order and
understanding.

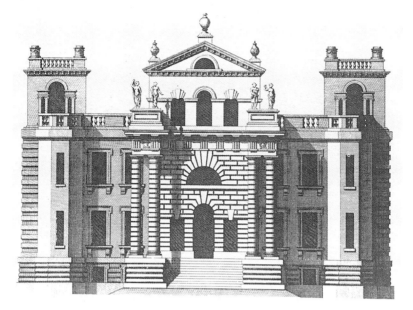

56 Seaton Delaval, 1721. Sir John Vanbrugh. The English Baroque school emphasized picturesque effects and personal invention within the broad framework of Classicism.

57 East Front of the Louvre, Paris, France, 1667–70. Claude Perrault. Perrault inadvertently undermined the objective foundations of Classicism as he attempted to improve them.

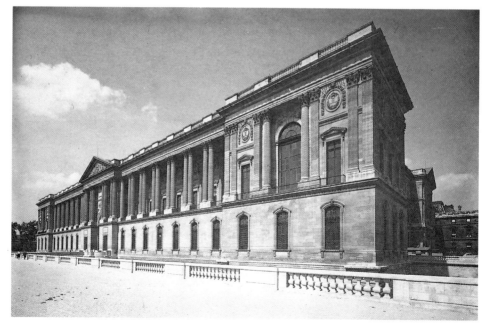

of Classical rules only in so far as it would allow him to substitute his own rules for those which had been followed since antiquity, but it did not occur to him that anyone might want to change *his* perfect rules sometime in the future.[47] None the less, Perrault's theory seriously attacked the hitherto complacent belief in objective principles of design.

Several British philosophers in the first half of the eighteenth century also explored how aesthetic judgements might be dependent upon mind, and therefore more subjective than the Baroque had so far cared to admit. Those who accepted the existence of rational rules for art had tended to assume that the mind judges the aesthetic merit of an object by intellectually measuring its qualities against universal standards. In his *Inquiry into the Original of Our Ideas of Beauty and Virtue* (1720), Francis Hutcheson (1694–1746) attempted to give a more satisfactory explanation of aesthetic perception by referring to several of Locke's empirical concepts. To begin with, he claimed, one cannot know beauty itself, but only the *idea* of beauty which an external object raises within the mind; furthermore, the idea of beauty is like one of Locke's secondary qualities, in that it exists only in the mind itself and is not a property of the external object. Beauty is not, he wrote, a 'quality supposed to be in the object, which would of itself be beautiful, without relation to any mind which perceives it'; and further, 'were there no mind with a sense of beauty to contemplate objects, I see not how they could be called beautiful'.[48] He noted that different men have different feelings about the beauty of the same sensory objects, depending upon their cultural, historical, national and temperamental differences. None the less, he still wanted to maintain some objectivity by claiming that certain characteristics in objects – like 'uniformity amidst variety' – will always raise the idea of beauty in any mind perceiving them. Differences of opinion are to be accounted for by the differing degrees to which the aesthetic sense is developed in individual minds.

Hume also explored this problem in his essay 'Of the Standard of Taste' (1757). He noted the inevitable Empiricist conclusion that 'beauty is no quality in things themselves. It exists merely in the mind which contemplates them, and each mind perceives a different beauty'.[49] None the less, Hume went on, common sense and the demands of practical action cause us to 'seek a Standard of Taste; a rule by which the various sentiments of men may be reconciled; at least a decision afforded confirming one sentiment, and condemning another'.[50] Through most of his essay, he attempted to show how certain characteristics in art objects have naturally pleased the human

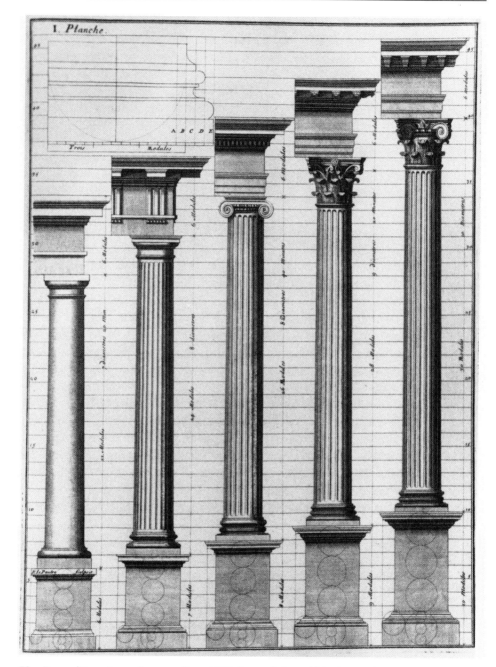

58 Perrault's system of proportion, 1683. Perrault based his Five Orders
on a module one third the diameter of a column, rather than the accepted
module of one diameter.

mind throughout history. Assuming that all human minds are structured similarly and therefore respond similarly to the same stimuli, there will always be a 'natural' emotional response to think of beauty when perceiving these characteristics. Lack of experience, deficiency in 'delicacy of feeling', lack of attentiveness and wrong mood mostly account for some people's inability to experience the natural response. Even so, Hume had to concede, 'different humors of particular men' and 'the particular manners and opinions of our age and country' cause variations in our responses to beauty that cannot be delimited by rules: 'it is almost impossible not to feel a predilection for that which suits our particular turn and disposition. Such preferences are innocent and unavoidable, and can never reasonably be the object of dispute, because there is no standard by which they can be decided.'[51]

The new preoccupation with subjectivity in the last stages of the Baroque was accompanied by a loss of vigour in the academies. It has already been mentioned that systematic art theory in France declined in the first half of the eighteenth century, and a similar trend can be found within the academies themselves. As Pevsner points out, for example, where earlier in the seventeenth century the directors and rectors gave the main lectures in the Paris academy – presumably in order to set out the principles of art to be followed by the academy – by the turn of the century the task of delivering the lectures was given over to the academy's historiographer, whose interests were not surprisingly more historical than theoretical. Rather than offer any original contributions to the theory of the arts, the historiographer preferred to report on the lives of past members of the academy, and even when he did deliver a lecture with a theoretical theme, more often than not he read an old lecture.[52] No theoretical direction came from the chair of architecture either, according to Chafee. After the deaths of the last great Rationalist professors François Blondel in 1686 and Philippe de la Hire in 1718, more than half a dozen undistinguished professors were appointed to the chair in the first half of the eighteenth century, none of whom seemed to offer any strong direction to the academy or even any influential precepts for teaching.[53] This irresolution apparently had ill effects on the students as well, for between 1702 and 1722 the Grand Prix awards had to be cancelled nine times due to lack of adequate candidates.

Given the trends already discussed in this chapter, it is not difficult to understand the academy's general malaise in the first half of the eighteenth century. The academies were founded in the first place on the assumptions that there are universal principles of art, and that these principles must be learned by anyone hoping to become a good

artist. Once it had been acknowledged that everyone might perceive a different beauty, and that artists should render their subjective responses to things more than the objective reality of the things themselves, the academies no longer had an obvious role to play in the training of the artist. In the nineteenth and twentieth centuries, it will be shown, some Romantic educators would examine how a school can help students discover their own internal sources of knowledge and, by implication, their sources of art; but in the first half of the eighteenth century no such idea was offered and the academies had become institutions without a clear purpose.

Interestingly, the universities in Europe during this period also slumped. So feeble had they become that the great thinkers of the day like Leibniz were reluctant to become associated with them.[54] While numerous social factors contributed to this educational malaise, among them must be counted the loss of faith in universal and rational principles which could be transmitted through the educational structure.

So by about 1750 Western philosophy had reached a crisis. Working within their new mechanistic analogy of the universe, the natural scientists and epistemologists attempted to establish several routes by which knowledge can be apprehended, none of which seemed entirely satisfactory. The Classicists in art and architecture who believed in universal and objective laws had seen the theoretical underpinnings of their claims chipped away, and suffered through the subjective frivolities of the Rococo. On the other side, the artists who pushed towards more personal expression found their path blocked by numerous attempts at reasserting some objective criteria for art. The next generation would have to redirect these ideas.

Notes

1 See Hauser for an extended discussion of this debate. *Social History*, vol. 2, pp. 158–60.

2 Artz, *Renaissance to Romanticism*, p. 162.

3 Galileo, *The Assayer*, pp. 183–4.

4 Galileo, *Dialogues Concerning Two New Sciences*, trans. Henry Crew and Alfonso de Salvio, The Macmillan Company, New York, 1914, p. 162.

5 René Descartes, 'Discourse on the Method of Rightly Conducting the Reason', in *The Philosophical Works of Descartes*, trans. Elizabeth Haldane and G. R. T. Ross, at the University Press, Cambridge, 1931, vol. I, p. 121.

6 Copleston, *History*, vol. 4, p. 28.

7 Descartes, 'Notes Directed Against a Certain Programme', in *Works*, vol.

I, p. 442.

8 Descartes, 'Rules for the Direction of the Mind', in *Works*, vol. I, p. 15.

9 Descartes, 'Rules', in *Works*, vol. I, p. 7.

10 *Ibid.*

11 *Ibid.*

12 Copleston, *History*, vol. 4, p. 129.

13 Jones, *History*, vol. 3, p. 193.

14 Jones, *History*, vol. 3, p. 191.

15 Francis Bacon, 'The Great Instauration', in *The New Organon and Related Writings*, ed. Fulton Anderson, Bobbs-Merrill Company, Inc., 1960, p. 22.

16 *Ibid.*

17 Bacon, *The New Organon*, p. 47.

18 *Ibid.*, p. 44.

19 Isaac Newton, *Mathematical Principles of Natural Philosophy*, trans. Andrew Motte, at the University Press, Cambridge, 1934, [orig. pub. 1687], p. 547.

20 See Kolakowski, *Positivist Philosophy*.

21 W. S. Fowler, *The Development of Scientific Method*, Pergamon Press, New York, 1962, p. 94.

22 Karl Popper, *The Logic of Scientific Discovery*, Harper & Row, New York, 1959; also Popper, *Conjectures and Refutations*, Routledge & Kegan Paul, London, 1963.

23 John Locke, *An Essay Concerning Human Understanding*, ed. Alexander Fraser, Dover Publications, Inc., New York, 1959, [orig. pub. 1690], vol. 1, pp. 121–2.

24 *Ibid.*, vol. 1, pp. 213–14.

25 *Ibid.*, vol. 2, pp. 325–6.

26 George Berkeley, *A Treatise Concerning the Principles of Human Knowledge*, in *Philosophical Works*, J. M. Dent & Sons Ltd, London, 1975, [orig. pub. 1710], p. 80.

27 *Ibid.*, p. 70.

28 David Hume, *An Enquiry Concerning Human Understanding*, ed. L. A. Selby-Bigge, Clarendon Press, Oxford, 1975, [orig. pub. 1748], p. 74.

29 David Hume, *A Treatise of Human Nature*, ed. L. A. Selby-Bigge, at the Clarendon Press, Oxford, 1978, [orig. pub. 1739], p. 218.

30 *Ibid.*, p. 198.

31 *Ibid.*, p. 254.

32 This interpretation is from Panofsky, *Idea*, pp. 104-5.

33 Giovanni Pietro Bellori, 'The Idea of the Painter, Sculptor, Architect, Superior to Nature by Selection from Natural Beauties', trans. Victor Velen, in Panofsky, *Idea*, p. 155.

34 *Ibid.*

35 *Ibid.*, p. 169.

36 *Ibid.*, p. 171.

37 In Beardsley, *Aesthetics*, p. 146.

38 Anthony Blunt, *Art and Architecture in France 1500–*, 4th edn, Penguin Books, Harmondsworth, 1980, p. 344.

39 Pevsner suggests in his *Academies of Art* (pp. 88–9) that the academies were founded largely as a means of centralizing the power of the Absolutist Kings in France. While unquestionably this was a contributing factor, it cannot be concluded that a causal connection exists between a certain social order and the existence of academies determined to set out universal principles of art. One has only to look at the Bauhaus, founded in the anarchy of the Weimar Republic after the First World War, to find a diametrically opposite social system leading to the same end (Pevsner, in fact, later denies suggesting a causal connection between social life and art; *ibid.*, p. 132).

40 Colbert established a number of academies in the 1660s: in 1661, the Académie Royale de Danse; in 1663, the Académie Royale des Inscriptions et Belle Lettres; in 1666, the Académie Royale des Sciences and the Académie de France à Rome; and in 1669, the Académie Royale de Musique. See Richard Chafee, 'The Teaching of Architecture at the Ecole des Beaux-Arts', in Arthur Drexler, *The Architecture of the Ecole des Beaux-Arts*, The Museum of Modern Art, New York, 1977, p. 61.

41 Pevsner, *Academies*, p. 138.

42 *Idée de la Perfection de la Peinture*, in Pevsner, *Academies*, p. 94.

43 In Pevsner, *Academies*, p. 106.

44 Claude Perrault, *Les dix livres d'Architecture de Vitruve*, Paris, 1673, p. 12, note 13; in Wolfgang Herrmann, *The Theory of Claude Perrault*, A. Zwemmer Ltd, London, 1973, p. 32.

45 Perrault, *Ordonnance des cinq espèces de colonnes selon la méthode des anciens*, Paris, 1683, p. VIII; in Herrmann, p. 60.

46 Perrault, in the preface to *Vitruve*; in Herrmann, p. 31.

47 Herrmann, p. 62.

48 Francis Hutcheson, 'An Inquiry into the Original of our Ideas of Beauty and Virtue', in Scott Elledge, ed., *Eighteenth Century Critical Essays*, vol. I, Cornell University Press, Ithaca, 1961, p. 356.

49 David Hume, 'Of the Standard of Taste', in John Lenz, ed., *Of the Standard of Taste and Other Essays*, Indiana, Bobbs-Merrill Company, Indianapolis, 1965, p. 6.

50 *Ibid.*, p. 5.

51 *Ibid.*, p. 20.

52 Pevsner, *Academies*, p. 105.

53 Chafee, 'Teaching of Architecture', p. 63.

54 William Boyd and Edmund King, *The History of Western Education*, Adam & Charles Black, London, 1975, p. 281.

6

The Enlightenment

Revolutionary foundations of the modern world

In an intense revolutionary period from about 1750 to the early nineteenth century known as the Enlightenment, Western culture realigned many of its basic assumptions and generated new ideas that were to shape subsequent thinking well into the twentieth century. The effects in politics are familiar enough: the French and American revolutions, the overthrow of monarchies throughout Europe, and the establishment of the republican and democratic ideals. In philosophy this period realized that the dualities in Renaissance/Baroque philosophy could not be resolved within the same set of inherited assumptions about nature, mind, and the relationship between the two. The strongest reaction was to split the various components apart, and to assert for the first time relatively independent versions of theories in which world is freed from mind and mind is freed from world. In this period we will find the clearest example yet of a Positivism that makes everything including human behavior and architecture completely determined by outside influences; we will see a Romantic rebellion that champions genius, inner emotional sources of art and culturally relative responses to beauty; and we will find a Neoclassicism that confidently asserts objective, timeless principles of art that are independent of individual sensibilities.

At the same time, we will find that each autonomous strand of thought unconsciously acquired elements from the opposite points of view. Even though the Neoclassicists maintained the existence of one universally shared design language, for example, some considered that different cultures or building programs might require different styles; and while the Romantics stressed the priority of the creative individual, some accepted that artists within a given culture might be governed by a common spirit, or *Volksgeist*. Artists and philosophers

often stepped from one camp to another without recognizing the incompatibilities between the two, and they often attempted to justify one view with arguments from its opposite. This unprecedented condition, in which contradictory artistic theories took concepts from the very views to which they were opposed, has led some art historians to invent terms like 'Romantic Classicism' to explain the overlap in this period.[1]

Positivism and the new deterministic sciences of man

Inspired by Locke's Empiricism and by the achievements of Newton's Positivist science, the philosophers of the French Enlightenment disregarded Bishop Berkeley's and David Hume's undermining of the Empiricist concepts, and attempted to extend the Empirical tradition into new areas. To start, they confidently revived the earlier Baroque ideas that nature is orderly and rational, and that its underlying structure can be fully apprehended by the human mind. They did not answer David Hume's attack on these two key concepts, other than perhaps by pointing to the spectacular successes of the natural sciences in laying bare the innermost workings of the physical world. These successes encouraged them to hold an optimistic view of the future, for no longer would mankind have to rely on superstitions or mystical explanations which had proven largely ineffectual in the past; in apprehending the true structure of reality, they believed, scientists would be able to predict and therefore control future events. For them, the application of empirical science in every endeavor would encourage unlimited progress, and would perfect the world.

In particular, the French *philosophes* wished to apply the new empirical science to the study of man himself. Man is a part of nature, after all, and so judicious empirical study ought to uncover those orderly laws which govern his behavior. And just as the natural sciences can use knowledge of natural laws to predict and control future events, a knowledge of the laws underlying man should allow scientists to predict and therefore direct human behavior in the interests of improving individuals and societies. Following Newton's Positivistic method, the *philosophes* proposed to look at many instances of man's behavior and induce a general law which holds universally true for all men. Typically they found their evidence by investigating the past. For example, Charles de Sécondat (1689–1755), Baron de la Brède et de Montesquieu, undertook a comparative study of many historical cultures in his book *The Spirit of the Laws* (1748), in order to determine

the underlying principles that shape societies' systems of law and government. Every particular system of government in history, he discovered, is an imperfect embodiment of one of only three types – a republican, monarchical, or despotic rule. Which type a particular society adopts, and in what version, is determined partly by the character of the people but mostly by the climate and geography of its location. For Montesquieu, social institutions are not so much the inventions of humans as they are the products of external causes.[2]

Although Montesquieu still attributed some freedom of choice to individuals in developing their particular system of law, many of his contemporaries pressed home the deterministic implications of the Positivist view. If man is simply one more component in the natural world, they asserted, then his behavior must be subject entirely to the mechanical cause and effect which governs the natural world. In this spirit several Enlightenment philosophers proposed a more extreme form of physical determinism. According to Julien Offray de La Mettrie (1709–51) in his *Natural History of the Soul* (1745), for example, humans are determined entirely by outside physical forces, have no intrinsic animating soul, and derive all of their ideas from outer sensations. Étienne Bonnot de Condillac (1715–80) developed the epistemological basis for such an extreme view in his *Treatise on Sensations* (1754). He simplified Locke's views and effectively discounted any mental operations like judgement or reflection which might be said to originate in the mind. All mental life, he maintained, derives entirely from sensation. Although Condillac argued elsewhere for the existence of free will, his epistemology clearly implied that the individual is nothing more than the sum of what he has acquired from the outside.

From this point of view, the influence of outside forces on the development of the individual becomes paramount. According to Claude-Adrien Helvétius (1715–71), since all faculties of the mind derive from sense, and since at birth no one has yet had any sensory experiences, then everyone enters the world exactly the same. Individuals develop differently only because they have been subjected to different external conditions. Indeed, Helvétius exclaimed, if it were possible to raise two people with exactly the same experiences, they would turn out to be virtually the same. He entirely ignored the influence of heredity or of any other internal and personal factors which might provide the individual with unique characteristics.

Carlo Lodoli (1690–1761), a Franciscan monk who was not an architect himself, was the first to apply these Positivistic concepts to architecture theory. Although he never wrote down his ideas, present-

ing them only in lectures at a school for young noblemen in Venice, two of his disciples recorded and later published his work. Francesco Algarotti brought out *Saggio sopra l'architettura* in 1757, while Andrea Memmo published *Elementi di Architettura Lodoliana* in 1786, twenty-five years after Lodoli's death. According to both accounts, Lodoli proposed two fundamental guiding ideas for architects: first, 'in architecture only that shall show that has a definite function, and which derives from the strictest necessity';[3] and second, 'architecture must conform to the nature of materials'.[4] Lodoli therefore dismissed the Classical language of design on the grounds that it derived from the timber construction of early ancient Greek temples, but then was transferred unchanged into construction in stone. The principle of 'honesty to materials' must condemn such practice. For examples of architecture which derive their forms from the nature of stone, Lodoli offered Stonehenge and the monuments of ancient Egypt. He further objected to the use of any ornament which disrupts the basic form or function of the building. Mere decoration has no logical justification.

Although Lodoli's theory exerted only limited influence on architects in the eighteenth century, it is clearly the forerunner of the functionalist theories which would come to dominate the Modernist movement in the twentieth century. Lodoli never pressed his idea to the logical conclusion of his more dogmatic successors – that is, that a building ought to be entirely shaped by the functions it must fulfil – but the conceptual seeds are there. Furthermore, his emphasis on the form adapting to the function tends to play up the changing and contingent, at the expense of the Classical preference for the timeless and unchanging.

The Positivist view also influenced educational thinking in this period. Universities throughout Europe, it will be remembered, had lost any strong direction in the latter stages of the Baroque when the belief in objective knowledge had faltered. At the new university of Göttingen, founded in 1737, and by the end of the century in all German universities, the renewed belief in objective knowledge led to a new conception of higher education. They abandoned the medieval idea of consolidating and presenting a canon of established truths, and opted instead to seek new scientific truths. All faculties realigned themselves in the spirit of modern science, established the principle of academic freedom, and offered courses of lectures that systematically presented the basic principles of the field. Many of these innovations brought universities back into the mainstream of European intellectual activities, but also tied them to one particular conception of knowledge – Positivism – that would dominate to the present.

The Romantic rebellion

Where Positivism in the Enlightenment attempted to carry on many of the Renaissance/Baroque ideas, particularly about science and objective knowledge, the emerging Romantic movement in the same period attacked the entire Renaissance/Baroque program. The Romantics objected to nothing less than the Renaissance separation of man from nature. The Romantics wished to reunite man with nature, and to heal the unfortunate ruptures in all aspects of human life which they believed followed from the Renaissance dualities. To help bring man back into harmony with the natural world, the Romantics attempted to establish what man's natural state must be, the state in which he must have happily existed before succumbing to the humanists' schisms; and from this emerged new philosophical justification for the virtues of emotion over reason, the primitive over the civilized, the personal over the shared, inner genius over outer rules.

A new conception of the individual

Jean-Jacques Rousseau (1712–78) offered the most compelling and influential account of man's natural and harmonious state. Thinkers in the Renaissance and Baroque, he believed, had painted an entirely false picture of man's true nature. For them, reason is the noblest of human attributes because it most distinguishes man from other objects and animals in the world, and because through reason man discovers the underlying secrets of nature's order. The degree to which a man cultivates his powers of reason is the degree to which he fulfils his potential as a human. Rousseau reversed this emphasis. In man's *natural* state, he claimed, emotions and feelings provide reliable guides to behavior, and supply more certain knowledge of the world than can reason itself. Although Rousseau did not explain more exactly the nature or source of this inner feeling, it seems to echo the Neoplatonic idea that knowledge implanted in the mind is apprehended through an immediate, intuitive and extra-rational procedure.

With this renewed assertion of the inner life of the individual, Rousseau offered a new conception of the human personality. In contrast to the Positivists, who held that the individual is shaped by forces from without, Rousseau insisted that the individual personality grows from within, according to its own internal form. And in contrast to the Rationalists and Platonists who held that individuals are imperfect copies of an ideal human prototype, Rousseau denied the existence of such a prototype and stressed the value of individual

idiosyncracies. The belief in the uniformity of human nature, which had been so crucial to most earlier epistemological and aesthetic theories, was now seriously under attack.

Unfortunately, Rousseau complained, although man in his natural state possesses a good moral sense, has immediate access to a reliable source of knowledge and grows into his own unique personality, the rise of civilization corrupts his inner nature and so leads to all of the ills found in a modern society. Men and women cannot follow their natural urges but 'lie under a perpetual restraint',[5] and in place of their good and moral feelings emerge the 'hateful and angry passions'. Those who stand closest to nature, and who therefore have had their natural feelings and passions least corrupted by society, are the ones who stand closest to virtue. The 'noble savage' is to be preferred to the civilized Rationalist. One cannot do away with society altogether, Rousseau realized; he conceded that most people must band together for their mutual advantage. In the least harmful society, he proposed, each person willingly enters into an agreement with others who share his views and agrees to abide by that society's rules. Ideally, the personal will of the individual matches closely the general will of the society to which he has submitted himself, and so the personal freedom of the individual is not unduly constrained.

In this spirit, Rousseau introduced a new conception of education which, in the next two centuries, would provide the philosophical foundations of what has come to be known as the 'progressive' theory of education. Just before Rousseau, educational theorists had taken up the Positivism of Condillac and Helvétius which held that, since the mind is determined by what it gets from the senses, the individual is completely a product of his or her education. Any impulses originating within the child they intentionally suppressed as evil, because most educators at the time accepted the Christian notion of original sin. Rousseau argued just the opposite. The individual grows naturally from within, and tends towards the virtuous when allowed to follow his own natural path. Indeed, since education is a social institution, like all other inventions of civilization it inevitably tends to corrupt the individual's natural growth.

Conceding that men do have to live in societies, Rousseau attempted to formulate an educational system which would impose the least amount of damage on the child's innately self-propelled nature. In *Émile* (1762), his important book on education, he set out the major precept of the 'progressive' view: 'Every mind has its own form, in accordance with which it must be controlled; and the success of the pains taken [in education] depends largely on the fact that he [the stu-

dent] is controlled in this way and no other.'[6] Education in the early
years should be non-prescriptive, Rousseau insisted. Teachers should
not try to teach the students anything, but rather should merely pro-
tect them from vice and the spirit of error. Left to their own devices
the students will grow of their own accord and will learn through
play. Rousseau advocated learning by doing, arguing that essential
lessons will be gained in playing with objects, comparing and contrast-
ing material properties, and investigating the potentiality of human
action on objects in the world. 'Teach by doing whenever you can',
Rousseau advocated, 'and only fall back upon words when doing is
out of the question'.[7] Later, when the student is ready for education in
specific subjects, Rousseau suggested using what has come to be
known as the heuristic method of education: 'Put the problems before
him and let him solve them himself. Let him know nothing because
you have told him, but because he has learned it for himself. Let him
not be taught science, let him discover it.'[8]

Romantic art theory

The emotional response to objects preoccupied Romantic aestheticians
and artists. In *Essay on the Sublime and the Beautiful* (1756), Edmund
Burke drew attention to an element in nature and art which he
believed to be even more important than beauty, the sublime. The
sublime in objects excites in the viewer feelings of danger, or of pain,
or of the overwhelming power of the object over the viewer. Even
though this quality was often found in objects which many in the
Renaissance and Baroque considered downright ugly, like grotesque
human faces or nightmarish landscapes, the exciting emotional res-
ponse it elicited seemed more significant to the Romantics than merely
recognizing a correspondence between a given object and some shared
rules of beauty.

The Storm and Stress (Sturm und Drang) movement in Germany
similarly focused attention on emotional reactions to awesome or
overpowering forces. In the decades from the 1770s to the 1790s
young poets and artists like Johann Wolfgang Goethe (1749–1832)
explored the emotional, intuitive side of human nature and, using an
emotive style of writing that would have been indecorous a generation
earlier, indulged in conveying to readers strong emotions they person-
ally had experienced. Goethe, for example, on visiting the Gothic
cathedral in Strassburg, at first objected to the 'confused capricious-
ness of Gothic ornament'[9] on the grounds that it violated all of the
classical rules of taste; but then suddenly he found his 'prejudices'

falling away: 'What unexpected emotions overcame me at the sight of the cathedral, when finally I stood before it! One impression, whole and grand, filled my soul, an impression which, resulting from the harmony of a thousand separate parts, I could savor and enjoy, but neither explain nor understand. They say that such are the joys of heaven.'[10]

In stressing the viewer's emotional response to objects, the Romantics had clearly moved the centre of attention away from the properties of the objects themselves – which had been the primary focus of most post-medieval art and architecture theory – and towards the viewer's interpretation of the objects. At first this did not necessarily imply artistic relativity, in which everyone sees his or her own beauty, because it was still conceptually possible to believe that everyone would experience the same emotional response to the same objects. As Rousseau's attack on the uniformity of human nature began to sink in, however, the Romantics increasingly asserted that each individual might have a different – yet equally valid – emotional reaction to the same external object, according to that individual's unique make-up and personality.

If the *perception* of art depends upon inner emotions, the early Romantics realized, then inner emotions must play an equally important role in the *creation* of art. The Romantics in the last half of the eighteenth century conceived of the inner artistic drive as nothing less than the vital force which drives nature itself. Just as this force causes an acorn to grow into an oak or causes a tree to bear fruit, so, too, it causes the artist to create artistic works. So where the Baroque offered the analogy of a finely tuned machine, the Romantics offered the analogy of a living plant. In contrast to the Classical tradition, which had the artist construct whole compositions from a kit of basic parts already existing (the Orders of Architecture, arcades, rooms, doors, etc. for architects; hands, feet, human bodies and landscape elements for painters), the Romantics now conceived of art as a matter of organic creation, in which the entire composition grows spontaneously and as a whole.

Inevitably this idea changed their views about those qualities which ought to be admired in artistic works. In contrast to the Classical preference for the orderly and regular, the finite and complete, and the smooth textures of man-made objects, the Romantics preferred the irregular and vigorous, the incomplete and growing, the rough textures of organic nature. Color appealing to the emotions was now more important than line appealing to the intellect, and so where the Classical strain in the Baroque had admired Poussin and Raphael, the

Romantics carried on the late Baroque enthusiasm for Michelangelo, Rubens and Rembrandt.[11] The Romantics also reversed the Classical preference for the civilized and sophisticated over the primitive and naive, on the Rousseau-inspired grounds that the primitive must express more intensely man's natural state (Figure 59).

The concept of genius

The Romantics also challenged the prevailing ideas about how artistic skill is acquired. As far as the Classicists were concerned, since the ultimate source of art lies outside the individual artist, either in nature or in a shared language of design, then anyone who studies hard can acquire the requisite knowledge and skill. This assumption lay at the very heart of the academic system. But when the Romantics contrarily located the source of ideas within the inner driving soul of the artist, they began to think that this inner drive must be given at birth, and cannot be acquired through study. While one might be able to learn rules about Classical proportion, one cannot learn how to make the force of nature course through one's soul: it is either there or not. Pressing the implications of this view even further, and reinforcing Rousseau's belief in the unique character of each individual, the Romantics also insisted that some artists possess the inner vital force more completely – or are able to channel it more effectively – than others. Those who possess the inner force most completely are genius- es, a blessed condition greatly cherished by the Romantics.

Rousseau warned that constraints imposed from without corrupt the natural growth of the individual's character; in the same way, the Romantics believed that outer rules and social conventions would con- strain the natural functioning of genius. According to Goethe, 'Principles [rules] hurt genius more than examples ... Schools and principles ... paralyze our powers of insight and action.'[12] So keen were the Romantics in the last half of the eighteenth century to reject the stultifying influence of academic training, that few bothered to fol- low Rousseau in considering what alternative educational structure might support their new conceptions. Only in the nineteenth and twentieth centuries would their successors explore how special kinds of education might enhance the workings of genius.

Possession of genius, most Romantics agreed, imposes on the artist a moral responsibility to use this gift forcefully, and to follow its inner directives no matter what the consequences. Rejecting as artificial con- straint anything that stood in the path of their inner urges, the early Romantics ignored not only the rules of the academies but also the

59 Thomas Gainsborough, *Market Cart*, 1787. In the spirit of Rousseau,
the Romantics preferred the primitive and naive over the civilized and
sophisticated.

manners and refinements of polite society. Here we see the modern
conception of the artist: oblivious to social conventions, striving to
create works which express inner drives yet caring less when others
fail to understand, seeking few material rewards, and answering only
to inner necessity.

A new concept of history

Parallel with these Romantic conceptions of man, nature and society
there developed a new conception of history which transformed subse-
quent theories of art and knowledge. Since antiquity, individual events
in the history of man and the universe were believed to follow a ratio-
nal, overall pattern. The Greeks elaborated a theory of recurring
cycles, for example, while the Christians proposed a theory of progres-
sive development towards a final goal. None of these patterns attribut-
ed to individuals much control over the pattern's general direction,
and so those who wrote histories of this kind concerned themselves
more with the grand logic and major events and personalities in each
age than they did with the local and ordinary events of everyday life.

The secularizing and humanizing spirit of the Enlightenment could
not tolerate this conception of history. Divine explanations of any-
thing were dismissed, of course, while the desire to establish sciences
of man and the emerging belief in the unique character of each indivi-
dual encouraged Enlightenment historians to seek their historical con-
ceptions in human behavior itself. In their histories, Giambattista Vico
(1688–1744) and Voltaire both drew close attention to the specific
details of customs, laws, literature and art in each age and, in so
doing, fleshed out the contribution made by individuals to the overall
pattern of history. For them, history results from the interplay of
human wills and passions.[13]

The more historians attacked the notion of history as a logically
unfolding grand plan, and the more they focused attention on the
local and idiosyncratic events in a given age, the more they questioned
the long-standing belief in the continuity and unity of history. Since
the Renaissance, the history of the West had been seen as a contin-
uous and ever improving development of the one true and proper cul-
ture inherited from ancient Greece and Rome. The Middle Ages, in
this view, was an unfortunate and barbaric interruption in Western
culture's true development. But in the Enlightenment, history came to
be seen as a series of separate compartments – the ancient world, the
Middle Ages, the Renaissance, and now the modern world – each
with its own intrinsic character and set of values. While Voltaire still

valued the most recent ages over the older ones on the grounds that they had achieved higher levels of sophistication, Vico proposed an influential new conception of history which held that each age has equal merit. Since each age reveals an interesting and equally valid aspect of human development, he reasoned, there are no grounds for any particular age to despise a past age as primitive or irrational.

Johann Gottfried Herder (1744–1803) used this new attitude to rethink the long-standing problem of artistic judgement. Classical theory had long proposed the existence of a universal faculty by which every mind judges whether a work possesses the absolute and timeless qualities of beauty; but from Herder's new historical perspective this notion was a nonsense. Just as each individual culture has its own particular religion, social organization and economic system, it also has its own particular form of art. Indeed, the art of a culture express-es that culture's unique underlying values. The history of cultures dis-plays a variety of artistic expressions so diverse that one cannot possibly say they are simply variations on the same underlying themes, nor can one argue that one culture's art is necessarily better than another's. Each culture has its own independent aesthetic ideals. Judgements about the quality of a work of art must be made relative to the standards of the culture that created it, not relative to an abso-lute standard of taste. Herder proposed in his *Critical Forests* (1769) to study various cultures in order to discover the psychological, physiological and environmental factors that determine each culture's sense of artistic beauty.

Although Herder had gone a long way towards asserting relativity of taste, he did not conclude that every individual is an autonomous unit as far as taste is concerned. For him, the basic unit of aesthetic taste is more at the level of the shared culture in any given age and place, because most individuals within such a grouping tend to value the same artistic ideals. Herder explained this tendency by referring to a *Volksgeist*, or shared spirit, that shapes the artistic expressions of individuals within that culture. The German Idealists in the next cen-tury elaborated this idea into the now more familiar theory of the 'Spirit of the Age'.

An important concept in architecture and art which logically fol-lowed from this new view of history was the idea of 'style'. As long as post-medieval Classical architects believed in only one timeless lan-guage of architecture, handed down to them from antiquity and founded on the objective principles of nature, there could be no idea of style, of different but equally valid design approaches. Either an architect understood the true language and designed correctly, or not.

With the advent of separate compartments in history, however, each with its own particular means of artistic expression, artists and architects became aware of other equally valid approaches besides their own. The word 'style', which signifies the particular aesthetic manner or values of any given culture or period, came increasingly into use and was firmly established by the mid-eighteenth century.[14]

As Sir John Summerson pointed out, three concepts can and did follow from this compartmental view of different styles in different places and times: the archaeological, the eclectic and the modernist. 'First, the concept of art through archaeology, this is, of the enrichment of the present by persistent inquiry into the nature of the past (as opposed to the acceptance of a traditional theory of antiquity). Second, a wider concept of eclecticism, of the power to choose between styles or to combine elements from different styles. Third, by analogy, the concept of a modern style, a style uniquely characteristic of the present.'[15] Interestingly, Summerson labels both the archaeological and the modern as romantic, because where the first betrays an irrational quest for a golden age past, the second equally betrays an irrational idealization of the future. Only the eclectic, he maintains, refuses to romanticize the past or future, and attempts instead to address the values of the present.

While the eclectic and the modernist concepts became more popular in the nineteenth century, the idea of archaeology dominated in the last half of the eighteenth. The Positivists, we have already seen, looked back to a range of previous cultures in order to discover the determinants which shaped them; the Classicists, we will see presently, undertook serious investigations of ancient Greek and Roman buildings; and the Romantics, we will see now, turned their attention to the Middle Ages.

Renewed interest in the medieval

Several factors contributed to the Romantic appreciation of the medieval period, after the centuries of scorn. First of all, the latter half of the eighteenth century saw a revival of the same religious mysticism which had dominated the Middle Ages, and which had periodically resurfaced in periods like the Age of Mannerism whenever the objective, rationalizing tendency faltered. This obviously helped clear away the humanist objections to the religious basis of the Middle Ages. And secondly, the Middle Ages represented to the Romantic mind a time when man was part of an organic whole, free from the fragmentation and alienation of the Renaissance and Baroque. In the construction of

the Gothic cathedrals, for example, the Romantics saw individual craftsmen willingly submitting themselves to the requirements of the larger project and becoming part of an organic social order. No one individual predominated over another, they thought, yet each was able to leave his imprint on the overall project. The attractions to the Romantics of the medieval themes, values and institutions echoed Rousseau's belief that if some kind of society is necessary, then one must be found that is least destructive to the natural human spirit and most supportive of man's attempts to reunite himself with the larger natural order.

The renewed interest in medievalism led to a revival of Gothic forms and decorative motifs, at first particularly in England. Although seventeenth-century architects – including Classicists like Wren and Hawksmoor – had on occasion employed the Gothic style when circumstances demanded it, from the early eighteenth century onwards architects as diverse as Vanbrugh, William Kent (1685–1748) and Batty Langley (1696–1751), and amateurs like Horace Walpole (1717–97) began to exploit more fully the romantic associations of the Gothic style, often taking considerable liberties with the original forms and decorative motifs (Figure 60). Only in the next century would a more serious Gothic Revival insist on historical accuracy.

By now it should be clear that the Romantic philosophy suffered from a serious paradox. At one moment, it attacked the Renaissance separation of the individual from nature and the individual from his cultural context, it wished to heal the ruptures which followed from elevating humans to a superior position, and it attempted to bring individuals back into harmony with their natural and social context; but the very next moment it offered a cult of creative genius more extreme than anything previously considered in the West, and gave the individual complete priority over nature and society. In terms of the design skill itself, the organic analogy implies that the artist is simply a medium through which the force of nature creates works of art, suggesting that the artist has no real control over this process and so takes no pride in his or her accomplishments; but the cult of creative genius contrarily stresses an active, originally creative nature which belongs \to the individual and over which that individual maintains command. Despite setting out to resolve the subject–object problem, in other words, the Romantic rebellion at the end of the eighteenth century offered a new version with greater extremes.

60 Gloucester Cathedral choir screen, Gloucester, England, 1742. William
Kent. A renewed interest in medievalism led to a revival of Gothic forms,
although at first they were not historically accurate.

Neoclassicism and the academies

Neoclassical art theory

The collapse of the Renaissance/Baroque system and the ensuing
frivolities of the Rococo engendered yet a third response, a self-con-
scious and almost moralistic revival of the Classical tradition. Repel-
led by the Rococo's subjectivity and sentimentality, the Neoclassical
writers and artists in the last half of the eighteenth century wished to
purge art of its excessive emotion, to free it from its reliance on the
subjective impressions of the individual and to find some objective
foundation for art that would give it once again a universal status.

Like their Renaissance predecessors in this endeavor, they intended

to find the objective principles of art in Nature itself. Yet like the Classicists before them, they did not intend art simply to copy nature's superficial appearance. As Sir Joshua Reynolds put it, a 'mere copier of nature can never produce anything great'.[16] Rather, they intended to revive the old concept of artistic Idealism, in which art copies the underlying archetypes from which all sensory objects imperfectly derive. So once again Classical art theory had to explain how the artist can discover those ideals behind sensory appearance.

The Neoclassicists revived the three traditional answers to this problem – normative idealism, metaphysical idealism and the reliance on Classical forms – and showed no more awareness of the philosophical inconsistencies in these three theories than their predecessors. All three views can be found juxtaposed indiscriminately throughout the literature of the entire movement and within the writings of the same author. Since the Neoclassicists made no significant changes to these inherited notions, to show the continuity of the ideas we need only quote from a few of the most influential writers without having to comment on the nature or origin of their ideas.

The concept of normative idealism shows most clearly in Sir Joshua Reynolds's *Discourses on Art*, a series of lectures given to the English Royal Academy from 1769 to 1790. Discussing the source of ideal artistic form, he claimed: 'it is from a reiterated experience and a close comparison of the objects of nature that an artist becomes possessed of the idea of that central form, if I may so express it, from which every deviation is a deformity'.[17] Johann Joachim Winckelmann also expounded this view in his early pamphlet *Thoughts on the Imitation of Greek Works in Painting and Sculpture* (1755). There are two ways to imitate beauty, he claimed; either by drawing from one beauty or by composing an ideal beauty out of the observations of many beauties. The former he disparaged as mere 'copying, drawing a portrait; 'tis the straight way to Dutch forms and figures; whereas the other leads to general beauty, and its ideal images, and is the way the Greeks took'.[18]

Almost in the same breath, these theorists then slipped into metaphysical idealism. In Reynolds's *Discourses*, for example, he claimed that the object of art is to express beauty: 'but the beauty of which we are in quest is general and intellectual; it is an idea that subsists only in the mind; the sight never beheld it, nor has the hand expressed it: it is an idea residing in the breast of the artist, which he is always labouring to impart, and which he dies at last without imparting'.[19] So where before the artist was supposed to find the ideals in reiterated experiences of sensory appearance, now he is supposed to find them

within himself in advance of sense. Similar confusion shows in Winckelmann. After making a distinction in an essay between sensual beauty which is recognized by the senses and intellectual beauty which is recognized by reason, Winckelmann argued the virtues of the latter over the former. Unfortunately, he continued, while the artist ought to aspire after the latter, a bad climate or mistaken intentions often leaves the artist content with the inferior beauties he finds in his 'crude impressions'. By disparaging sensory impressions and by linking the more perfect beauty with reason and the intellect, he gave the mind some knowledge of perfect beauty which is antecedent to sense experience.

Similar expressions of normative idealism and metaphysical idealism can be found sprinkled throughout the writings of all the Neoclassicists. However, these were only theoretical explanations of the source of ideal artistic form; in actual practice, the Neoclassicists all agreed, the source of form is to be found in the works of the ancients. As Reynolds put it, generalizing universal ideals from particular sensory objects is 'painful, and I know but of one method of shortening the road; this is, by a careful study of the works of ancient sculptors; who, being indefatigable in the school of nature, have left models of that perfect form behind them, which an artist would prefer as supremely beautiful'.[20]

The Neoclassicists did not expect artists to copy the works of the ancients mindlessly, for that, they realized, would lead to lifeless artistic images. Instead, they hoped the artists would imitate the Classical forms with a trained and sensitive eye, always questioning the reasons behind the form's particular configurations. This distinction between mere copying and knowledgeable imitation – already proposed by Alberti – saved the Neoclassicists from becoming purely archaeologists, but it also confronted them once again with the old circular argument: the artist is supposed to examine the ancient works in order to understand the underlying principles of art, but he must already know the principles in order to see the virtues of the objects before him.

The Neoclassicists disagreed entirely with the Romantic concept of art as personal expression. Winckelmann, for example, pointed out with admiration that the ancients purified their images of personal feelings, because feelings divert the mind from the truly beautiful. Art is the discovery of something external to the artist, not the expression of something from within. The Romantic concept of genius, on the other hand, made rather deeper inroads. According to Reynolds, good art does seem to be created by 'inspiration; a gift from heaven'.[21] But

genius is not a 'kind of magick … out of the reach of rules of art'; nor
is it 'a power which no precepts can teach, and which no industry can
acquire'.[22] Like everything else in nature, he explained, genius must
have some cause and therefore must be controlled by some rational
principles. The nature of genius might be such that the underlying
rules are not immediately obvious, but none the less the rules are
there. So although Reynolds grudgingly conceded the existence of
genius, he stripped away those qualities which the Romantics had
most admired – God-given, special to the artist and possessed by only
a few, and beyond rational explanation – and left genius as little more
than objective, rational guidelines naturally existing within everyone.
The paintings of Jacques Louis David (1748–1825) express most force-
fully the return of art to Classical principles, with grand themes,
sharply focused light and precise shadows, solid figures standing paral-
lel to the picture plane. (Figure 61)

Architecture theory

The Neoclassical architects also reacted against what they considered
to be the capricious, arbitrary and subjective Rococo, and insisted on
returning architecture to objective foundations. Like the artists, they
fell into confusion about the nature of these foundations and about
how they might be apprehended. The contradictions show clearly in
Étienne-Louis Boullée (1728–99), one of the leading proponents of the
Neoclassical view. In his essay 'Architecture, Essay on Art' he posed
the question, 'is architecture merely fantastic art belonging to the
realm of pure invention or are its basic principles derived from
Nature?'[23] Claude Perrault, Boullée claimed, asserted the former and
'denied that architecture had its source in nature: he called it fantastic
art that was pure invention'.[24] For this view Perrault's buildings must
be censured: 'You admire [Perrault's work] but the architect himself
has admitted that it is based on pure fantasy and owes nothing what-
soever to nature. Your admiration is therefore the result of a particu-
lar point of view and you should not be surprised to hear it criticized,
for the so-called beauty that you find in it has no connexion with
nature, which is the source of all true beauty.'[25] Boullée cited the views
of modern philosophy as proof of the connection between nature and
principles of beauty. 'All our ideas, all our perceptions come to us via
external objects.'[26] The architect must discover the laws in nature and
then make them tangible in buildings, avoiding at all costs the person-
al and capricious fantasies in his mind.

In other parts of his essay, however, Boullée contrarily suggested

61 Jacques Louis David, *The Death of Marat*, 1793. David's work expresses a forceful return to Classical and rational principles, with grand themes and sharply focused light.

62 Etienne-Louis Boullée, *Project for a Memorial to Isaac Newton*, 1784.
This work carries to the extreme the architectural possibilities of rational
and intellectually pure constructs like spheres.

that the source of an architectural idea will be found within the archi-
tect's imagination. For example, he attacked Vitruvius' definition of
architecture as the art of construction, because it confuses the effect
for the cause:

> In order to execute, it is first necessary to conceive. Our earliest ances-
> tors built their huts only when they had a picture of them in their
> minds. It is this product of the mind, this process of creation, that con-
> stitutes architecture and which can consequently be defined as the art of
> designing ... Thus the art of construction is merely an auxiliary art
> which, in our opinion, could appropriately be called the scientific side
> of architecture.[27]

These essential 'pictures in the mind' are for Boullée the Platonic
solids beloved of Rationalist architects throughout history.[28] His own
work carries to an extreme the architectural possibilities of pure
spheres, cubes and triangles, all intellectually pure constructs derived
more from human reason than from the sensory appearance of nature
(Figure 62). Indeed, so preoccupied was Boullée with these inner
visions of architectural form that he complained about the practical
problems of building inhibiting his purely theoretical studies. Although
an architect's 'genius must be able to spread its wings freely', when he
undertakes practical work for a client he 'must not listen to the voice

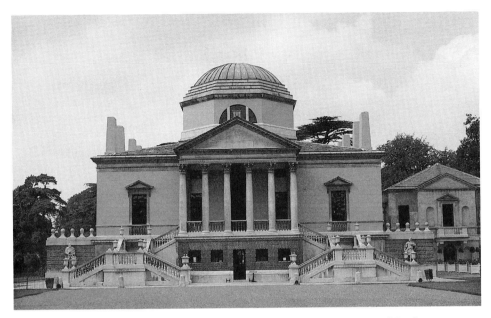

63 Chiswick House, Chiswick, England, begun 1725. Lord Burlington.
Burlington and others revived the architecture of Palladio.

of his genius but descend to the level of those he must please'.[29]

Like most of the artists, the Neo-Classical architects accepted that a careful study of ancient work provides the surest route to understanding the timeless principles of nature. In the eighteenth century, however, it became less clear which ancient works ought to be studied. Some, like Piranesi, continued to argue for the superior quality of Roman forms, while others, like Winckelmann, championed the Greeks. In England early in the eighteenth century, Colin Campbell (d. 1729), Lord Burlington (1694–1753), and William Kent (1685-1748) revived the classicism of Palladio (Figure 63). Yet others who still professed belief in rational principles even argued the merits of the Gothic. Amédée-François Frézier (1682–1773) for example, described the Gothic as a precisely calculated structural system whose principles, once apprehended, could be infused into modern buildings. Michel de Frémin also considered the Gothic to be more rationally designed than the Classical and therefore a more appropriate choice for study. With the new conception of history as a series of equally valuable compartments it had become difficult to defend the work of any given culture as the only true expression of timeless principles of form.

Perhaps to avoid this problem, the Abbé Marc-Antoine Laugier (1713–69) proposed looking back to the beginning of civilization itself for the ultimate source of architectural form. He conjectured the first

ever building as a primitive hut standing in the clearing of a forest, comprised only of four tree-columns and a simple gable-end roof of branches (Figure 64). Vitruvius, of course, had also traced the origins of architecture from primitive beginnings, but Laugier proclaimed this primitive hut as a general archetype upon which all subsequent architecture should be based. Architecture which comes closest to this pure and rational structure of columns, beams and gable-ends is architecture which comes closest to the true principles of nature.

Despite the Neoclassical preoccupation with timeless principles, some of its adherents suggested that different settings might require different versions of the timeless language. Jacques-François Blondel, for example, the professor of architecture at the Académie Royale, whose appointment to the chair in 1760 finally broke the chain of undistinguished professors throughout the first half of the eighteenth century, was less dogmatic about the absolute validity of architectural forms than his distant relative François Blondel had been a century earlier. Buildings should certainly be designed according to rational principles, he agreed with all Classicists, and these principles are to be found in objective nature. He even complained about the wide variety of schemes submitted for the completion of the Louvre, because if every architect had designed according to rational principles there would be little variation. However, he continued, *different* building projects present different building problems, the special nature of which ought to be expressed in the building form. Gay, pompous or elegant activities demand gay, pompous or elegant buildings. Blondel still expected that these various expressions would be phrased in the language of Classicism, so in this sense the timeless principles still shape the building form as much as the idiosyncratic functional requirements of individual building problems; Blondel was no Positivist. Yet clearly he made one of the first attempts to temper the universalizing demands of Classicism with the particularizing demands of Positivism.

The revived academies

Previous chapters have shown a relationship between the fortunes of the art academies and the degree to which theorists believed in the Rationalist and Classical concept of objective sources of form. The first suggestions of an academic form of education emerged in the Renaissance, when the theorists were setting out the objective laws or 'science' of design; the academies were founded in the age of Mannerism, when the belief in design as an objective, rule-based

64 Frontispiece to Laugier's *Essai sur l'Architecture*, 1753. This shows an imaginary primitive hut as the original source of all architectural principles.

activity strengthened; they were firmly institutionalized in the Baroque
when the preoccupation with rule and rational order reached its
height; and then in the Rococo phase of the Baroque, when the sub-
jective tendency overtook the objective one in the minds of the artists,
the academies lost their vigor.

Given such a trend, one would expect the Neoclassicists' renewed
belief in objective sources of art to be accompanied by a strong revival
of the academic system; and indeed it was. The sheer number of aca-
demies in Europe jumped from twenty-five in 1740 (of which only ten
or so were proper academies) to well over one hundred in 1790.[30] The
major cities of Europe, including London, Stockholm, St Petersburg,
Berlin, Vienna, Madrid and Rome, all boasted art academies that
trained the artistic elite. During this period several colonies of the
European countries also established academic systems of education,
including Mexico (Real Academia de S. Carlos de Nueva España,
1785), and the United States followed suit (Academy of Fine Arts in
Philadelphia, 1805).

After half a century of indirection caused by a succession of undis-
tinguished professors and directors, the important artists and theorists
of the age once again took over the academic chairs and turned the
academies to some philosophical purpose. One has only to list some
of the professors and directors of the main European academies in the
last half of the eighteenth century in order to see the renewed status
of the academic system: Jacques-François Blondel appointed to the
chair of architecture at the Académie Royale d'Architecture, Sir
Joshua Reynolds elected President of the Royal Academy in London,
Winckelmann made an honorary member of the Roman Academy and
of the Dresden Academy, and J.-N.-L. Durand made professor at the
new École Polytechnique in Paris.

In teaching methods, these renewed academies differed little from
their predecessors in the Baroque. Students still worked as apprentices
in the workshops of their masters and attended the academy in order
to learn the general principles behind practice. In the academy they
acquired the principles of art or architecture by studying and copying
the works of great masters under the supervision of the professors and
by attending lectures on general matters, including perspective,
descriptive geometry and history. The dualistic educational system of
the Baroque – which taught supposedly universal principles of art or
architecture in the academy side by side with the personal ideas of a
master in the apprenticeship workshop – continued unchanged
throughout this period. Only in the next century would the influential
École des Beaux-Arts in Paris alter this traditional arrangement.

Immanuel Kant and the synthesis of subject and object

The Romantic movement, it was mentioned earlier, wished to recon-
cile the dualities it had inherited from the Baroque between man and
nature and between mind and world. For many Romantics this
remained little more than a spiritual statement of unfulfilled intention,
but in the work of Immanuel Kant (1724–1804) this general desire was
transformed into a carefully reasoned reconciliation of subject and
object so ingenious that it redirected most of subsequent philosophy.
In one sense Kant was the last of the great Baroque philosophers, con-
sciously struggling with the dualities of that age and placing all his
faith in the powers of his own reason to resolve them; but in another
sense he was the fountainhead of later German Idealism and
Romanticism, showing the limits of reason and demonstrating the
inevitable role of the subjective and intuitive mind in the apprehension
of knowledge.

The Copernican Revolution in philosophy

In the *Critique of Pure Reason* (1781), the first book of his trilogy,
Kant attempted to reconcile the conflict between Rationalism and
Empiricism. Each side of the Baroque debate offered part of the expla-
nation of knowledge, he pointed out, but each alone was incomplete.
On the one side, where the Empiricists stressed the importance of
sense impressions, they failed to realize that experience alone is not
sufficient for understanding. For example, one may hear a quick
sequence of four clanging sounds originating in the sensory world, but
only when one understands the concept 'clock striking four' will the
sounds have meaning. Concepts are necessary in order for the percep-
tions to make sense, yet the Empiricists treated concepts as if they
were fictions or mere words. On the other side, while the Rationalists
emphasized the rational, conceptual basis of knowledge, they failed to
realize that a concept without any experiential basis says little about
reality. If a scientist claims the existence of a new physical element but
has no way of demonstrating its existence empirically, his claim does
not offer useful knowledge about the world. So Kant made a clear dis-
tinction between intuitions, the immediate impressions of sense, and
understanding, the mind's ability to think in concepts, and then insist-
ed:

> To neither of these powers may a preference be given over the other.
> Without sensibility no object would be given to us, without understand-

ing no object would be thought. Thoughts without content are empty, intuitions without concepts are blind. It is, therefore, just as necessary to make our concepts sensible, that is, to add the object to them in intuition, as to make our intuitions intelligible, that is, to bring them under concepts. These two powers or capacities cannot exchange their functions. The understanding can intuit nothing, the sense can think nothing. Only through their union can knowledge arise.[31]

Baroque philosophy had confused these two functions, Kant suggested, because 'hitherto it has been assumed that all our knowledge must conform to objects'.[32] That is, his predecessors had assumed that the knowledge we possess about the world ultimately derives from objects which exist independently of ourselves. Whether philosophers believed that this knowledge enters our minds through the senses or is implanted there at birth, none of them seriously considered that the mind might have *created* its knowledge of the outside world.

When scientists find themselves holding a troublesome hypothesis, Kant knew from his study of the natural sciences, they sometimes trade it for another which they hope will resolve the problems. He quoted the example of Copernicus, who switched from a geocentric to a heliocentric hypothesis of planetary motion. Inspired by the considerable advantages which accrued to astronomy in this reversal, Kant proposed his own 'Copernican Revolution' in metaphysics. Rejecting the old hypothesis that all our knowledge conforms to objects, he proposed instead to 'make trial whether we may not have more success in the task of metaphysics, if we suppose that objects must conform to our knowledge'.[33]

Kant accordingly developed a theory of knowledge in which the mind actively helps construct its own knowledge of the outside world. To use a rough analogy, Kant conceived of the mind as an active processing machine, and of the sense impressions gained from the outer world as the raw material to be processed. In the first stage of this 'processing' of knowledge, in what Kant termed the 'Transcendental Aesthetic', the structure of the mind imposes on to the incoming flux of sensory impressions the basic concepts of Space and Time. According to the Empiricists, space is merely a concept derived from the experience of outer objects (i.e., some external objects are perceived to be further away, some closer, some on top of others, some below); but as Kant pointed out, the experience of 'outer' objects already implies a spatial relation, and thus the concept of space must exist in the mind before the experience. Using a similar argument, Kant explained how concepts of Time must also exist antecedently to experience in order to structure experiences of one event following

another. For Kant, then, the ideas of Space and Time are 'aesthetic' in the sense that they are immediate, sensuous and not reasoned; and they are 'transcendental' in the sense that they are not derived *from* experience but rather are necessary preconditions *for* experience. Kant, incidentally, assumed that the innate sense of space is based on Euclidean geometry, and that the sense of time is absolute, not relative.

In the second stage of processing knowledge, in what Kant termed the 'Transcendental Analytic', the mind transforms the incoming perceptions (which have already been filtered through the concepts of Space and Time) into logical conceptions. In this stage the mind 'pigeon-holes' the sensory data into a number of pre-established categories of thought, including unity, negation, cause and effect.[34] These categories provide the innate *forms* that organize the varying *contents* of experience. For example, empirical experience may provide impressions of 'crowness' and 'blackness', but the mind provides the generic relation 'All – are – ' that allows the mind to think 'All crows are black'. Empirical data may provide evidence of 'fire' and 'heat', but the mind provides the generic relationship ' – causes – ' that allows of the concept 'fire causes heat'. This latter category is especially significant, for it answers David Hume's attack on causality, the basis of all science. According to Hume, cause-and-effect relations cannot be found in empirical evidence, and must therefore be figments of the subjective imagination. That relationships between causes and effects are inventions of the mind, Kant readily accepted; but since the concept of cause and effect is an innate and universal category with which all human minds organize their experiences, all minds will conceive of the same causal relationships when faced with the same raw data from the outside world.

Since the mind's innate processing facility is a necessary precondition for reasoning and for making sense of the incoming sense impressions, it is quite impossible for the human mind to stand outside itself and to see the world-as-it-really-is, to see impressions before they are filtered and pigeon-holed. The mind's own internal structure marks a limit beyond which it cannot claim to have scientifically valid knowledge about reality. Strictly speaking the mind cannot even be sure that the perceptions and conceptions it senses within itself are caused by something 'out there'. Most minds are not content with this partial apprehension of reality, Kant appreciated, and so he suggested a third stage of thinking – the 'Transcendental Dialectic' – in which the mind attempts to step beyond its filtered sense experience in order to discern the ultimate reality. The mind in this stage examines its various per-

ceptions and conceptions and then rationally attempts to reconstruct the kind of outside world which might have induced them. The mind convinces itself that the perceptions it receives in the *phenomenal* world are really caused by an objective world of things-in-themselves, what Kant called a *noumenal* world. It also convinces itself of the existence of God and of souls. The mind believes all three of these rational constructions exist, but since they are outside the bounds of the mind's ability to perceive them, it must remain forever agnostic about their actual existence.

Art as a mode of cognition

Although Kant firmly cut off any access to ultimate reality through purely rational or sensory channels, in his later books he supplied some limited access through a third channel of aesthetic feeling. He gave philosophical justification to the idea – previously only suggested by various writers – that feelings and art can pierce to the heart of reality and reveal truths otherwise inaccessible. In this he provided the conceptual foundations for much subsequent Romantic art theory, although he would have resisted the extremes to which his theories were later put.

In the *Critique of Pure Reason*, it has just been seen, Kant discussed the mind's relationship to the world of necessity, to the world of deterministic science. In the second book of his trilogy, the *Critique of Practical Reason* (1788), he discussed the opposite side of the duality, the mind's relationship to the world of freedom. In order to give any reality to moral life, he argued, one must assume that the individual's will to do things must be free from physical causality. Otherwise the individual would have no choices and could not be held morally responsible for his or her actions. Kant had already argued in his first 'Critique' that the phenomenal world of science is subject to causality and thus it could not be a suitable realm for the will; but there is no reason to assume that the noumenal realm is also subject to causality, particularly since in Kant's theory causality is something given by the mind to the phenomenal world, and thus is not a property of the ultimate reality at all. So without damaging the integrity of either the causal world or the free will, one could reasonably assume that the will resides in the noumenal realm. And just as the mind's cognitive faculty of *understanding* organizes the incoming flux of sensory impressions in the phenomenal world, Kant suggested that a cognitive faculty of *pure reason* directs and organizes the will's desires and actions in the noumenal realm.

In the final book of his trilogy, *The Critique of Judgement* (1790), Kant attempted to bridge the gap between these two realms by looking for some faculty of the mind which 'makes possible the transition from the mode of thought according to the principles of the one to that according to the principles of the other'.[35] There is a faculty of the mind, Kant suggested, which does seem to stand half-way between cognition on the one extreme and desire or will on the other; that is, the faculty for feeling pleasure or displeasure. Between the act of recognizing an object and then desiring that object stands an act of feeling pleasure for the object. And just as cognition is organized by the understanding and desire is organized by pure reason, feeling is organized by the power of *judgement*. For in feeling pleasure or displeasure upon viewing an object, one is judging its ability to evoke certain emotions. So aesthetic judgements, Kant proposed, might well bridge the gap between the two worlds.

According to Kant, the special character of an aesthetic experience reveals itself in the curious paradox that it is simultaneously both objective and subjective. It is objective in the sense that whenever someone judges an object to be beautiful, implicitly he or she is claiming it must be beautiful for anyone viewing it. This is unlike judging mere pleasantness, in which one easily admits other equally valid opinions (Kant noted that a 'smell which one man enjoys gives another a headache').[36] Yet despite this belief in the objectivity of aesthetic judgements, they are clearly subjective. That is, when one reports on the beauty of an object, one is saying less about a quality in the object itself than about one's feelings towards the object. In an aesthetic experience, Kant suggested, a beautiful object arouses the mind's faculties to a more intense and harmonious activity than is possible upon viewing ordinary objects, and as a consequence creates a feeling of pleasure. In a certain sense, the mind is free-wheeling, not seriously directed towards attaining rational knowledge of the outside world, and so is able to enjoy the harmony between itself and its object without being overly concerned with particular sense impressions or particular concepts. In fact, if the mind does try to subsume the aesthetic experience under a rational concept, it disturbs the aesthetic quality of the experience and transforms it into a mere rational judgement. In looking at the object extra-rationally, in other words, the mind gains special knowledge about the object which cannot be explained rationally but which is felt intuitively just the same. And since all minds are the same in Kant's theory, all minds will experience the same feelings upon seeing the same beautiful object, and thus will concede the universality of the experience.

Kant made a similar point from the other side, by explaining meta-physically how artistic genius creates aesthetic objects. Genius is a curious phenomenon, according to Kant, for although the genius may express ideas through physical techniques, the special character of the work seems to be spiritual. That is, there is a certain magic in the work of genius which cannot be rationally measured or physically explained, yet which clearly sets the work apart from that of a mere craftsman. Furthermore, although the artistic genius seems on first impression to copy nature, on closer inspection he would appear to be recording a more ideal nature not seen anywhere in phenomenal appearance. And finally, even though the artist seems to be creating his own work, very often he is not fully aware of what he is doing until he has completed the final product. According to Kant, these var-ious characteristics of genius can only be explained in terms of some extra- or supra-personal force acting through the artist, giving him ideas while at the same time partially directing his actions. In Kant's philosophy such spiritual or non-physical forces are to be found only in the noumenal realm, from which it follows that the genius must be discovering ideas in the noumenal realm of things-in-themselves and then expressing them concretely in the phenomenal realm of appear-ance. The artist of genius effectively sees the ultimate reality which is barred to the scientists, and then reveals it through his or her art to lesser mortals.

By linking this extra-sensory and extra-rational faculty of the mind to the noumenal realm of things-in-themselves, Kant believed he had found the faculty which 'makes possible the transition from the realm of natural concept to that of the concept of freedom'.[37] He was cer-tainly the first in the history of the West to recognize explicitly the subject–object problem and the confusion which it causes, and he offered an intriguing solution. This is not to say that his theory was free from problems. As will be seen, his successors objected to his concept of the noumenal realm, and later developments in physics and geometry revealed viable alternatives to the absolute Time and the Euclidean geometry that he claimed were wired into the human mind. But these shortcomings did not invalidate his intentions or the means by which he attempted to resolve the dualities. His theory provided the conceptual basis for most subsequent attempts at resolving the same problems.

Notes

1 Sigfried Giedion, *Spätbarocker und romantischer Klassizismus*, Munich, 1922; and discussed in Henry Russell Hitchcock, *Architecture: Nineteenth and Twentieth Centuries*, Penguin Books, Ltd, Harmondsworth, 1978, p. 13.

2 Collingwood, *Idea of History*, pp. 78–9.

3 Algarotti, *Saggio*, p. 62; in Emil Kaufmann, *Architecture in the Age of Reason: Baroque and Post Baroque in England, Italy, France*, Dover Publications, New York, 1968, p. 96.

4 Algarotti, *Saggio*, p. 65; in Kaufmann, *Age of Reason*, p. 97.

5 Jean-Jacques Rousseau, *A Discourse on the Arts and Sciences*, in *The Social Contract and Discourses*, trans. G. D. H. Cole, J. M. Dent & Sons Ltd, London, 1973, p. 6.

6 Jean-Jacques Rousseau, *Émile*, trans. Barbara Foxley, J. M. Dent & Sons Ltd, London, 1974, p. 58.

7 *Ibid.*, p. 144.

8 *Ibid.*, p. 131.

9 Goethe, 'On German Architecture – D. M. Errini a Steinbach', 1773, in Lorenz Eitner, *Neoclassicism and Romanticism 1750-1850* (vol. 1 of the Sources and Documents/History of Art Series, ed. H. W. Janson), Prentice-Hall International, Inc., London, 1971, p. 75.

10 *Ibid.*, p. 76.

11 Frederick Hartt, *Art: A History of Painting, Sculpture, Architecture*, vol. II, Prentice-Hall, Inc., Englewood Cliffs, NJ, 1976, p. 315.

12 Goethe, 'On German Architecture', in Eitner, *Neoclassicism*, p. 75.

13 Copleston, *History*, vol. 6, part 1, pp. 193–4.

14 Georg Germann, *Gothic Revival in Europe and Britain: Sources, Influences and Ideas*, trans. Gerald Onn, Lund Humphries with the Architectural Association, London, 1972, p. 181.

15 John Summerson, *Architecture in Britain 1530-1830*, Penguin Books Ltd, Harmondsworth, 1979, p. 407.

16 Sir Joshua Reynolds, *Discourses on Art*, ed. Robert Wark, Yale University Press, New Haven and London, 1975, p. 41.

17 Reynolds, *Discourses*, p. 45.

18 Johann Joachim Winckelmann, *Thoughts on the Imitation of Greek Works in Painting and Sculpture*, in Lorenz Eitner, *Neoclassicism*, vol I, p. 11.

19 Reynolds, *Discourses*, p. 171.

20 *Ibid.*, p. 45.

21 *Ibid.*, p. 42.

22 *Ibid.*, pp. 94, 96.

23 Étienne-Louis Boullée, 'Architecture, Essay on Art', trans. Sheila de Vallée, in Helen Rosenau, *Boullée and Visionary Architecture*, Academy Editions, London, 1976, p. 85.

24 *Ibid.*, p. 83.

25 *Ibid.*

26 *Ibid.*, p. 86.

27 *Ibid.*, p. 83.

28 Not Plato's original solids, but the cube, sphere, cylinder, cone and pyramid.

29 Boullée, 'Architecture', p. 84.

30 Pevsner, *Academies*, p. 141.

31 Immanuel Kant, *The Critique of Pure Reason*, trans. Norman Kemp Smith, The Macmillan Press Ltd, London, 1933, p. 93.

32 *Ibid.*, p. 22.

33 *Ibid.*

34 Kant, *Critique of Pure Reason*, p. 113.

35 Immanuel Kant, *Critique of Judgement*, trans. J. H. Bernard, Hafner Press, New York, 1951, p. 12.

36 *Ibid.*, p. 123.

37 *Ibid.*, p. 33.

7

The nineteenth century

Philosophical relativism and artistic eclecticism

The nineteenth century opened with a mood quite different from the Enlightenment. Before, individuals had faced the world with confidence and self-assurance, convinced that the universe is structured according to rational, objective principles, and equally convinced that the human mind is fully capable of apprehending those principles. These two convictions faltered at the beginning of the new century. The Enlightenment philosophers had undermined many of the arguments in support of these beliefs; and the optimistic faith in human rationality diminished in face of the French Revolution's reign of terror and the terrible social conditions of the Industrial Revolution. Man was now seen as irrational and aggressive, not rational and enlightened. Fyodor Dostoevsky (1821-81) summed up the resulting mood of anxiety and alienation in 'Notes from Underground' (1864): '[We] have lost all touch with life, we are all cripples, every one of us.'[1] For the new man of the nineteenth century, he despaired, there is no rational order in the world to apprehend, and no rational human powers by which to apprehend it even if it did exist.

Two philosophers in this period, Søren Kierkegaard (1813–55) and Friedrich Nietzsche (1844-1900), squarely faced this crisis of confidence. Existing, as Kierkegaard viewed it, is tied up with deciding. Individuals face choices in everything they do, and how they choose will mould who they are. Unfortunately, with the loss of rational principles in the world, individuals no longer have reliable guides for making choices, and consequently suffer feelings of division, alienation and loneliness. Kierkegaard concluded that the only way out is to commit oneself passionately to one of the choices. The commitment is not made on rational grounds, for such grounds no longer exist; rather, the commitment is made as a 'leap of faith'. For Kierkegaard, the ulti-

mate leap of faith is to the Christian God, Who then helps individuals make decisions.

Nietzsche also believed in the futility of rational thinking and objective knowledge. As a classical philologist, he was well aware that many classical texts are really only subsequent scholars' reconstructions and interpretations of a few remaining fragments. By analogy, he argued, philosophers and scientists can never find the 'original text' of the world's structure. They can only offer interpretations and reconstructions that reflect their own personal preconceptions more than the supposed structure of the world. Seeking order is simply a desperate attempt to impose reason on to what is in fact chaos. 'God is dead', Nietzsche proclaimed as a way of stressing this uncomfortable new reality. Not even Kierkegaard's leap of faith can offer salvation from the purposeless and orderless world. The main challenge in life is to accept this reality and shrug it off. The great individuals in life, Nietzsche enthused, are those who can act decisively despite the pointlessness of the human condition. Those like Alexander the Great and Napoleon are *overmen* because they struggle against great odds to impose their will on to a chaotic world. Great artists also fall into this camp. The artist struggles with materials, personal passions, and other artists to create new interpretations of the world. Every new artistic interpretation fights to replace the older ones, and is replaced in turn by newer views. Each view is equally valid, since no objective standards exist against which to judge them good or bad.

The unprecedented problem of philosophical and cultural relativity also confronted the architects in this period. The erosion of Classicism's objective foundations and the Enlightenment discovery that each age has its own values and forms of artistic expression left architects wondering in what style they should build. Many architects could not abide this new and painful relativism, and sought to reestablish timeless principles. Other, bolder, architects accepted the challenge of relativism, and actively sought an architectural style appropriate for the new century. But how does one suddenly invent a new style? Most of the nineteenth-century architects avoided this problem by looking for previous styles that might fit the new circumstances. This was a century of architectural eclecticism, in which designers revived every conceivable previous tradition from Greek to Gothic, Byzantine to Baroque, Renaissance to Romanesque (Figures 65, 66). A few architects, like Karl Friedrich Schinkel (1781–1841), discussed how they might even invent their own style; and while there were some notable experiments in this direction, most efforts grafted several styles together or juxtaposed new technology like the iron

frame on to traditional forms. No architects in this period were interested in a complete Nietzschean relativity, where architectural forms are developed purely at the whim of the designer. The choice of a particular style was always justified in terms of its functional, or aesthetic, or religious suitability for a particular project or for the age. Only in the late twentieth century would Nietzsche's views inspire extreme architectural relativity.

Classicism and the Ecole des Beaux-Arts

Those who sought to re-establish objective principles naturally turned to Classicism. They despised its mannered uses in the late Baroque and Rococo, and thought they could regain its original objective character by returning more rigorously to its original sources. An accurate, even archeological, revival of previous rational Classical buildings became the goal. But now that there was a recognition of different styles in different cultures, which Classicism should they revive? The earliest Classical architects in the century including Karl Friedrich Schinkel, William Wilkins (1778–1839) and Alexander Thomson (1817–75) chose to emulate the architectural forms of ancient Greece, while others like Charles Barry (1795–1860) turned to the forms of the Italian Renaissance (Figure 67). From the middle of the century on, architects including J.-L.-C. Garnier (1825–98), Sir Reginald Blomfield (1856–1942), and Daniel Burnham (1846–1912) even travelled full circle and revived the Classicism of the Baroque (Figure 68). They returned to Classical roots for objectivity, only to find themselves back in arguments about style.

Jean-Nicolas-Louis Durand (1760–1834), the professor of architecture at the Ecole Polytechnique in Paris, offered what was to be an influential way out of this dilemma. Rather than think about Classicism as specific stylistic elements, like the Five Orders, or as specific compositional rules which create one particular version of the language, he suggested that Classicism should be considered more abstractly, as general concepts which lie behind all good style. In his textbooks, *Précis des leçons d'architecture données à l'Ecole royale polytechnique* (1802–05) and a later appendix to the *Précis*, the *Partie graphique des cours d'architecture faits à l'Ecole royale polytechnique* (1821), Durand explained how this works.

Like any good textbook, Durand's *Précis* begins by discussing the aims of architecture. Good architecture, Durand suggested, satisfies two essential requirements: convenience and economy. Economy he

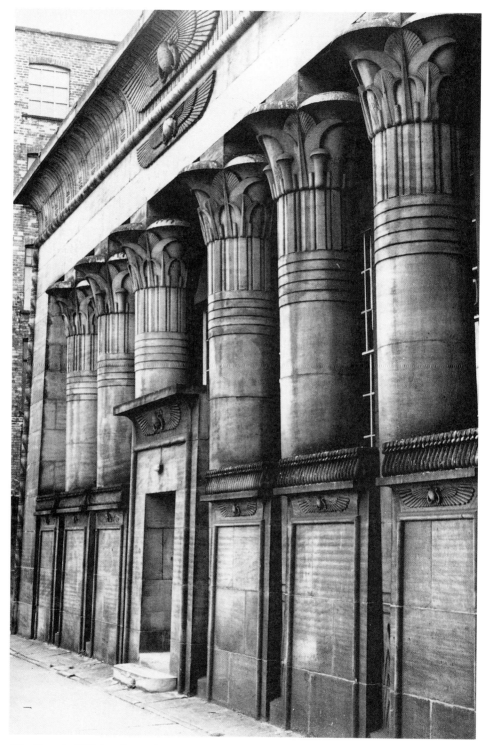

65 Temple Mill, Leeds, England, 1842. Joseph Bonomi, Jr. In the eclectic nineteenth century, even ancient Egyptian forms were revived.

66 Royal High School, Edinburgh, Scotland, 1825–. Thomas Hamilton. A Greek revival in the early nineteenth century sought the original source of Classicism, as opposed to the Roman version that had dominated since the Renaissance.

described as achieving the greatest possible effect for the least amount of financial outlay. Convenience he described by referring to Vitruvius' three qualities of durability, convenience and beauty. For these Durand substituted solidity, commodity and salubrity, the last referring not to beauty at all, but rather to sanitary and healthful conditions. Many architects aspire to create beauty in buildings, Durand pointed out, but they search in vain for beauty's secrets in proportions of nature, or in the primitive hut. A building will become beautiful only if the architect attends strictly to economy, construction, commodity and healthful conditions: 'Beauty appears naturally when one occupies oneself with disposition [the careful arrangement of functional parts] … Beauty disappears when one concerns oneself with architectural decoration.'[2]

So far this sounds Positivist: consider the practical requirements of the job at hand, and an appropriate and beautiful form will naturally emerge. In his discussion of economy and in all of his illustrative drawings, however, his true architectural predilections appear. The most economical buildings according to Durand just happen to possess symmetry, regularity and simplicity, precisely those qualities found in rational Classicism. On these grounds he dismisses Baroque forms of

67 Travellers' Club, Pall Mall, London, England, 1829–31. Sir Charles Barry.
In a revival of a revival, the nineteenth century revisited the Italian
Renaissance for its interpretation of Roman forms.

68 Opera House, Paris, France, 1861–74. J.-L.-C. Garnier. Baroque versions of Classicism fuelled a popular revival at mid-century.

Classicism as in St Peter's in Rome as 'examples of the grave effects which result from the ignorance or lack of observation of the true principles of architecture'.[3] Every illustration in his book displays architecture organized on a rigid grid, symmetrically arranged on at least one axis and often about a central point, and modelled with rep- etitious geometrical elements, like arcades and pilasters, taken from traditional Classicism (Figure 69).

 As long as buildings possessed these essential rationalistic qualities, Durand did not care in which stylistic trappings they happened to be clothed. In his *Recueil et parallèle des édifices en tout genre, anciens et modernes* (1800), he drew Egyptian, Greek, Roman, Gothic and Renaissance buildings in the same draughting style and to the same scale, arranged by building type, to illustrate the qualities that are common to them all. Durand had defined Classicism so broadly – sim- ply as rational, geometrical planning – that he could find it in any number of architectural traditions. He no doubt believed he had acknowledged the equal validity of many styles, while still retaining objective standards by which we can design and evaluate particular buildings. Of course, the more generally and abstractly one defines a particular quality, the more likely one is to find it in a wider number of examples. If we define 'house' as any building with a sheltering roof, then almost all buildings are houses. What this denies are the

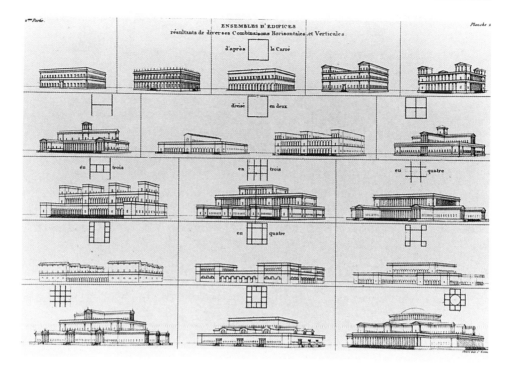

69 A plate from Durand's *Précis des leçons d'architecture*, 1802–05. This illustrates how basic architectural elements are combined according to rational, geometrical rules.

equally interesting differences among the examples. Defining Gothic as Classical makes us overlook its unique characteristics, while reducing its shared features to the most banal commonalities. None the less, this strategy proved popular for subsequent theorists who also wished to retain objective truths in a world of proliferating views and styles. The Bauhaus 'basic' design course inherited Durand's strategy, as we will see in the next chapter.

The Ecole des Beaux-Arts

The influential Ecole des Beaux-Arts supported and transmitted the Classical impulse through the nineteenth century and well into the twentieth. The Ecole was founded in the aftermath of the French Revolution, as part of a general movement to establish and reorganize academies covering a range of disciplines. In 1819, the Ecole Spéciale de l'Architecture and Ecole Spéciale de la Peinture et de la Sculpture were joined to form the 'Ecole Royale des Beaux-Arts'. Although each section retained its own faculty and curriculum, this joint school intended to treat architecture as one of the fine arts. The formal

alliance with fine arts inevitably stressed the aesthetic aspects of architecture over practical matters of construction. Many schools of architecture in the twentieth century inherited this idea of linking architecture to art, and therefore acquired this same emphasis.

At first the Ecole des Beaux-Arts continued the usual arrangement of the academy system. Students attended lectures in the academy on subjects including history, mathematics and building construction, where they learned universal principles applicable to all design. At the same time, they worked as apprentices in an architect's studio, or *atelier*, where they learned to design in the manner or style of their master while helping him with his own commissions. Although this system still maintained the traditional duality between theory and practice, it usually ensured that the students conceived of design in practical terms, because they continually faced real problems in real practices. As the century progressed, however, the Ecole changed this arrangement. The architects eventually separated their offices from the ateliers where they taught. The architect and his employees continued to work on real commissions in his office, while in the atelier the students under his charge worked solely on make-believe design projects. Although a number of students continued to work part-time in offices, for the first time in the history of Western architectural education students could complete an entire course of study without ever working on a real building design or without even watching a practitioner work on a real building design. This inevitably exacerbated the duality between theory and practice.

The Ecole des Beaux-Arts became the most important school of architecture in the nineteenth century. Students from around the world travelled to study there, and took back home not only the architectural ideas they had acquired but also the Beaux-Arts conception of education. The Ecole des Beaux-Arts consequently became the model for design education at exactly the same time that the number of formal architecture schools mushroomed around the world. These new schools were created partly because of the rapid increase in the number of building commissions, and partly because architects wished to increase their professional status in society. In England, the students themselves founded the independent Architectural Association (1847), and, for the first time, schools of architecture were established in universities. King's College (1841) and University College (1842) in London at first offered part-time courses; by the end of the century King's College and then the Liverpool School of Architecture pioneered full-time courses in architecture based on the Beaux-Arts model. Other British universities eventually followed suit.

In North America, MIT provided the first formal architectural edu-
cation in 1865, based explicitly on the Beaux-Arts. Other departments
soon followed in the University of Illinois (1867), Cornell (1871) and
the Universities of Toronto and Montreal (1876). The Morrill Act of
1862 empowered the United States Congress to give federal land to
each state, the sale of which was intended to finance state colleges
dedicated to providing practical education. Many states included
departments of architecture in their new colleges, often tied to
Faculties of Engineering. Despite the obvious bias towards the tech-
nical which this alliance usually implied, these schools along with
most others eventually took up the by now pervasive Beaux-Arts
system – if not in detail at least in the general approach to teaching –
and many even imported their teachers from Paris. By the beginning
of the twentieth century, the Beaux-Arts had become the standard
model for architecture teaching everywhere, together with its underly-
ing tensions between theory and practice.

German Idealism, Romanticism, and the Gothic Revival

The Romantic view that first appeared in the Enlightenment became a
major cultural force in the first decades of the nineteenth century. The
preferences for unities rather than dualities, intuitions and emotions
rather than reason, the personal and subjective rather than the objec-
tive and shared, shaped everything from political thought to philoso-
phy and art theory.

An important development in the Romantic point of view came
from the philosophical successors to Kant, collectively known as the
German Idealists. Like him, they wished to reconcile the various duali-
ties in Western philosophy including those between man and world,
sense and reason. They admired Kant's pioneering efforts in this res-
pect, but they did not think he had gone far enough. There were sev-
eral dualities in Kant's own theories, after all, which they thought also
ought to be resolved. Kant had made a distinction between the *con-
tent* of experience, which is given in sensory impressions, and the *form*
of experience, which is supplied by the mind; and he had made a dis-
tinction between the *phenomenal* world, which can be known ratio-
nally and empirically, and the *noumenal* world of things-in-
themselves, which lies beyond rational or empirical knowledge. To the
German Idealists these demanded some synthesis.

Fichte

Johann Gottlieb Fichte (1762–1814) modified Kant's theories in a series of publications including the *Basis of the Entire Theory of Science* (1794). According to Fichte, Kant had painted himself into an impossible corner with his concept of the thing-in-itself, or the noumenal realm. For Kant the noumenal realm causes the phenomenal world which is perceived by individual minds, but even in his own theory causality is a product of the mind and not a characteristic of ultimate reality. So by Kant's own arguments, the noumenal realm cannot be the cause of the phenomenal realm. Since this was the noumenal realm's only function in Kant's theory, and since Kant maintained that it could not be known by the human mind anyway, Fichte felt free to abandon it altogether. This left Fichte with the phenomenal world itself as the sole source of knowledge. But since the phenomenal world in Kant's theory is shaped by the mind's structuring and organizing activities, Fichte concluded that nature must be nothing more than an expression or manifestation of human thought. He argued that both the form and content of the world derive solely from the operations of the mind. In making a non-material intellect the cause of reality, Fichte rejected the Materialism that dominated the Positivist theories a century before, and returned to the Idealism of Anaxagoras, Leibniz, Berkeley and Kant.

Potentially this view could have led Fichte into solipsism, in which the outer world and other people within it are only inventions of one's own mind. Berkeley found himself in a similar position a century earlier, and employed God to provide the continuity of a shared mental construction. Fichte resorted to a similar solution, although relying less on the God of traditional Christian theology. The world is created not by individual finite minds, Fichte argued, but rather by a supra-individual, transcendental intelligence. He called this intelligence the ego, and spoke of it as if it were a collective Mind in which individual finite minds participate.

In a sense this collective Mind or 'transcendental ego' is simply the sum total of all individual minds alive at any moment, but for Fichte it has a life greater than individual minds because it continues to exist even when finite minds come and go. It embodies all human consciousness through all time. Like God in Berkeley's theory, Fichte's 'transcendental ego' constructs the world antecedently to any individual mind's consciousness of it, and it provides continuity when finite minds are born and then die. In Fichte's later writings this transcendental ego took on a life of its own, and became a divine Absolute

which had transcended even human thought. Although one might be tempted to give the transcendental ego spatial or temporal qualities (it resides here in space or it began life at this time), Fichte resisted attributing to it any physical characteristics and treated it instead as a process or activity. The force that drives this process, Fichte continued, is a moral will that continually strives to realize an ideal moral world order. Fichte had his transcendental ego proceeding through several stages on its way to the final world order, each characterized by an increasing degree of freedom and an increasing influence of reason over instinct.

From Fichte's Idealist philosophy several of his successors derived concepts of considerable importance to the theory of art, including the now pervasive notion of a 'Spirit of the Age'. But before turning to these developments, it is worth pausing for a moment to consider Fichte's Idealist programme. To Empiricist ears, the idea that a shared Mind creates the physical world sounds far-fetched. Where exactly is this Mind, and how can a non-physical entity create physical reality? Fichte's answer to the latter, that the transcendental ego creates the physical world in order to have a field in which to act morally, hardly satisfies the modern sceptic. But is the modern, common-sense alternative any less troublesome? The modern materialists consider a physical world to exist before any consciousness emerges, and so they have an equally troubling problem of explaining how material objects create non-material spirit. The German Idealists simply chose to reverse the emphasis, exchanging one set of problems for another.

A potential advantage of stressing the mental aspects of reality over the physical is that it supports more easily the concept of free will within the individual. As in the old Greek organic analogy, since each individual mind participates in that force which animates the world, it potentially has some control over the direction the animating force will take. In the materialist view, in contrast, the individual's participation in the physical world means that he or she is entirely subject to physical causality. So while the program of German Idealism might at first glance gain little sympathy among modern readers, and while its special, almost private language sometimes discourages those who would like to know more about the philosophical foundations of several influential concepts like the Spirit of the Age, it cannot be dismissed as irrelevant metaphysics.

Schelling

Friedrich Wilhelm Joseph von Schelling (1775–1854), originally a disci-

ple of Fichte, employed these ideas to give philosophical justification
to the Romantic theories of artistic creation. According to Schelling,
there is a universal ego or Mind – what he called the Absolute – in
which finite minds participate, and which creates the physical world.
Nature is a visible form of the Absolute, the Absolute is an invisible
form of Nature. Like Fichte, Schelling posited the Absolute as a self-
organizing, self-developing activity, driven by its own inner creative
energy and heading towards a final goal. Complete self-consciousness
is the ultimate goal to which Schelling's Absolute aspires, but which it
can never quite achieve.

Physical reality is the outward, physical manifestation of the
Absolute, so everything in the physical world, including creations of
man, are reflections of the Absolute. And since the Absolute progress-
es through various stages of development, each with its own unique
characteristics, likewise all physical objects will pass through equiva-
lent stages and express equivalent characteristics. With this view,
Schelling and all other German Idealists can explain why most people
at a given time in a given place share a similar outlook, or why the
artists in any given period will tend to use similar stylistic means of
expression. The shared Absolute has reached a particular stage in its
development, and then manifests itself physically through the minds of
those who participate in it. So while in the twentieth century we use
the phrase 'spirit of an age' to refer vaguely to a general mood in a
period, in the German Idealism the phrase literally referred to a coer-
cive spiritual entity at a particular point in its development.

The artist is the mechanism through which the Absolute expresses
itself in concrete, physical terms. Indeed, a work of art is the ultimate
objectification of the Absolute, the clearest expression possible in
physical terms. In art all opposites are reconciled – the objective and
subjective, the real and ideal, the conscious and unconscious. For this
reason, when we observe a work of art we have a feeling of satisfac-
tion that all contradictions are solved. The human mind in the percep-
tion of a work of art intuitively feels this ultimate resolution of
everything within the Absolute, even though it cannot know it ratio-
nally. For this reason art gives a clearer expression of ultimate reality
than even philosophy or science.

Many Romantic artists in the first decades of the nineteenth centu-
ry, as one might expect, readily agreed with this new power of art.
For them, it also gave increased justification to the Enlightenment con-
cept of the autonomous genius. The Romantics found it easy to step
from the notion of creative forces acting through the artist to the
notion of those forces originating within the artist himself. A work of

art, they now conceived, was not so much a window on to reality as a window on to the inner spirit of the artist himself. So the nineteenth-century Romantics fell into the same paradox as their predecessors. They considered artistic intuitions at one moment to be an act of *knowing*, of discovering pre-existent truths in the shared Spirit, and at the next moment to be an act of *creating*, of inventing ideas from within personal inner resources and rivaling the Spirit itself. In his poem 'The Eolian Harp' Coleridge offered an analogy of the mind as a wind-harp which sums up this duality perfectly. In some passages he described the 'wind' which creates the music as an objective power of nature impinging upon the poet, while in other passages he equated the wind to an inspiration originating within the poet himself.[4] When Romantic artists in this period stressed the former, they found them-selves attempting to attune themselves with the prevailing Spirit; and when they stressed the latter, they found themselves developing a cult of unbridled genius and protesting at any restrictions on the artist's freedom to express whatever his or her genius invented.

Hegel

Schelling gave priority to intuition over reason, arguing that at the level of reason man and nature are still divided. Only in artistic intu-itions are all dualities in the world finally resolved. Georg Friedrich Wilhelm Hegel (1770–1831), the best-known and most influential of the German Idealists, reversed this emphasis. Like Fichte and Schelling, Hegel asserted that a shared, transcendental Mind creates the physical world. Hegel called the transcendental mind the Absolute Spirit.[5] And like his predecessors, he claimed that the Absolute Spirit evolves from a lower, primitive state to a higher, more sophisticated one. More than either Fichte or Schelling, however, Hegel held that the Absolute Spirit is entirely rational. Indeed, he sometimes called the Absolute 'infinite reason'.

Now if the Absolute Spirit is rational, and if it embraces finite human minds, then a finite human mind that thinks rationally should be able to discover within itself the underlying logic of the Absolute. Like many of the Rationalists before him, Hegel assumed that if the real is rational, then the rational must be real. Anything which can be rationally thought must necessarily exist. Unlike the Rationalists, though, this connection between the rational and the real does not result from God implanting knowledge of the outside world's struc-ture within the human mind, but rather from the mind intimately participating in that which creates and runs the world.

By virtue of this intimate connection, the human mind should be able to reflect on itself and then 'reconstruct' the underlying order of nature. Unfortunately, Hegel pointed out, none of the mental tools so far offered in philosophy are adequate to the task. Traditional reason (what Hegel called *raisonnement*) creates artificial pigeon-holes into which perceptions of the world are dumped arbitrarily and randomly; it divides where no divisions exist. The other alternative usually offered – intuitionism – abandons concepts altogether and hopes to find true knowledge in undifferentiated immediate experience; it arbitrarily runs together what reason randomly split apart. Even worse, neither of these mental tools can adequately capture the evolving nature of the Absolute Spirit. A new kind of logical thinking, Hegel recognized, would have to be developed in order to capture the dynamic nature of knowledge. The logic in the evolution of the Absolute can be likened to a bud developing into a blossom:

> The bud disappears when the blossom breaks through, and we might say that the former is refuted by the latter; in the same way when the fruit comes, the blossom may be explained to be a false form of the plant's existence, for the fruit appears as its true nature in place of the blossom. These stages are not merely differentiated; they supplant one another as being incompatible with one another. But the ceaseless activity of their own inherent nature makes them at the same time moments of an organic unity, where they not merely do not contradict one another, but where one is as necessary as the other; and this equal necessity of all moments constitutes alone and thereby the life of the whole.[6]

To capture the logic behind this evolutionary pattern, Hegel borrowed from Fichte and then developed the notion of dialectical triads. At one moment the Absolute Spirit and its physical manifestations in the world embodies one idea, or thesis. This inevitably gives rise to the completely opposite idea, the *antithesis*. Both the thesis and antithesis are then fused or reconciled to become the *synthesis*. At earlier and therefore more primitive stages in the Absolute Spirit's development, no synthesis is fully complete; it therefore effectively becomes a thesis, which demands an antithesis, and so on. Each stage moves the Absolute Spirit further along its evolutionary path, and closer to its final goal when all opposites are fully resolved. The final resolution brings Idea and World together into pure Spirit.

Now if art is a reflection of the Absolute, and if the Absolute is continually evolving towards a final goal, then in order to understand art one must examine its development over time. Hegel himself offered

an overview of the evolution of art in his lectures at the University of Berlin posthumously published as the *Philosophy of Fine Art* (1835). In its earliest stages, the Absolute Spirit manifested itself as symbolic art, in which physical form dominates over spiritual content. Early Western and all Oriental art displays this character. Symbolic art gave way to Classical art, in which form and spirit are equally balanced; this is the art of Classical antiquity and the Renaissance. And finally, in Christian art and in the art of Hegel's own time, Romantic art replaced Classical, and spirit dominates form. By relating specific art movements to specific phases of the Absolute Spirit, Hegel further advanced the idea that each age possesses a particular spirit to which all artistic work must inevitably conform.

Later eminent historians attempted to interpret art and architecture history through similar Hegelian triadic patterns, even though not all of them professed belief in the complete Hegelian system of metaphysics. Heinrich Wölfflin (1864–1945) in *Principles of Art History* (1929) and his pupil Paul Frankl (1879–1962), in *Principles of Architectural History* (1914) attempted to identify a set of polar opposite characteristics between which art always vacillates. In Frankl's system, first the Renaissance displays certain rational characteristics like compositions of autonomous spatial units; then the Baroque pursues the opposite emotional extreme characterized by compositions which fuse parts into a whole greater than the parts; then the Rococo brings both of these to a higher plane; then the Neoclassical movement reverts to the characteristics of the Renaissance phase, now infused with emotional overtones. Even later historians who professed no belief in Hegel at all and who sought no triadic patterns still interpreted architectural history as if it were determined by an all-encompassing Spirit. Nikolaus Pevsner in his influential *Pioneers of the Modern Movement from William Morris to Walter Gropius* (1936) argued that modernist art and architecture is the only acceptable style for the twentieth century, because it expresses the contemporary 'spirit of the age'. Indeed, anyone who asserts that art and architecture ought to express the 'modern spirit' implicitly continues this German Idealist tradition, even though he or she may have no sympathy for the idea of a transcendental Absolute Spirit.

The Gothic Revival

In the Enlightenment, as we saw, the Romantic desire to heal the dualities of the post-Renaissance age led to a rediscovery and a reappreciation of the Middle Ages, including its social institutions, its val-

ues, and its art and architecture. Although Gothic forms were revived, the Enlightenment architects employed them fancifully, more as impressions of the Gothic than faithful reproductions. The beginning of the nineteenth century saw a similar eclectic use of the Gothic. Architects like John Nash (1752-1835) and Karl Friedrich Schinkel varied from Classical to Gothic, depending upon what they saw as the needs of the particular job at hand.

At the same time, the Gothic found a more earnest group of supporters, artists and architects who valued medieval ideas exclusively and who wished to revive the Gothic as thoroughly and as accurately as possible. The Nazarene Brotherhood, a small circle of young artists founded in Vienna around 1806 and later expanded to other circles in Rome, preferred the emotional over the rational, the primitive over the sophisticated, untamed nature over nature dominated by man. They discovered these qualities in the paintings of medieval German masters, and enthusiastically set out to emulate the medieval works. Copying the works of admired masters was, of course, the usual learning method in both the apprenticeship system and the Classical academies. Unlike both traditional educational systems, however, no living practitioners of their desired art could serve as masters. To solve this problem, the Nazarenes immersed themselves into a medieval way of life, hoping that their re-created medieval culture would put them in the right mental framework to create medieval masterpieces. They established an artists' commune in a deserted monastery in Rome, modelled it after their conception of a medieval workshop, wore their hair long and affected the spirit of brotherhood and piety. Their view, incidentally, involved a conceit. They accepted that artistic production is governed by a prevailing spirit or culture, and they willingly sought its guiding influence. But they themselves were able to stand outside a prevailing Spirit of which they disapproved just long enough to overthrow it and replace it with another one more agreeable to their personal interests. This once-only revolution is reminiscent of Perrault's own conceit that he could change the objective rules of Classicism just once, and then for evermore they would remain objective for everyone else. In the twentieth century, as we will see, this became a popular strategy for a number of thinkers.

Augustus Welby Northmore Pugin (1812-52) also wished to revive the medieval world and its artistic manifestations. At first this theme does not immediately reveal itself in his writings. In *The True Principles of Pointed or Christian Architecture* (1841), for example, he appeared to argue the positivist view that form derives from function: 'The two great rules for design are these: 1st, that there should be no

features about a building which are not necessary for convenience, construction or propriety; 2nd, that all ornament should consist of enrichment of the essential construction of the building.'[7] Positivists in the twentieth century claimed Pugin as one of their own in light of this view. But in other writings he made it clear that only one kind of architecture – the Gothic – can satisfy these two requirements. In *Contrasts* (1836) he compared medieval architecture to many other styles, and found in favour of the former. As an ardent Catholic, he elsewhere explained the superiority of the Gothic on the grounds that it was created by the only proper social order, medieval Catholicism. The Middle Ages represented for him a period that cherished the right cultural values, and placed individuals into spiritual harmony. This harmony inevitably showed in the works they created: 'Such effects can only be produced on the mind by buildings, the composition of which has emanated from men who were thoroughly imbued with devotion for, and faith in, the religion for whose worship they were erected.'[8]

Pugin insisted that the medieval culture and its buildings ought to be resuscitated as accurately as possible, without any adjustments or concessions to the nineteenth century. In *The Present State of Ecclesiastical Architecture in England* (1843) he insisted that 'it is therefore of the highest importance to set forth the beauty and fitness of the ancient churches, and the necessity of adhering strictly to them as the models for our imitation'.[9] Correctness, in this view, is more important than innovation or personal creativity. In *The True Principles of Pointed* or *Christian Architecture* he noted: 'Indeed, if we view pointed architecture in its true light as Christian art, as the faith itself is perfect, so are the principles on which it is founded. We may indeed improve in mechanical contrivances to expedite its execution, we may even increase its scale and grandeur; but we can never successfully deviate one tittle from the spirit and principles of pointed architecture. We must rest content to follow, not to lead.'[10] Like the Nazarenes, Pugin wished to revive a former world spirit, and in this sense he believed that an individual can step outside the prevailing spirit and change its direction. But once the spirit is moved back on to a correct course, all individuals should follow once again the dictates of the prevailing cultural attitudes. He himself built in an accurate Gothic style that is difficult to discern from the original (Figure 70).

John Ruskin (1819–1900) developed Pugin's ideas further, although he denied any influence from Pugin and wished to distance himself from Pugin's Catholicism. Restating a by now familiar Romantic theme, Ruskin asserted that architecture reflects the way of life of

70 St Giles, Cheadle, Staffordshire, England, 1841–46. Augustus Welby Northmore Pugin. In contrast to the earlier, somewhat frivolous revival of Gothic architecture, Pugin's buildings are difficult to discern from the medieval originals.

those who make it. A building and its ornament freezes in physical form the inner emotional state, set of beliefs and moral outlook of its creator. For this reason, good architecture can only result from emotionally stable and morally good people. Unfortunately, Ruskin bemoaned, the social divisions and moral turpitude of the nineteenth century prohibit its members from developing their own inner goodness; only in the morally healthy Middle Ages were individuals able to achieve the desired standards. To build good buildings, one must first revive the good culture of the Middle Ages.

Ruskin equated moral goodness with truth. Since moral decisions are objectively right or wrong, according to him, then they must also be true or false. And since an artist's inner moral fibre determines the quality of his artistic expressions, an artist who possesses Ruskin's conception of moral goodness must necessarily create truth. On these grounds Ruskin could assess those artists he admired, like Turner, as truthful, while those he disapproved of, like Constable, he could dismiss as untruthful. The Romantic link between art and the inner life of the artist is, in Ruskin, developed into a method of artistic criticism which focuses on the artist more than the art.

Like Pugin, Ruskin's quest for absolute truth compelled him to stress correctness over originality. In *The Seven Lamps of Architecture* (1849) he noted: 'A day never passes without our hearing our English architects called upon to be original, and to invent a new style ... We want no new style of architecture ... Originality in expression does not depend on invention of new words ... The forms of architecture already known are good enough for us, and far better than any of us: and it will be time enough to think of changing them for better when we can use them as they are.'[11]

William Morris (1834-96) consolidated several themes in Pugin and Ruskin, and pointed the way to yet another form of Romanticism in the last decades of the century, the Arts and Crafts Movement. Like Ruskin, Morris saw art as an expression of the inner life of its creator. The inequities and divisions in Victorian society had virtually ruined the artists' inner spirit and had consequently led to low standards and poor craftsmanship; only in the Middle Ages, Morris pursued the familiar theme, did a spiritually healthy society engender spiritually healthy individuals who then created high-quality work. Where Pugin had hoped everyone would realize the virtues of medieval Catholicism and return to it willingly, Morris campaigned more forcefully for a social revolution.

Morris established a company, Morris, Marshall & Faulkner, Fine Art Workmen in Painting, Carving, Furniture, and the Metals, which

modelled itself on medieval craft practices. In intention, Morris & Co. appeared to follow a positivist line, because it claimed to derive its products' forms from the inherent qualities of the materials used and from a clear expression of constructional realities. This impression was certainly reinforced by Pevsner, who attempted to portray Morris as the first real functionalist.[12] But Morris's designs were just as thoroughly influenced by traditional – often medieval – forms and decorative systems. In light of this, and in light of Morris's convictions about the social and spiritual superiority of the Middle Ages, his interest in design which expresses material and construction should be seen as yet one more aspect of a Romantic attitude to the medieval world. Where the Renaissance had set design apart from construction and the designer apart from the builder, the Middle Ages joined designer and builder in the same person and created a language of design derived to a greater extent from the problems faced in building. In this sense, Morris's interests in the aesthetic possibilities of craftsmanship demonstrate the recurring preoccupation of the Romantic tradition to heal dualities.

That the Romantic impulse lies behind Morris's interest in craftsmanship shows clearly in the Arts and Crafts Movement he inspired. A number of its members, including Richard Norman Shaw (1831–1912), C. R. Ashbee (1863–1942) Charles F. Annesley Voysey (1857–1941), and Charles Rennie Mackintosh (1868–1928) continued to search for design ideas derived from good craftsmanship and the properties of constructional materials; most of them, like Morris, continued equally to derive their ideas from traditional and usually medieval forms. A favorite theme for the architects was the English vernacular house with steep gables, half-timbering, and picturesque planning (Figure 71). At the same time, many of the Arts and Crafts designers saw design as a matter of personal artistic expression. They did not feel constrained to follow accepted rules either of Classicism or of the Gothic, but rather relied on their own sense of taste and visual judgement to transform inherited forms into something new. Mackintosh even sought what he called a 'Free Style' that would follow no known tradition, but that would derive from craftsmanship and his own inner sense of taste. The duality of the Romantic tradition shows once again: that aspect which stresses the individual as part of a larger social and spiritual context encourages the continued use of Gothic forms and Gothic attitudes to craftsmanship; while that aspect which stresses the priority of individual creative powers encourages the concept of design as personal expression. Romantic painting in this period stressed an emotional response to nature out of control (Figure 72).

71 Leys Wood, Groombridge, Sussex, England, 1868–69. Richard Norman Shaw. Arts and Crafts architects revived English medieval houses with steep gables, half-timbering and picturesque planning.

72 Joseph Mallord William Turner, *Slave Ship (Slavers Throwing Overboard the Dead and Dying, Typhoon Coming On)*, 1840. Romantic paintings stressed an emotional response to nature out of control.

Romantic educational theory

None of the nineteenth-century expressions of Romanticism could tolerate the academies. To the Gothicists, students in the academies learned entirely the wrong architectural language. Pugin denounced it all as pagan. The Gothicists could have offered an educational program still based in the academies, merely substituting Gothic design principles for Classical ones. But the academies were too closely identified with the Renaissance rejection of medievalism, and so the Gothicists championed instead a return to the old medieval craft guild education with training on the job. Although few achieved this ideal, in one notable case – at the construction of the new Houses of Parliament in Westminster – they established an informal school on the building site to train the builders how to produce medieval forms.[13]

The Arts and Crafts architects and guilds could not tolerate the academies either, given the former's interest in personal artistic expression and the latter's continuing belief in a timeless language of form. These architects opposed any kind of rule from without; when the Royal Institute of British Architects attempted in the early 1890s to make architecture more like a profession, with more stringent educational requirements and restrictions on entry into the field, the Arts and Crafts architects strongly objected. Norman Shaw and T. G. Jackson edited a book called *Architecture, a Profession or an Art?*, setting out the primacy of artistic expression, and many of the best-known architects left the RIBA in protest.

Concomitant with their Romantic and Gothic Revival roots, the Arts and Crafts architects and artists established informal versions of the medieval craft guilds. Arthur Mackmurdo (1851–1942) founded the Century Guild in 1882; Walter Crane and Lewis Day, with support from influential artists and architects of the day including Shaw, Lethaby, Prior, Webb and William Morris, founded the Art Workers' Guild in 1884; and C. R. Ashbee founded the Guild and School of Handicraft in 1888, to mention the most significant. The members gathered regularly in these guilds to hear lectures, debate burning questions, observe demonstrations of crafts and even undertake design commissions. This demonstrated the continuing identification of the Romantic tradition with the medieval educational structure. Only a few years later, as we will see, Walter Gropius built a similar concept of the medieval craft guild into the educational foundations of the Bauhaus.

New ideas in education theory came from Friedrich Froebel

(1782–1852) in this period, although they had limited influence on any
of the established forms of art and architectural education in the nine-
teenth century. Froebel sought a balance between the inherent inner
growth of the individual and the structured guidance which a society
can offer from without. Following the then current German Idealist
view, Froebel conceived of the child's inner driving spirit as nothing
less than the transpersonal divine spirit. Since all individuals are driv-
en by the same extra-personal impulse, then it follows that the child
must pass through the same stages of growth as those experienced by
everyone else in the child's society. So while the child should be
allowed to grow from within and follow its own self-motivated direc-
tion, adults who represent the final form towards which it is growing
can help the child understand its inner potential by offering advice
and serving as a role model. Just as the Romantics wished to draw
upon the support of traditions they admired while still following their
own creative urges, Froebel hoped children could find support in the
adult's traditions while still following their own inner urges. Frank
Lloyd Wright later credited his design success to playing as a small
boy with the 'Gifts', some educational toys devised by Froebel.[14]

Positivism and artistic determinism

Theorists like Durand and Pugin, we have seen, sometimes incorporat-
ed Positivist ideas into their own theories; but this was usually to help
justify an architectural style they preferred on other grounds. A more
extreme form of Positivism also carried forward from the
Enlightenment into the nineteenth century, developed first by the
philosopher Auguste Comte (1798–1857) who gave the name
Positivism to this point of view. Comte was part of the same conser-
vative reaction to the late Baroque that had found expression in
Romanticism, although his conservatism was more extreme. While the
Romantics merely wanted to place the individual back into some
social context, the conservative movement in which Comte participat-
ed wanted to deny the primacy of the individual entirely. As the worst
consequences of untrammeled individual freedom were experienced –
for example, as the French Revolution seemed to destroy social struc-
tures and communal ties, and as the Industrial Revolution seemed to
destroy nature, family and village – a conservative political and social
movement arose which demanded a return to the traditional commu-
nal structure. The late Baroque liberals had attempted to remove the
individual from the ties of traditional social structures and to think of

society as nothing more than a loose aggregate of independent, autonomous, reasoning beings brought together in common assent under the rules of natural right and natural law, but the conservatives denied these concepts had any reality whatsoever.[15] On the contrary, they argued, the society and its traditional institutions have priority over the individual. Just like the Romantics, these conservatives generally turned to the Middle Ages as the model for the ideal society, finding in those times all the desirable virtues they felt had been trampled under by the late Baroque.

In Comte's writings, including *The Positive Philosophy* (1830–42), he gave extreme expression to this anti-liberal mood, arguing that the society precedes the individual logically and psychologically and completely determines his behavior. According to Comte, concepts like 'individual' and 'freedom' are nothing more than metaphysical dogmas which prevent the creation of a genuine social order. In contrast to the late Baroque thinkers, who conceived of man's imaginative, cognitive and social propensities as inherently self-generated and autonomous, Comte made them contingent upon a transpersonal social structure that he claimed was the primary reality. Man outside his role in a social structure was inconceivable to Comte.

After arguing that man's behavior is completely determined by his culture, Comte then developed an idea taken from Montesquieu that the society under which the individuals are subsumed is governed by historical and other laws analogous to the laws governing natural phenomena. Comte saw society as a vast, deterministic structure that can be investigated scientifically and, like Hegel, as an evolutionary system that progresses through stages. Comte posited three progressive stages, each more sophisticated than the last. First is the theological stage, in which man explains natural phenomena in terms of spiritual forces; this is supplanted by the metaphysical stage, in which man explains things in terms of ultimate realities behind phenomenal appearance; and in the third and final stage of human progress, the positive stage, man rightfully limits himself to describing only that which he can see in phenomenal appearance.

The German Idealists were still working in the middle stage, the followers of Comte pointed out, whereas philosophy ought to be concerned with the final positive stage. Karl Marx (1818–83) proposed the philosophy of the final stage in his theory later known as Dialectical Materialism. In writings including *The Communist Manifesto* (1848) and *Das Kapital* (1867) Marx took up Hegel's concept of a dialectical Absolute Spirit and transformed everything mental and spiritual in Hegel's system into things purely physical. Hegel had posited a collec-

tive consciousness or Absolute Spirit that logically unfolds with the unfolding of consciousness; for Marx this spiritual entity could not be seen anywhere in phenomenal appearance and thus was too metaphysical to place at the source of all human actions. For the Hegelian spiritual force Marx substituted the purely material forces of social and economic development, thereby determining all individual actions by physical events in the socio-economic realm. All changes in politics, in aesthetic taste and indeed in the entire history of ideas merely reflect underlying economic changes: 'Does it require deep intuition to comprehend that man's ideas, views and conceptions, in one word, man's consciousness, changes with every change in the conditions of his material existence, in his social relations and in his social life? ... What else does the history of ideas prove, than that intellectual production changes in character in proportion as material production is changed?'[16]

In the intellectual fashion of the day, Marx also conceived of human society passing through three stages, now described in socio-economic terms: the first stage of feudalism gives way to capitalism, which in turn gives way to the final stage of communism. Only in the communist stage will individuals finally free themselves from outer deterministic forces, Marx suggested. In communism 'the extraneous objective forces that have hitherto governed history pass under the control of man himself. Only from that time will man himself, more and more consciously, make his own history ... It is the ascent of man from the kingdom of necessity to the kingdom of freedom.'[17] Unfortunately, Marx never convincingly explained how this might be possible. And given the physical determinism of his system, it is difficult to see how the Marxist view can ever explain human free will. In the Hegelian system, in which individual minds are connected with the determining spiritual force, the possibility exists that individual minds might exert some influence on that which determines; but once Marx transformed that extra-physical force into something purely materialistic he landed himself squarely in the physical determinism of the Baroque scientists.

Hippolyte Taine (1828–93) offered a similar deterministic conception for art. In his *History of English Literature* (1864) he argued that all social phenomena – especially works of art – can be explained entirely as the logical result of the race, the environment and the epoch within which the social phenomena developed.[18] The historian should be like a scientist, he suggested, and should concentrate his or her efforts on discovering the general laws which govern the production of various elements of human culture. He opposed the Romantic

notion that a personal genius might be able to work outside the constraints of culture and surroundings. A literary work, he maintained 'is not a mere play of the imagination, the isolated caprice of an excited brain, but a transcript of contemporary manners and customs'.[19]

Numerous architectural theorists in this period also appealed to the concept of physical or social determinism. Mention has already been made of Durand and Pugin; others expressed these ideas even more forcefully. Jean-Baptiste Rondolet (1734–1829) argued in his *Traité théorique et pratique de l'art de bâtir* (1802–03) that architectural form derives entirely from the art of construction and has nothing to do with imaginative art. Viollet-le-Duc (1814–79), in his inaugural lecture in 1864 as Professor of the History of Art and Aesthetics at the Ecole des Beaux-Arts, attempted to demonstrate how the great art from any period reflects the forces of the civilization which produced it.[20] Auguste Choisy (1841–1909) gave the most influential view of Positivism at the end of the century in his *Histoire de l'Architecture* (1899). He argued that the form of a building follows logically and immediately from the technical means available to the designer, that different ages possess different technical means, and therefore that designers in any given age will operate within the style implied by the available technology. Individual designers in this view have little or no say in the development of forms; forms inevitably emerge, Reyner Banham has noted of this view, as the result of a kind of 'abstract necessity'.[21] Choisy claimed, for example, that the flying buttress in Gothic architecture 'far from being invented, imposed itself'.[22] Of Gothic architecture in general he claimed 'the seeds [of the style] incubate in obscurity, and suddenly we witness various hatchings that imply only the logic of the facts'.[23] Banham called this view 'constructional fatalism', the result of a strictly deterministic view of architectural history, and pointed out that it is 'an approach that depreciates personal effort, and tended to leave his followers standing about waiting for a new structural principle like the flying buttress, to impose itself'.[24] So where one aspect of Romanticism conceived of the artist as a passive medium through which the Absolute Spirit manifests itself in the physical world, the Positivists conceived of the artist as a medium through which purely physical forces manifest themselves. The initiative of the individual in both views is subsumed under larger, transpersonal forces.

This conception of the artist as a passive receptor of forces outside himself presented the Positivists with a methodological problem: unless the artist is willing to stand about waiting for a form to reveal itself, how can he actively seek out or manifest the form when a com-

mission requires him to do so? Faced with a similar problem, the Nazarenes had attempted to generate forms by simulating the cultural conditions out of which the forms had originally emerged. The Positivists chose instead to utilize the scientific method of the natural sciences. Assuming that human artefacts are shaped by laws similar to those which govern nature, and further assuming that the empirical scientific method is the means for discovering those laws, then it would be only a short step to using the methods of science for discovering the artistic or architectural forms intrinsically contained in a given set of contextual determinants.

Auguste Comte and then John Stuart Mill (1806–73) explored the possibilities of the empirical method and revived the inductive method of Newton. According to Mill, the scientist gathers together many instances of the phenomenon under scrutiny and then induces from these a general law which holds true for all of them. Like many empiricists before him, he conceded the difficulties inherent in passively hoping an amorphous body of facts will suddenly of their own suggest a law; so like many empiricists before him, he grudgingly conceded the need for some initial guess or hypothesis about what the law might be. Hypotheses ought to be used with caution, he agreed with his predecessors, and ought to be verified through rigorous testing.

The Realist movement of writers and painters attempted to apply a similar procedure to art. The Realists proposed to replace both Romanticism – which had attempted to record the feelings of the artist – and Neoclassicism – which had attempted to show the ideal reality behind appearance – with a 'scientific' art that would record only the visual 'facts' of experience. Emile Zola (1840–1902) set out this new artistic program for literature. In his essays 'Naturalism in the Theatre' and 'Experimental Novel' (1880) Zola described the novelist as a scientist who finds truth in art through the patient accumulation of, and induction from, the empirical observation of life. Literature for the Realist attempts to present a slice of life as objectively as possible, without intervention or distortion by the writer, so that the reader can understand in its detail the slice of life presented. In such a literature, according to Zola, the imagination no longer has a function.

Similar sentiments were to be found among the painters. As early as 1836 John Constable (1776–1837) conceived of painting as a branch of natural philosophy and pictures as experiments, and in the middle of the century this became an explicit program for the Realist painters under the leadership of Gustave Courbet (1819–77). Art, Courbet pro-

claimed, should attempt to reproduce visible objects as accurately as possible, and should report the objects' colors, textures and forms without regard for the nobleness of the subject matter (Figure 73). The Impressionists inherited the Realist attitudes and carried to the extreme the idea that painting should represent nothing more than that which is immediately apprehended in visual appearance. They attempted to capture in their paintings the sensory impressions seen in an instant, thus rendering the world as a blur of action (Figure 74). They were so concerned to show the world as it 'really is', and not to mediate or interfere with the impressions in any way, that they made a virtue out of visual innocence. Constable said he tried to forget he had ever seen a painting every time he sat down to paint from nature, and Monet (1840-1926) wished he had been born blind and then suddenly received his sight. No longer was it considered useful to have any knowledge about the abstract principles of art taught in the academies, nor was it thought desirable to have Romantic insights into the ultimate reality of things. All that counts is that which is immediately received by the passive mind.

German educators in this period consolidated the grip of the Positivist view on universities. Wilhelm von Humboldt (1767–1835), with the help of Fichte, founded the University of Berlin in the first decade of the nineteenth century and gave it an even stronger Positivist program. The emphasis was to be on scientific research rather than on teaching and examining, and professors were to be chosen for their abilities to create new knowledge more than for their skills at transmitting existing knowledge. Here are the seeds of the modern research university, and under it all lies the Positivist conception of knowledge. Eventually all universities around the world, to a greater or lesser degree, would take up this view.

The shift to abstraction in art

In the last few decades of the century artists explored a new conception of art which moved it increasingly away from its source of many centuries, sensory nature. The first ideas came from the Post-Impressionist Georges Seurat (1859–91), who at first thought he was merely extending the principles of Impressionism. Like the Impressionists, he wanted to capture in his paintings the shimmering quality of outdoor light; but instead of relying on informal observations of color and optical effects as his predecessors had done, he turned to a rigorous study of the contemporary scientific theories of

73 Gustave Courbet, *Pierre-Joseph Proudhon and His Family*, 1865–67.
Like the Realist movement in the seventeenth century, Courbet insisted on
a faithful representation of phenomenal appearance without idealising the
subject matter or the image.

74 August Renoir, *Le Moulin de la Galette*, 1876. The Impressionists
carried Realism to the extreme, recording images that are perceived in the
blur of an instant.

color and light. Out of this study he developed a new method of painting which not only captured the sought after qualities of light, but also created an unexpected harmony and structure in the painting that was independent of the subject matter it represented (Figure 75). According to one historian of modern painting, 'suddenly Seurat understood what a 'picture' was – an orderly structure made up of rhythm, balance, and contrasts'.[25]

Seurat's contemporary, Paul Cézanne (1839–1906), also explored the new possibilities. Working back and forth between the object of nature and the form he could distill from it, Cézanne gradually abstracted the images of things and then used the laws he discovered as a formal structure for reinterpreting the original sensory data. Although Cézanne insisted on discovering for himself these underlying structures and would not rely on any academic formulae, he soon found himself echoing the Neoclassical idea that these structures are the 'Platonic' essences of the cylinder, the cone and the sphere (Figure 76). And even though he discovered these structures in his own subjective experience, he was convinced that they are objective properties of the world: 'I take the colors, the nuances as I find them and they become objects without any mediation on my part.'[26] So just as the naive phenomenalism of the early Renaissance gave way to a more theoretical concern in Alberti with the structure behind appearance so, too, did the naive phenomenalism of the Impressionists give way to a similar concern with artistic structure in Seurat and Cézanne.

Two other Post-Impressionists, Paul Gauguin (1848–1903) and Vincent van Gogh (1853–90), started from a similar position but then moved in the opposite direction. Gauguin agreed with Seurat and Cézanne that form and color have their own autonomous qualities, but where his two compatriots saw these qualities as characteristics of an objective reality, Gauguin saw them more as vehicles for expressing inner emotions. Feelings can be conjured up by colors and forms relatively independent of the subject matter they represent. The point of art for Gauguin was less to represent natural appearance than to express an emotional reaction to nature, and so he began substituting for sensory nature his own dreams and emotions as the source and content of his paintings (Figure 77). He advised fellow artists to paint by heart, because in the memory colored by emotions the natural forms would become more integrated. And later in his career, echoing a notion of Rousseau's, he sought the primitive people on the South Sea Isles, whom he believed to be less corrupted by modern society and thus closer to true feelings. Van Gogh learned from Gauguin about the expressive qualities of color and line, and then used this

75 Georges Seurat, *Circus Sideshow*, 1887–88. Seurat returned to the stylistic devices of ancient conceptual art – little modelling, figures in frontal or profile views, limited perspective – and discovered an underlying harmony and structure that was independent of the subject matter.

76 Paul Cézanne, *Still Life with Apples and Oranges*, 1895–1900. Cézanne abstracted from phenomenal appearance its underlying forms, and discovered the Neoclassical geometrical shapes: the cylinder, the cone and the sphere.

insight to represent the emotional truth behind appearance (Figure 78).
Van Gogh wanted to show in his paintings not so much the phenome-
nal appearance of a landscape, for example, but rather the 'enormous
power and solidity of the soil'.[27] This underlying spiritual reality could
be brought to the surface, he thought, by distorting the visual appear-
ance according to the emotions he felt.

So even though avant-garde painters at the end of the century were
moving inexorably away from sensory appearance as the source of art,
the directions they chose followed the now familiar strands of
Classicism and Romanticism. One direction sought the structure
behind appearance that stands independently of particular sensory
phenomena, while the other explored the expressive capabilities of
form that respond to the feelings of the artist. One side would lead
ultimately to the absolute objectivity of De Stijl and Mondrian, while
the other would lead to the extreme subjectivity of German
Expressionism. Each would find its way into the Bauhaus and
Modernism.

77 Paul Gauguin, *The Day of the God (Mahana no Atua)*, 1894. As a
source of art, Gauguin substituted for sensory nature his own dreams and
his emotional reactions to nature.

78 Vincent van Gogh, *The Starry Night*, 1889. Van Gogh sought to express the emotional truth behind nature by distorting appearance according to his emotional reactions.

Notes

1 'Notes from Underground', in *The Best Short Stories of Dostoyevsky*, trans. D. Magarshack, Modern Library, New York, n.d., pp. 239-40.

2 Durand, *Précis*, pp. 19-20.

3 *Ibid.*, plate 2 of the drawings following p. 71.

4 Noted in Beardsley, *Aesthetics*, p. 254.

5 'Spirit' is a somewhat misleading translation of the German word 'Geist'; Geist means mind or intellect and does not necessarily have the religious overtones of the English word 'spirit'.

6 Georg Wilhelm Hegel, *The Phenomenology of Mind*, trans. J. B. Baillie, Allen & Unwin, London, 1949, p. 68.

7 Augustus Welby Pugin, *The True Principles of Pointed or Christian Architecture*, Academy Editions, London, 1973, p. 1.

8 Augustus Welby Pugin, *Contrasts; or, A Parallel between the Noble Edifices of the Fourteenth and Fifteenth Centuries, and Similar Buildings of the*

Present Day; Shewing the Present Decay of Taste: Accompanied by Appropriate Text, Humanities Press, New York, 1969, p. 5.

9 Augustus Welby Pugin, *The Present State of Ecclesiastical Architecture in England*, Charles Dolman, London, 1843, p. 11.

10 Pugin, *Principles*, p. 10.

11 John Ruskin, *The Seven Lamps of Architecture*, Dana Estes & Company, Boston, n.d., p. 191–4.

12 Pevsner, *Pioneers of Modern Design*.

13 Briggs, *Architect in History*, p. 370.

14 Frank Lloyd Wright, *An Autobiography*, Duell, Sloan and Pearce, New York, 1943, pp. 13-14.

15 See Robert Nisbet, *The Sociological Tradition*, Heinemann, London, 1966, p. 12.

16 Karl Marx and Friedrich Engels, *Communist Manifesto*, trans. Samuel Moore, Penguin Books, Harmondsworth, 1967, p. 102.

17 Friedrich Engels, 'Socialism: Utopian and Scientific', in Robert Tucker (ed.), *The Marx–Engels Reader*, W. W. Norton Co. Inc., New York, 1972, pp. 637-8.

18 Hippolyte Adolphe Taine, *History of English Literature*, vol. I, trans. Henry van Laun, The Colonial Press, New York, 1900, p. 13.

19 *Ibid.*, p. 1.

20 Chafee, 'Teaching of Architecture', in Drexler, *Beaux-Arts*, p. 103.

21 Reyner Banham, *Theory and Design in the First Machine Age*, The Architectural Press, London, 1960, p. 27.

22 Choisy in Banham, p. 27.

23 *Ibid.*

24 Banham, p. 27.

25 Werner Haftman, *Painting in the Twentieth Century*, trans. Ralph Manheim, Lund Humphries, London, 1965, vol. I, p. 22.

26 In Haftman, p. 32.

27 In Haftman, p. 24.

8

The twentieth century (I)

The reaction to relativism in philosophy

Many of the nineteenth-century philosophers had struggled with the conclusion of the Enlightenment that no certain knowledge of the world is possible. Some, like Kierkegaard and Nietzsche, accepted this relativism as an inevitable reality and attempted to make their own personal peace with its implications; others, like Hegel, battled on to find other means by which certainty in knowledge could be attained. Early twentieth-century philosophy struggled with the same problem and offered similar responses.

Like Nietzsche, John Dewey (1859–1952) accepted that no absolutely certain knowledge of the world is possible. Men have a fundamental need to seek security, he pointed out, and for this reason traditional philosophers have always sought a dream world of absolute truths. But the theories they invented are only that: inventions that tell us more about their creators' insecurities than they do about a 'real' world of truth. Instead of looking for security in elaborate metaphysical inventions, he suggested, men ought to ensure their security by controlling their environment through scientific means. Human intelligence may not be able to discover eternal truths about some timeless reality, but it can discover empirical knowledge about the here-and-now that can guide the creation of a better world. Dewey named his philosophy Pragmatism, after a similar view developed by Charles Saunders Peirce (1889–1914). Although Dewey denied the existence of objective truths, he did not succumb to the completely relativistic idea that every subjective view is equally valid. Most individuals will agree that certain social, artistic and scientific goals are worth achieving, he maintained, and so it is possible to build a consensus about the ends to which philosophy and practical actions should be directed. This approximation to certainty is the best we can

hope for; anyone who demands more certainty than this, Dewey suggested, suffers from a mild neurosis.

Compared to Dewey, most of the other philosophers in the first half of the twentieth century were neurotics. Like most of their nineteenth-century predecessors, they wished to limit the damage of relativism by finding secure foundations for objective knowledge. All of them acknowledged Kant's thesis that knowledge of the world is partly constructed by the mind, and so like their post-Kantian predecessors they had to develop notions of how the subjective mind can discover objective truths.

According to Henri Bergson (1859–1941), certain knowledge of the world can be gained in intuitions. There is an ultimate reality that can be known, he claimed. But like the Romantics before him, he complained that the normal rational procedures of thinking by concepts tend to distort and to divide where no divisions exist. If one relies on intuitions instead, and looks inward to one's own nature, one will experience a 'duration', or a 'life force' (*élan vital*), that comprises all things from consciousness and matter to time and the absolute. This force is creative and evolutionary, and is responsible for the existence and the characteristics of the objects seen in phenomenal appearance. Compared to his Romantic predecessors, Bergson offered a more dynamic, evolutionary conception of the reality that is discovered in the intuitions. But like them he still had difficulty in justifying his necessary claim that the 'duration' experienced by one mind is the same 'duration' as that experienced by other minds. He had to rely on a version of Descartes's argument: when I query my own intuitions, I can conceive of qualities like materiality and eternity that imply a shared world; and if I can conceive of it, it must exist.

Alfred North Whitehead (1861–1957) pursued a more Rationalist search for objective truths. In his view, there is an objectively real world that exists independently of those who perceive it, and it is organized according to logical patterns. Like Rationalists before him, Whitehead claimed that these patterns underlying reality can be captured in mathematics. Human minds and the mathematical structure of the universe are in harmony, he further maintained; if a pattern can be thought, then it probably exists in the world. Unlike some previous Rationalists, Whitehead insisted that any pattern deduced in the mind must be tested against empirical observations to ensure its real existence. But he was no Empiricist. Where Empiricists had always insisted that pattern would somehow magically present itself as the scientist dispassionately scrutinized the phenomena, Whitehead recognized that deep underlying mathematical patterns would never suddenly appear

all by themselves in contingent phenomenal 'facts'. He acknowledged the vicious cycle that had plagued Western epistemology from the beginning: one must have an idea of a pattern in order to know which facts can test it, but presumably one cannot have an idea of a pattern in advance of the facts. To resolve this problem, Whitehead intriguingly employed the imagination: 'The true method of discovery is like the flight of an aeroplane. It starts from the ground of particular observation; it makes a flight in the thin air of imaginative generalization; and it again lands for renewed observation rendered acute by rational interpretation.'[1] So the scientist/philosopher examines some phenomena, makes a conjecture about their underlying mathematical pattern, and then tests this conjecture against the phenomena. This conception of scientific discovery went a long way to resolving some of the traditional disputes between Rationalism and Empiricism in science; but it also brought an unwelcome component of subjectivity. If the mathematical patterns are invented in the scientist's mind and only later tested against empirical reality, then it stands to reason that many different scientists might invent many different patterns, a great number of which might equally well explain the same phenomena. How would one decide which is true? Whitehead recognized the relativistic consequence of his theory:

> There may be rival schemes, inconsistent among themselves; each with its own merits and its own failures. It will then be the purpose of research to conciliate the differences. Metaphysical categories are not dogmatic statements of the obvious; they are tentative formulations of the ultimate generalities ... Rationalism is an adventure in the clarification of thought, progressive and never final. But it is an adventure in which even partial success has importance.[2]

Even though his scientific method employed subjective inventions of the imagination, over time, he believed, it would approximate more and more closely to the real patterns of the universe.

The quest for certainty took an even more extreme turn in Edmund Husserl (1859–1938), one of the major proponents of Phenomenology. We will examine Husserl in some detail, because Phenomenology has enjoyed a revival among some recent architectural theorists. He exclaimed in his diary in 1906: 'I have been through enough torments from lack of clarity and from doubt that wavers back and forth ... Only one need absorbs me: I must win clarity, else I cannot live; I cannot bear life unless I can believe that I shall achieve it.'[3] The philosophies of pragmatism and historicism distressed him, because their relativism rejected any possibility of an absolute philosophy. So

he set out to establish a new method by which certain knowledge of the world can be gained.

Husserl turned to the ideas of his teacher Franz Brentano (1838–1917), who had developed a new version of Empiricism. Earlier Empiricists from Locke on had developed the notion that external objects 'cause' impressions of themselves in the mind, like 'redness' or 'sweetness' or 'solidity'. The mind then performs various operations on these sensory contents to produce higher-order concepts like infinity or physical extension. We have already seen two problems with this theory. First of all, Berkeley and Hume showed we cannot be sure that the impressions 'in here' are caused by shared objects 'out there'. Secondly, even if the sensory material does originate in an outside world, Kant showed that we cannot receive it directly and unchanged. The mind actively imposes on to its perceptions preconceived concepts, which means that the subjective mind helps construct its own knowledge of the world. This being so, how can we be sure that the constructed knowledge in one mind is the same as that in another?

Brentano proposed to place Empiricism on firmer, more objective ground by examining more carefully the contents of our consciousness. It is in the consciousness that the sensory impressions reside, after all, and so exploring the nature of these data might give some clues about their objective character. Now if we examine our consciousness, we discover certain emotions, desires, ideas, judgements, and so on. That we actually experience these is self-evident and irrefutable, and therefore these experiences provide infallible knowledge about something, at least. Berkeley would claim that these experiences are self-generated within the mind and are not caused by anything external, but Brentano hoped to avoid this conclusion by noting a special characteristic of these experiences. Every experience we have in our consciousness, he pointed out, refers to an object. We do not simply desire, we desire an object; we do not simply experience a sound, we experience a sound caused by something. Every act of consciousness 'intends', to use Brentano's phrase, an object which clearly resides outside the mind. Furthermore, since acts of consciousness and their objects are intimately tied together, it can be assumed that the objects themselves are immediately immanent in consciousness. Consciousness does not construct or interpret knowledge of the outside world, as Kant had insisted; it merely discloses or displays it. Therefore, Brentano concluded, infallible knowledge about the world can be found by interrogating the inner consciousness.

Husserl took up this concept of 'intentionality' and proceeded to

develop a method by which the certain, infallible truths in the con-
sciousness can be reliably apprehended. The task of philosophy, he
insisted, is to report without prejudice on the objective phenomena –
what he called 'essences' – within consciousness. Like many philoso-
phers before him, Husserl expressed concern that our common view of
things distorts and confuses our true intuitions, and so we must rid
ourselves of these prejudices. To do this Husserl proposed a
Phenomenological reduction, which requires emptying the conscious-
ness of everything that derives from scientific inference or rational
thinking. In particular, one cannot employ notions of space, time or
causality, those concepts that Kant had shown are imposed on sense
impressions by the mind. If all theories, all philosophies, all interpreta-
tions are 'bracketed out', to use Husserl's phrase, one will be left with
the absolutely pure data of consciousness, the authentic reality.

Now since sensory impressions in their raw state comprise an end-
lessly changing flux of colors, tastes, tactile sensations and so on, these
data alone do not yet reveal the underlying structure which gives sta-
bility and universality to our knowledge. So in Husserl's second stage
of the Phenomenological method, the eidetic reduction, one abstracts
timeless essences from these raw data. In this process the mind
becomes aware of the changeless forms – the essences – behind senso-
ry appearance.

According to Husserl, if one performs the Phenomenological
method satisfactorily, one is left with absolutely certain knowledge of
the world's pure essences, undistorted by rationalizing concepts and
independent of the individual mind's subjective point of view. In this
consciousness of pure essences there are no artificial divisions: the past
merges both with the present and with premonitions of the future,
mind merges with the objects it intends, feelings are an integral part
of human experience. This is the Romantic ideal achieved, and it
stands in sharp contrast to the classifying and dissecting of earlier
rationalizing and scientific enterprises. Furthermore, since all acts of
consciousness including judging and feeling are tied to objective, infal-
lible truths about the world, it provides certain and objective founda-
tions for ethical and aesthetic judgements. Right and wrong answers
replace subjective opinions.

These claims obviously appealed to those in the twentieth century
who despised the philosophical relativism they had inherited and who
sought certainty in its place. Max Scheler (1874–1928) applied
Phenomenological ideas to anthropology and religion, Carl Rogers
(1902–87) developed a Phenomenological psychology of the personali-
ty, while Theodor Lipps (1851–1914) employed a version of 'intention-

ality' in his theory of empathy in art. According to this theory, an individual projects on to objects a feeling of sympathy or empathy that allows him or her to identify with something psychical in the object. This is why we talk of 'movement' in a line, or 'stress' in a gesture.

One might question, however, if Phenomenology satisfactorily solved the problems of Empiricism. Although Husserl denied he was a solipsist and even developed a theory of intersubjectivity to demonstrate that other minds exist and that they share the same universal essences, the fact that he places certain knowledge of the world entirely within the subjective mind still leaves open the possibility that each mind creates its own reality. He has to take it on faith that the experiences 'in here' correspond to objectively shared and verifiable objects 'out there'. Furthermore, Husserl had hoped to avoid subjectivity of knowledge by 'bracketing out' all of the organizing concepts like space, time and causality which Kant had shown are constructions of the subjective mind. Yet in his eidetic reduction, when he distills out of the flux of sensory impressions their underlying essences, is Husserl not reimposing concepts in another guise? To argue that this essence is the changeless form of which those phenomena are particular instances, for example, depends upon the concept of identity, or resemblance, which Hume had shown is a construction of the mind. And if the underlying essences are ever going to say something useful about the public world we understand in common sense, they will have to account for space, time and causality which, again, are constructs placed on the data by the mind. Phenomenology may offer an interesting account of the relationship between inner consciousness and the objects to which consciousness refers, but it does not save Empiricism from the subjective consequences driven home by Hume, nor does it provide certain foundations for objective knowledge.

The opposed sources of architectural form

The conflict between the relativists and those who sought certainty also defined the development of architectural theory in the first decades of the twentieth century. Classicists continued to search for timeless, objective principles of design which would be shared by all, while those inspired by the continuing Romantic tradition relished the personal freedom which followed on the collapse of any generally agreed design principles.

Julien Guadet (1834–1908), the professor of theory at the Ecole des

Beaux-Arts, summed up the case for universal principles of archi-
tecture at the turn of the century in his four-volume textbook
Eléments et théorie de l'architecture (1901–04). His views are particu-
larly interesting, because his was the last and most sophisticated
explanation of Classicism just before Modernism overthrew this long
tradition in the 1920s and 1930s. Guadet, we will see, tried to sub-
sume within Classicism a number of the disparate architectural
philosophies that had challenged its dominance over the last century.

Like Durand almost a century before, Guadet wished to define
Classicism not as a particular style, but rather as a general attitude to
design. According to Guadet, the Classical in the arts is that which is
based on the invariable principles of logic, reason and method, that
which history has shown to be eternally valid for all times, countries,
climates and schools, and thus that which has attracted universal
admiration. Because Classicism is not a style but rather a set of prin-
ciples, Guadet disapproved of mere 'archaeologists' who copied forms
without understanding their underlying logic. He pointed with admira-
tion to the innovators in his own lifetime who discovered in historical
precedents the timeless principles of form, and who then employed
those principles to create unprecedented yet objectively beautiful
building forms. For Guadet it is this study of universal principles, not
superficial appearance, that should preoccupy architectural education.

While later in the twentieth century this sentiment led to teaching
abstract principles not immediately tied to architectural form itself
(for example, principles of visual design or social behavior), for
Guadet these principles were always in – and about – architectural
form and its geometry. Like his academic predecessors, he held that
the architect selects elemental forms like walls, doors, windows,
columns, vaults and stairs from a timeless and universally valid 'arse-
nal of architecture',[4] and then adds them together according to geo-
metrical principles including axiality, symmetry and proportion
(Figure 79).

Acknowledging the Positivist stress on external contingency, and
following his academic predecessor J.-F. Blondel, Guadet maintained
that different briefs, climates, cultures and sites require different
arrangements of the universal elements. He wrote, for example, that
when deploying the architectural elements in any given design the
architects must accommodate the client's special requirements, and
must adjust the form according to whether it will be built in the city,
or the country, or the seaside or the mountains. However, Guadet
pointedly rejected the Positivist notion that a design idea originates in,
or is solely determined by, these outside constraints. He noted that the

79 Julien Guadet, *A Hospice in the Alps*, 1er grand prix, 1864. Guadet's own prize-winning student work expressed his faith in the traditional principles of Classical architecture: elemental forms composed according to axiality, symmetry and proportion.

brief or program

> gives you a list of requirements and indicates to you their relations, but
> it suggests to you neither their combination, nor their proportion; that
> is your affair. Still less should the brief impose solutions on you, and I
> have never understood prescriptions of this kind.[5]

Nor can building technique ever determine architectural form; a study
of building techniques

> ... can only come later, when the student already has sufficient idea of
> the forms and resources of architecture: first of all he must be shown
> what can be built; later, he will see by what means it can be construct-
> ed, in other words, the realization of a thing he must already have con-
> ceived.[6]

Forms are first created with universally objective design elements and
compositional principles; only later do outside constraints and techno-
logical possibilities modify these forms.

Like his Classical predecessors, then, Guadet assumed that architec-
tural forms and their organizing laws lead an autonomous existence as
objective properties of the world, independent of individual designers'
temperaments, cultural differences, climates and so on. But where
many of his predecessors (like Boullée) hoped that they could discover
these forms and laws in objective nature itself through empirical meth-
ods, Guadet recognized the philosophical and practical inadequacies of
this view, and opted instead for a version of Descartes's theory of vir-
tually innate ideas. This idea shows in his discussion of beauty. 'Beauty
is the splendor of truth', and 'art is therefore the pursuit of beauty in
truth and for truth'; but whereas in the 'imitative arts truth is nature,
in the creative arts, most notably in architecture, truth is ... the con-
science. If truth for the painter and sculptor is in the external world,
for us [the architects] it resides within ourselves.'[7] In other words, the
architect judges the beauty of a composition by measuring it not
against the 'facts' of nature, but rather against his own inner sense of
beauty. In the Rationalist tradition, Guadet maintained that each mind
has prefigured within itself the objective and universal truths of art,
waiting to be discovered by anyone who looks carefully within.

Like Descartes, Guadet did not think that these truths are immedi-
ately obvious to anyone who casually examines the contents of his or
her own mind. If they were, all people would be successful designers
the moment they turned their attention to design, without any educa-
tion or experience. This obviously does not happen, and so like
Descartes, Guadet assumed the inner truths must be *virtually* innate:

that is, they must be potentialities within the mind which blossom only upon the occasion of some experience and practice. He said of composition, for example, that it 'can only be learned through many exercises, through examples and advice, through actual experience built on the experiences of others'.[8] In other words, the designer must study examples of good design out in the world until the innate potentialities within him are awakened, at which time he can rely completely on his own inner resources. And since these inner potentialities are the same in every mind, the inner resources that result from study are universally objective. The only difference between Guadet and Descartes in this respect is that where Descartes had the mind thinking rationally when discovering and using these inner resources, Guadet doubted whether purely rational, or analytical, thinking would ever discover a good design idea: 'more often [your thinking] will be synthetic, springing up whole within your spirit; this means of creation, which puts to flight the theories and methods of traditional logic, which denies Bacon and Descartes, is intuition, the true birthplace of artistic ideas'.[9] This is not to say the inner resources themselves are a-rational (they cannot be if the Classical architecture derived from them is claimed to be rational), but only that the experienced and mature mind has direct, intuitive access to its inner resources.

Guadet offered a subtle and intriguing explanation of the sources of architectural form, in which the mind first discovers prefigured within itself objective information about the outside world, and then actively creates architectural form in response both to the logic of this inner material and to the outer constraints of the design problem at hand. Interestingly, his method of design parallels Whitehead's method of science: both have the individual making a conjecture about a possible form/pattern and then modifying it in light of outside circumstances. As long as the architectural style from which Guadet derived his 'objectively universal' principles and elements remained relatively stable, he could no doubt believe he had satisfactorily explained how form can be created within the individual and yet still remain objectively beautiful. But when the architectural fashion changed in the first decades of the twentieth century and allowed of a style which others would claim is just as objectively beautiful but not as clearly derived from Guadet's elements and principles, it became less obvious *which* objective world, exactly, is prefigured in the architect's mind. One begins to suspect that the architectural principles derive less from an objective world prefigured in the mind than from the structure of the mind imposing itself on the world, as Kant suggested.

German Idealism and Romanticism came together in the first

decades of the century in the German Expressionists. Paul Scheerbart (1863–1915), Bruno Taut (1880–1938) and Adolf Behne (1885–1948), among others, reasserted the old desires of these traditions to reconcile the dualities between man and nature, world and spirit, subject and object. They also revived Romanticism's dualistic notion of the artist on the one hand as a passive receptor of existing outside spiritual and cultural forces, and on the other hand as a creative inventor of spiritual and cultural forces not yet existing.

Behne, for example, at first insisted that artists are simply the passive mechanism through which the transpersonal World Spirit manifests itself. The World Spirit 'sends its rays into man, the artist, and thereby releases the work of art'.[10] Now since the World Spirit creates objective nature and hence artistic form antecedently to the existence of any particular individuals, Behne reasoned, there must be in the Spirit some immutable, eternal *Kunstform*, or artistic shape, that provides the eternal structure of art. Each artist strives to express this ideal form in all of his or her work, but because of imperfections in the material world can only create imperfect copies, or *Gestaltung*. And since the total structure of the art object is already prefigured in the Spirit itself, determining the 'resulting work in every detail', the harmony of all the parts in a work of art is guaranteed even if the artist does not consciously worry about its overall order. In fact, if the artist does try to impose a controlling or dominant formal concept upon his work he or she will destroy its underlying spirit.

But like his Romantic predecessors, Behne juxtaposed on this passive view of the artist the contrary idea that the artist stands in advance of the prevailing spirit and can invent new ideas. An artist can only be receptive to the World Spirit in suitable cultural conditions, Behne agreed with the other Expressionists, and these conditions no longer exist in contemporary Germany. A small group of creative individuals who understand these cultural and spiritual matters must band together to create the requisite social order so that other, lesser, mortals may tap into the Spirit once again. Scheerbart, Taut and Behne all believed that this new social order could be established by building great unified works of art – what Behne called *Gesamtkunstwerke* – modelled along the lines of Gothic cathedrals and intended as the spiritual center for the new society (Figure 80). So in contrast to the earlier notion of the artists as passive receptors of forces already existing, the artists in this side of Expressionism are elite, creative geniuses and leaders of men. Taut noted: 'The whole project must be exclusive, just as great art always exists first in the artist alone. The public may afterward learn from it or wait until a

159

80 Bruno Taut, *House of Heaven*, 1920. The German Expressionists hoped to further their aesthetic and spiritual program by building a *Gesamtkunstwerke* – a great unified work of art based roughly on Gothic cathedrals.

teacher comes.'[11] Only the artists and architects can lead men back to a spiritual unity, and Taut implored the designer to 'remember his high, magnificent, priest-like, divine calling and to seek to raise the treasure that lies in the depths of men's souls'.[12] Erich Mendelsohn's Einstein tower captured the spirit of this Expressionism (Figure 81).

So by the end of the First World War architectural theory had articulated three main sources of design ideas. On one side, Choisy and the functionalists (discussed in the last chapter) maintained that form derives logically and inevitably from purely material determinants like structure, climate and purpose. On the other side, the German Expressionists considered form at one moment to derive purely from

81 Einstein Tower, Potsdam, Germany, 1917–21. Erich Mendelsohn.
Mendelsohn abandoned reference to previous architectural traditions and
developed a personal language of form that he hoped would evoke strong
emotional reactions.

inner sensibilities and feelings, and at the next moment to be the phys-
ical manifestation of a transpersonal Spirit. Somewhere in between lay
Guadet and the Academies, who acknowledged both the influence of
outside contraints and the power of inner intuitive sources, yet still
maintained a belief in timeless, objective forms.

The opposed sources of artistic form

The fine artists in this period continued to move away from sensory
nature as the ultimate source of art and, like their nineteenth-century
predecessors, pursued two variations on the theme: one stressing the
objective, suprapersonal characteristics of form, the other stressing
form's personal, expressive possibilities.

 The Analytical Cubists Pablo Picasso (1881–1974) and Georges
Braque (1882–1963) took up Cézanne's interest in the structure behind
appearance. Like Cézanne, they began with nature as their subject
matter, and then tried to discover an underlying order in those natural
images. Yet they were more obsessed than Cézanne with finding the
objective, measurable truth behind mere appearance. Pictorial, illu-
sionistic paintings, they complained, render too indeterminate a view
of the world. Picasso noted: 'It is impossible to ascertain the distance
from the tip of the nose to the mouth in a Raphael. I should like to
paint pictures in which that would be possible.'[13] The problem with
illusionistic painting, they realized, is that it represents nature as seen
from one viewpoint only. To make the image look 'realistic' the
painter must literally stand in one place and must paint only that
which is seen in one instant. But this method of painting obviously
renders a partial and distorted view of the object's true reality, for it
cannot show what the object looks like from other viewpoints or at
other times. As far as Picasso and Braque were concerned, the pictori-
al, single-viewpoint image is too subjective, literally, because it is
based on the individual subject's personal view of the world.

 Taking one of the most radical steps in the history of post-
Renaissance art, they decided that the only way to capture the object's
true reality is to abandon altogether the single viewpoint and to paint
the object as seen from all points of view simultaneously. They
walked around the object looking at it from all angles, made notes
about its exact dimensions and underlying geometrical forms, and
then mentally added up this 'objective' data to arrive at an image that
expresses everything simultaneously. Like an architect's ground plans,
sections and elevations, the Cubist painting analytically describes an

ideal mental picture of an object, a conceptual picture which cannot be seen from any one viewpoint yet which embodies that which is seen from all viewpoints (Figure 82). They intended to present the universal view, not the idiosyncratic and subjective. In this sense they had returned to the conceptual art of the Middle Ages, and of the ancient world before the Greek cultural revolution.

The Dutch De Stijl movement abstracted from sensory nature even more. The final step to pure formalism shows most strikingly in a series of paintings by Piet Mondrian (1872–1944) from about 1914 to 1920. At first Mondrian painted naturalistic landscapes, but inspired by the Analytical Cubists he began abstracting out of his images their underlying geometrical order. He went even further and simplified the geometrical order itself to its constitutive elements, until he was painting nature as a pattern of small vertical and horizontal lines. Originally he intended the proportions of these lines to capture the rhythms of the natural objects, like waves moving towards a jetty, but to Mondrian's reductive mind even this was too idiosyncratic a subject for painting. He soon generalized his approach and, instead of representing the rhythms of particular objects, he began painting what he thought was a more universal rhythm behind all objects. By about 1920 he had dropped reference to sensory nature altogether and had arrived at his definitive, universal picture: the familiar thin, black, horizontal and vertical lines subdividing the picture plane into rectangular panels, the latter of which were occasionally painted in primary colors (Figure 83). To Mondrian this style of painting captured the simplest, most elemental structure behind all of nature and thus had universal significance.

In 1917 he formed the De Stijl group along with other similarly-minded artists, including Theo van Doesburg and J. J. P. Oud, and in 1920 he named their new style Neo-Plasticism. The theoretical justification he gave for this new style can be seen as a logical extension of the Platonic and Neoclassical epistemological tradition. There is, he claimed, a realm of timeless forms behind superficial appearance that can be expressed in pure geometry. And since those timeless forms are objective properties of the world external to the individual artists, their geometry is governed by objective laws of art, free from subjective interpretation and representational association. According to Mondrian, only when art is freed from representing things can one achieve a universal and unvarying response according to what he called the 'fixed objective laws of plastic composition'. The artist who uses these laws 'frees himself from individual sentiments and from particular impressions which he received from the outside, and ...

82 Pablo Picasso, *La Bouteille de vieux marc*, 1912. Picasso abandoned the single viewpoint of previous representational art and attempted to show objects as seen from all points of view simultaneously. This, he hoped, would offer objective, universal knowledge of the object.

83 Piet Mondrian, *Composition with Red, Yellow and Blue 'Ex-Mart Stam'*, 1928. Mondrian reduced sensory appearance to what he believed was its most fundamental, elemental structure.

breaks loose from the domination of individual inclinations within him'.[14] This rejection of individual inclinations Banham called the 'depersonalization of art'.[15]

The Naturlyrismus and then the Jugenstil movements contrarily explored the subjective in painting. Both examined forms and colors as the means by which they might convey their emotional reactions to things. The Jugenstil proponent Hermann Bahr noted: 'When I make a chair, I pursue the same purpose as when I paint a picture or when a poet writes a poem – I want to communicate to others a feeling that has taken hold of me.'[16] Henri van de Velde (1863–1957), the Belgian architect whom Gropius later claimed as one of his philosophical predecessors, also stressed the expressive force inherent in lines and colors: 'A line is a force, it borrows its force from the energy of the man who drew it.'[17] Similar ideas in the first decade of the new century came from the Brücke painters, a group of former architecture stu-

dents who formed a Nazarenean type of artistic community in 1905, and the Neue Künstlervereinigung (New Artists' Association) founded in 1909 by the Russian artist Wassily Kandinsky (1866–1944).

Kandinsky, who later developed some of the pedagogical theories at the Bauhaus, finally realized the full consequences of the ideas they were pursuing. If art is the expression through color and form of feelings originating within the artist's soul, then the artist should be able to express his or her feelings directly, without making any reference to sensory objects. Kandinsky was convinced that 'the harmony of colours and forms can be based on only one thing: a purposive contact with the human soul'.[18] Vibrations within the soul of the artist can be raised to the surface and expressed visually by means of the vibrating harmonies in pure color and form. Freed from the restraints of the sensory and material world altogether, the artist in Kandinsky's view is free to act as he feels, responding only to an inner necessity. The paintings he created have been termed Abstract Expressionism, to denote their two essential characteristics (Figure 84). Not all of the Künstlervereinigung members were willing to follow Kandinsky to this conclusion, so in 1911 he formed the Blaue Reiter, a radical breakaway group including Franz Marc (1880–1916) and Paul Klee (1879–1940). In the usual Romantic fashion, the Blaue Reiter painters considered themselves to be the 'harbingers of a new spiritual culture, rooted in the manifestations of the naive soul', and, according to Marc, the searchers for the 'inner mystical construction of the world'.[19]

By 1920 the two strands of artistic formalism – Neo-Plasticism and Abstract Expressionism – offered clearly opposing attitudes to the sources of artistic form. Even though both had given up all contact with the visible world as the original source of images, one embodied the belief that form exists as an independent entity, governed by objective laws and accessible to anyone who looks for it, while the other insisted that form originates in the soul of the artist, responds to his or her inner emotions, and depends to a large part on the soul's personal and even mystical nature. These fundamental differences, together with the equally fundamental differences in architecture theory just discussed, created a tense climate in the arts just after the First World War. Many artists, architects, and theorists were dismayed at the range and clamour of competing 'isms', yet the underlying assumptions of these views were so diametrically opposed that no common ground seemed possible.

84 Wassily Kandinsky, *Improvisation No. 30 (Canons)*, 1913. Kandinsky
believed he could express emotions directly through abstract form itself,
without explicit reference to sensory objects.

The Bauhaus conflation

The Bauhaus, most scholars agree, marks a watershed in twentieth-
century architectural history between the early proliferation of com-
peting theories and the later emergence of one dominating paradigm,
the International Style. In the standard interpretation of the Bauhaus,
offered first by its founder Walter Gropius and later by the early his-
torians of the Modern Movement, Nikolaus Pevsner and Sigfried
Giedion, the Bauhaus was seen to rise dramatically above the compet-
ing 'isms' of the time and to offer a modern vision of design and edu-

cation appropriate for the new century. In this view, the Bauhaus not only found an objective 'language of vision' that finally rid design of the subjectivism and relativism of the previous century, but also finally developed a modern and progressive alternative to the old art academies.

This view is not accurate. To begin with, Banham pointed out, 'While repudiating the "false standard of the academies", [the proponents of the Modern Movement] accepted many academic ideas without knowing where they had come from'. The aesthetic theories of the Bauhaus in particular 'resemble those of French academic origin'.[20] The other revision of the traditional history of the Bauhaus came from Wolfgang Pehnt and Marcel Franciscono, both of whom showed how the Expressionist foundations of the Bauhaus were far more pervasive than was formerly believed.[21] So instead of viewing the Bauhaus as a filter that blocked the Expressionist extremes and the decaying Academic tradition, it is more accurate to think of the Bauhaus as a melting pot into which many of the earlier Neoclassical, Romantic and Positivist ideas were blended. Unfortunately, we will see, the Bauhaus developed not so much a synthesis as an uneasy conflation of these earlier traditions.

Confusion in the first year

Walter Gropius (1883–1969) founded the Bauhaus in 1919, by fusing two existing institutions in Weimar: the Academy of Fine Arts, which was one of the traditional German academies, and the School of Arts and Crafts, which was established by Van de Velde in 1903. By bringing together a traditional art academy and a school of handicraft training, the Weimar Government and Gropius hoped to integrate the arts with technology and create a new style appropriate to the machine age. A careful review of Gropius's speeches and manifestoes of the time, however, shows that he overlaid his interest in art and craft training with Expressionist preoccupations, and thus ambiguously drew conceptions of design from two opposing traditions.

The founding manifesto of 1919 begins with a Positivist call to find the source of art and design in the craftly consideration of material and function:

> Architects, sculptors, painters, we all must return to the crafts! For art is not a 'profession'. There is no essential difference between the artist and the craftsman. The artist is an exalted craftsman. In rare moments of inspiration, transcending the consciousness of his will, the grace of heaven may cause his work to blossom into art. But proficiency in a

craft is essential to every artist. Therein lies the prime source of creative imagination.[22]

To reunite art and craft Gropius proposed as a model for the Bauhaus the medieval German *Bauhütten*, or craft guilds. Workers in the Bauhütten were not divided into those who conceptualized and those who built, he pointed out, but rather were trained to design and execute in one continuous process. The medieval artist/craftsmen found their forms in the nature of their materials, in their constructional systems and in the functional uses to which the objects would be put. Given Gropius's stated aims, plumping for the medieval craft guilds in favor of the standard academic system made sense. The academies, after all, were explicitly established in order to separate theory from practice and design from application, while the guilds had successfully integrated both sides for many centuries. Gropius proposed to re-establish as fully as possible the educational structure of the guilds which was, of course, the master/apprenticeship system based in the workshop. There would be no teachers or pupils, but masters, journeymen and apprentices. In the spirit of this system, Gropius originally proposed no separate lectures on underlying principles. Everything the students needed to learn would be acquired by working on practical projects under the guidance of an experienced master.

But upon this materialist conception of design Gropius superimposed the contrary spiritual ideas of the Expressionists. The Gothic cathedral with its 'thousands of stone figures, pinnacles, and rosettes' clearly did not derive from considerations of material and purpose alone, he claimed, but rather sprang out of a 'spiritual movement, a religious sense of longing of an entire people'.[23] In such periods of spiritual strength and purpose 'the artist reads the spiritual parallels of his time and represents them in pure form'.[24] Continuing with a familiar Romantic theme, Gropius noted that contemporary society no longer possesses this spiritual feeling, and so fails to provide the artists their essential spiritual nourishment. When Gropius stressed the Positivist side of his theory, he advised his students to cope with this lack of spiritual support by forgetting about high art altogether; they must patiently wait for a new spirit to arrive, and until it does they must be content to create humble, functional objects. But when he stressed the Romantic side of his theory, he asserted that a small, elite group of artists might be able to create a new spiritual unity in which the rest of society could then participate. He saw the Bauhaus as one of several 'small, secret, self-contained societies, lodges. Conspiracies will form which we will want to watch over and artistically shape a

secret, a nucleus of belief, until from the individual groups a universally great, enduring, spiritual–religious idea will rise again, which finally must find its crystalline expression in a great *Gesamtkunstwerke*.'[25] Feininger's woodcut illustration on the cover of the first Manifesto and Program for the Bauhaus betrays the Expressionist orientation (Figure 85).

With this emphasis on the powers of the artists to stand in advance of the times and to create a new spiritual reality, Gropius inevitably took up the other side of Romanticism that stresses creative genius. The goals of the Bauhaus will include, he promised, the 'avoidance of all rigidity; priority of creativity; freedom of individuality'.[26] And further, 'feeling is ... the source of inspiration, of invention, of the creative ability to form and to build in the widest sense of the word'.[27]

In the very first year of the Bauhaus, then, Gropius had conflated three opposing conceptions of the source of form: the artist is supposed to ignore lofty spiritual demands and let the practical requirements of function and material craft generate his forms; at the same time, he is supposed to ignore practical demands and existing spiritual conditions and create a new spiritual unity and a new style for the age; and yet further, he is supposed to search out the existing spirit and passively let it flow through him. Gropius expected the Bauhaus students to follow these simultaneously. In his speech for the first show of student work he criticized those who took excessive pride in the 'craft' and material 'finish' of their work at the expense of conceptual 'ideas': 'First of all, the appearance: many beautiful frames, impressive display, finished pictures. For *whom*, actually? I had particularly requested that *sketches* of *projects* and ideas also be submitted. Not a single painter or sculptor has submitted ideas for compositions, which in fact should form the *core* of such an institution as ours. Who today is capable of painting a completely executed, finished picture?'[28] Yet soon after this speech, and many times throughout the history of the Bauhaus, he criticized the students for avoiding shop work and for retreating into mere design by drawing. He also pointed out the shortcomings of designs by 'pencil strategists' in comparison with those by students who learned about materials and processes in craft training. The superimposition of Romantic and Positivist ideas demanded simultaneously both conceptual ideas free from the dominance of material exigency, and non-conceptual, deterministic form found solely in the practice of craft.

85 Lyonel Feininger, cover illustration for the *Manifesto and Program of the Weimar Bauhaus*, 1919. Feininger's woodcut illustration for the founding manifesto of the Bauhaus reveals the school's early Expressionist orientation.

The split between *Werklehre* and *Formlehre*

On one crucial point both the Positivist and Expressionist strands in Gropius's thinking were agreed: the students should not be given any preconceived ideas about form. The Positivist side desired the students to have an open mind so that they could see the correct form as it presented itself in the operations of craft, while the Expressionist side desired the students to have an open mind so that they could either discover the Spirit as it presented itself to them, or invent a new Spirit unencumbered by past conceptions. So in opposition to the entire Western tradition of design education in the apprenticeship system and the academies, Gropius refused in the first year of the Bauhaus to present any patternbooks, or exemplars, or lectures on principles of form. He was confident, on the basis of his dualistic theory, that the students would find sufficient sources of form within the workshop activities alone.

Unfortunately, Gropius soon discovered, the students were not learning to design in the shops. They were acquiring craft skills, but they did not know to what forms these skills should be applied. Gropius realized he had no recourse but to give the students some additional training in conceptual design. He was forced to split the staff and the curriculum into the *Werklehre*, or instruction in craft, and the *Formlehre*, or instruction in conceptualization and the principles of design. In so doing he returned to the same dual system of education in the academies. Gropius regretted this split, but he did not think it resulted from inadequacies in his basic philosophy. In modern times, he explained, art has been divorced from everyday life for so long that few now combine both skills.

But the problem did arise because of confusion in Gropius's intentions. Gropius employed the medieval workshop because it successfully integrated art and technology; but he failed to realize that the medieval system worked successfully because all the workers shared a specific repertoire of forms and patterns. A *Bauhütte* worker could be both artist and craftsman because he created variations on established themes. When Gropius forced into this system the Positivist and Expressionist conceptions of design, both of which reject any preconceived repertoires of form, he removed from the system the very structure that had allowed guild apprentices to learn about form without relying on abstract lectures.

So Gropius needed some instruction in design, but instruction that would not give the students preconceptions about particular forms. For this he turned to the contemporary avant-garde painters. By 1920,

when the need for some preliminary instruction in the Bauhaus was painfully obvious, the abstract painters discussed in the last section had already explored what they considered to be the essential, underlying characteristics of form in the abstract, divorced from any particular phenomena. To teach the Bauhaus students these abstract characteristics of form seemed like the ideal solution to Gropius, because the students could learn about visual form without compromising the Positivist and Expressionist abhorrence of preconceived ideas.

Johannes Itten (1888–1967) developed the first theoretical design instruction at the Bauhaus. Like all Romantics before him, he desired a fusion of subject and object, man and nature, spirit and matter. And like previous Romantics, Itten assumed that the mind possesses an immediate, intuitive apprehension of nature's essence. He based his own conception of this intuitive apprehension on Theodor Lipps's theory of empathy. According to Lipps, we remember, man unconsciously animates the surrounding world by projecting his own feelings on to inanimate objects, thus making the world seem less divorced from himself. As Itten understood this idea, developing the student's innate artistic abilities is one and the same with developing his innate psychological ability to 'feel' himself into the object before him, and then to reproduce his feelings in a work of art. In the foundation course, or *Vorkurs*, Itten had the students express their emotional responses to themes like 'storm' and 'war' through quickly executed chalk and charcoal drawings. As a concession to Gropius's Positivism, Itten also had the students respond emotionally to constructional materials. By encouraging his students to experiment randomly and creatively with materials like paper, cloth, wood and paint, Itten hoped they would discover within themselves certain feelings about the materials that would help direct their creation of form. To Positivists these exercises showed how materials create form, but in Itten's theory the form derives ultimately from the subject's reaction to materials, not from some intrinsic properties of the materials themselves (Figure 86).

Following the usual Romantic convention, Itten insisted that these inner emotions emerge only if the students are freed from their previous cultural conditioning and returned to what Banham called the 'noble savagery of childhood'.[29] In the preliminary course, Itten intended to liberate the students' creative powers. He consequently revived Rousseau's instruction to let the students learn through self-directed work. He thought they should discover for themselves their own internally generated perceptions and knowledge. This

86 V. Weber, a study of materials, 1920–21. This was a typical student exercise in Itten's preliminary course.

Romantically inspired tenet of education became one of the hallmarks of most subsequent Modernist education.

Like most Romantics before him, however, Itten was not content to let just any perceptions and emotions emerge from this self-directed study. Some emotional responses to objects, like those captured in the medieval painters Bosch, Master Francke and Grünewald, Itten claimed, are more profound or correct than others because they avoid the later Renaissance/Baroque dualities. So restating an idea first explored by the Nazarenes more than a century before, Itten asked the students to immerse themselves in the 'right' emotional culture in

order to encourage the 'right' emotional responses to objects. Itten
took as his model an Oriental – rather than a Christian – monastery,
and encouraged his students to shave their heads, follow special diets,
chant prayers, undertake meditation and breathing exercises before
drawing, and wear robes which combined a monk's cowl and an
artist's smock. The students also explicitly studied the German primi-
tive paintings, to discover the 'basic principles which underlie all cre-
ative activity in the visual arts'.[30] Itten fell into the common paradox
in Romanticism that, at one moment, wishes to free the students from
all outer constraint while, at the next moment, wishes to immerse the
students in the proper social milieu.

Gropius supported Itten's educational theories at first, because they
seemed to offer the students guidance without constraint. But Itten
became so concerned with the spiritual well-being of the students that
he increasingly feared the practical training in the workshops would
destroy their reflective, inner resources. Gropius still wanted form to
arise out of material and function in the workshop, and so he eventu-
ally became disillusioned with Itten and his cultist leanings altogether.

The spirit of the times was ultimately against Itten's Romanticism.
After 1921 much German thinking shifted away from Expressionism,
with its emphasis upon personal expression and intuition, and towards
Neo-Plasticism, with its impersonal, 'objective laws' of form. The
Bauhaus first became acquainted with De Stijl ideas through Lyonel
Feininger and van Doesburg, and increasingly many of the Bauhaus
staff and students came to agree with these two that the Bauhaus must
be purged of its 'rampant romanticism'.[31] After several arguments with
Gropius over the organization and management of the shops, Itten
finally resigned in the spring of 1923. Gropius still hoped to reconcile
the fundamental split between *Formlehre* and *Werklehre* by giving all
of the students some basic training in the principles of design, so he
turned the *Vorkurs* over to teachers who were more inclined to the De
Stijl ideas, Joseph Albers (1888–1976) and László Moholy-Nagy
(1895–1946).

In the artistic and educational theories of these two one can clearly
discern a shift from the earlier Romantic preoccupation with the sub-
ject to a Positivistic and Neoclassical preoccupation with the object.
Albers, for example, stressed the Positivist notion that form objectively
derives from the inherent nature of functions and materials: 'Economy
of form depends on function and material. The study of the material
must, naturally, precede the investigation of function. Therefore our
studies of form begin with studies of materials.'[32] Itten had conducted
exercises with materials, of course, but where he had asked the

students to discover their feelings about the materials, Albers contrarily expected them to discover the inherent characteristics of the materials themselves. He asked them to 'solve certain given problems in technique and form by making original constructions out of a great variety of materials ... These constructions must demonstrate the qualities and possibilities of the materials by fulfilling the technical requirements set forth in the wording of the problem.'[33]

Moholy-Nagy, for his part, reasserted the Neo-Classical belief in an objective and universally valid language of design that exists independently of individual predilections or tastes. Inspired by De Stijl, he attempted to show that all art and architecture – no matter what its style – consists of lines, planes, masses and colors composed according to principles including balance, proportion and rhythm (Figure 87). These elements and organizing principles Moholy-Nagy termed a universal 'language of vision'. Like his Neoclassical predecessors, he expected that knowledge of this language would infallibly guide students to design beautiful objects.

Gropius was delighted with the new formulation of the *Vorkurs*. Moholy-Nagy's 'language of vision' seemed to provide a solid and universal base of knowledge about form that could guide the students to create beautiful objects without leading them into preconceived styles. Indeed, Moholy-Nagy's *Vorkurs* continues to provide the conceptual foundations for many first-year architecture courses even today. Yet just how universally applicable is this language? It clearly derived from the simple, planar style of Elementarism which he was developing in parallel with van Doesburg, and as long as students designed within that particularly Bauhaus style it could be said that they followed Moholy-Nagy's visual principles. But can we say that a Gothic cathedral derives from Elementarist aesthetics? By some creative formal analysis we might describe how Gothic forms are really complex versions of points, lines and planes, but no one can reasonably expect that a master mason thinking about points, lines and planes *alone* would have generated a Gothic cathedral. The principles in the 'language of vision' might be sufficiently universal to describe *after the fact* all artistic production, in other words, but knowledge of this language alone would never have generated the wide variety of architectural forms in the history of the world. And once one concedes that the language really only generates a certain range of styles, then its claim to universality disappears. Moholy-Nagy's language is really a normative guide to a particular Modernist aesthetic.

Even Moholy-Nagy himself used his principles to encourage the 'correct' style. In a story related by Banham, he once chastised one of

87 László Moholy-Nagy, *Composition A II*, 1924. Moholy-Nagy rejected
Itten's Expressionism and attempted to demonstrate that all art and
architecture rationally reduces to lines, planes, masses and colors composed
according to principles of balance, proportion and rhythm.

his students for changing earlier cylindrical milk jugs into drop-shaped ones: 'Wagenfeldt, how can you betray the Bauhaus like this? We have always fought for simple basic shapes, cylinder, cube, cone, and now you are making a soft form which is dead against all we have been after.'[34] Neoclassicism also claimed to have established universal principles of design, but with the hindsight of history we can see that these were stylistically laden. Sufficient time has passed to see Moholy-Nagy's universal language of vision in a similar light.

By 1923, with the shift to objective formalism complete, Gropius felt that the Bauhaus had finally established the ideal system of art and design education. Intriguingly, he believed he had accomplished this because he and his age had managed to resolve the subject–object problem: 'The dominant spirit of our epoch is already recognisable although its form is not yet clearly defined. The old dualistic world-concept which envisaged the ego in opposition to the universe is rapidly losing ground. In its place is rising the idea of a universal unity in which all opposing forces exist in a state of absolute balance.'[35] And in consequence of resolving the subject–object problem, Gropius believed he had finally reconciled all of the competing 'isms' that had previously plagued Western theory. Gropius insisted – and all who came after him in the subsequent Modern Movement continued to insist – that with the establishment of the Bauhaus approach there would be no more 'styles', only correct solutions to architectural and artistic problems. Indeed, at Gropius's instigation, most subsequent twentieth-century architects and theorists have disparaged the concept of 'style' as standing for the superficial and contingent. This response is natural enough. The concept of style had developed in the first place when theorists in the Enlightenment challenged the belief in timeless, objective principles. Once Gropius reaffirmed universal principles, the concept of style would have to be attacked.

As far as Gropius was concerned, this new conception of design and education combined and reconciled all the desirable components of artistic and architectural production. It awakened the students' inner creative potentials and encouraged original responses to the new conditions of the twentieth century; but it avoided mere subjective responses and stylistic anarchy by offering universal principles of form that infallibly guide its adherents to produce objectively beautiful forms. His own design for the school expressed his ideal (Figure 5). Gropius's new conception seemed to offer something to everyone in the early decades of the new century. For those who stressed originality and a break with the past, he institutionalized the concept of the avant-garde. For those who despised the artistic and philosophical rel-

ativism of their predecessors, he offered infallible guides to timeless
artistic certainties. Gropius's new system of education so clearly
embodied the new Spirit of the Age in the twentieth century that it
was eventually taken up by most schools of architecture throughout
the world.

Unfortunately, his system was still riddled with contradictory
notions about the source of design ideas. For different reasons at dif-
ferent points in his theory, he placed the principles of design first in a
shared Spirit, then in the common structure of all minds, then in the
individual mind, and then in the objective characteristics of physical
materials and craft processes. Should the designer trained in the
Bauhaus method turn his back on his culture, or immerse himself in
it? Should he respond to his own inner creative urges or to the
demands of craft and function? Does his age demand a new set of
forms, or can he employ forms invented in the previous age?[36] Despite
its subsequent successes in overthrowing the academic system of
design education, Gropius's theory remained an uneasy conflation, not
a reconciliation, of opposing conceptions of design.

The Modern Movement

Modernism as Positivism

The ideas summed up in Gropius's synthesis captured the attention of
avant-garde artists and architects throughout Europe. No longer
would the avant-garde fight among themselves to determine the basic
direction of modern design; now they needed to sell the new consoli-
dated ideas to an as yet unwilling public. To fight for the acceptance
of the new ideas, they formed the Congrès Internationaux
d'Architecture Moderne (CIAM) in 1928, and five years later in
Britain, the Modern Architectural Research Group (MARS). Their
strategy was simple but effective. Rather than present the new
'International Style' as yet one more aesthetic style in a long history of
styles, they offered it as the one true way of building that would for
ever replace all style. This was possible, they asserted, because the
new approach was not about mere image; it was about how to build
functionally, rationally and economically. Ludwig Hilberseimer wrote
several books while at the Bauhaus, for example, which interpreted
the new style as the inevitable result of materials and constructional
processes. This emphasis on function and economy at the expense of
appearance parallels Durand's arguments over a century before for the

universal nature of Classicism.

In stressing hard-nosed function as the basis of the new approach, the Modern Movement acquired a Positivistic slant. The modernists began to speak of architecture as a 'problem-solving' activity. Given any set of technical, economic or social conditions, the architect finds in these conditions the perfect, functional solution. Gropius made this point in a speech to Harvard upon becoming the Professor of Architecture in 1937:

> My intention is not to introduce a, so to speak, cut and dried 'Modern Style' from Europe, but rather to introduce a method of approach which allows one to tackle a problem according to its particular conditions. I want a young architect to be able to find his way in whatever circumstances; I want him independently to create true, genuine forms out of the technical, economic and social conditions in which he finds himself instead of imposing a learned formula on to surroundings which may call for an entirely different solution. It is not so much a ready-made dogma that I want to teach, but an attitude toward the problems of our generation which is unbiased, original and elastic.[37]

For some, the Positivism ran even deeper. From the Enlightenment philosophers onwards, the Positivist tradition had conceived of the individual as an object in a purely materialistic world, whose behavior is completely determined by outside physical forces. Some modernists turned this into architectural determinism, in which buildings shape people. Moholy-Nagy in his 1928 book *Von Material zu Architektur* (published in English in 1947 as *The New Vision*), set out his ideas about the universal language of form, the objective properties of materials and the importance of learning by doing. He then introduced the concept of 'biological function'. The experience of space, he claimed, results from external sensory material impinging upon the human organism. After asserting that these external experiences shape the individual's biological well-being, he approvingly repeated Adolf Behne's quote from Heinrich Zille that 'you can kill a man with a building just as easily as with an axe'.[38] Architectural determinism remained a theme throughout much of the Modern Movement.

Roughly parallel with the emergence of the Modern Movement in architecture grew Analytical Philosophy and Logical Positivism. Proponents of these two views saw themselves as continuing the Empiricist and Positivist traditions in rejecting metaphysics and seeking to base knowledge on empirical facts. Ludwig Wittgenstein (1889–1951) offered a radical form of Empiricism in his *Tractatus Logico-Philosophicus* (1922), where he maintained that the meaning of

any statement follows directly from its relation to a possible empirical fact. By this criterion, most assertions in philosophy and logic say nothing meaningful. Later, in lectures gathered by his students and published posthumously as *Philosophical Investigations* (1953), he showed how most philosophical problems may be reduced to a sloppy use of language. He proceeded to 'solve' the problems of philosophy like Descartes's mind–body problem by clarifying the misuse of language that generated them in the first place.

The Logical Positivists drew back from this extreme conclusion, yet admired Wittgenstein's rigorous Empiricism. Rudolf Carnap, Moritz Schlick, Otto Neurath and Kurt Gödel, among others, discussed throughout the 1920s and 1930s how the empirical principle dissolves many philosophical problems as meaningless, and how a strict Empiricism can establish objective, scientific truths. They encountered a number of the problems that had plagued Empiricism before (for example, how can we be sure on empirical grounds that the sensory experiences of one individual are the experiences of others?); none the less, we can see a clear relationship between the Modern Movement's desire to find its architectural forms in the material 'facts' of the design problem and the Logical Positivist desire to find its scientific truths in the 'facts' of empirical sense.

Modernism as Classicism

Over a century before, Durand used Positivist arguments to justify his favorite forms, the rational geometry of academic Classicism. The Modernists equally used Positivist arguments to justify their favorite forms, the stripped-down machine aesthetic of Gropius and Le Corbusier (Figure 88). Even further, many in the Modern Movement tried to show that the modern aesthetic is really Classicism in its purest and most timeless form. The Bauhaus had already asserted some of the philosophical parallels between Classicism and Modernism: good architecture is based on a universal language, and this language is comprised of simple elements rationally organized. Le Corbusier (1887–1965) made the relationship even more explicit. In *Vers une Architecture* (1923) he drew clear parallels between the traditional Classical language of ancient Greece and the new aesthetic of the machine, even juxtaposing a picture of the Parthenon against that of an automobile. Like all Classicists before him, he expressed a preference for the regular solids of 'cubes, cones, spheres, cylinders or pyramids' as the 'most beautiful forms', and maintained that our perception of these forms 'put us into a state of satisfaction (in conso-

88 Villa Savoye, Poissy, France, 1928–30. Le Corbusier. The early Modernists rejected all previous architectural styles, although they sometimes argued that the new machine aesthetic was really Classicism in its purest form.

nance with the laws of the universe which govern us and to which all our acts are subjected)'.[39] He disparagingly noted that Gothic architecture is not based on these timeless forms and so is not 'beautiful'.

Having made the case that timeless principles underlie nature, Classicism and his own machine aesthetic, Le Corbusier then curiously brought subjective invention back into design. He dismissed the view that natural forms inspired the Doric column, and noted instead that the '*Greeks created a plastic system* ... so pure that it gives almost the feeling of a natural growth. But none the less, it is entirely man's creation.'[40] The character of a design, he further insisted, 'is a pure creation of the mind'.[41] And while he maintained that 'architecture has nothing to do with the various "styles"', he then went on to note with pride that 'our epoch is determining, day by day, its own style'.[42] These dualities between objective and subjective, timeless and contingent, Classicism and Positivism, appear time and again throughout the literature of the Modern Movement. The Bauhaus conflation failed to achieve a true resolution of the earlier debates, and so the various contradictions continued to run through subsequent Modernist thinking.

Modernism spread rapidly to the United States, helped by a number

of the Bauhaus faculty who fled Nazi Germany and took teaching positions in American colleges and universities. Besides Gropius at Harvard, they included Moholy-Nagy (Director of the New Bauhaus, now the Institute of Design, Chicago, 1937–46), Marcel Breuer (1902–81) (Associate Professor of Architecture, Harvard, 1937–46), and Joseph Albers (who from 1933 to 1950 lectured at Black Mountain College, Cincinnati Art Academy, Yale, Harvard and Pratt, and in 1950 was chairman of the Department of Design at Yale). Positioned in some of the most influential schools in America, they and their successors managed to overthrow the Beaux-Arts system then dominant in American architectural education. In its place they offered the 'Bauhaus method' that still dominates many schools today. Any school that tells students to avoid preconceptions; that teaches the 'basic design' principles of point, line, plane, rhythm, balance, proportion, etc., in the first year studio; that insists on creativity over tradition; that seeks a new expression for a new age but disparages the word 'style', has inherited the Bauhaus tradition together with its paradoxes.

Notes

1 Alfred North Whitehead, *Process and Reality: an Essay in Cosmology*, The Macmillan Company, New York, 1929, p. 7.
2 *Ibid.*, pp. 12-14.
3 In Herbert Spiegelberg, *The Phenomenological Movement: A Historical Introduction*, 2nd edn, vol. 1, Martinus Nijhoff, The Hague, 1976, p. 82.
4 Julien Guadet, *Eléments et théorie de l'Architecture*, 4th edn, Librairie de la Construction Moderne, Paris, 1909, vol. I, p. 87.
5 *Ibid.*, p. 102.
6 *Ibid.*, p. 7.
7 *Ibid.*, p. 99.
8 *Ibid.*, p. 100.
9 *Ibid.*, pp. 100–1.
10 In Marcel Franciscono, *Walter Gropius and the Creation of the Bauhaus in Weimar: the Ideals and Artistic Theories of Its Founding Years*, University of Illinois Press, Urbana, 1971, p. 115.
11 *Ibid.*, p. 98.
12 *Ibid.*, p. 102.
13 In Haftmann, *Painting*, p. 99.
14 In Osborne, *Aesthetics*, p. 59.
15 Banham, *Theory and Design*, p. 152.
16 Haftmann, *Painting*, p. 54.
17 *Ibid.*
18 *Ibid.*, p. 118.
19 *Ibid.*, p. 119.

20 Banham, *Theory and Design*, p. 15.

21 Wolfgang Pehnt, *Expressionist Architecture*, Thames and Hudson, London, 1973; and Franciscono, *Walter Gropius*.

22 Walter Gropius, 'Programme of the Staatliche Bauhaus in Weimar', April 1919, in Hans Wingler (ed.), *The Bauhaus*, MIT Press, Cambridge, Mass. and London, 1978, p. 31.

23 Gropius, speech to representatives of Weimar crafts and industries, spring 1919, in Franciscono, *Walter Gropius*, p. 62.

24 Gropius, address to the Bauhaus students, held on the occasion of the yearly exhibition of student work in July 1919, in Wingler, *Bauhaus*, p. 36.

25 *Ibid.*

26 Gropius, 'Programme of the Bauhaus', in Wingler, *Bauhaus*, p. 32.

27 Gropius, statement of 1919 in *Ja: Stimmen des Arbeitsrates für Kunst in Berlin*, in Franciscono, p. 69.

28 Gropius, address to students, in Franciscono, *Walter Gropius*, p. 140.

29 Banham, *Theory and Design*, p. 279.

30 *Ibid.*

31 Feininger, from a letter to Julia Feininger dated 7 September 1922, in Wingler, *Bauhaus*, p. 56.

32 Josef Albers, 'Concerning Fundamental Design', in Bayer, Herbert, Walter Gropius and Ise Gropius, eds, *Bauhaus 1919–1928*, The Museum of Modern Art, New York, 1938, p. 114.

33 *Ibid.*

34 From a letter to Nikolaus Pevsner, in Banham, *Theory and Design*, p. 282.

35 Gropius, 'Theory and Organization of the Bauhaus', in Bayer *et al.*, *Bauhaus*, p. 20.

36 Supporters of the Modern Movement were happy to demand a new artistic expression for a new age when this argument supported their own stylistic revolution; but they did not like to have this same argument turned against the Modernist style itself several generations later. Witness the Modernist hostility to Post-Modernism when the latter claimed to be the new Spirit of the Age in the late 1970s.

37 Walter Gropius, a statement made for *The Architectural Record*, May 1937, in Gropius, *The Scope of Total Architecture*, George Allen & Unwin Ltd, London, 1956, p. 21.

38 László Moholy-Nagy, *The New Vision*, Daphne M. Hoffman, trans., George Wittenhorn, Inc., New York, 1947, footnote, p. 59.

39 Le Corbusier, *Towards a New Architecture*, Frederick Etchells, trans., The Architectural Press, London, 1946, pp. 31, 21.

40 *Ibid.*, pp. 192-3.

41 *Ibid.*, p. 198.

42 *Ibid.*, pp. 27, 9.

9

The twentieth century (II)

Late Modernism

After the Second World War, Modernism clearly emerged as the paradigm of architecture and architectural education. Practitioners of traditional styles no longer received the prestigious commissions, and the new generation of architecture students learned the International Style in programs fashioned after the Bauhaus. The wartime devastation provided unprecedented opportunities to rebuild the cities of Europe in the new style, while the corporations in the United States embraced its austere, rational image. The orthodox International Style continued throughout the 1950s in notable buildings like Mies van der Rohe's Seagram Building (1958) and Skidmore, Owings and Merrill's Lever House (1952) (Figure 89).

Throughout the history of the West, however, we have seen how a period preoccupied with rational objectivity often engenders a subjective reaction. Mannerism after the Renaissance, the rise of artistic subjectivity after the Baroque's rational extremes, the Romantic reaction to the Enlightenment's positivism, are all examples of the pattern. Likewise, after the Second World War, a more expressionistic movement rose to challenge the International Style. For lack of a better term, we might call this baroque reaction Late Modernism. A number of the modern masters led this 'revolt from reason', as Pevsner disparagingly termed it.[1] Le Corbusier shocked his followers with his design for Notre-Dame-du-Haut at Ronchamp (1950–55) (Figure 90). It violated most of his own previous rules for design, and celebrated curvilinear and non-orthogonal forms. Although a number of metaphors have been offered as the source of this design, it is so unprecedented and intensely personal that Le Corbusier's earlier claims to basing architecture on objective principles fly out of the window. Other well-known examples of this new expressionism

89 Lever House, New York, NY, 1951–52. Gordon Bunshaft and Skidmore, Owings and Merrill. The orthodox post-war International Style portrayed an austere, rational image.

90 Notre-Dame-du-Haut, Ronchamp, France, 1950–52. Le Corbusier. Le Corbusier shocked his rationalist followers by indulging in what they considered to be a subjective essay in Expressionism.

91 Sydney Opera House, Sydney, Australia, designed 1957. Jørn Utzon. This is another example of the Expressionism in post-war Modernism.

include Frank Lloyd Wright's Guggenheim Museum in New York (1946–59) and Marin County Civic Center (1959–64), Eero Saarinen's TWA Terminal at Kennedy Airport in New York (1956–62), Jörn Utzon's Sydney Opera House (1957–73) (Figure 91), and Bruce Goff's Bavinger House in Oklahoma (1951–57). Like the rise of artistic subjectivity in the the late Baroque, these architects offered little philosophical justification for their new turn of direction.

Perhaps this new mood reflected a similar struggle in contemporary philosophy to reconcile the subjective self with an objective world. Maurice Merleau-Ponty elaborated Phenomenology after the Second World War, and attempted to rescue this tradition from what many began to see as Husserl's slip into idealism. That is, the more Husserl 'bracketed' his experiences and discovered knowledge deeply hidden inside the ego, the more it began to appear that this new knowledge was constructed by mind and not simply discovered in experience. Merleau-Ponty tried to reaffirm the reality of a world outside our consciousness of it.

The other major post-war philosophical movement, Existentialism, came to more subjective conclusions from Phenomenological beginnings. Jean-Paul Sartre took for granted the existence of an external world, and accepted the Phenomenological idea that one can, by looking into consciousness, strip away all preconceptions and see the world for what it really is. Unfortunately, what one discovers are not the clear, indubitable truths that Husserl had sought, but a terrifying and absurd world of blurred images and sounds where everything is loose and separated. Even worse, one loses an enduring sense of self or personality, because self turns out to be an equally artificial construction. In face of this existential nothingness, Sartre then asserted, individuals must make their own focus and center. This echoes Nietzsche's response to the loss of certainty a century and a half before. For Sartre, individuals have complete freedom to choose their own direction, and they must accept complete responsibility for their choices. Ayn Rand expressed this priority of the individual in her novel, *The Fountainhead* (1943). Her architect protagonist (a thinly disguised Frank Lloyd Wright) defiantly refuses to compromise his Modernist principles to the point of ruining his career. The climax of the novel has him blowing up a 'compromised' building in defence of his own personal vision of truth. Here we have the old Romantic image of the artist, standing in advance of society, disdaining its disapproval of him and following his own vision wherever it might take him.

Once the dogmatic rules of the International Style were loosened

after the war, personal expression became the mainstay of much Modernism throughout the 1960s. In the hands of architects like I. M. Pei, Paul Rudolph, James Stirling (Figure 92) and the New York Five, creative shape-making became an end in itself. The desired effect was now architecture as inventive three-dimensional sculpture, not architecture as an expression of timeless principles of nature, or architecture as solving functional requirements. Where the expressionists in the 1940s and 1950s had experimented with curvilinear and plastic forms, many of the architects in the 1960s returned to a stronger rectilinear geometry. Paul Rudolph's Art and Architecture Building at Yale (1963) exemplified the new image and, in the minds of many, represented the priority of a visual 'formalism' over function (Figure 93). Although Rudolph had studied under Gropius at Harvard, he publicly disparaged the concept of function. He noted that even Mies van der Rohe, the archetypal 'functionalist', selectively chose which problems to solve in order to further his aesthetic ends. Rudolph also disparaged Gropius's concept of the architecture team, and stressed instead the priority of individual creativity.

Positivism and environmental design

Two sides of the 1960s culture eventually objected to this subjective formalism. This was a decade with a strong social conscience, and many students and architects found this formalism to be too arid, too selfish, too detached from the problems of the world (the Yale Art and Architecture Building was mysteriously gutted by fire at the height of the 1960s student revolts). This was also the decade of the 'space race'. Many placed great faith in the powers of science and technology to solve all of society's problems, including those related to the built environment. These two sides of the sixties culture converged in their efforts to reform architecture and give it a more solid foundation than personal expression. On one thing the reformers agreed: architecture should be more responsive to people and their needs.

Although the reforms took many directions, one of the most interesting in terms of this book's central theme was the effort to remove architecture from the world of subjective aesthetics and to make it a rigorous empirical science. The reformers conceived of this as a radical departure for architecture, but we have seen this quest before: in the Enlightenment's 'sciences of man' and their first functionalist theories; in nineteenth-century Positivist theories of art and architecture; and in Gropius and Moholy-Nagy. This time around,

92 History Faculty Building, Cambridge, England, 1964. James Stirling. Modernists in the 1960s ignored the arguments in early Modernism for timeless principles and functionalism, and explored architecture as creative shape-making.

93 Yale University Art and Architecture Building, New Haven, Conn., 1959–63. Paul Rudolph. Rudolph disparaged the concept of functionalism he had learned from Gropius at Harvard, and stressed the priority of personal creativity.

however, the idea went beyond a general statement of intention and blossomed into a major research effort. The new research attempted to develop two key components: a body of scientific knowledge about how people use and are affected by buildings, and a rigorous method for applying this knowledge to design problems.

The first component developed into the environmental psychology movement in the mid-1960s. At the core of this enterprise was the belief that man and environment are separate entities which act on each other. Man can obviously shape his environment, but equally the environment can shape man. Proponents of this movement consequently conceived of their work as research into 'man–environment relations'. Empirical studies were conducted to explore how people behave in certain environmental settings. Some studies placed individuals in controlled artificial settings, others unobtrusively studied people in carefully selected real spaces. The aim always was to discover invariant relationships between a particular spatial configuration and a particular human behavior. The Environmental Design Research Association (EDRA) was formed, and numerous papers were written. The most significant of these studies were compiled in a voluminous book by Harold Proshansky, William Ittelson and Leanne Rivlin, *Environmental Psychology: Man and His Physical Setting* (1970).

Despite some initial insights into human behavior in buildings, this movement ran into problems. People did not seem to act invariantly the same in the same setting; they could adapt the same behavior to different environments, and they could change behavior in the same environment. Other factors like cultural background or personality seemed to shape behavior as much as the physical setting. The more the researchers accounted for all of the factors involved, the less specific were the laws which governed man–environment relations. Many had hoped to build a body of knowledge that architects could use to shape buildings, but the knowledge was so general that even sympathetic architects had difficulty seeing how this information would generate a particular architectural form.

In conceiving of their work as the relationship between man and environment, the environmental psychologists had solidly built the subject–object problem into their philosophical foundations.[2] As we have seen before, thinking of man and world as two objects in a system allows us to see how one might shape the other, but it does not easily allow us to see how the two sides might interactively shape each other. For this reason some environmental psychology lapsed into architectural determinism. Unfortunately, even those who wanted to attribute more autonomy or control to the individual could not easily

see how this would work.

The second component of this scientific enterprise, a rigorous method, grew into the Design Methodology movement. Research began under the direction of Horst Rittel at the Hochschule für Gestaltung in Ulm, West Germany in the 1950s, inspired by the operations research that came out of the Second World War. Great Britain held the first international meeting of methodologists in London in 1962 and sponsored a number of other important conferences and theorists throughout the sixties. In the United States, Horst Rittel moved to Berkeley in the early sixties, and was later joined there by Christopher Alexander who began his work at Harvard and MIT.[3] Other notable methodologists in this period included Geoffrey Broadbent, Anthony Ward, Bruce Archer, Raymond Studer, Marvin Manheim, Thomas Markus and J. Christopher Jones.

Christopher Alexander set out the most influential design method in *Notes on the Synthesis of Form* (1964). Referring explicitly to Gropius and Moholy-Nagy, he restated the Bauhaus arguments for a design method: design consists of solving functional problems; the problems of the modern world are too unprecedented to solve with past solutions; and modern problems are too complex to solve with personal intuitions. Alexander offered a design method based on the Empiricists' scientific induction. Restating Gropius as well as the empiricist scientists like Newton, he insisted that the designer must avoid all preconceptions, because preconceptions impose solutions that have not been discovered in the problem. In the first stage of design – what Alexander called *analysis* – he advised the designer to gather together the objective requirements of the problem and then draw up a list of their relationships. As in Bacon's inductive method, this list should identify which requirements are in conflict, which go together, and which have no relationship. Out of this analysis emerges a pattern of interrelated subsets of problems.

In the second stage of design – what Alexander called *synthesis* – this pattern of interrelated subsets 'will then lead to a physical object whose structural hierarchy is the exact counterpart of the functional hierarchy established during the analysis of the problem'.[4] About this he says no more. Once the hard work of analysis is done, for Alexander synthesizing a form is almost inconsequential. As designers who used this method quickly discovered, however, the process of translating a diagram of relationships into an architectural form was far from inconsequential. Those who rigorously followed Alexander's precepts and avoided all preconceptions usually ended up with abstract 'bubble diagrams' of forms without hints of structure, materi-

al or an organizing geometry. Furthermore, Alexander's method suffered from the same circular problem that plagues the inductive method in science: one is supposed to discover a pattern in the facts, but one must first have an idea of the pattern in order to know which facts should be considered.

By the beginning of the 1970s some researchers in this movement had grown disillusioned with their progress. Many of the methods taken over from science and product engineering did not seem to sit well on the architect's designing activities, nor were they generating better buildings. Horst Rittel proposed a 'second generation' of methods that rejected the idea of the architect as someone who applies objective knowledge to a problem. He conceived of the architect and the eventual building users as equally ignorant, and proposed that, through structured argumentation about design issues, the designer and users would eventually develop together the ideal solution to the problem. This blossomed into the participatory design movement. Although its intentions were admirable, its effect was to highlight a problem lurking in the Positivist approach. The more closely an architectural form was tailored to the desires and values of particular people at a particular time, the less could it accommodate future occupants whose desires and values were perhaps quite different. This movement ignored those issues which are timeless and shared in favor of those which are more temporary and contingent, even though buildings live long beyond their occupants.

Despite these problems with environmental psychology and design methodology, a number of schools of architecture reorganized themselves to teach the new scientific approach. In 1960 Lord Llewelyn Davies rejected the Beaux-Arts method still flourishing in the Bartlett School of Architecture in University College London, and replaced it with a rigorous education in the basic sciences that impinge on architecture. In his inaugural lecture 'The Education of an Architect' he argued the case for environmental determinism, and concluded that the architect must 'be taught something of anatomy, physiology, and the psychology of the special senses. He must also understand enough physics to predict the physical conditions which will be produced within his buildings by his design'.[5] The school would teach basic theory alone; the architectural offices would later show students how to apply those theories to practice. He restated Vitruvius' original split between theory and practice, only now the theory is not about architectural form itself, but about the forces that shape form. Later in the decade the University of California at Berkeley followed suit, teaching design methods and the social and physical determinants of form

rather than a language of form itself. This approach was called 'environmental design', because it purported to teach general principles common to all the design fields that create the built environment. Numerous schools around the United States in the 1970s followed Berkeley in this concept.

Structuralism

Another broad tradition of ideas developed in the 1960s, known as Structuralism. It was not a tightly organized movement at first, and indeed not everyone who worked within its general framework admitted to its title. Only later, was the term applied to a general philosophical attitude that had emerged in fields from linguistics and psychology to sociology, anthropology and architecture.

Structuralism arose in linguistic theory. First Ferdinand de Saussure's *Cours de linguistique générale* (1916) and later the Prague Linguistic Circle's *Thèses* (1929) developed the idea that language should be studied as a functional system, rather than as a series of isolated linguistic facts. The focus of attention should be on the *structure* of the system, on the relationships between the system's elements. Linguists in this new approach began to see that, behind diverse languges around the world, one can find a common structure of which individual languages are variations. The implication seemed to be that this generic structure must be built into the human mind. Individual cultures then work out their own language variations within the framework of these inner mental structures.

In the 1960s this idea was extended to other social sciences. Thinkers including Noam Chomsky in linguistics, Claude Levi-Strauss in anthropology and Jean Piaget in developmental psychology looked for 'deep structures' within the mind that guide other personal and collective human behaviors as well as language. The anthropologists sought to show that different cultures around the world and throughout history are really variations on a few themes. The universal structure of the human mind allows of a large but not infinite number of possibilities, and individual cultures responding to localized conditions, previous traditions and so on, work out their own specific variation within this framework. The psychologists similarly attempted to explain different personalities and behaviors as variations on these shared human structures.

This was, in essence, a return to Kant. Like Kant, the Structuralists wanted to show how human knowledge and human behavior result

from interactions between information from the outside world and the active structuring and organizing processes of the mind. In different variations, they took up Kant's idea that the mind provides the form while the world provides the content. Where other philosophies tended to focus on one at the expense of the other, Structuralism drew close attention to the relations between mind and world, and the mechanisms by which they interact. This put Structuralism at odds with just about every other contemporary philosophy. Against the Logical Positivists and Phenomenologists, the Structuralists asserted that the mind does not passively receive knowledge from the outside; it actively imposes structure on to this material. Against the behavioralists and architectural determinists, the Structuralists showed that individuals are not entirely subject to whims of outside force or influence; they also actively regulate themselves from within. And against the Existentialists, the Structuralists asserted that there are limits to freedom of action and choice, since the organizing structures within the mind allow of only a finite and perhaps limited range of possibilities.

Jean Piaget's auto-regulating model of the mind

Kant had proposed that these organizing structures within the mind are innately wired into every human brain. This ensured objective knowledge for him, since every mind imposes the same structure on to sense experience. Some Structuralists agreed. Noam Chomsky, for example, argued that the human brain innately possesses a universal set of linguistic rules. But as we saw in the discussion of Kant earlier, the concept of innate structures has some difficulty accounting for evolution or change in our organizing concepts. For example, to understand the sensory experience of 'silvery, buzzy, floating material in the sky', we need the mental concept of 'airplane'; but the concept of 'airplane' obviously is not innately built into the human mind.

Jean Piaget, the Swiss psychologist and philosopher, improved on Kant by showing how sensory data and the mind's categories – what he called mental *schemata* – mutually construct each other.[6] The mental schemata are not innately given at birth, but rather develop and evolve in regulated response to outside stimuli. Piaget discovered this process by extensively studying the cognitive and motor skill development of children. Consider a young child attempting to pick up a ball. At first he cannot co-ordinate his actions – he does not yet possess a schema for picking up balls – and so he experimentally thrashes

about. Through this play, the child eventually discovers that if he grasps his hands together in just such a way he can pick up the ball. Pleased with the result, the child tries the same action again, and realizes the same effect. He eventually remembers this action as a schema. Once internalized, the schema gives the child competence to solve the problem of grasping a ball at any time in the future, without further experimentation.

As the child acquires these schemata, he adds them to an inner repertoire. Faced with any new problem, he first searches this repertoire to see if any existing schema will solve it. If one does, Piaget says that the existing schema *assimilates* the problem. If no existing schema works, the child selects the one closest to the actions he desires, and experiments with it until a successful new schema emerges. Piaget says that this schema has been *accommodated* to the problem. Where assimilation enables the individual to deal easily with problems he has already encountered, accommodation enables him to elaborate his existing repertoire and deal successfully with unprecedented problems. The more he solves problems, the more his repertoire of solutions grows. Piaget's idea – more than any other theory we have seen so far – reconciles free will and causality. The physical world cannot completely determine an individual's behavior, because the individual creatively generates his or her own behavior patterns from inner resources; and the individual cannot stand outside physical causality entirely, because the physical world reinforces those proposed schemata which work and rejects those which do not.

The same idea explains how we gain knowledge of the outside world. When faced with some sensory experience, we scan our repertoire of schemata for a concept that gives it sense. A resident of a remote island, upon seeing 'silvery, buzzy, floating material in the sky' might try to subsume the experience under his existing schemata of 'bird' or 'bee'. This solution obviously fails as the 'bird' grows to enormous proportions upon its approach, and so these schemata are creatively adjusted to accommodate the new experience. Once the new idea of 'bird with men in it' or 'airplane' emerges, it can then assimilate and therefore understand future observances of airplanes. More than any theories before, this reconciles the differences between Empiricism and Rationalism. Although sense experience provides the content of knowledge, it can only be understood when the mind imposes form upon it; but the mind adjusts its forms as it tests them against the sense experience. Piaget's theory also begins to explain the curious relationship between knowledge and creation that we explored in the introduction to this book. They both employ the same inherent

mechanisms in the mind, actively creating 'form' to test against the outside world.

Theories of science

Although they did not consider themselves to be Structuralists, several notable philosophers of science in this same period developed similar ideas. In *The Logic of Scientific Discovery* (1959) and *Conjectures and Refutations* (1963) Karl Popper attacked the inductive method of the Empiricists. In this method, the scientist was supposed to avoid all preconceptions or hypotheses and gather together the relevant 'facts' of nature. As Popper pointed out, however, the scientist does not know which facts to gather until he or she has some hypothesis about which facts might be interesting or significant. A falling apple was not a significant 'fact' until Newton's emerging notions of gravitation led him to see its significance. The scientist must begin with a hypothesis. Now some Empiricists had grudgingly admitted the use of hypotheses, as we have seen, but they always maintained that the hypothesis should derive from the facts. Popper disagreed. The hypothesis is merely a convenient starting conjecture about a possible natural law, and it could originate in data, or in analogies from another field, or even in a creative flight of the imagination (to use Whitehead's phrase). The bolder the conjecture the more powerful it might be.

Once the scientist has proposed a conjecture from whatever source, Popper continued, he or she then *tests* it against the world to see if it successfully accounts for the facts. In traditional induction, one tests a hypothesis by finding supporting evidence. The more evidence which confirms it, the more confident we are that it describes a true law of nature. According to Popper, this is no reliable test of a theory. Finding three hundred and one white swans to prove that all swans are white does not guarantee that the three hundred and second swan will not be black. The true test of a conjecture consists in attempting to refute it with at least one case of contrary evidence. As long as no contrary evidence can be found, we can continue to hold the hypothesis as a tentative explanation of the world's structure; but with one refutation we must reject it and try our luck with another conjecture.[7] Popper's model of science is deductive, because the scientist deduces possible tests from a tentatively held general law. As in Piaget, the mind creatively invents a possible solution to a problem, tests it against the world and then either accepts it or modifies it and tests it again.

Thomas Kuhn in this period examined an underlying pattern in the history of Western science. In the *Structure of Scientific Revolutions* (1962) Kuhn noted a recurring cycle. Most of the time, scientists in a given field work within a paradigm, a shared set of norms. The paradigm identifies the interesting problems and establishes the criteria for successful experiments. An example of a paradigm is the Ptolemaic idea that the heavenly bodies rotate around the earth. Researchers accept the paradigm as given, and focus their attention on the 'puzzles' which the paradigm creates. Assuming the heavenly bodies rotate around the earth, how can we explain why the planets appear to reverse their direction on occasion? The intent of research is to fix problems and add cumulatively to the existing body of 'facts' which have already been discovered by one's scientific predecessors. Kuhn calls this *normal* science.

On occasion, however, some problems within a paradigm prove insoluble. The more researchers attempt to iron out the wrinkles, the more other problems and anomalies emerge. These problems become so severe that the scientific community acknowledges a crisis. Some researchers attempt to reconcile the theory with the facts through *ad hoc* adjustments, but a few scientists begin to explore how the problems might be resolved by changing the basic assumptions of the paradigm itself. Copernicus proposed to think of the heavens revolving around the sun rather than the earth, for example. Numerous alternative theories are proposed, each one claiming to account for the facts more satisfactorily. Many scientists cling to the old paradigm, factions grow up espousing their favorite alternatives, and a period of sometimes acrimonious debate ensues. Eventually one of the new ideas comes to dominate, and the entire scientific community takes it up as a new paradigm. At this point a scientific *revolution* has replaced an old tradition with a new paradigm. Kuhn noted, by the way, that the scientific community sometimes accepts a paradigm as much for social reasons (the prestige of the researcher who proposed it) and aesthetic reasons (one proposed paradigm is more 'elegant' than another), as for factual empirical reasons.

A comparison to Piaget is interesting. Like a collective mental schema, a scientific paradigm provides the conceptual tools which enable scientists to solve identified and familiar problems. At the height of its power a paradigm *assimilates* the scientists' problems. When it can no longer adequately solve problems, then the revolutionary scientists creatively experiment with new paradigms. The old paradigm eventually is *accommodated* to the new problems. The same mental structures and procedures that guide individual human behavior and knowledge

can be seen in Kuhn's theory to guide the collective work of a scientific community.

Norberg-Schulz's theory of architecture

In *Intentions in Architecture* (1963) Christian Norberg-Schulz developed a number of these Structuralist ideas into a theory of architecture. While Norberg-Schulz considered himself to be a Phenomenologist, and he began his theory with Empiricist and Phenomenological concepts, we will see that his ideas about the source of form owe more to Piaget than to Husserl.

Our awareness of the physical world is given through perception, he declared in the spirit of Empiricism; we can only infer from our inner sense data the existence of an outer world of objects; and we build up from our inner data abstract knowledge like causality. From Phenomenology, however, Norberg-Schulz took the idea that we have active 'intentions' towards the objects of our perceptions. That is, our *attitudes* towards objects influence our perceptions as, for example, when we overestimate the sizes of things like coins that we consider valuable. Ordinarily, our intentions towards objects consist of simple classifications, like 'fish, flesh or fowl', which allow us to navigate the day-to-day problems of the world. The more we study an object, however, the more these ordinary classifications fail to 'grasp' its essence. If we wish to go beyond these superficial and inadequate conceptions, we must learn how to 'attain' the object's deeper essence.

Here we expect Norberg-Schulz to restate Husserl, to suggest that we look deeper into our consciousness and discover there true and invariant Phenomenological essences. But Norberg-Schulz turned instead to Piaget, and brought in a degree of personal and cultural relativity that would have been repugnant to Husserl. Norberg-Schulz referred to Piaget's research extensively. He described how mind and world interact through mental schemata, how schemata impose a structure on to perceptions, and how schemata change over time as they adapt to new circumstances. He noted how schemata are acquired through personal experimentation, and how different individuals consequently develop their own personal set of schemata. Of particular interest to architects, Norberg-Schulz showed how our sense of space is also organized by mental schemata. Although science has developed rational conceptions of space like Euclidean space and Cartesian grids, these are inventions just like all other schemata. The schemata with which we organize space in our ordinary dealings with

the world are less abstract, and refer to 'up', down', 'beside', 'behind' and so on.

Norberg-Schulz pointed out that individuals are not completely free to develop their own schemata. Culture and socialization guide the individual's experimentations along pre-established lines, and lead to a particular language, set of classifications, and patterns of socially acceptable behavior. Socialization, Norberg-Schulz says, is both 'necessary and dangerous'. It integrates the individual into a common world and gives him or her more skill than he or she would probably accomplish through random experimentation, but it also 'fossilizes' concepts and makes it more difficult for the individual to break out of schemata that possibly no longer work. So knowledge for Norberg-Schulz is objective only to the degree that a culture has similarly directed the development of its members' mental schemata.

Science and art, according to Norberg-Schulz, are two different but equally valid conceptual schemes for understanding the world. Each has its own advantages and disadvantages, each has its own proper role. Science stresses thought, and strives for as dispassionate and objective an account of external phenomena as possible. It creates structures and concepts of great power, as the development of science has shown, but it is divorced from our more common perceptual experiences. Art, on the other hand, although more colored by cultural and personal factors, stresses a more immediate and intuitive perception. He noted that if we want to understand the mood of a person, a glance at his or her face may reveal all; but a scientific investigation would take a long time and perhaps never fully discover what the more immediate perceptions had revealed in an instant.

Here Norberg-Schulz has restated the idea first tentatively explored by the Romantics that art captures a reality different from – but not inferior to – that captured by science. Significantly, though, where earlier theories had these artistic intuitions capturing the true structure of nature, in Norberg-Schulz they more modestly express (or 'concretize', to use his term) the artist's inner mental schemata. That is, art reveals the inner structures with which the artist understands the world, not an objective structure of the world itself.

Often, the artist portrays schemata that are already well-established and widely shared by others in the artist's culture by virtue of a socialization that directed them all along certain lines. When this happens, Norberg-Schulz notes, there is a high probability that anyone similarly educated in the culture will immediately recognize the artwork as something familiar, as a recognizable 'style'. Less often, a particularly creative artist will see that old schemata no longer appro-

priately account for a changed world. Through Piaget's mental process
of accommodation, this artist experiments to realign his schemata
with the new outside realities. Although this work is not understood
by others at first, it possibly offers genuinely new and appropriate
insights which can enrich our understanding of the world. With his
other emphasis on the coercive influence of socialization, Norberg-
Shulz implies that, once established, some of these new conceptual
schemes are eventually taken up as a new cultural tradition, or style,
through which most artists subsequently express themselves. Although
Norberg-Schulz does not refer to Kuhn's theory of scientific revolu-
tions (which was published only the year before), we can see here a
parallel between scientific paradigms and artistic styles, and a similar
description of a cyclical pattern of stability and change. In Norberg-
Schulz this pattern is tied to Piaget's mental processes of assimilation
and accommodation. He aptly summed up his philosophy with a
quote from Whitehead: 'The art of progress is to preserve order amid
change, and change amid order.'[8]

Norberg-Schulz, with some justification, believed he had solved the
subject–object problem and its dualities between science and intuition,
matter and spirit. ' "Physical" and "psychical" objects', he noted, 'are
logical constructions based upon phenomena which, as such, can nei-
ther be called physical nor psychical; they are only classified to allow
for a convenient division of work within the sciences.'[9] In a later
book, *Existence, Space & Architecture* (1971), Norberg-Schulz pro-
posed a theory of 'existential space' to describe the intimate relation-
ship between the individual and the space he or she inhabits. Space
expresses the individual's inner mental schemata, as before, but in the
new theory this additionally serves the 'existential' purpose of project-
ing one's being into the world. Beyond this point the theory moves
away from the central theme of this book.

The conjecture-analysis model of design

Bill Hillier, John Musgrove and Patrick O'Sullivan more directly
explored the implications of Structuralism's cognitive theories for the
design method. In their paper 'Knowledge and Design' (1972) they
took up the theme that the mind actively structures its knowledge, and
turned this against the Modernist prohibition against preconceptions.
Just as Popper had demonstrated that a hypothesis provides the essen-
tial starting point for formulating a scientific law, they argued that
preconceptions provide the necessary starting point for developing a
design idea. The designer requires a 'plan for finding a route through

problem material that would otherwise appear undifferentiated and amorphous',[10] and this plan derives from previous solutions to similar problems.

To illustrate their point, let us take as an example the description of design without preconceptions in Alexander's *Notes on the Synthesis of Form*. Alexander explained how the designer of a new kettle – without thinking about any previous kettles – can draw up a list of kettle design requirements. His list included twenty-one items, such as it must not be difficult to pick up when it is hot, and it must not be able to boil dry and burn out without warning.[11] But if the designer really did abandon all previous notions about kettles, how did he know that kettles sometimes burn dry, or that kettles are sometimes too hot to pick up? His list presupposes previous experiences with existing kettle designs, and without these previous experiences he would not know what the requirements of a good kettle design should be. Previous ideas about kettle designs, in other words, have provided him with the concepts necessary to structure his solution.

'Knowledge and Design' and a subsequent paper by Hillier and Adrian Leaman, 'How is Design Possible' (1974), developed a method of design that parallels Piaget and Popper. In this theory, a designer possesses a repertoire of solution types (cognitive schemata) which have successfully solved design problems in the past. Faced with a new design problem, the designer first searches through his existing repertoire for a solution which possibly matches the problem. He imposes the solution on to the problem, and then tests it to see how it answers the problem's requirements. This test consists of analyzing the proposed solution in terms of how people are likely to behave within it, how it is likely to perform in the given climate and on the given site, how much it is likely to cost, what cultural meaning it is likely to impart, and so on. If the designer is lucky, and the consequences of the proposed solution type closely match the requirements of the problem, then the design is finished. In Piaget's terms, the designer has assimilated the problem to an existing solution type.

More often, however, the existing solution type does not sit comfortably on the new problem. The designer either abandons this solution type and tries another from his repertoire, or he creatively experiments with the solution type in light of its shortcomings and proposes a new one. This new idea is then tested, and the cyclical procedure continues until the evolving solution matches the design problem's requirements. In Piaget's terms, the solution type has been accommodated to the new problem. Once the designer has developed this new solution type, he adds it to his existing repertoire as a pos-

sible starting point for future problems. Hillier and his colleagues took Popper's terms *conjecture–refutation* and changed them to *conjecture–analysis* to describe this cyclical and deductive model of design. In *The Social Logic of Space* (1984) Hillier and Julienne Hanson developed these ideas further, and studied the 'deep structures' in the spatial organization of cities and buildings that reflect these structuring activities in the mind.

Like other Structuralist theories, this one focused attention not solely on mind or the world but on the interactions between the two. It consequently explained more clearly the respective roles of artistic invention and scientific analysis in the design process. In the conjecture mode, the designer draws upon his or her existing cognitive schemata and uses extra-rational and artistic procedures of analogy, metaphor and sudden flashes of insight to create new ideas; while in the analysis mode the designer uses rational and rigorously scientific thinking to study the consequences of that new idea for the requirements of the design problem. This theory reinterprets the design theories we have examined so far. As the Romantics maintained, design ideas are created within inner creative resources; but these ideas derive from previous ideas, not mystical resources, and they are eventually adapted to the requirements of the problem. As the Positivists insisted, design ideas are shaped by material constraints; but instead of generating the form, the material constraints test forms already existing. And as the Classicists maintained, designers draw upon a pre-existing repertoire of forms; but the elements in this repertoire are not static entities derived from nature or the mind of God. They derive from previous solutions to similar problems, and they grow and change over time as they are employed to solve new problems.

Pattern Language

The more Christopher Alexander analyzed design problems into their component parts, the more he discovered patterns that appeared time and again. He eventually dismissed his earlier work in *Notes on the Synthesis of Form* as a misunderstanding, and proceeded to examine more closely these recurring patterns in design. In so doing, we will see, he took up many of the Structuralist ideas, although he did not think of himself as belonging to that tradition.

In *The Timeless Way of Building* (1979) Alexander pointed out that in traditional places like Italian hill towns and English market towns, the untrained occupants created buildings and town layouts which are more coherent, more beautiful and better adapted to their cultures and

climates than Modernist designs. Furthermore, although these traditional designs were created for a particular time and place, visitors from other times and places feel immediately at home because the designs seem to possess a 'timeless quality'. Traditional cultures, Alexander concluded, employed a universal design language which adapts to particular requirements, but which ensures that the designs always follow timeless principles of good design.

Alexander studied many traditional building and town forms to uncover the nature of this universal design language. He discovered that these forms could be broken down into simple patterns of form. The most successful courtyard designs, for example, always exhibit the same three geometrical properties. First, the building's circulation system always passes through the courtyard; second, it always has a view to a more distant space; and third, it always has a transitional arcade or veranda. Individual courtyards may be constructed in different sizes, styles or materials, but successful ones always follow this geometrical pattern. According to Alexander, these patterns appear time and again because they successfully resolve conflicting forces which are always at play in a courtyard's use. People like to go out into a courtyard, but are inhibited by an abrupt change from inside to outside; hence the covered transition space. People do not like to enter dead-end spaces; hence the courtyard is made part of the circulation system. People feel claustrophobic in too enclosed a space; hence the long-distance view out. These tendencies are facts of human nature, and so anyone who tries sensibly to accommodate them in a design will inevitably produce this geometrical pattern (Figure 94).

Alexander and his colleagues discovered 252 other patterns in the timeless forms of traditional cultures, ranging from one which describes the optimal size of a region, through others which shape streets, markets and squares, building forms and room layouts, structural systems and construction details, down to one which selects the color scheme. *A Pattern Language* (1977) systematically described each of these in the same way: a part of the built environment is isolated for discussion, the human tendencies affected by it are explained, and the geometrical pattern which resolves the inherent conflicts is described.

In traditional cultures, Alexander noted, people learned and used these design patterns naturally and unconsciously, just as one acquires and uses a spoken language. When learning a language we listen to statements by others, unconsciously invent the rules which we think must govern those statements, attempt statements based on our invented rules, then adjust the rules as we are corrected by other com-

94 Christopher Alexander, a diagram from his *Pattern Language*. This diagram expresses the three essential characteristics that Alexander discovered in all successful courtyards: the building's circulation system passes through the courtyard; the courtyard has a view to a more distant space; and a veranda stands between the building and the courtyard.

petent speakers of the language. Once the rules have been 'internalized' in this fashion, one can create an endless number of creative yet understandable statements. Similarly, Alexander noted, the traditional builder sees successful buildings around him, unconsciously invents the rules which he thinks organizes them, and in so doing internalizes the patterns shared by his culture. These patterns then guide his own creative ideas as he accommodates the particular requirements of his particular problem.

Unfortunately, Alexander complained, Modernism cut our ties to this traditional language and imposed upon us an artificial language of design. Although one might suggest that these are merely different but equal languages, Alexander insists that only the traditional language successfully accommodates inherent human tendencies. To help us rediscover the timeless way, Alexander offered his books as the 'textbooks' for a forgotten language. Once we have studied the textbook and internalized this language, we should be able to 'forget' it and employ it unconsciously once again. Intriguingly, this is the Nazarenes' early nineteenth-century program in another guise; they,

too, proposed a once-only realignment of the prevailing world-view that, once accomplished, would unconsciously guide all subsequent artistic production. The only difference is that for the idea of a shared spiritual view, Alexander substituted a shared language based in inherent human behavior.

Alexander's pattern language shares a number of themes with the other Structuralist theories we have examined. It sees individual designs as variations worked out within the constraints of a larger shared structure; it describes how this structure is passed down through cultural traditions; and it stresses the essential role of designers' preconceptions in acquiring those traditions. It does differ in one important respect, regarding the timelessness of this structure. Norberg-Schulz and Hillier *et al.*, thought of the structure as something that evolves over time. Although all humans share the same innate mental processes for comprehending and acting on the world, and although the coercive influence of a shared culture tends to direct its members down similar paths, the active, experimental nature of adjusting mental schemata to the world ensures that the shared structure eventually adapts to new outside conditions. Different periods, different cultures, different creative individuals in those cultures, will evolve different design languages within the general limits of the human capacities and the geometrical possibilities of architectural form. Alexander, on the other hand, conceived of this structure as more static. When he discussed the human behavioral tendencies which the patterns resolve, he did not allow that these might be culturally or individually relative. For example, in one pattern he insisted that everyone should sleep in a room with a window facing east, so that the sun will wake them naturally. Those who prefer other arrangements, Alexander noted, are ignoring fundamental biological matters.[12] Although it may have taken traditional cultures some time to develop the timeless architectural responses to universal human needs, once the patterns are established they remain stable.

Post-Modernism and Post-Structuralism

Although these philosophical and architectural movements in the 1960s and 1970s saw themselves as overthrowing or at least realigning many of the earlier Modernist ideas, they still shared with Modernism a number of fundamental asssumptions. They confidently accepted that philosophy and science increasingly would be able to understand complex matters including human behavior, creativity, social organiza-

tions, ecological systems and aesthetic meaning. They further assumed that, armed with increasing knowledge and technology, they would be able to solve many of the world's problems. Although most of these movements no longer believed in or sought absolute knowledge, in the spirit of Dewey's Pragmatism they were optimistic that they could develop concepts and knowledge sufficient for most practical purposes.

In the mid-1970s this optimism soured. The world's problems seemed to be getting worse. Poverty and racism were not eradicated, they were on the rise. Public housing projects meant to replace slums had turned into high-rise slums themselves. In the Unites States, losing the Vietnam War further contributed to a loss of confidence. And after almost twenty years of research into environmental psychology and various design methods, the built environment seemed even more ugly and less functionally suited to an evolving society.

The new mood engendered a reorientation of the arts and philosophy. Termed Post-Modernism in art and architecture and Post-Structuralism in philosophy, the new movements intentionally set themselves in opposition to Modernism and everything for which it stood. All strands of the new thinking abandoned Modernism's proposed solutions to problems; some dramatically changed the problems they would tackle; others pessimistically insisted that humans are not even capable of understanding the world, let alone solving its problems.

At the time of writing, we are still living in the creative and intellectual fervor that has attended this reorientation. As we approach the present in this history, it becomes quite difficult to maintain a historical perspective. Without sufficient hindsight we cannot yet see which ideas will have a lasting influence, and which will quietly disappear in a few years. Until time tells, in this final section we must necessarily make subjective selections from all of the ideas courting attention. Furthermore, proponents of cultural revolutions always wish to set themselves apart from the past, in order to highlight the novelty of their ideas. To balance this tendency in recent design theory, we will look for the continuities as much as the changes.

Post-Modern Eclecticism

Robert Venturi wrote the first manifesto for the new view in architecture. Presciently published in 1966, *Complexity and Contradiction in Architecture* was not fully appreciated until the mood had changed a decade later. Venturi attacked Modernism on two fronts. First, he objected to their rejection of tradition. The Modernists were so keen to stress the unique circumstances of the modern world, he noted, that

they lost touch with what always stays the same. Although we know
that Modernists had sought timeless principles, their prohibition
against preconceptions prevented them from looking for these prin-
ciples in the history of architecture itself. Venturi rejected this prohibi-
tion, and drew attention once again to architecture's own history.
Second, he objected to Modernism's preference for the rational and
simple. 'In their attempt to break with tradition and start all over
again, they idealized the primitive and elementary at the expense of
the diverse and the sophisticated.'[13] Visual blandness was the result.
Venturi preferred the visual complexities and contradictions in the
Mannerist, Baroque and Rococo periods, and proceeded to introduce
his readers to the visual delights of these traditions. His own designs
derived from principles he had discovered in these precedents (Figure
95). Now why did Venturi choose these particular precedents in his-
tory and not others? He offered a few reasons why we ought to prefer
his chosen styles, but he left the door open to the possibility that one
might choose any other historical styles according to personal taste.
Venturi – perhaps inadvertently – revived the nineteenth-century con-
cept of architectural eclecticism.

These two themes – find sources of form in history, and prefer the
mannered and subjective over the rational and objective – caught the
imagination of the first Post-Modernist architects in the 1970s and
early 1980s. Bored with the unproductive environmental psychology
and design methodology movements, and offended by the visual steril-
ity of Modern architecture, these architects returned to a version of
the 1950s subjective formalism, which focused on the visual possi-
bilities of a free play of form. But where the 1950s architects played
with abstract forms, the Post-Modernists rummaged through history,
selected fragments of forms from previous styles (usually Classicism),
and collaged them together. The traditional forms were taken out of
context and stripped of their original meanings; they chose a particu-
lar tradition for its visual interest and its vague reference to the past,
not because, say, Classicism represented timeless principles, or Gothic
represented medieval values. Like sixteenth-century Mannerism, the
Post-Modern forms were employed at first in a jokey manner. Michael
Graves, one of the pioneers in this new movement, designed a house
based roughly on an Italian palazzo (Figure 96). He grossly overscaled
the columns and bases, turned apparent symmetries into asymmetries
and slammed a giant keystone out of its place over the door and on to
the hillside behind, where it became a gazebo. The early Post-
Modernists still used modern construction systems like concrete and
steel frames, and so these vaguely traditional forms and details were

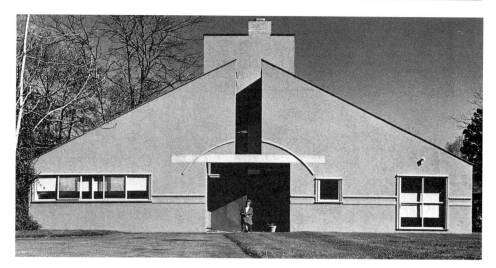

95 Vanna Venturi House, Philadelphia, PA, 1963. Venturi Scott Brown and
Associates. In the face of Modernism's basic precepts, Robert Venturi and
Denise Scott Brown revived the concept of learning from historical prece-
dent, and chose complex mannered forms over austere rational ones.

96 Plocek House, Warren Township, New Jersey, 1977–79. Michael Graves.
Graves led the early Post-Modern movement with mannered versions of
Classicism married to Modernist forms.

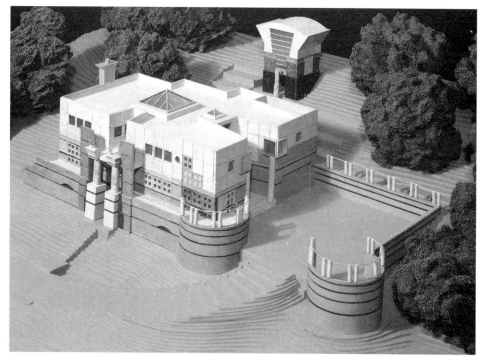

often reduced to a thin veneer on a basically modern building. Notable proponents of this new approach included Charles Moore, James Stirling (Figure 97) and Robert Venturi.

Post-Modern Classicism

Just as the casual revival of Gothic forms in the late eighteenth century led to a serious archaeological revival of Gothic in the next century so, too, did this jokey Mannerism eventually give way to a more serious revival of Classicism and its principles in the early 1980s. Several generations of architects had come of age without any real knowledge of the Classical language against which Modernism had rebelled, and so once the early Post-Modernists had tentatively reintroduced some its elements, curiosity grew to understand the original language. The architectural publishing houses reprinted books of Classical architects, like K. F. Schinkel's *Sammlung architectonischer Entwürfe*,[14] and forgotten student texts on Classicism, like Arthur

97 The Clore Gallery for the Turner Collection, Tate Gallery, London, England, 1980–84. James Stirling, Michael Wilford and Associates. The mannered use of historical details on Modernist forms characterized the Post-Modern movement of the 1980s.

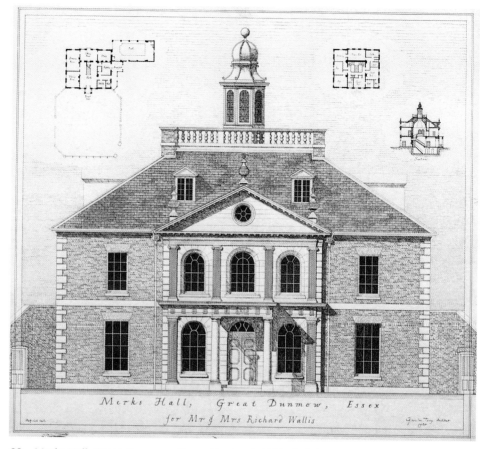

98 Merks Hall, Great Dunmow, Essex, England, 1981. Quinlan Terry. The mannered revival of Classicism in early Post-Modernism soon fuelled an interest in Classicism properly executed. Quinlan Terry quietly designed accurate Georgian revival buildings from the early 1960s onwards.

Stratton's *Elements of Form and Design in Classic Architecture*.[15] The journal Architectural Design published a number of essays in editions entitled 'Post-Modern Classicism', 'Free-Style Classicism' and 'Neo-Classicism' that discussed the language, its revival and its implications.[16] A closer look at twentieth-century history turned up long ignored architects like Sir Edwin Lutyens and John Russell Pope who quietly continued the Classical tradition during the Modernist period. Quinlan Terry, who had been designing accurate Georgian revival buildings in relative obscurity since 1962, suddenly became fashionable (Figure 98). In a number of polemical articles and books, the Krier brothers Rob and Leon proposed a wholesale return to pre-Modern architecture and planning. They advocated traditional

99 The New European Quarters, Luxembourg, 1978. Leon Krier. The Krier brothers, Leon and Rob, propose a wholesale return to pre-Modern architecture and planning. They advocate traditional European city plans with squares, markets and largely Beaux-Arts planning concepts.

European city plans with squares, markets and Beaux-Arts planning principles, and designed and illustrated classically inspired buildings (Figure 99).

What was the philosophical justification for Classicism this time around? Quinlan Terry, a devout Christian, revived the view that the Five Orders of architecture are God-given. Also reviving Durand's arguments for Classicism at the turn of the nineteenth century, he insisted that Classicism is more functional, economical and honest to materials and construction.[17] Rob Krier, in *Architectural Composition* (1988), similarly discussed Classicism as if it were the only objectively correct way to build and to satisfy functions. After explaining that his book discusses the rules that guide architectural composition, he denied that he was rewriting the 'bible'; rather, he was merely re-establishing basic principles that have gone astray in the modern world.[18] He referred fleetingly to the marvellous inventions of Le Corbusier, and then proceeded to illustrate his book with Classical buildings and his students' essays on Classical themes. Like a latter-day Durand or Guadet, he systematically laid out basic elements like stairs, doors and rooms of every logical proportion and configuration, and explained the rules by which they are composed into complete buildings. And like Durand, he showed how Gothic buildings really follow the same principles of Classicism, if only we look deeply enough.

Robert Stern took a more relativistic – what he called 'humanist' – view. He conceived of styles as languages. Like languages, they evolve over time and adapt to new conditions. There have been many independent and successive styles in the history of the West, and while they are equally valid, the Classicism of the Graeco-Roman culture has been dominant. Like languages, styles have two components, syntax (form) and rhetoric (content). Modernism threw away the traditional rhetoric of Classicism, according to Stern, but kept the syntax. The Post-Modern world has simply returned to a more explicit use of the Classical rhetoric. Stern noted that architects like the Kriers adhere to the grammar but not the rhetoric, others like Terry revive the old grammar and rhetoric wholesale, while others are trying to adapt both to the realities of the pluralistic Modern world.[19] Stern implied that we use Classicism not because it is a timeless language, or because only it solves our functional and constructional problems, but simply because it is the mainstream of our continually evolving Western tradition. So where some proponents of the revived Classicism returned to a pre-Enlightenment quest for absolute truth and certainty, others accepted the relativity of knowledge and style and saw pragmatic value in continuing to work within a strong and evolving cultural tradition.

On one thing all Post-Modernist architects agreed: the subject matter of architecture is architectural form itself, not the abstract or scientific determinants of form that came to dominate many American schools of architecture in the 1970s. Schools in this period revived an interest in aesthetics and visual form, many asked students to study architectural precedents after their banishment in the Bauhaus, some even taught specific languages of architectural form like Classicism. A number of schools changed their names back to 'architecture' from 'environmental design' to reflect the new emphasis.

Post-structuralism and deconstructivism

Another reaction against the 1960s drew more extreme – even diametrically opposed – conclusions. Known as Post-Structuralism in philosophy, deconstructionism in the arts and literature and deconstructivism in architecture, this movement began as a new approach to literary criticism in the late 1970s. According to Jacques Derrida, the founder of this new approach,[20] Western philosophy still believes that it can gain access to perfect knowledge and truth. Similarly, literary criticism believes it can uncover the author's true meaning in a text. Restating Nietzsche's view exactly, Derrida denied that we can ever have per-

fect, unmediated access to objective truths. Like Nietzsche, he did not believe that we can get back to an original 'text'; all efforts to find order and objective truth in the world are desperate and fruitless attempts to see order where no order exists. To illustrate his point, Derrida 'deconstructed' the texts of several philosophers including Plato and Rousseau to uncover the contradictions in their logic. In a sense he performed psychoanalysis on the 'unconscious' of Western philosophy and its 'logocentric' reason, showing how the texts never mean what they say or say what they mean.[21] Many of the boundaries in Western philosophy, like those between literature and philosophy, sciences and humanities, pure and applied research, are artificial consequences of 'logocentric reasoning'.

In *The Truth in Painting* (1987) Derrida turned this approach to aesthetics. Most Western art theory since Plato has examined art's relationship to truth. Some thinkers like Plato denied that art could gain reliable access to objective truths about the world; others like Kant and the Romantics maintained that art might have a more immediate and reliable access to truth than even science or philosophy. Derrida attacked the claims of Kant and his successors. Kant, we may remember, had shown how all rational and sensory knowledge of the world is shaped by categories the human mind imposes upon it. Although we can never know the world as it really exists, the fact that all minds imposed the same structure on their knowledge ensures that they all see the world in the same way. For those who none the less want access to the world as it really exists, Kant suggested that an aesthetic faculty of the mind steps beyond the mental categories and 'sees' ultimate reality, even though it cannot rationally explain what it sees. Derrida discounted this on two fronts. First, even in rational and sensory knowledge, different minds impose different categories, preconceptions and personal agendas on their knowledge; therefore they all see the world differently. Second, the aesthetic judgement cannot escape this subjectivity. Derrida discussed an example of how two different critics – Heidegger and Meyer Schapiro – looked at the same painting by Vincent van Gogh and, based on opposed political viewpoints, drew opposed conclusions about what the painting represented. Even if the artist could apprehend an absolute truth, no two viewers of the work of art would ever see it the same way.

Although Derrida did not seem to think that we can ever entirely escape from our 'logocentric' tradition (his task was to critique it so that we do not easily fall prey to its false charms), others were more willing to take this critique to a nihilistic extreme.[22] In literary criticism and the fine arts 'deconstruction' came to mean a radical under-

mining of all previous concepts without supplying anything in their place. Everything from the history of wars to the autonomous self became 'texts' ripe for deconstructing as contradictory and fictitious metaphors. Nothing means anything, anything means nothing. Hierarchies were dismantled, judgements about the relative merits of high art and low art were dismissed. It became fashionable to 'obliterate the differences between Roger Rabbit and Henry James'.[23] An element of deconstruction urged destruction of all previous thinking in order to clear the ground for the new sensibility. Since the concept of the autonomous self was 'deconstructed' as an artificial conceit, it also became fashionable to disparage or ignore the author's role in the creation of the literature or art. Deconstructionism curiously joined with Positivism in rejecting the significance of the creator, although it did so more as a polemical attack on all previously cherished ideas than as a necessary characteristic of its position. Starting from the same point of radical relativity Nietzsche, for example, contrarily glorified the artists because they could laugh in the face of a senseless world and impose their will on chaos.

In architecture in the 1980s a number of these ideas fused with visual images from 1920s Russian Constructivism to become 'deconstructivism'. Architects including Peter Eisenman, Daniel Libeskind, Zaha Hadid and Bernard Tschumi developed architectural forms that expressed a world without order or logic. Fragments of forms crashed into others, incomplete and twisted grids disoriented rather than organized, and dynamic forms defied gravity by hovering dramatically over the composition without visible means of support (Figure 100). The deconstructivists restated Derrida's idea that order is an illusion, a desperate and futile attempt to organize a world that has no meaning or objective structure. The architects noted that all previous architecture had tried artificially to impose order, and this was a conceit and a sham. It is more honest, they said, to express our chaotic existential reality with appropriately chaotic architectural forms. Peter Eisenman, the leading architectural proponent of deconstructivism, wanted architecture to 'dislocate' its users by subverting their expectations and desires. He hoped they would feel uncomfortable in his buildings and so more directly face the discomfort of their existential condition. In *The House of Cards* (1988) he explained how he designed a house with columns intruding into the dining space, and how these forced the occupants to change unpredictably the dining experience. Violently disruptive effects are necessary, Eisenman thought, in order to dissolve architecture's artificial oppositions between structure and decoration, abstraction and figuration, figure and ground, form and

100 Biocenter for the University of Frankfurt, Frankfurt, Germany, 1985–. Peter Eisenman. A leading proponent of Deconstructivism, Eisenman attempts to express our chaotic existential reality with complex and fragmentary architectural forms.

function. Once we have purged our thinking of these artificial constructs, architecture can explore the 'between' within these categories.[24] Eisenman also thought that dissolving these constructs would free us from pathologically repressive order.

So where is the source of form for deconstructivism? Although this is not a question that they have explicitly asked or answered, we can infer a few ideas. Clearly form is not Positivistically derived from function or use; Eisenman wants his forms to subvert and transform how people live and use buildings, not respond to them. Equally clearly, form is not an objective property of the external world, as in Classicism; individuals arbitrarily and therapeutically invent their own personal order and structure. Nor is form generated from within creative inner resources, as the Romantics had claimed. Eisenman accepted the 'deconstruction' of the autonomous self and tended to disparage the role of the individual self in the design of buildings. Is form determined by a prevailing Spirit of the Age? Here we start to come closer. The deconstructivists disagreed with the prevailing 'logocentric' world-view, showed how all architecture reflects this outdated view, proposed a new existential condition of subjectivity and disor-

der, and then demanded that architecture ought to reflect this new view. Indeed, by disparaging the individual creative will, they have to assume that, once the violent realignment of thinking is completed, designers will naturally and unselfconsciously respond to the new existential condition and reflect it in their work. This is the program of Perrault, the Nazarenes, the Gothic Revivalists, Gropius and Alexander again, a demand for a once-only realignment of the pervasive forces that shape architectural or artistic form. Where earlier versions opted for the shared language of Classicism, or the shared cultural spirit of medievalism, or a shared language based in human behavior, the deconstructivists opted for a shared existential predicament. Although they all stressed coercive forces and disparaged the role of the individual in shaping form, they all leave us wondering how one particular group of individuals is able suddenly to break free from this coercion, reorient culture and artistic production, and then quietly slip back into unselfconscious alignment with the new coercive force.

The astute reader will have noticed an intriguing parallel between the Post-Modernist reaction against Modernism and the early nineteenth-century reaction against the Enlightenment. Both the Enlightenment and Modernism confidently believed in the powers of humans to understand and control the world. Both set out timeless and rational principles of architecture and undertook ambitious programs to understand human behavior so that it could be nurtured and directed. Both eventually succumbed to a loss of confidence, as their programs failed to fulfil their promise or ran into conceptual difficulties. Nietzsche and Derrida both echoed an existential crisis in the next generation, and questioned whether any objective knowledge is possible. Eclecticism in architecture followed the loss of confidence in both periods. The nineteenth-century eclecticism continued until the establishment of the Modern Movement in the 1920s; it is obviously too soon to tell how long the late twentieth-century eclecticism will run. Both periods also experienced a Classical revival, as some theorists and architects wished to maintain objective truths in the face of existential uncertainty. It is always dangerous to postulate close parallels or recurring patterns in history, since the differences between periods are often more significant than the similarities. None the less, as we struggle with our intellectual and aesthetic problems in the late twentieth century, we might find some guidance and even comfort in the thought that our predecessors have travelled this ground before.

Have we answered our original question about the source of architectural form? That probably depends upon the reader's personal inclination. Whether one seeks certainty or bravely faces relativity, focuses on the self or the world, prefers clear reason or rich sense, thinks logically or emotionally follows intuitions, one will probably find a number of attractive ideas in this history commensurate with one's own personal outlook. All of these intellectual traditions have problems, as we have seen; if we have learned anything from this history, it is that no perfect answer to our question has ever emerged. Appropriating Whitehead's phrase, the quest of our predecessors to explain the source of our design ideas has been 'an adventure in the clarification of thought, progressive and never final. But it is an adventure in which even partial success has importance.'[25]

Throughout most of our history, curiously, theorists seemed more interested in asserting one-sided extremes than in seeking the balanced view. They apparently found it easier to understand and promote simple aphorisms than to juggle the complex dualities of the subject–object problem. A few notable theorists – Kant, Guadet, Gropius, Piaget, Norberg-Shulz, Hillier and his colleagues – made the effort to solve this problem with varying degrees of success. A number of their theories consequently came closer to explaining the cycles of stylistic continuity and change and the respective roles of reason and sense, logic and intuition, and tradition and invention. Yet almost as soon as these theories were proposed, their successors broke off into one-sided extremes again. In our own time, one cannot imagine more diametrically opposed views than the quest for absolute certainty in Post-Modern Classicism and the nihilism of Deconstructivism. Perhaps with the fuller understanding of the subject–object problem that this brief history has afforded, we might seek again the complex but rewarding middle ground.

Notes

1 Nikolaus Pevsner, *An Outline of European Architecture*, Penguin Books, Harmondsworth, 1977, p. 429.

2 Bill Hillier and Adrian Leaman noted this philosophical problem in their paper 'The Man–Environment Paradigm and its Paradoxes', *Architectural Design*, August 1973, pp. 507–11. Although they did not refer to the subject–object problem, they explained how 'man–environment relations' directly descended from the troublesome split between 'organism' and 'environment' that the eighteenth-century biologists Buffon and Lamarck had proposed.

3 Gary T. Moore, ed., *Emerging Methods in Environmental Design and Planning*, The MIT Press, Cambridge, Mass., 1970, p. ix.

4 Christopher Alexander, *Notes on the Synthesis of Form*, Harvard University Press, Cambridge, Mass., 1964, p. 131.

5 Richard Llewelyn Davies, 'The Education of an Architect', an inaugural lecture delivered to University College London on 10 November 1960, p. 9.

6 Piaget and his associates have written numerous books on this general subject, but for the most direct exposition of his epistemological theory, see Jean Piaget, *Structuralism*, trans. Chaninah Maschler, Routledge & Kegan Paul, London, 1971; Piaget, *The Principles of Genetic Epistemology*, trans. Wolfe Mays, Routledge & Kegan Paul, London, 1972; and Piaget, *Biology and Knowledge*, trans. Beatrix Walsh, Edinburgh University Press, Edinburgh, 1971.

7 Other philosophers have objected to the claim that one piece of contrary evidence immediately refutes a theory. Unwelcome data which seem to contradict a cherished theory can be accounted for in a number of ways, including misadjusted apparatus, uncontrollable outside conditions, that they are statistically irrelevant and so on. See, for example, A. J. Ayer, *Philosophy in the Twentieth Century*, Vintage Books, New York, 1984, pp. 132-4. Also see several of the essays in Imre Lakatos and Alan Musgrave, eds, *Criticism and the Growth of Knowledge*, Cambridge University Press, London, 1970.

8 Piaget quotes Alfred North Whitehead, *Process and Reality*, New York, 1929, p. 515.

9 Christian Norberg-Shulz, *Intentions in Architecture*, The MIT Press, Cambridge, Mass., 1965, p. 82.

10 Hillier, Bill, *et al.* 'Knowledge and Design', EDRA 3, 1972, pp. 29/3/1–29/3/14.

11 Alexander, *Notes*, p. 60.

12 Christopher Alexander, Sara Ishikawa and Murray Silverstein, *A Pattern Language*, Oxford University Press, New York, 1977, p. 657.

13 Robert Venturi, *Complexity and Contradiction in Architecture*, The Museum of Modern Art, New York, 1966, p. 23.

14 Reprinted as *K. F. Schinkel: Collected Architectural Designs*, Academy Editions/St Martin's Press, London, 1982.

15 Arthur Stratton, *Elements of Form and Design in Classic Architecture*, Studio Editions, London, 1987; first published in 1925. Also Arthur Stratton, *The Orders of Architecture*, Studio Editions, London, 1986; first published in 1931.

16 Charles Jencks, ed, 'Free-Style Classicism', *Architectural Design*, Vol. 52, No. 1–2, 1982; Geoffrey Broadbent, ed., 'Neo-Classicism', *Architectural Design*, Vol. 49, No. 8–9, n.d.; Charles Jencks, ed, 'Post-Modern Classicism', *Architectural Design*, 5/6, 1980.

17 Quinlan Terry, 'Seven Misunderstandings About Classical Architecture', in

Quinlan Terry, Architecture Design and Academy Editions, London, 1981, pp. *xii–xiv*.

18 Rob Krier, *Architectural Composition*, Rizzoli, New York, 1988, pp. 7-8.

19 Robert Stern, 'Classicism in Context', in Charles Jencks, ed., 'Post-Modern Classicism', *Architectural Design* 5/6, 1980, pp. 38–9.

20 Jacques Derrida, *Of Grammatology*, trans. Gayatri C. Spivak, Johns Hopkins University Press, Baltimore, 1976.

21 Christopher Norris, 'Deconstruction, Post-Modernism and the Visual Arts', in *What is Deconstruction?*, Academy Editions/St Martin's Press, London, 1988, p. 7.

22 *Ibid.*, p. 29. On these grounds, Norris wants to distance Derrida from Post-Modernists who think they can completely overthrow previous thinking and start afresh.

23 David Lehman, *Signs of the Times: Deconstruction and the Fall of Paul de Man*, Poseidon Press, New York, 1991, p. 80.

24 Norris, 'Deconstruction', p. 27.

25 Alfred North Whitehead, *Process and Reality*, New York, 1929, p. 14.

Bibliography

Ackerman, James S. *et al.*, eds, *Medieval Architecture*, The Garland Library of the History of Art, 4, Garland Publishing, Inc., New York, 1976.

Ackerman, James S., '*Ars sine scientia nihil est*: Gothic theory of architecture at the cathedral of Milan', in Ackerman *et al.*, *Medieval Architecture*.

Alberti, Leon Battista, *On Painting*, trans. John Spencer, Yale University Press, New Haven and London, 1966 [orig. pub. 1435–36].

— *Ten Books on Architecture*, trans. James Leoni, Alec Tiranti Ltd, London, 1955 (Leoni edn. orig. pub. 1755, first published by Alberti as *De re aedificatoria*, 1485).

Alexander, Christopher, *Notes on the Synthesis of Form*, Harvard University Press, Cambridge, Mass., 1964.

— *The Timeless Way of Building*, Oxford University Press, New York, 1979.

Alexander, Christopher, Sara Ishikawa and Murray Silverstein, *A Pattern Language*, Oxford University Press, New York, 1977.

Allen, T. W., W. R. Halliday and E. E. Sikes, eds, *The Homeric Hymns*, The Clarendon Press, Oxford, 1936.

Aristotle, *The Works of Aristotle*, trans. W. D. Rose, The Clarendon Press, Oxford, 1928.

Artz, Frederick B., *From the Renaissance to Romanticism*, University of Chicago Press, Chicago, 1962.

Athanassakis, Apostolos, *The Homeric Hymns*, The Johns Hopkins University Press, Baltimore, 1976.

Augustine, Saint, *Confessions*, trans. J. G. Pilkington, Liveright, NY, 1943.

Ayer, A. J., *Philosophy in the Twentieth Century*, Vintage Books, New York, 1984.

Bacon, Francis, 'The Great Instauration', in *The New Organon and Related Writings*, ed. Fulton Anderson, Bobbs-Merrill Company, Inc., Indianapolis, Indiana, 1960 [orig. pub. 1620].

Bacon, Roger, *Opus Majus*, trans. Robert Burke, University of Pennsylvania Press, Pennsylvania, 1928.

Banham, Reyner, *Theory and Design in the First Machine Age*, The Architectural Press, London, 1960.

Barnes, Harry Elmer, *An Intellectual and Cultural History of the Western World*, Dover Publications, Inc., New York, 1965, in three volumes.

Bayer, Herbert, Walter Gropius and Ise Gropius, eds, *Bauhaus 1919–1928*, The Museum of Modern Art, New York, 1938.

Beardsley, Monroe, *Aesthetics from Classical Greece to the Present: A Short History*, Macmillan, New York, 1966.

Bellori, Giovanni Pietro, 'The Idea of the Painter, Sculptor, Architect, Superior to Nature by Selection from Natural Beauties', trans. Victor Velen, in Panofsky, *Idea*.

Benton, Tim and Charlotte with Dennis Sharp, eds, *Form and Function: A Source Book for the History of Architecture and Design 1890–1939*, Crosby Lockwood Staples, London, 1975.

Berkeley, George, *A Treatise Concerning the Principles of Human Knowledge*, in *Philosophical Works*, J. M. Dent & Sons Ltd., London, 1975 [orig. pub. 1710] .

Blunt, Anthony, *Art and Architecture in France 1500–1700*, 4th edn, Penguin Books, Harmondsworth, 1980.

— *Artistic Theory in Italy 1450–1600*, Oxford University Press, Oxford, 1940.

Boullée, Étienne-Louis, 'Architecture, Essay on Art', trans. Sheila de Vallée, in Helen Rosenau, *Boullée and Visionary Architecture*, Academy Editions, London, 1976.

Boyd, William and Edmund King, *The History of Western Education*, Adam & Charles Black, London, 1975.

Briggs, Martin, *The Architect in History*, Da Capo Press, New York, 1974.

Broadbent, Geoffrey, ed., 'Neo-Classicism', *Architectural Design*, Vol. 49, No. 8–9, n.d.

— *Design in Architecture: Architecture and the Human Sciences*, John Wiley & Sons Ltd., London, 1973.

Brown, Roger and Ursula Bellugi, 'Three Processes in the Child's Acquisition of Syntax', in *Language and Education*, Routledge & Kegan Paul and the Open University, London, 1972.

Bruno, Giordano, *The Heroic Frenzies*, trans. Paul Eugene Memmo, Jr, The University of North Carolina Press, Chapel Hill, 1966.

Campbell, Colen, *Vitruvius Britannicus*, London, 1715.

Cassirer, Ernst, Paul Kristeller and John Randall, Jr, eds, *The Renaissance Philosophy of Man*, University of Chicago Press, Chicago, 1948.

Cassirer, Ernst, *The Individual and the Cosmos in Renaissance Philosophy*, trans. Mario Domandi, Basil Blackwell, Oxford, 1963.

Chafee, Richard, 'The Teaching of Architecture at the Ecole des Beaux-Arts', in Drexler, *Architecture of the Beaux-Arts*.

Chaucer, Geoffrey, *The Canterbury Tales*, edited from the Hengwrt manuscript by N. F. Blake, Edward Arnold, London, 1980.

Choisy, Auguste, *Histoire de l'Architecture*, Gauthier-Villars, Paris, 1899.

Clark, Roger and Michael Pause, *Precedents in Architecture*, Van Nostrand Reinhold Company Inc., New York, 1985.

Cline, Barbara Lovett, *Men Who Made a New Physics*, The New American Library, New York, 1965.

Collingwood, R. G., *The Idea of History*, Oxford University Press, Oxford, 1961.

— *The Idea of Nature*, Oxford University Press, London, 1976.

Condivi, Ascanio, *The Life of Michelangelo*, trans. Alice Sedgwick Wohl, Phaidon Press Ltd, Oxford, 1976 [first pub. 1553].

Conrads, Ulrich and Hans Sperlich, *The Architecture of Fantasy: Utopian Building and Planning in Modern Times*, trans. and eds Christiane Crasemann Collins and George R. Collins, Frederick A. Praeger, Publishers, New York, 1962.

Copleston, Frederick, *A History of Philosophy*, Image Books, Garden City, 1963, in 9 volumes.

Curtis, S. J. and M. E. A. Boultwood, *A Short History of Educational Ideas*, University Tutorial Press, London, 1965.

Da Vinci, Leonardo, *The Notebooks of Leonardo Da Vinci*, Jean Paul Richter, comp. and ed., Dover Publications, Inc., New York, 1970.

— *Treatise on Painting*, trans. Philip McMahon, Princeton University Press, Princeton, 1956.

de Zurko, Edward Robert, *Origins of Functionalist Theory*, Columbia University Press, New York, 1957.

Derrida, Jacques, *Of Grammatology*, trans. Gayatri C. Spivak, Johns Hopkins University Press, Baltimore, 1976.

Descartes, René, *The Philosophical Works of Descartes*, trans. Elizabeth Haldane and G. R. T. Ross, at the University Press, Cambridge, 1931.

Dostoyevsky, Fyodor, 'Notes from Underground', in *The Best Short Stories of Dostoyevsky*, trans. D. Magarshack, Modern Library, New York, n.d.

Drexler, Arthur, *The Architecture of the Ecole des Beaux-Arts*, The Museum of Modern Art, New York, 1977.

Durand, J.-N.-L., *Précis des leçons d'architecture données à l'Ecole royale polytechnique* (Paris, 1802–05), republished by Dr Alfons Uhl, Nordlingen, 1981.

— *Partie Graphique des Cours d'Architecture* (Paris, 1821), republished by Dr Alfons Uhl, Nordlingen, 1981.

Dvorak, Max, *Idealism and Naturalism in Gothic Art*, trans. Randolph J. Klawiter, University of Notre Dame Press, Notre Dame, Indiana, 1967 [orig. pub. 1928].

Eisenman, Peter, *The House of Cards*, Oxford University Press, New York, 1988.

Eitner, Lorenz, *Neoclassicism and Romanticism 1750–1850* (Sources and Documents / History of Art Series, ed. H. W. Janson), Prentice-Hall International, Inc., London, 1971.

Elledge, Scott, ed., *Eighteenth Century Critical Essays*, Cornell University Press, Ithaca, 1961.

Engels, Friedrich, 'Socialism: Utopian and Scientific', in Robert Tucker, ed., *The Marx-Engels Reader*, W. W. Norton Co. Inc., New York, 1972.

Ficino, Marsilio, *Five Questions Concerning the Mind*, in Ernst Cassirer, Paul Kristeller, John Randall, Jr, eds, *The Renaissance Philosophy of Man*, University of Chicago Press, Chicago, 1948.

Fowler, W. S., *The Development of Scientific Method*, Pergamon Press, New York, 1962.

Franciscono, Marcel, *Walter Gropius and the Creation of the Bauhaus in Weimar: the Ideals and Artistic Theories of Its Founding Years*, University of Illinois Press, Urbana, 1971.

Frankl, Paul, *Gothic Architecture*, Penguin Books, Harmondsworth, 1962.

— *Principles of Architectural History: The Four Phases of Architectural Style 1420–1900*, trans. James O'Gorman, The MIT Press, Cambridge, Mass., 1968.

Galilei, Galileo, *Dialogues Concerning Two New Sciences*, trans. Henry Crew and Alfonso de Salvio, The Macmillan Company, New York, 1914.

— *The Assayer*, trans. Stillman Drake and C.D. O'Malley, in *The Controversy on the Comets of 1618*, University of Pennsylvania Press, Philadelphia, 1960.

Garrett, Lillian, *Visual Design: A Problem-solving Approach*, Van Nostrand Reinhold Company, New York, 1967.

Gelernter, Mark, 'The Concept of Design and its Application', in *Companion to Contemporary Architectural Thought*, eds Ben Farmer, Hentie Louw and Adrian Napper, Routledge, London, 1993.

— 'Beyond the Bauhaus: Integrating Technology and Design in the Studio', in Marc Angelil, ed., *Architecture, the City and Technology*, Butterworth Architecture, 1991, pp. 135–8.

— 'Between Invention and Discovery: Reconciling the Subject–Object Problem in Western Design Theory', in the proceedings of the Association of Collegiate Schools of Architecture seventy-eighth national conference, San Francisco, March 1990, pp. 90–7.

— 'Reconciling Lectures and Studios', *The Journal of Architectural Education*, 41, No. 2, 1988, pp. 46–52.

— 'Teaching Design Innovation Through Design Tradition', in the proceedings of the Association of Collegiate Schools of Architecture seventy-sixth national conference, Miami, March 1988, pp. 441–5.

— 'Christopher Alexander's Pattern Language', in *The Architects' Journal*, 177, No. 1, 5 January 1983, pp. 17–21.

Germann, Georg, *Gothic Revival in Europe and Britain: Sources, Influences and Ideas*, trans. Gerald Onn, Lund Humphries with the Architectural Association, London, 1972.

Giedion, Sigfried, *Spätbarocker und romantischer Klassizismus*, Munich, 1922.

— *Space, Time and Architecture*, 5th ed, Cambridge, Mass., 1967.

Gombrich, Ernst, *Art and Illusion: A Study in the Psychology of Pictorial Representation*, Phaidon Press, London, 1977.

Gropius, Walter, *The Scope of Total Architecture*, George Allen & Unwin Ltd, London, 1956.

Guadet, Julien, *Eléments et Théorie de l'Architecture*, 4th edn, I, Librairie de

la Construction Moderne, Paris, 1909.

Haftman, Werner, *Painting in the Twentieth Century*, I, trans. Ralph Manheim, Lund Humphries, London, 1965.

Harris, Errol, *Nature, Mind and Modern Science*, George Allen and Unwin Ltd, London, 1954.

Hartt, Frederick, *Art: A History of Painting, Sculpture, Architecture*, vol. II, Prentice-Hall, Inc., Englewood Cliffs, NJ, 1976.

Hauser, Arnold, *Mannerism*, 1, Routledge & Kegan Paul, London, 1965.

— *The Social History of Art*, 4 vols, Routledge & Kegan Paul, London, 1962.

Hegel, Georg Wilhelm, *The Phenomenology of Mind*, trans. J. B. Baillie, Allen & Unwin, London, 1949.

Herrmann, Wolfgang, *The Theory of Claude Perrault*, A. Zwemmer Ltd, London, 1973.

Hillier, Bill, John Musgrove and Patrick O'Sullivan, 'Knowledge and Design', in *EDRA 3*, 1972, pp. 29/3/1–29/3/14.

Hillier, Bill and Adrian Leaman, 'The Man–Environment Paradigm and its Paradoxes', *Architectural Design*, August 1973, pp. 507–11.

Hillier, Bill and Adrian Leaman, 'How is Design Possible?', *Journal of Architectural Research*, III, 1974, pp. 4–11.

Hillier, Bill and Julienne Hanson, *The Social Logic of Space*, Cambridge University Press, Cambridge, 1984.

Hitchcock, Henry Russell, *Architecture: Nineteenth and Twentieth Centuries*, Penguin Books Ltd, Harmondsworth, 1978 [first printed 1958].

Hume, David, *A Treatise of Human Nature*, ed. L. A. Selby-Bigge, at the Clarendon Press, Oxford, 1978 [orig. pub. 1739].

— 'Of the Standard of Taste', in Lenz, John, ed., *Of the Standard of Taste and Other Essays*, Bobbs-Merrill Company, Indianapolis, Indiana, 1965.

Hutcheson, Francis, 'An Inquiry into the Original of our Ideas of Beauty and Virtue', in Scott Elledge, ed., *Eighteenth Century Critical Essays*, vol. I, Cornell University Press, Ithaca, 1961.

Jencks, Charles, ed., 'Free-Style Classicism', *Architectural Design*, Vol. 52, No. 1–2, 1982.

— 'Post-Modern Classicism', *Architectural Design*, 5/6, 1980.

Jones, W. T., *A History of Western Philosophy*, Harcourt, Brace and World, Inc., New York, 1969, in 4 volumes.

Kant, Immanuel, *Critique of Judgement*, trans. J. H. Bernard, Hafner Press, New York, 1951.

— *The Critique of Pure Reason*, trans. Norman Kemp Smith, The Macmillan Press Ltd., London, 1933.

Kaufmann, Emil, *Architecture in the Age of Reason: Baroque and Post Baroque in England, Italy, France*, Dover Publications, New York, 1968 [first pub. 1955].

Kolakowski, Leszek, *Positivist Philosophy*, trans. Norbert Guterman, Penguin Books, Harmondsworth, 1972.

Kostof, Spiro, ed., *The Architect: Chapters in the History of the Profession*,

Oxford University Press, New York, 1977.

— *A History of Architecture: Settings and Rituals*, Oxford University Press, New York, 1985.

Krier, Rob, *On Architecture*, Academy Editions, London, 1982.

— *Architectural Composition*, Rizzoli, New York, 1988.

Kuhn, Thomas, *The Structure of Scientific Revolutions*, second edition, in the *International Encyclopedia of Unified Science*, II, No. 2, University of Chicago Press, Chicago, 1970.

Lakatos, Imre and Alan Musgrave, eds, *Criticism and the Growth of Knowledge*, Cambridge University Press, London, 1970.

Laugier, Abbé Marc Antoine, *Essai sur l'Architecture*, Paris, 1753.

Le Corbusier, *Towards a New Architecture*, trans. Frederick Etchells, The Architectural Press, London, 1946.

Lehman, David, *Signs of the Times: Deconstruction and the Fall of Paul de Man*, Poseidon Press, New York, 1992.

Levey, Michael, *Early Renaissance*, Penguin Books, Harmondsworth, 1977.

Llewelyn Davies, Richard, 'The Education of an Architect', an inaugural lecture delivered to University College London on 10 November 1960.

Locke, John, *An Essay Concerning Human Understanding*, ed. Alexander Fraser, Dover Publications, Inc., New York, 1959 [orig. pub. 1690].

Marx, Karl and Friedrich Engels, *The Communist Manifesto*, trans. Samuel Moore, Penguin Books, Harmondsworth, 1967.

Mead, Margaret, *Continuities in Cultural Evolution*, Yale University Press, New Haven, 1964.

Meyerhoff, Hans, ed., *The Philosophy of History in Our Time*, Anchor Books, Garden City, 1959.

Moholy-Nagy, László, *The New Vision*, Daphne M. Hoffman, trans., George Wittenborn, Inc., New York, 1947 [orig. pub. 1928].

Montessori, Maria, *Montessori Method*, trans. A. E. George, Heinemann, London, 1912.

Moore, Gary T., ed., *Emerging Methods in Environmental Design and Planning*, The MIT Press, Cambridge, Mass., 1970.

Musgrove, John, ed., Sir Banister Fletcher's *History of Architecture*, 19th edn, Butterworths, London, 1987.

Newman, Oscar, *Defensible Space: People and Design in the Violent City*, Architectural Press, London, 1973.

Newton, Isaac, *Mathematical Principles of Natural Philosophy*, trans. Andrew Motte, at the University Press, Cambridge, 1934 [orig. pub. 1687].

Nisbet, Robert, *Social Change and History: Aspects of the Western Theory of Development*, Oxford University Press, London, 1970.

— *The Sociological Tradition*, Heinemann, London, 1966.

Norberg-Shulz, Christian, *Intentions in Architecture*, The MIT Press, Cambridge, Mass., 1965.

Norris, Christopher and Andrew Benjamin, *What is Deconstruction?*, Academy Editions/St Martin's Press, 1988.

Osborne, Harold, *Aesthetics and Art Theory: An Historical Introduction*, Longmans, Harlow, Essex, 1968.

Palladio, Andrea, *The Four Books of Architecture*, trans. Isaac Ware, Dover Publications, Inc., New York, 1965 (Ware edition orig. pub. 1738, first pubished by Palladio as *I Quattro Libri dell' Architettura*, 1570).

Panofsky, Erwin, *Idea: A Concept in Art Theory*, trans. Joseph Peake, Harper and Row, New York, 1968 [orig. pub. 1924].

Pehnt, Wolfgang, *Expressionist Architecture*, Thames and Hudson, London, 1973.

Pérez-Gómez, Alberto, *Architecture and the Crisis of Modern Science*, The MIT Press, Cambridge, Mass., 1983.

Pestalozzi, Jean Heinrich, *How Gertrude Teaches Her Children*, trans. L. E. Holland and F. C. Turner, London, 1894.

Pevsner, Nikolaus, *Academies of Art Past and Present*, Cambridge University Press, Cambridge, 1940.

— *An Outline of European Architecture*, Penguin Books, Harmondsworth, 1977 [orig. pub. 1943].

— *Some Architectural Writers of the Nineteenth Century*, Oxford, 1972.

— *Pioneers of Modern Design from William Morris to Walter Gropius*, Penguin Books, Harmondsworth, 1974. First published in a different form as *Pioneers of the Modern Movement* in 1936.

Piaget, Jean, *Biology and Knowledge*, trans. Beatrix Walsh, Edinburgh University Press, Edinburgh, 1971.

— *Structuralism*, trans. Chaninah Maschler, Routledge & Kegan Paul, London, 1971.

— *The Principles of Genetic Epistemology*, trans. Wolfe Mays, Routledge & Kegan Paul, London, 1972.

Plato, *The Dialogues of Plato*, trans. B. Jowett, 4th edn, The Clarendon Press, Oxford, 1953.

Plotinus, *Enneads*, trans. Stephen MacKenna, The Medici Society Ltd, London, 1926.

Popper, Karl, *The Logic of Scientific Discovery*, Harper & Row, New York, 1959.

— *Conjectures and Refutations*, Routledge & Kegan Paul, London, 1963.

— *The Poverty of Historicism*, Routledge & Kegan Paul, London, 1976.

Pugin, Augustus Welby, *Contrasts; or, A Parallel between the Noble Edifices of the Fourteenth and Fifteenth Centuries, and Similar Buildings of the Present Day; Shewing the Present Decay of Taste: Accompanied by Appropriate Text*, Humanities Press, New York, 1969 [first published 1836].

— *The Present State of Ecclesiastical Architecture in England*, Charles Dolman, London, 1843.

— *The True Principles of Pointed or Christian Architecture*, Academy Editions, London, 1973 [first published 1841].

Rapoport, Amos, *House Form and Culture*, Prentice-Hall, Inc., Englewood Cliffs, 1969.

Reynolds, Sir Joshua, *Discourses on Art*, ed. Robert Wark, Yale University Press, New Haven and London, 1975.

Rittel, Horst, 'Son of Rittelthink', an interview in 'The Design Methods Group 5th Anniversary Report', University of California, Berkeley, January 1972.

Robertson, D. S., *Greek and Roman Architecture*, 2nd edn, Cambridge University Press, Cambridge, 1980.

Rosenau, Helen, *Boullée and Visionary Architecture*, Academy Editions, London, 1976.

Rousseau, Jean-Jacques, *A Discourse on the Arts and Sciences*, in *The Social Contract and Discourses*, trans. G. D. H. Cole, J. M. Dent & Sons, London, 1973.

— *Émile*, trans. Barbara Foxley, J. M. Dent & Sons Ltd, London, 1974.

Ruskin, John, *The Seven Lamps of Architecture*, Dana Estes & Company, Boston, n.d. [first published 1849].

Russell, Frank., ed., *Quinlan Terry*, Architectural Design and Academy Editions, London, 1981.

Schinkel, K. F., *K. F. Schinkel: Collected Architectural Designs*, Academy Editions/St Martin's Press, London, 1982.

Schön, Donald, *Invention and the Evolution of Ideas*, Tavistock Publications, London, 1963.

Seidel, Andrew, 'Teaching environment and behaviour: have we reached the design studios?', *Journal of Architectural Education* 34, pp. 8–13.

Skinner, B. F., *Beyond Freedom and Dignity*, Alfred A. Knopf, New York, 1972.

Spiegelberg, Herbert, *The Phenomenological Movement: A Historical Introduction*, 2nd edn, I, Martinus Nijhoff, The Hague, 1976.

Spinoza, Benedictus, *Ethics*, trans. A. Boyle, J. M. Dent & Sons Ltd, London, 1910.

Stern, Robert, 'Classicism in Context', in Charles Jencks, ed., 'Post-Modern Classicism', *Architectural Design* 5/6, 1980.

Stevens, Gary, *The Reasoning Architect: Mathematics and Science in Design*, McGraw-Hill, Inc., 1990.

Stenhouse, Lawrence, *Culture and Education*, Thomas Nelson and Sons Ltd., London, 1967.

Stratton, Arthur, *Elements of Form and Design in Classic Architecture*, Studio Editions, London, 1987. [orig. pub. 1925].

— *The Orders of Architecture*, Studio Editions, London, 1986. [orig. pub. 1931].

Summerson, Sir John, *Architecture in Britain 1530–1830*, Penguin Books Ltd, Harmondsworth, 1979.

Taine, Hippolyte Adolphe, *History of English Literature*, I, trans. Henry van Laun, The Colonial Press, New York, 1900.

Tanner, J. *et al.*, *The Cambridge Medieval History*, at the University Press, Cambridge, 1929.

Terry, Quinlan, 'Seven Misunderstandings About Classical Architecture', in *Quinlan Terry*, Architecture Design and Academy Editions, London, 1981.

Tucker, Robert, ed., *The Marx–Engels Reader*, W. W. Norton Co., Inc., New York, 1972.

Vasari, Giorgio, *The Lives of the Artists*, trans. George Bull, Penguin Books Ltd, Harmondsworth, 1965.

— *Vasari on Technique*, trans. Louisa Maclehose, J. M. Dent & Co., London, 1907.

Venturi, Robert, *Complexity and Contradiction in Architecture*, The Museum of Modern Art, New York, 1966.

Viollet-le-Duc, Etienne, *Entretiens sur l'architecture*, Paris, 1863.

Vitruvius, *The Ten Books on Architecture*, trans. Morris Hicky Morgan, Dover Publications, Inc., New York, 1960.

Watkin, David, *Morality and Architecture*, Clarendon Press, Oxford, 1977.

Whitehead, Alfred North, *Process and Reality: an Essay in Cosmology*, The Macmillan Company, New York, 1929.

— *Science and the Modern World*, The Macmillan Company, New York, 1926.

Wingler, Hans, ed., *The Bauhaus*, MIT Press, Cambridge, Mass. and London, 1978.

Wölfflin, Heinrich, *Principles of Art History: The Problem of the Development of Style in Later Art*, trans. M. D. Hottinger, Dover Publications, Inc., New York, 1950.

Wright, Frank Lloyd, *An Autobiography*, Duell, Sloan and Pearce, New York, 1943.

— *Ausgeführte Bauten und Entwürfe von Frank Lloyd Wright*, Verlag Ernst Wasmuth AG, Berlin, 1910.

Index